E. H. GOMBRICH

SYMBOLIC IMAGES
STUDIES IN THE ART OF
THE RENAISSANCE
II

Symbolic Images

Studies in the art of the Renaissance

by E. H. Gombrich

with 170 illustrations

PHAIDON

PHAIDON PRESS LIMITED, 5 CROMWELL PLACE, LONDON SW7

PUBLISHED IN THE UNITED STATES OF AMERICA BY
PHAIDON PUBLISHERS, INC.
AND DISTRIBUTED BY PRAEGER PUBLISHERS, INC.
III FOURTH AVENUE, NEW YORK, N.Y. 10003

FIRST PUBLISHED IN VOLUME FORM 1972

ISBN 0 7148 1495 4
LIBRARY OF CONGRESS CATALOG CARD NUMBER: 74-158098
PRINTED IN GREAT BRITAIN BY R. & R. CLARK LIMITED, EDINBURGH

CONTENTS

PREFACE

IN the Preface to my volume *Norm and Form*, which is devoted to problems of style, patronage and taste in the Italian Renaissance, I mentioned that a second part dealing with Renaissance symbolism was in preparation. In the event it took longer to complete this sequel than I had anticipated, for I decided to depart from the principle I had adopted in the previous volume and also in *Meditations on a Hobby Horse*. While these are collections of published papers, more than a third of the content of this volume is new. I felt the need to bring the volume up to date, not so much by the addition of bibliographical references (which can never be complete) but by attempting to clarify the present situation in this important branch of Renaissance studies.

The nineteenth century regarded the Renaissance as a movement of liberation from the monkish dogmatism of the Middle Ages expressing its new-found enjoyment of sensuous pleasure in the artistic celebration of physical beauty. Some of the greatest historians of Renaissance painting such as Berenson and Wölfflin still stood under the spell of this interpretation, which dismissed all concern with symbolism as irrelevant pedantry. One of the first scholars to react fiercely against this aestheticism of the *fin de siècle* was Aby Warburg, the founder of the Warburg Institute, with which I have been connected for most of my scholarly life. In his intellectual biography, which I have recently published, I have shown how painfully even he had to emancipate himself from this unhistorical view to make us aware of the importance which patrons and artists of the period attached to types of subject matter which can no longer be explained without drawing on forgotten esoteric lore.

It was this need which gave rise to the systematic study of Renaissance symbolism, a study often and very one-sidedly equated with the activities of the Warburg Institute. It found its most influential representative in the great Erwin Panofsky who made this new, luxuriant branch of study known under the name of Iconology. Inevitably this new approach also changed the character of art-historical literature. While the earlier masters of the genre were able to analyse the formal harmonies of Renaissance masterpieces in unencumbered pages of lucid prose, iconological studies must carry masses of footnotes quoting and interpreting obscure texts. Naturally this detective work has its own thrills, and I hope that my lengthy and controversial essay on *Botticelli's Mythologies* conveys something of the exhilaration I felt when I returned to this kind of research after six years of war work.

Even at the time, however, I felt and I wrote that the relative ease with which Neo-Platonic texts could be used as a key to the mythological paintings of the Renaissance posed a problem of method. How could we tell in any particular case whether we were entitled to use this key, and which of the many possibilities open to us should be chosen? The question became acute when disparate interpretations were offered by several scholars, each supported by a wealth of erudition. The number of fresh connections between pictures and texts which might be acceptable to a court of law as evidence remained regrettably rare. The passage of time and the frequency with which the method was used without proper controls only increased these misgivings. None other than Erwin Panofsky expressed his own qualms with his unfailing urbanity and wit in a remark which I have chosen as a motto for the

Introduction to this volume. This new introduction on *Aims and Limits of Iconology* is principally addressed to fellow students of a technique that will remain indispensable to art historians. The aesthetic issue that may concern the art lover even more is discussed in my hitherto unpublished lecture on Raphael's *Stanza della Segnatura*, the greatest of the symbolic cycles of the Renaissance.

However incomplete this lecture may be, it shows, I believe, that the opposition which iconology has frequently encountered for its alleged concentration on intellectual rather than on formal aspects of art rests on a misunderstanding. We cannot write the history of art without taking account of the changing functions assigned to the visual image in different societies and different cultures. In the Preface to *Norm and Form* I argued that the artist's creativity can only unfold in a certain climate and that this has as much influence on the resulting works of art as a geographical climate has on the shape and character of vegetation. I may add here that the function a work of art is intended to serve may guide the process of selection and breeding no less than it does in gardening and agriculture. An image intended to reveal a higher reality of religion or philosophy will assume a different form from one that aims at the imitation of appearances. What iconology has taught us is the degree to which this purpose of art to reflect the invisible world of spiritual entities was taken for granted not only in religious but also in many branches of secular art.

This is the theme of my paper *Icones Symbolicae*, after which this volume is named. It is the longest and, I fear, the most technical of the essays here assembled. In its original form it dealt precisely with the Neo-Platonic notion of images as instruments of a mystical revelation. I have now considerably expanded its scope to pay more heed to the equally influential teachings of Aristotelian philosophy which link the visual image with the didactic devices of the medieval schools and with the Rhetorical theory of metaphor. I have also extended the chronological span of this survey to show the survival of these ideas into Romanticism and down to the theories of symbolism developed by Freud and Jung.

Here, I trust, lies the justification in making such specialized studies accessible to a wider public. The traditions with which they deal are of more than antiquarian interest. They still affect the way we talk and think about the art of our own time. While I was at work on this volume I received an invitation for a one-man show at the Royal College of Art which carried a quotation from the introduction to its catalogue (by Peter Bird): 'An image of something transcendent pointing to an unseen world of feeling and imagination'. The conventional eulogy of the enigmatic symbols created by contemporary artists still echoes the ancient metaphysical notions with which I am here concerned. Knowing their antecedents and their implications will help us to decide how far we want to accept or reject such claims.

In conclusion I wish to thank the editors of journals in which these essays were first printed, most of all my colleagues on the Editorial Board of the Journal of the Warburg and Courtauld Institutes, for permitting me to re-publish them. Mr. David Thomason and Miss Hilary Smith kindly assisted in the preparation of the manuscript and Dr. I. Grafe of the Phaidon Press was as indefatigable and perceptive as ever with his help and advice.

London, June 1971 E. H. G.

Introduction: Aims and Limits of Iconology

There is admittedly some danger that iconology will behave, not like ethnology
as opposed to ethnography, but like astrology as opposed to astrography.
 Erwin Panofsky, *Meaning in the Visual Arts*,
 New York, 1955, p. 32

The Elusiveness of Meaning

IN the centre of Piccadilly Circus, the centre of London, stands the statue of Eros
(Fig. 1), meeting-point and landmark of the amusement quarters of the metro-
polis. The popular rejoicings in 1947 which greeted the return of the God of Love
as the master of revels from a place of safety to which the monument had been
removed at the outset of the war showed how much this symbol had come to mean
to Londoners.[1] Yet it is known that the figure of the winged youth aiming his
invisible arrows from the top of a fountain was not intended to mean the God of
earthly love. The fountain was erected from 1886 to 1893 as a memorial to a great
philanthropist, the seventh Earl of Shaftesbury, whose championship of social
legislation had made him, in the words of Gladstone's inscription on the monu-
ment, 'An example to his order, a blessing to this people, and a name to be by them
ever gratefully remembered'. The statement issued by the Memorial Committee
says that Albert Gilbert's fountain 'is purely symbolical, and is illustrative of
Christian Charity'. According to the artist's own word, recorded ten years later in
a conversation, he desired indeed to symbolize the work of Lord Shaftesbury:
'The blindfolded Love sending forth indiscriminately, yet with purpose, his missile
of kindness, always with the swiftness the bird has from its wings, never seeking to
breathe or reflect critically, but ever soaring onwards, regardless of its own perils
and dangers.'

Eight years later another statement of the artist shows him veering a little closer
to the popular interpretation of the figure. 'The Earl had the betterment of the
masses at heart,' he wrote in 1911—'and I know that he thought deeply about the
feminine population and their employment. Thus, with this knowledge added to
my experience of continental habits, I designed the fountain so that some sort of
imitation of foreign joyousness might find place in cheerless London.' Perhaps
Eros is Eros after all?

But another puzzle remains. A persistent rumour has attributed to the artist
the intention of alluding to the name of Shaftesbury by showing the archer with
his bow pointing downwards as if the shaft had been buried in the ground. At
least one witness claimed in 1947 to have heard this explanation from the artist's

I

own lips before the unveiling of the monument. Alas, Gilbert himself in his state-ment of 1903 counted this 'silly pun' by 'some ingenious Solon' among the many indignities he had to endure on the revelation of the fountain, which he had not been allowed to complete according to his design. His idea had been a drinking fountain, and he admitted in the same context that the chains by which the beakers were fastened, were developed by him on the basis of Shaftesbury's initials, an idea he evidently thought much superior to the one he was eager to refute.

Close as the story is to our own time—Gilbert died in 1934—the conscientious writer of the *Survey of London* to whose research the above account is indebted, admits to a certain amount of uncertainty. How much meaning did the artist have in mind? We know that he was an opponent of the 'coat and trouser school' of public monuments and keen to persuade the Committee to accept a different image as a monument. He had gained his reputation as a sculptor of such mythological themes as 'Icarus', and he was obviously captivated by the artistic possibilities of embodying in the monument another such figure which demanded a lightness of touch; his Eros, poised on tiptoe, is a variant of the famous sculptural problem so brilliantly exemplified in Giovanni da Bologna's *Mercury* (Fig. 2). Should we not say that this was the meaning of the work that mattered to the artist, regardless of the symbolic reference or punning allusions that have become the concern of the iconologist?

But whatever motives Gilbert may have had in choosing his theme, he also had to persuade his Committee by accommodating his desire to a given commission and situation. The quarrel whether it was the Committee or the artist who was concerned with the 'true' meaning of the sculpture would get us nowhere. What we might find at the end of such a dispute would only be that 'meaning' is a slippery term, especially when applied to images rather than to statements. Indeed the iconologist may cast back a wistful glance at the inscription by Gladstone quoted above. Nobody doubts what it means. True, some passers-by may look for an interpretation of the statement that Shaftesbury was 'an example to his order', but nobody would doubt that the statement has a meaning which can be established.

Images apparently occupy a curious position somewhere between the statements of language, which are intended to convey a meaning, and the things of nature, to which we only can give a meaning. At the unveiling of the Piccadilly fountain one of the speakers called it 'a remarkably suitable memorial to Lord Shaftesbury, for it is always giving water to rich and poor alike . . .'. It was an easy, indeed a some-what trite comparison to make; nobody would infer from it that fountains mean philanthropy—quite apart from the fact that giving to the rich would not fall under this concept.

But what about the meaning of works of art? It looks quite plausible to speak of various 'levels of meaning' and to say for instance, that Gilbert's figure has a

representational meaning—a winged youth—that this representation can be re-
ferred to a particular youth, i.e. the God Eros, which turns it into the *illustration*
of a myth, and that Eros is here used as a *symbol* of *Charity*.[2] But on closer inspec-
tion this approximation to meaning breaks down on all levels. As soon as we start
to ask awkward questions the apparent triviality of representational meaning dis-
appears and we feel tempted to question the need invariably to refer the artist's
form to some imagined significance. Some of these forms, of course, can be named
and classified as a foot, a wing, or a bow, but others elude this network of classifi-
cation. The ornamental monsters round the base (Fig. 3) no doubt are meant partly
to represent marine creatures, but where in such a composition does the meaning
end and the decorative pattern begin? More is altogether involved in the interpre-
tation of representational conventions than literally 'meets the eye'. The artist
depends far more than the writer on what I called, in *Art and Illusion*, 'the be-
holder's share'. It is characteristic of representation that the interpretation can
never be carried beyond a certain level of generality. Sculpture not only abstracts
from colour and texture, it also cannot signify any scale beyond itself. Eros in
Gilbert's imagination may have been a boy or a giant, we cannot tell.

If these limitations of the image may seem of little concern to the interpreter
eager to arrive at the meaning of it all, the next level of illustration presents more
serious problems. Clearly there are some aspects of the figure which are meant to
facilitate identification—the winged youth as an archer (Fig. 143) calls up one and
only one figure in the mind of the educated Westerner: it is Cupid. This applies
to pictures exactly as it applies to literary text. The crucial difference between the
two lies of course in the fact that no verbal description can ever be as particularized
as a picture must be. Hence any text will give plenty of scope to the artist's ima-
gination. The same text can be illustrated in countless ways. Thus it is never
possible from a given work of art alone to reconstruct the text it may illustrate.
The only thing we can know for certain is that not all its features can be laid down
in the text. Which are and which are not, can only be established once the text has
been identified by other means.

Enough has been said about the third task of interpretation, the establishment
of symbolic references in our particular instance, to show the elusiveness of the
concept of meaning. Eros meant one thing to the London revellers, another to the
Memorial Committee. The pun of shafts-bury seems to fit the circumstances so
well that it might be argued that this cannot be an accident. But why not? It is the
essence of wit to exploit such accidents and to discover meanings where none were
intended.

But does it matter? Is it really with the intention that the iconologist is primarily
concerned? It has become somewhat fashionable to deny this, all the more since
the discovery of the unconscious and of its role in art seems to have undermined

the straightforward notion of intention. But I would contend that neither the Courts of Law nor the Courts of Criticism could continue to function if we really let go of the notion of an intended meaning.

Luckily this case has already been argued very ably in a book concerned with literary criticism, D. E. Hirsch's *Validity in Interpretation*.[3] The main purpose of that astringent book is precisely to reinstate and justify the old common-sense view that a work means what its author intended it to mean, and that it is this intention which the interpreter must try his best to establish. To allow for this restriction of the term *meaning* Hirsch proposes to introduce two other terms the interpreter may want to use in certain contexts, the terms *significance* and *implication*. We have seen for instance that the significance of the figure of Eros has changed beyond recognition since the period in which it was set up. But it is because of such situations that Hirsch rejects the facile view that a work simply means what it means to us. The meaning was the intended one of symbolizing Lord Shaftesbury's Charity. Of course the choice of the figure of Eros may also be said to have had *implications* which account both for its meaning and its subsequent change of significance. But while the interpretation of meaning can result in a simple statement like the one issued by the memorial committee, the question of implication is always open. Thus we have seen that Gilbert opposed the 'coat and trouser school' and wished through his choice to bring a note of foreign gaiety into the stodgy atmosphere of Victorian England. To spell out and interpret this kind of intention one would have to write a book, and that book would only scratch the surface, whether it deals with the heritage of puritanism, or with the idea of 'foreign joyousness' prevalent in the eighteen-nineties. But this endlessness in the interpretation of implications is by no means confined to works of art. It applies to any utterance embedded in history. Gladstone, it will be remembered, referred to Lord Shaftesbury in the inscription on the memorial as 'an example to his order'. Not every modern reader may immediately catch the meaning of that term, since we are no longer used to think of the peerage as an order. But here as always it is clear that the meaning we seek is the one Gladstone intended to convey. He wanted to exalt Lord Shaftesbury as a person whom his fellow peers could and should emulate.

The implications of the inscription, on the other hand, are perhaps more open to speculation. Was there a hint of political polemics in calling the Earl 'an example to his order'? Did Gladstone wish to imply that other members of the order interested themselves too little in social legislation? To investigate and spell out these implications would again lead us to an infinite regress.

No doubt we would find fascinating evidence on the way about Gladstone and about the state of England, but the task would by far transcend the interpretation of the meaning of Gladstone's statement. Dealing, as he does, with literature rather

than art, Hirsch comes to the conclusion that the intended meaning of a work can only be established once we have decided what category or genre of literature the work in question was intended to belong to. Unless we try to establish first whether a given literary work was intended as a serious tragedy or as a parody, our interpretation is likely to go very wrong indeed. This insistence on the importance of such a first step may at first look puzzling, but Hirsch shows convincingly how hard it is for the interpreter to retrace his steps once he has taken such a false turning. People have been known to laugh at tragedies if they took them to be parodies.[4]

Though traditions and functions of the visual arts differ considerably from those of literature the relevance of categories or genres for the business of interpretation is the same in both fields. Once we have established that Eros belongs to the tradition or institution of memorial fountains we are no longer likely to go very wrong in its interpretation. If we took it to be an advertisement of theatre-land we could never find our way back to the intended meaning.

Iconography and Iconology

It may be argued that any conclusions derived from an example of late Victorian art are scarcely applicable to the very different situation of Renaissance art which, after all, is the principal subject of these studies. But the historian will always do well to proceed from the known to the unknown, and he will be less surprised to discover the elusiveness of meaning that confronts the interpreter of Renaissance art, once he has discovered the corresponding problem at his very doorstep.

Moreover the methodological principles established by Hirsch, particularly the principle of the primacy of genres—if it may so be called—applies to the art of the Renaissance with even greater stringency than it does to the nineteenth century. Without the existence of such genres in the traditions of Western art the task of the iconologist would indeed be desperate. If any image of the Renaissance could illustrate any text whatsoever, if a beautiful woman holding a child could not be presumed to represent the Virgin and the Christchild, but might illustrate any novel or story in which a child is born, or indeed any textbook about child-rearing, pictures could never be interpreted. It is because there are genres such as altar paintings, and repertoires such as legends, mythologies, or allegorical compositions, that the identification of subject matters is at all possible. And here, as in literature, an initial mistake in the category to which the work belongs, or worse still, ignorance of possible categories will lead the most ingenious interpreter astray. I remember a gifted student whose enthusiasm for iconology so carried him away that he interpreted St. Catherine with her wheel as an image of Fortuna. Since the Saint had appeared on the wing of an altar representing the Epiphany he was led from

there to a speculation of the role of Fate in the story of salvation—a train of thought which could easily have led him to the postulation of a heterodox sect if his initial mistake had not been pointed out to him.

The identification of texts illustrated in a given religious or secular picture is usually considered part of iconography. Like all kinds of historical detective work the solution of iconographic puzzles needs luck as well as a certain amount of background knowledge. But given this luck the results of iconography can sometimes meet exacting standards of proof. If a complex illustration can be matched by a text which accounts for all its principal features the iconographer can be said to have made his case. If there is a whole sequence of such illustrations which fits a similar sequence in a text the possibility of the fit being due to accident is very remote indeed. I believe that there are three such examples in this volume which meet this standard. One identifies the astrological text or texts illustrated in the *Sala dei Venti* in the Palazzo del Te (pp. 109–118), the second explains the version of the story of Venus and Mars in the same Palace (p. 108); and the third fits Poussin's Orion to a text which not only tells but also explains the story, an explanation Poussin embodied in his illustration (pp. 119–122).

Other essays are concerned with more speculative interpretations, but then they deal with iconological rather than iconographic problems. Not that the distinction between these disciplines is very obvious, or that it would be important to make it so. But by and large we mean by iconology, since the pioneer studies of Panofsky, the reconstruction of a programme rather than the identification of a particular text.

The procedure need only be explained to show both its interest and its hazards. There is a number of images or cycles in the art of the Italian Renaissance which cannot be explained as the straightforward illustration of a given existing text. We know moreover that patrons occasionally either invented subjects to be represented or, more often, enlisted the aid of some learned man to supply the artist with what we call a 'programme'. Whether or not this habit was as frequent, particularly in the fifteenth century, as modern studies appear to suggest it is hard to say; but examples of this kind of 'libretto' have certainly come down to us in great numbers from the second half of the sixteenth century onward. If these programmes in their turn had consisted of original inventions or fantasies the task of reconstructing such a lost text from a picture would again be pretty hopeless. But this is not so. The genre of programmes was based on certain conventions, conventions closely rooted in the respect of the Renaissance for the canonic texts of religion and of antiquity. It is from a knowledge of these texts and a knowledge of the picture that the iconologist proceeds to build a bridge from both sides to close the gap between the image and the subject matter. Interpretation becomes reconstruction of a lost piece of evidence. This evidence, moreover, should not only help the iconologist to identify the story which may be illustrated. He wants to get at the meaning of

that story in that particular context: to reconstruct—in terms of our example—what Eros on the fountain is intended to signify. He will have little chance of doing so, if he has little feeling for the kind of programme a Victorian memorial committee was likely to impose on an artist. For taking the work as such, there is no limit to the significance that might be read into it. We have called the fish-like creatures around the fountain ornamental, but why should they not allude to the fish-symbol of Christ or, conversely, be intended as monsters over which Eros-Charity is seen to triumph?

One of the essays in this volume deals with the problems arising from this methodological uncertainty. It raises the question whether Raphael's *Stanza della Segnatura* has not been frequently over-interpreted. While its specific suggestions are unlikely to meet with universal assent, the problem of the limits of interpretation could not well be omitted from a volume concerned with symbolism in Renaissance art. For all iconological research depends on our prior conviction of what we may look for, in other words, on our feeling for what is or is not possible within a given period or milieu.

The Theory of Decorum

Once more we come back to the 'primacy of genres' postulated before. This is obviously not a place to attempt a survey of all the categories and usages of art that can be documented from the Renaissance. Not that such a survey could never succeed. Emile Mâle[5] has exemplified the principles along which it might be attempted for religious art and Pigler[6] and Raymond van Marle[7] have at least made a beginning for secular subjects. But these serve the iconographer rather than the iconologist, listing possible subject matter.

Luckily Renaissance authors have not been totally silent on the principles by which these subjects were to be used in given contexts. They obviously relied on that dominant consideration of the whole classical tradition, the notion of *decorum*. The application of this term was larger in the past than it is now. It signified what was 'fitting'. There is fitting behaviour in given circumstances, a fitting style of speech for given occasions and of course also fitting subjects for given contexts.

Lomazzo in the Sixth Book of his *Trattato*[8] has a list of suggestions for various types of places, starting, strangely enough, with such places as cemeteries where a number of episodes from the Bible relating to death are mentioned such as the Death of the Virgin, the Death of Lazarus, the Descent from the Cross, the burial of Sarah, Jacob dying and prophesying, the burial of Joseph and 'such lugubrious stories of which we have many examples in the Scriptures' (Chap. XXII). For council rooms, on the other hand, which are used by 'secular princes and Lords',

he recommends such subjects as Cicero speaking about Catilina before the Senate, the Council of the Greeks before sailing for Troy, the conflicts of captains and wise men such as Lycurgus, Plato and Demosthenes among the Greeks, and Brutus, Cato, Pompey and the Caesars among the Romans, or the contest for the arms of Achilles between Ajax and Ulysses. There follows an even longer list of Biblical and ancient subjects for court buildings, of feats of military prowess for palaces, while fountains and gardens demand 'stories of the Loves of the Gods where water, trees and other gay and delightful things' come in, such as Diana and Actaeon, Pegasus calling forth the Castalian springs, the Graces washing themselves by a spring, Narcissus by the well, etc.

These and similar stories were clearly filed in the minds of Renaissance people in such a way that they could easily name, say, Biblical stories involving fire, or Ovidian stories involving water. Nor did this principle of decorum remain a dead letter. Montorsoli's Orion Fountain in Messina (Figs. 4–6) is as good an example as any to show this principle at work, with its decorative marble reliefs described by Vasari,[9] showing twenty mythological episodes involving water, such as Europa crossing the sea, Icarus falling into the sea, Arethusa changed into a fountain, Jason crossing the sea etc. (Fig. 6), not to mention the various nymphs, river god and marine monsters completing the decoration in accordance with the rules of decorum.

What these examples suggest, then, is a simple principle of selection which is easy to discern. We may call it the principle of intersection—having in mind the use of letters and numbers arranged on the sides of a chequerboard or map which are used conjointly to plot a particular square or area. The Renaissance artist or artistic adviser had in his mind a number of such maps, listing, say, Ovidian stories on one side and typical tasks on the other. Just as the letter B on such a map does not indicate one field but a zone which is only narrowed down by consulting the number, so the story of Icarus, for instance, does not have one meaning but a whole range of meaning, which in its turn is then determined by the context. Lomazzo used the theme because of its association with water, while the humanist who advised on the decoration of the Amsterdam Townhall selected it for the Bankruptcy Court (Fig. 7) as a warning against high flying ambition, while Arion's rescue by a dolphin symbolizes, not water, but insurance against shipwreck (Fig. 8).

Not that the intersection of two such requirements would necessarily satisfy the demand of the Renaissance patron for the most fitting image. The overmantel by Benedetto da Rovezzano (Fig. 9) provides an instance of an even richer interaction: for a fireplace something involving fire was clearly *de rigueur*—the most conventional subject being the smithy of Vulcan (Fig. 10). But here we have the story of Croesus and Cyrus with the pyre meeting one requirement of a fitting subject, the

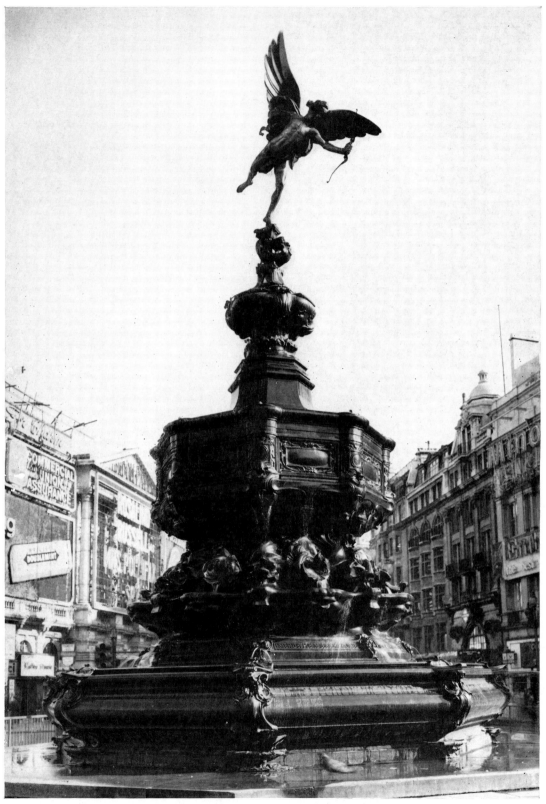

1. ALBERT GILBERT: *Eros*. London, Piccadilly Circus

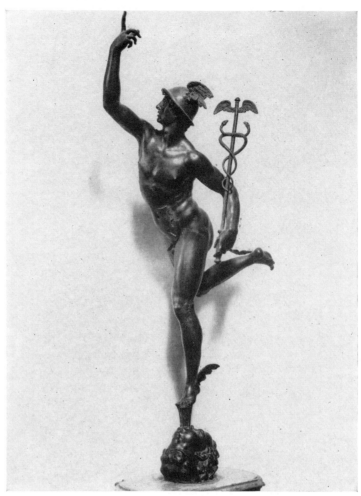

2. Giovanni Bologna: *Mercury*. Florence, Museo Nazionale

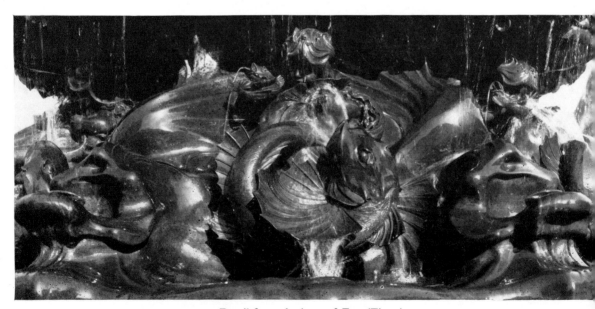

3. Detail from the base of *Eros* (Fig. 1)

4. GIOVANNI ANGELO MONTORSOLI: *The Fountain of Orion*, 1548. Messina

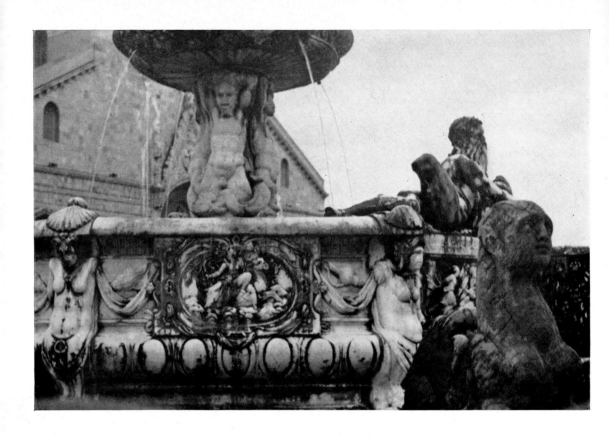

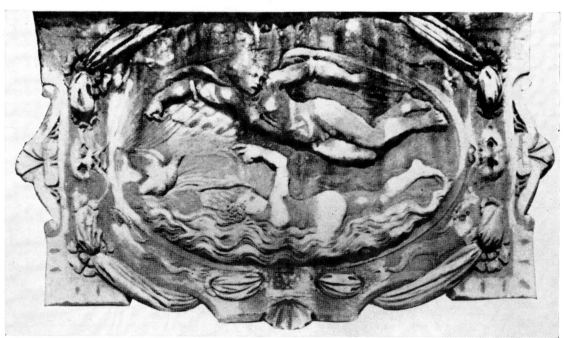

5–6. *Europa on the Bull* and *The Fall of Icarus*. Details from Montorsoli's *Fountain of Orion* (Fig. 4)

7–8. *The Fall of Icarus*; *Arion on a Dolphin*. Amsterdam, Town Hall. Engravings from Jacob van Campen, *Afbeelding van 't stadt huis van Amsterdam*, 1661

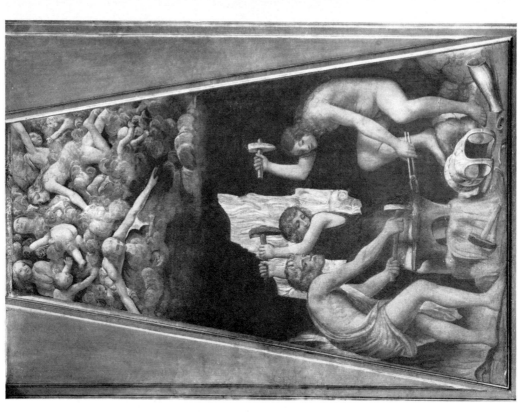

10. Bernardino Luini: *The Forge of Vulcan*. Milan, Brera

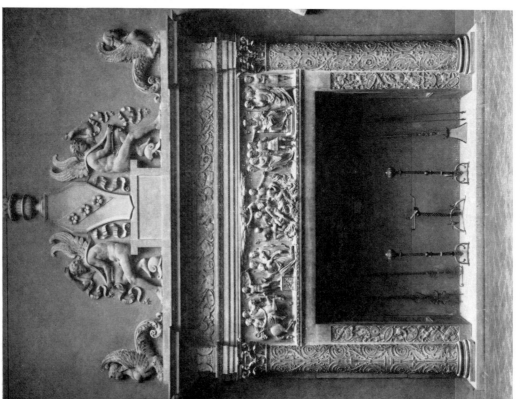

9. Benedetto da Rovezzano: *Mantelpiece*. Florence, Museo Nazionale

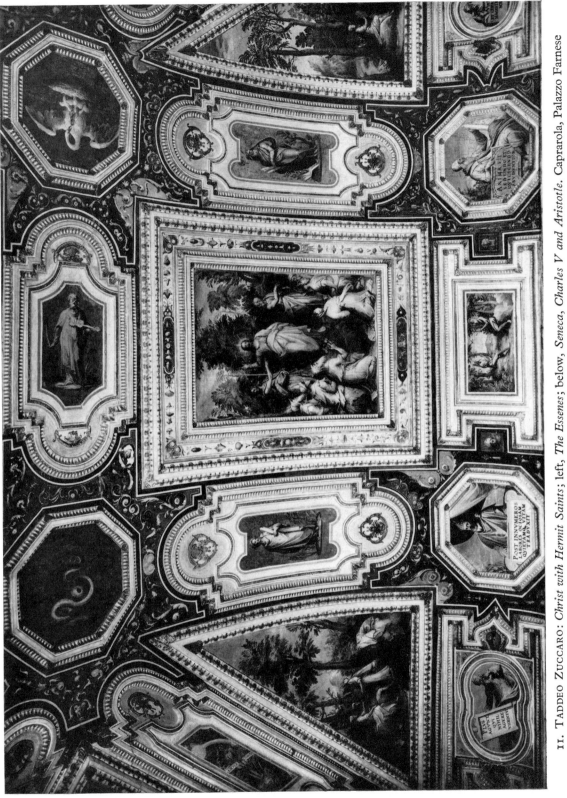

II. TADDEO ZUCCARO: *Christ with Hermit Saints*; left, *The Essenes*; below, *Seneca, Charles V and Aristotle*. Caprarola, Palazzo Farnese

12. TADDEO ZUCCARO: *Pagan Anchorites*; below, *Cato and Solyman*. Caprarola, Palazzo Farnese

13. TADDEO ZUCCARO: *The Gymnosophists*; below, *Cicero*. Caprarola, Palazzo Farnese

14. TADDEO ZUCCARO: *The Druids*. Caprarola, Palazzo Farnese

15. TADDEO ZUCCARO: *The Hyperboreans*; above, *Diogenes*; below, *Solyman and Euripides*.
Caprarola, Palazzo Farnese

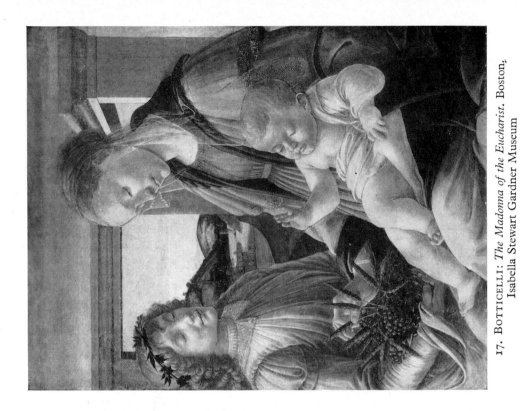

17. BOTTICELLI: *The Madonna of the Eucharist.* Boston,
Isabella Stewart Gardner Museum

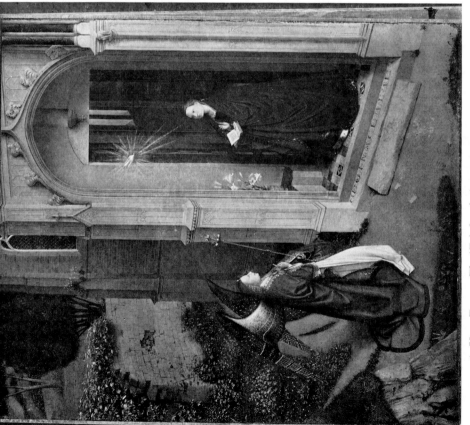

16. VAN EYCK: *The 'Friedsam' Annunciation.* New York,
Metropolitan Museum of Art

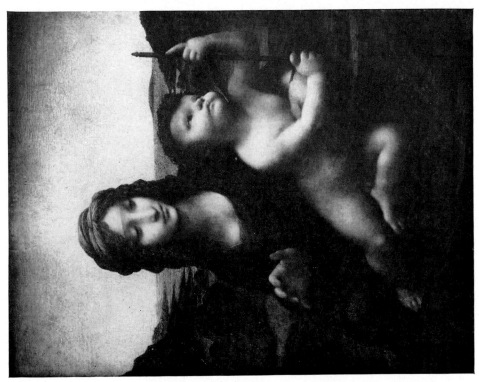

19. LEONARDO DA VINCI (copy after): *Madonna with the Yarn-Winder*. Coll. Duke of Buccleuch

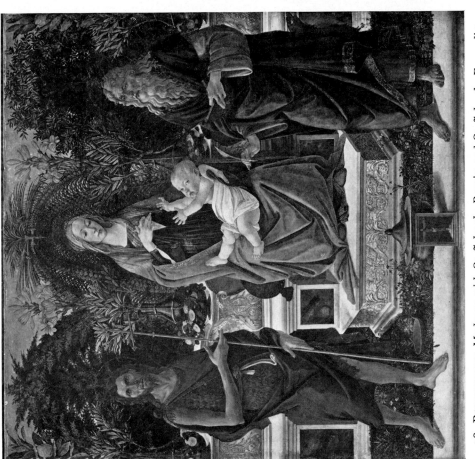

18. BOTTICELLI: *Madonna with St. John the Baptist and St. John the Evangelist.* Berlin, Staatliche Museen

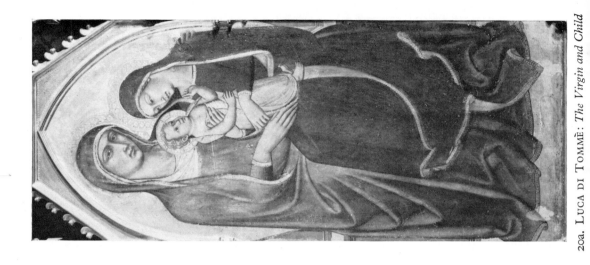

20a. LUCA DI TOMMÈ: *The Virgin and Child*

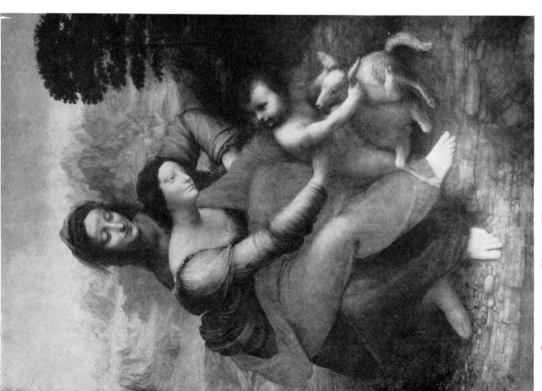

20. LEONARDO DA VINCI: *The Virgin and Child with St. Anne.*

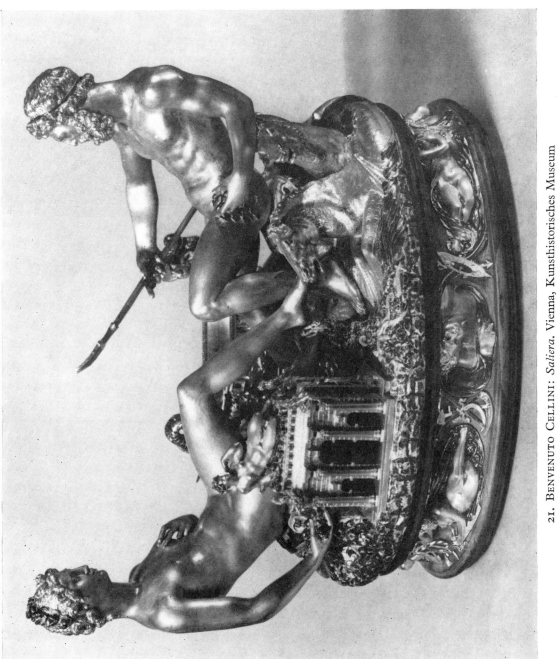

21. Benvenuto Cellini: *Saliera*. Vienna, Kunsthistorisches Museum

22. G. M. BUTTERI and G. BIZZELLI: *Grotesques* from the ceiling of the first Uffizi corridor, Florence, 1581

story of Solon's warning to 'remember the end' the equally important specification for a story with a moral lesson.

There were other requirements to be considered, not least among them the predilections and aptitudes of the artists concerned. It is often implied that the Renaissance programme paid no heed to the artist's creative bent, but this is not necessarily true. The repertory from which to choose was so rich and varied that the final choice could easily be adapted both to the demands of decorum and the preferences of the artist. Again it is not always easy to decide where, in these intersections, priority was to be sought. Describing to Aretino his frescoes from the life of Caesar, Vasari starts with the predilection which his patron has for this hero, which will make him fill the whole palace with stories from the life of Caesar. He had begun with that of Caesar's flight from Ptolemy when he swam across the water pursued by soldiers. 'As you see, I have made a melée of fighting nudes, first to demonstrate the mastery of art, and then to conform to the story.'[10]

Here, perhaps, Vasari was his own master and could please himself, but we know that artists would not meekly submit to any invention thrust upon them. In this as in many other respects the programmes which Annibale Caro drew up for Taddeo Zuccaro's decorations in the Palazzo Caprarola deserve to be studied as paradigms. The one for the bedroom with mythological figures relating to night and to sleep is easily available in Vasari's Life of Taddeo Zuccaro.[11] The other, for the studio of the prince, may be even more worth pondering in its implications for the iconologist.[12] Unfortunately these learned humanists had plenty of time and were fond of displaying their erudition. Their writings, therefore, tend to tax the patience of twentieth-century readers, but we may look at some passages to sample the mode of procedure, relegating the full text to an appendix (pp. 23–25), where connoisseurs of the *genre* can explore it further.

The themes to be painted in the Study of the illustrious Monsignore Farnese must needs be adapted to the disposition of the painter, or he must adapt his disposition to your theme. Since it is clear that he did not want to adapt to you we are compelled to adapt to him to avoid muddle and confusion. Both the subjects relate to themes appropriate to solitude. He divides the vault into two main sections, fields for scenes, and ornament to go around.

Caro goes on to suggest for the central field 'the principal and most praised kind of solitude, that of our religion, which differs from that of the Gentiles, for ours left their solitude to teach the people, while the Gentiles withdrew from the people into solitude'. Hence Christ will occupy the middle and then St. Paul, St. John the Baptist, St. Jerome and others if there is room for them (Fig. 11). Among the pagans withdrawing into solitude he suggests some of the Platonists who gouged out their own eyes so that sight should not distract them from philosophy, Timon, who hurled stones at the people, and others who handed their writings to the

people while avoiding contact with them (Fig. 12). Two fields should show the Law conceived in solitude: Numa in the vale of Egeria and Minos emerging from a cave. Four groups of hermits should fill the corners: Indian gymnosophists worshipping the sun (Fig. 13), Hyperboreans with sacks of provisions (Fig. 15), Druids 'in the oak forests which they venerated . . . let them be dressed as the painter wishes, provided they all wear the same' (Fig. 14), and Essenes, 'a Jewish sect solely dedicated to the contemplation of divine and moral matters . . . who could be shown with a repository of the garments they have in common' (Fig. 11).

The ten oblong fields of the decoration Caro proposes to fill with the reclining figures of philosophers and Saints, each with an appropriate motto, while the seven little upright fields accommodate historic figures who withdrew into solitude, including Pope Celestine, Charles V (Fig. 11) and Diogenes (Fig. 15).

There remain twelve tiny fields and since they would not accommodate human figures I would put some animals both as grotesques and as symbols of the theme of solitude. [The corners will take Pegasus (Fig. 13), a griffon, an elephant turning towards the moon (Fig. 13), and an eagle seizing Ganymede]; these should signify the elevation of the mind in contemplation; in the two little squares facing each other . . . I put the lonely eagle, gazing at the sun, which in this form signifies speculation, and the creature in itself is solitary, only bringing up one of its three offspring, casting two out. In the other I place the phoenix, also turned to the sun, which will signify the exaltedness and refinement of the concepts and also solitude, for it is unique.

Of the remaining six small round fields one is to hold the serpent that shows astuteness, eagerness and prudence of contemplation and was therefore given to Minerva (Fig. 11), the next a solitary sparrow, the third another bird of Minerva such as the owl, the fourth an erithacus, another bird reputed to seek solitude and not to tolerate companions. 'I have not yet found out what it looks like but I leave it to the painter to do as he thinks fit. The fifth a pelican (Fig. 11), to which David likens himself in his solitude when he fled from Saul, let it be a white bird, lean because it draws its own blood to feed its young. . . . Finally a hare, for it is written that this animal is so solitary that it never rests except when alone. . . .

There remain the ornaments which I leave to the imagination of the painter, but it would be well to remind him to adapt himself, if he can, in various ways and select as grotesques instruments of solitary and studious people such as globes, astrolabes, armillary spheres, quadrants, sextants, . . . laurels, myrtles and . . . similar novelties.[12]

This point apart, the painter followed Caro, who probably added the further inscriptions and examples necessitating some changes in lay-out.

Two related questions will spring to mind when we read such a programme and compare it with the finished painting. The first, whether we could have found the meaning of the pictures without the aid of this text, in other words, whether we would have been successful in reconstructing the programme from the pictures

alone. If the answer is in the negative, as I think it would have to be, it becomes all the more urgent to ask why such an enterprise would have failed in this particular instance, and what obstacles there are in general which impede this work of retranslation from picture to programme.

Some of the difficulties are fortuitous but characteristic. Caro does not claim to know how to dress Druids, and leaves the matter to the painter's fancy. One obviously would have to be a thought-reader to recognize these priests as Druids. Similarly with the bird 'Erithacus', about which Caro has read in Pliny, who describes its propensity for solitude. We do not know to this day what bird, if any, was meant, and so, again, Caro gives the painter licence to draw on his own imagination. We could not know, and we could not find out.

There are other instances where Caro's programme demands such fanciful scenes that the painter had difficulty in reproducing them legibly: would we be able to guess that one of the Platonic philosophers is represented as gouging out his eyes, or that the tablet emerging from the wood is intended to save its owner any contact with the people? Would even the most erudite iconologist remember these stories and their connection with the Platonic school?

Vasari, at any rate, could not. Though he was exceptionally well informed about Caprarola and was a friend of Annibale Caro, though he knew the main theme of the cycle to be Solitude and correctly reported many of the inscriptions in the room, and identified Solyman (Fig. 12), he misinterpreted some of the action in this panel (Fig. 12), which he describes as 'many figures who live in the woods to escape conversation, whom others try to disturb by throwing stones at them, while some gouge out their own eyes so as not to see'.[13]

But even where the difficulties of identifying the stories and symbols are less formidable than Caro and Zuccaro made them in this instance, we might still be perplexed by the meaning to be assigned to the individual symbols if Caro's text were not extant to enlighten us.

For though they are all assembled here for their association with solitude, nearly every one of them has other associations as well. The elephant worshipping the moon (Fig. 13) is used by Caro himself in the neighbouring bedroom for its association with night;[14] Pegasus, as we have seen, can decorate a fountain for its link with the Castalian spring; needless to say it can also be associated with Poetry or with Virtue. The phoenix, as a rule, stands for Immortality and the pelican for Charity. To read these symbols as signifying Solitude would look very farfetched if we did not have Caro's words for it.

The Dictionary Fallacy

The programme confirms what has been suggested here from the outset, that

taken in isolation and cut loose from the context in which they are embedded none of these images could have been interpreted correctly. Not that this observation is surprising. After all, it is even true of the words of an inscription that they only acquire meaning within the structure of a sentence. We have said that it is clear what Gladstone meant when he called Lord Shaftesbury 'An example to his order', but the word 'order' derives this definite meaning only from its context. In isolation it might mean a command, a regularity or a decoration for merit. It is true that those who learn a language are under the illusion that 'the meaning' of any word can be found in a dictionary. They rarely notice that even here there applies what I have called the principle of intersection. They are offered a large variety of possible meanings and select from them the one that seems demanded by the meaning of the surrounding text. If Lord Shaftesbury had been a monk the term 'his order' would have had to be interpreted differently.

What the study of images in known contexts suggests is only that this multiplicity of meaning is even more relevant to the study of symbols than it is to the business of everyday language. It is this crucial fact that is sometimes obscured through the way iconologists have tended to present their interpretations. Quite naturally the documentation provided in their texts and footnotes gives chapter and verse for the meaning a given symbol can have—the meaning that supports their interpretation. Here, as with language, the impression has grown up among the unwary that symbols are a kind of code with a one-to-one relationship between sign and significance. The impression is reinforced by the knowledge that there exist a number of medieval and Renaissance texts which are devoted to the interpretation of symbols and are sometimes quoted dictionary-fashion.

The most frequently consulted of these dictionaries is Cesare Ripa's *Iconologia* of 1593, which lists personifications of concepts in alphabetical order and suggests how they are to be marked by symbolic attributes.[15] Those who use Ripa as a dictionary rather than read his introduction and his explanations—and there are more entertaining books in world literature—easily form the impression that Ripa presents them with a kind of pictographic code for the recognition of images. But if they spent a little more time with the book they would see that this was not the author's intention. It turns out, in fact, that the same 'principle of intersection' that has been postulated of programmes such as Caro's applies to Ripa's technique of symbolization. Luck will have it that he also lists the concept of Solitude and that his description reads like a précis of Caro's much more ample characterization: The Allegory is to be represented as 'A woman dressed in white, with a single sparrow perched on the top of her head and holding under her right arm a hare and in her left hand a book'. Both the hare and the sparrow figure among Caro's symbols, and though we would not usually call the sparrow a solitary creature Ripa quotes the 102nd Psalm which says '*Factus sum sicut passer solitarius in tecto*'. If

anyone, however, now wanted to interpret any hare or any sparrow in a Renaissance painting as signifying Solitude he would be much mistaken.

Ripa establishes quite explicitly that the symbols he uses as attributes are illustrated metaphors. Metaphors are not reversible. The hare and the sparrow may be used in some context for their association with solitude, but they have other qualities as well, and the hare, for instance, can also be associated with cowardice. Ripa was also quite clear in his mind that the method only worked if it was aided by language. 'Unless we know the names it is impossible to penetrate to the knowledge of the significance, except in the case of trivial images which usage has made generally recognizable to everybody.' If we ask, then, why Ripa went to the trouble of devising such unrecognizable personifications, the answer must be sought in a general theory of symbolism that goes beyond the immediate task of deciphering.

Philosophies of Symbolism

It is to this problem that the major essay in this volume is devoted. In *Icones Symbolicae* two such traditions are distinguished, but neither of them treats the symbol as a conventional code. What I have called the Aristotelian tradition to which both Caro and Ripa belong is in fact based on the theory of the metaphor and aims, with its aid, to arrive at what might be called a method of visual definition. We learn about solitude by studying its associations. The other tradition, which I have called the Neo-Platonic or mystical interpretation of symbolism, is even more radically opposed to the idea of a conventional sign-language. For in this tradition the meaning of a sign is not something derived from agreement, it is hidden there for those who know how to seek. In this conception, which ultimately derives from religion rather than from human communication, the symbol is seen as the mysterious language of the divine. The augur interpreting a portent, the mystagogue explaining the divinely ordained ritual, the priest expounding the image in the temple, the Jewish or Christian teacher pondering the meaning of the word of God had this, at least, in common, that they thought of the symbol as of a mystery that could only partly be fathomed.

This conception of the language of the divine is elaborated in the tradition of Biblical exegetics. Its most rational exposition is to be found in a famous passage from St. Thomas.[16]

Any truth can be manifested in two ways: by things or by words. Words signify things and one thing can signify another. The Creator of things, however, can not only signify anything by words, but can also make one thing signify another. That is why the Scriptures contain a twofold truth. One lies in the things meant by the words used—that is

the literal sense. The other in the way things become figures of other things, and in this consists the spiritual sense.

The allusion here is to the things which are mentioned in the narrative of the Bible and which are seen as signs or portents of things to come. If the Scriptures tell us that Aaron's rod 'brought forth buds, and bloomed blossoms, and yielded almonds' (*Numbers*, xvii.8) this could be interpreted as foreshadowing the cross, the almond itself providing a symbol, its shell being bitter like the passion but its kernel sweet like the victory of the redemption.

But St. Thomas warns us not to take this technique as a method of translating unambiguous signs into discursive speech. There is no authoritative dictionary of the significance of things, as distinct from words, and in his view there cannot be such a dictionary:

It is not due to deficient authority that no compelling argument can be derived from the spiritual sense, this lies rather in the nature of similitude in which the spiritual sense is founded. For one thing may have similitude to many; for which reason it is impossible to proceed from any thing mentioned in the Scriptures to an unambiguous meaning. For instance the lion may mean the Lord because of one similitude and the Devil because of another.

St. Thomas, as will be perceived, again links this lack of a definite meaning of 'things' with the doctrine of metaphor. But where metaphors are conceived to be of divine origin this very ambiguity becomes a challenge to the reader of the Sacred Word. He feels that the human intellect can never exhaust the meaning or meanings inherent in the language of the Divine. Each such symbol exhibits what may be called a plenitude of meanings which meditation and study can never reveal more than partially. We may do well to remember the role which such meditation and study once played in the life of the learned. The monk in his cell had only few texts to read and re-read, to ponder and to interpret, and the finding of meanings was one of the most satisfying ways of employing these hours of study. Nor was this merely a matter for idle minds seeking employment for their ingenuity. Once it was accepted that revelation had spoken to man in riddles, these riddles embodied in the Scriptures and also in Pagan myths, demanded to be unravelled again and again, to provide the answers for the problems of nature and of history. The technique of finding meanings would help the priest composing his sermons day in day out on given texts which had to be applied to the changing events of the community, it would sanction the reading of pagan poets, which would otherwise have to be banished from the monastic libraries, it would give added significance to the fittings of the church and to the performance of sacred rites.

Nobody who has looked into medieval and Renaissance texts concerned with symbolism can fail to be both impressed and depressed by the learning and ingenuity expended on this task of applying the techniques of exegetics to a vast

range of texts, images or events. The temptation is indeed great for the iconologist to emulate this technique and to apply it in his turn to the works of art of the past.

Levels of Meaning?

But before we yield to this temptation we should at least pause and ask ourselves to what extent it may be appropriate to the task of interpreting the pictures or images of the past. Granted that any of these images could be seen to carry all kinds of implications—to allude to Hirsch's use of the terms—were they intended to carry more than one meaning? Were they intended, as is sometimes postulated, to exhibit the distinct four senses which exegetics attributed to the Holy Writ and which none other than Dante wished applied to the reading of his poem?

I know of no medieval or Renaissance text which applies this doctrine to works of pictorial art. Though such an argument *ex silentio* can never carry complete conviction, it does suggest that the question needs further examination. Such an examination might well take its starting-point from St. Thomas' distinction, quoted above, of the way words and things may be said to signify. Recent iconological literature has paid much and justified attention to the symbolic potentialities of things represented in religious paintings, particularly those of the late Middle Ages.

Panofsky, in particular, has stressed the importance of what he calls 'disguised symbolism' in early Netherlandish art.[17] 'Things' represented in certain religious paintings support or elaborate the meaning. The light falling through the church window in the Friedsam *Annunciation* (Fig. 16) is a metaphor for the Immaculate Conception,and the two styles of the building for the Old and the New Testaments. Even though one might wish for more evidence that these symbols and metaphors were commissioned to be *painted*, there is no doubt that religious pictures do embody things as symbols. It is certainly not for nothing that Botticelli made the Christchild bless grapes and wine, the symbols of the Eucharist (Fig. 17), and that the trees in the background of the Berlin Madonna (Fig. 18) were intended as symbols was attested by the scrolls with quotations from the Scriptures.[18]

> I was exalted like a cedar in Libanus and as a cypress tree on the mountains of Hermon. I was exalted like a palm tree on the seashore, and as rose plants in Jericho, and as a fair olive tree in the plain; and I was exalted as a plane tree.
>
> (*Ecclesiasticus*, xxiv.3, 12–14)

The possibility of making 'things' signify was not lost on such masters as Leonardo, who represented the Christchild playing with a yarnwinder (Fig. 19) recalling the shape of the cross.[19] But to what extent are these and similar examples applications of the principle of several meanings? The event is illustrated and the things figuring in the event echo and expand the meaning. But this symbolism can only function in support of what I have proposed to call the dominant meaning,

the intended meaning or principal purpose of the picture. If the picture did not represent the Annunciation, the windows could not signify by themselves, and if the ears of corn and the grapes were not the object of blessing in a painting of the Madonna, they would not be transformed into the symbol of the Eucharist. Here as always the symbol functions as a metaphor which only acquires its specific meaning in a given context. The picture has not several meanings but one.

In my view this is not contradicted by the best documented application of exegetics to a painting in the Renaissance, Fra Pietro da Novellara's famous description of Leonardo's *St. Anne* (Fig. 20):

> It represents the Christ Child, about a year old, as if about to slip out of his mother's arms, grasping a lamb and seeming to hug it. The mother, as if about to rise from the lap of St. Anne, grasps the Child to take him from the lamb, that sacrificial animal which signifies the passion. St. Anne, rising a little from her seat, seems to want to keep her daughter from taking the child away from the lamb: this would perhaps stand for the Church that does not want to have the passion of Christ prevented.[20]

The learned *frate*, Vice General of the Carmelite Order, was probably puzzled by the amount of movement Leonardo had introduced into a subject which was traditionally represented in the form of a hieratic group. Maybe the artist had the answer ready for those who asked for an explanation. But to interpret the interaction of the figures in terms of the coming drama of salvation does not, by itself, introduce a different level of meaning. The traditional group, such as we see it on a fourteenth-century Sienese altar (Fig. 20a), had never been conceived as a realistic representation. No one was expected to believe that the Virgin ever settled in the lap of her mother with the Christchild in her arms. The child is the Virgin's symbolic attribute and the Virgin in her turn the attribute of St. Anne. It is the same type of symbolic nexus which is discussed in the essay on Tobias and the Angel in this volume (pp. 26–30). Its symbolism is not hidden, but overt. Admittedly Novellara's tentative identification of St. Anne with the Church introduces an extraneous element which may have been alien to Leonardo's intention.

In this respect Novellara's interpretation differs significantly from that given in a sonnet on the same picture by Girolamo Casio which concludes:

> St. Anne, as the one who knew
> That Jesus assumed the human shape
> To atone for the Sin of Adam and Eve
> Tells her daughter with pious zeal:
> Beware if you wish to draw Him back
> For the heavens have ordained that sacrifice.[21]

In this interpretation, it will be noticed, there is no hint at two meanings. It is only implied that St. Anne had prophetic gifts and interpreted the portent of

'things' at the time. In this version, then, the painting could still be seen as a genuine illustration rather than as an allegory.

The Psycho-analytic Approach

It so happens that the example chosen has also been paradigmatic for the psycho-analytic interpretation of a work of art. In his famous essay on Leonardo Freud saw in this composition a memory of the artist's youth, for the illegitimate child had been adopted into the family, he had had 'two mothers', one of whom may have had reason to hide her bitterness behind a forced smile. It can be shown that Freud was much influenced in his reading of the childhood story of Leonardo by D. Merezhkovsky's historical novel[22] and that he was scarcely aware of the iconographic tradition on which Leonardo drew.[23] But too much emphasis on these sources of error would miss the more important methodological point of what is involved in interpreting an image. For even if Freud's reading of the situation rested on firmer evidence, even if Leonardo had been found on the couch to associate his childhood situation with this particular painting, it should still be obvious that the painting does not mean to refer to his mother and stepmother, but signifies St. Anne and the Virgin. It is important to clarify this issue, because the discoveries of psycho-analysis have certainly contributed to the habit of finding so many 'levels of meaning' in any given work. But this approach tends to confuse cause and purpose. Any human action, including the painting of a picture, will be the resultant of many, indeed an infinite number of contributory causes. Psychoanalysis likes to speak in this context of 'over-determination' and the concept has its value as a reminder of the many motivations that may overlap in the motivation of anything we say, do, or dream. But strictly speaking any event that occurs is 'over-determined' if we care to look for all the chains of causation, all the laws of nature which come into operation. If Leonardo's childhood experience should really have been one of the determining causes for his accepting a commission to paint St. Anne and the Virgin so, we may assume, were other pressures which might conceivably be traced to their source. Maybe the problem attracted him for its difficulty, maybe he was just in need of money.[24] What would matter in any of these cases is only that the innumerable chains of causation which ultimately brought the work into being must on no account be confused with its meaning. The iconologist is concerned with the latter, as far as it can be determined. The historian should remain aware of the complexity and elusiveness of the first.

Perhaps we best escape from the perplexities posed by the problem of intentionality by insisting more firmly than Hirsch has done that the intended meaning is not a psychological category at all. If it were, a sentence written by a computer

could have no meaning. We are rather concerned with categories of social accep-
tance, as is the case with all symbols and sign systems. It is these which matter to
the iconologist, whatever penumbra of vagueness they may of necessity exhibit.

Benvenuto Cellini's description of his own *Saliera* (Fig. 21) may provide an
illustration of this point. It is a clear and conventional application of the principle
of *decorum*. Being destined for salt and pepper, products of the sea and of land,
he decorated it fittingly with the figures of Neptune and of the personification of
Earth. But in describing his famous masterpiece he wanted to stress that this was
not all: 'I arranged for the legs of the male and female to be gracefully and skilfully
intertwined, one being extended and the other drawn up, which signified the
mountains and the plains of the earth.'[25] It would be futile to ask whether this little
conceit was intended from the outset, nor would it be kind to enquire whether
Neptune's knees signify the waves of the sea. Clearly the artist is entitled further
to embroider on his ideas and to rationalize what he has done in terms of such
explanations. What matters here is surely that the work does not resist this parti-
cular projection of meaning. The interpretation produces no contradiction, no
jarring split. In looking at a work of art we will always project some additional
significance that is not actually given. Indeed we must do so if the work is to come
to life for us. The penumbra of vagueness, the 'openness' of the symbol is an
important constituent of any real work of art, and will be discussed in the essay on
Raphael's *Stanza della Segnatura*.[26] But the historian should also retain his humility
in the face of evidence. He should realize the impossibility of ever drawing an exact
line between the elements which signify and those which do not. Art is always open
to afterthoughts, and if they happen to fit we can never tell how far they were part
of the original intention. We remember the conflicting evidence about the pun of
'shafts-bury' which had either been saddled on Gilbert's Eros or had been part of
his original intention.

Codes and Allusions

It so happens that even the example of such a pun can be paralleled from the
Renaissance. Vasari tells us that Vincenzio da San Gimignano carried out a façade
painting after a design by Raphael, showing the Cyclops forging the thunderbolt
of Jove, and Vulcan at work on the arrows of Cupid.[27] These, we read, were intended
as allusions to the name of the owner of the house in the *Borgo* in Rome which
these paintings adorned, one *Battiferro*, meaning hitting iron. If the story is true
the subject was chosen as what is called in heraldry a 'canting device'. The story
of such allusions should be quite salutary reading for the iconologist, for we must
admit again that we could never have guessed.

Thus Vasari also describes the festive apparatus designed by Aristotile da San

Gallo in 1539 for the wedding of Duke Cosimo de' Medici and Eleonora of Toledo.[28] The paintings, which drew on a vast repertory of history, heraldry and symbolism, illustrated episodes in the rise of the Medici family and the career of the Duke himself. But between the story of Cosimo's elevation to the Dukedom and his capture of Monte Murlo there was represented a story from Livy's twentieth book, of the three rash envoys from the Campania, driven from the Roman Senate for their insolent demands, an allusion, as Vasari explains, to the three Cardinals who vainly thought to remove Duke Cosimo from the Government. This is indeed an 'allegorical' reading of history since 'allegory' means literally 'saying something else'. Once more nobody could possibly guess the meaning if the painting were preserved outside its context. But even in such an extreme case it would be misleading to speak of various levels of meaning. The story refers to an event, just as Eros refers to Shaftesbury's Charity. In the context it has one intended meaning, though it is a meaning which it was thought wiser not to make too explicit, since it might have been better not to pillory the Cardinals.

It is characteristic, though, that this recourse to a code was taken in the context of a festive decoration, which would be taken down immediately. Secret codes and allusions of this kind have much less place in works of art intended to remain permanent fixtures.

Codes, moreover, cannot be cracked by ingenuity alone. On the contrary. It is the danger of the cipher clerk that he sees codes everywhere.

Sometime in the dark days of the Second World War, a scientist in England received a telegram from the great Danish physicist Niels Bohr, asking for 'news of Maud'.[29] Since Bohr had been one of the first to write about the possibilities of using nuclear fission for the construction of a super-bomb, the scientist was convinced that the telegram was in code. Bohr evidently wanted to have news of M-A-U-D, 'Military application of uranium disintegration'. The interpretation seemed so apt that the word was in fact later adopted as a code word for the work on the atomic bomb. But it was wrong. Bohr really wanted news of an old nanny who lived in southern England and whose name was Maud. Of course it is always possible to go further; to postulate that Niels Bohr meant both his nanny and the atom bomb. It is never easy to disprove such an interpretation, but as far as iconology is concerned it should be ruled out unless a documented example is produced.[30]

To my knowledge neither Vasari nor any other text of the fifteenth or sixteenth century ever says that any painting or sculpture is intended to have two divergent meanings or to represent two distinct events through the same set of figures. The absence of such evidence seems to me to weigh all the more heavily as Vasari was obviously very fond of such intricacies both in his own art and in the inventions of his scholar-friends. It is indeed hard to imagine what purpose such a double

image should serve within the context of a given cycle or decoration. The exercise of wit, so relished by the Renaissance, lay precisely in the assignment of a meaning to an image which could be seen to function in an unexpected light.

The Genres

We come back to the question of decorum and the institutional function of images in our period. For the exposition of ambiguity, the demonstration of plenitude had indeed a place in Renaissance culture, but it belonged to that peculiar branch of symbolism, the *impresa*. The combination of an image with a motto chosen by a member of the Nobility was not often witty but more frequently the cause of wit in others. I have discussed the philosophical background of this tradition in the essay on *Icones Symbolicae*.[31] But the freefloating symbol or metaphor to which various meanings could be assigned with such ease and relish differs both in structure and purpose from the work of art commissioned from a master. At the most they were applied to the cover of paintings or were expanded in the fresco cycles which centred on such an image.

But if the iconologist must pay attention to the technique of the *impresa* and its applications, he should not forget to attend to the other end of the spectrum of Renaissance art, the free play of form and the grotesque which could equally be fitted into the theory of decorum. In contrast to the stateroom, a corridor, and especially a garden loggia, did not have to stand on dignity. Here the amusing grotesque was allowed to run riot and artists were not only permitted but even enjoined by Renaissance authors such as Vasari to let themselves go and display their caprice and inventiveness in these 'paintings without rule'.[32] The enigmatic configuration, the monsters and hybrids of the grotesque, are professedly the product of an irresponsible imagination on holiday. Take any of these images in isolation and place it in a conspicuous place in a solemn building and everyone would be entitled to look for a deep symbolic significance. The grotesque would become a hieroglyph, asking to be unriddled (Fig. 22). It is true that even in the Renaissance some writers made play with this affinity between the grotesque and the sacred symbols of ancient mysteries, but they did so only in order to defend a kind of art for which the theory of decorum had so little respect.[33] Unlike the serious *letterati*, the laity enjoyed the play of forms and the dreamlike inconsequence of meanings it engendered. I know of no more striking document to illustrate the freedom from logical constraints which was permitted in a Renaissance garden than the description given by Giovanni Rucellai of the shaped shrubs in his Villa di Quaracchi, where one could see 'ships, galleys, temples, columns and pillars . . . giants, men and women, heraldic beasts with the standard of the city, monkeys, dragons, centaurs, camels,

diamonds, little spirits with bows and arrows, cups, horses, donkeys, cattle, dogs, stags and birds, bears and wild boars, dolphins, jousting knights, archers, harpies, philosophers, the Pope, cardinals, Cicero and more such things'.[34]

No wonder that the owner tells us that there is no stranger who can pass without looking for a quarter of an hour at this display. Still, it is clear that if this list of images occurred in any other context than that of a garden it would challenge the ingenuity of any icolonogist to find a meaning in this juxtaposition of the Pope and cardinals with Cicero and philosophers, giants, camels and harpies.

Once more we see a confirmation of the methodological rule emphasized by Hirsch: interpretation proceeds by steps, and the first step on which everything else depends is the decision to which genre a given work is to be assigned. The history of interpretations is littered with failures due to one initial mistake. Once you take watermarks in sixteenth-century books to be the code of a secret sect the reading of watermarks in the light of this hypothesis will appear to you possible or even easy;[35] it is not necessary to refer to examples nearer home, nor need we scoff at such failures. After all, if we did not know from independent evidence that Taddeo Zuccari's fresco cycle for which Caro's programme has been quoted was designed for the customary *studiolo* into which the Prince could withdraw from the bustle of the court and that it is therefore devoted to the theme of solitude, we would almost certainly interpret the room as a place of worship of a syncretistic sect.

Iconology must start with a study of institutions rather than with a study of symbols. Admittedly it is more thrilling to read or write detective stories than to read cookery books, but it is the cookery book that tells us how meals are conventionally composed and, *mutatis mutandis*, whether the sweet can ever be expected to be served before the soup. We cannot exclude a capricious feast which reversed all the orders and accounts for the riddle we were trying to solve. But if we postulate such a rare event, we and our readers should know what we are doing.

One methodological rule, at any rate, should stand out in this game of unriddling the mysteries of the past. However daring we may be in our conjectures—and who would want to restrain the bold?—no such conjectures should ever be used as a stepping stone for yet another, still bolder hypothesis. We should always ask the iconologist to return to base from every one of his individual flights, and to tell us whether programmes of the kind he has enjoyed reconstructing can be documented from primary sources or only from the works of his fellow iconologists. Otherwise we are in danger of building up a mythical mode of symbolism, much as the Renaissance built up a fictitious science of hieroglyphics that was based on a fundamental misconception of the nature of the Egyptian script.

There is at least one essay in this volume to which this warning applies. The interpretation of Botticelli's Mythologies in the light of Neo-Platonic philosophy

remains so conjectural that it should certainly not be quoted in evidence for any further Neo-Platonic interpretation that could not stand on its own feet. I have given the reason in a brief new introduction for my including this paper despite its risky hypothesis. I hope it gains some fresh support from some of the general considerations put forward in the essay on *Icones Symbolicae*. But the conclusions of that paper luckily do not depend in their turn on the acceptance of my interpretation of this particular set of pictures. Even if Maud really just meant Maud, some telegrams in wartime meant more than they said.

Appendix: Annibale Caro's Programme for Taddeo Zuccaro

from Bottari-Ticozzi, *Raccolta di Lettere*, III, pp. 249–56

Annibal Caro al P. fra Onofrio Panvinio

L'invenzioni per dipigner lo studio di monsig. illustriss. Farnese è necessario che siano applicate alla disposizion del pittore, o la disposizion sua all'invenzion vostra; e poichè si vede che egli non s'è voluto accomodare a voi, bisogna per forza che noi ci accomodiamo a lui, per non far disordine e confusione. Il soggetto d'ambedue è di cose appropriate alla solitudine. Egli comparte tutta la volta in due parti principali; che sono vani per istorie, ed ornamenti intorno a'vani. Parleremo de'vani, dove hanno a star l'istorie che sono d'importanza. Sono questi vani di quattro sorte; maggiori, minori, piccoli e minimi; e così di quattro sorte invenzioni bisogna fare per dipignerli. Per li maggiori, maggiori; per gli minori, di men figure; per li piccoli, d'una sola figura; e per gli minimi che non son capaci di figure, di simboli, e d'altre cose che non siano figure umane. De'quattro vani maggiori due ne sono in mezzo della volta, e due nelle teste. In uno di quelli del mezzo, che è il principale, farei la principale e più lodata specie di solitudine, che è quella della nostra religione; la quale è differente da quella de' Gentili, perchè i nostri sono usciti della solitudine per ammaestrare i popoli, ed i Gentili, dai popoli si sono ritirati nella solitudine. In uno dunque de'gran quadri del mezzo farei la solitudine de' cristiani; e nel mezzo d'esso rappresenterei CRISTO nostro signore, e dagli lati poi di mano in mano, Paolo apostolo, Giovanni precursore, Ieronimo, Francesco e gli altri (se più ve ne possono capire) che, di diversi luoghi uscendo dal deserto, venissero incontro ai popoli a predicar la dottrina evangelica; fingendo dall' una parte del quadro il deserto, dall'altro le genti.

Nell'altro quadro d'incontro a questo farei, per lo contrario, la solitudine de'Gentili, e metterei più sorte di filosofi, non che uscissero, ma che entrassero nel deserto, e voltassero le spalle ai popoli; esprimendo particolarmente alcuni de' Platonici, che si cavassero anco gli occhi, perchè dalla vista non fossero impediti di filosofare. Ci farei Timone, che tirasse de' sassi alle genti; ci farei alcuni che, senza esser veduti, stendessero fuor delle macchie alcune tavole o scritti loro, per ammaestrare le genti senza praticar con esse. E queste due sarebbono l'istorie degli due vani principali di mezzo, che conterrebbono la materia della solitudine in universale. In uno di quelli delle teste, che verrebbe ad essere il terzo maggiore, verrei al particolar del legislator de Romani, e farei Numa Pompilio nella valle d'Egeria, con essa Egeria Ninfa, a ragionar seco appresso a un fonte, con boschi ed antri, e tavole di leggi d'intorno. Nell'altro dell'altra testa di rincontro, farei Minos, primo legislatore della Grecia, che uscisse d'un antro con alcune tavole in mano, e che nell' oscuro dell'antro fosse un Giove, dal quale egli diceva d'aver le leggi.

Negli quattro quadri minori faremo le quattro nazioni trovate da voi. E perchè il pittore intenda, in uno i Ginnosofisti, nazion d'India, pure in un deserto, ignudi, in atto di contemplanti e di disputanti; e ne farei alcuni volti al Sole, che fosse a mezzo del cielo, perchè loro costume era di sacrificare a mezzogiorno. Nel secondo, gli Iperborei Settentrionali, vestiti, coi gesti medesimi di disputare e contemplare, sotto arbori pomiferi, con sacchi di riso e di farina intorno, di che viveano; e non sapendo il lor abito, me ne rimetto al pittore. Nel terzo i Druidi, magi de' Galli, fra selve di querce, le quali aveano in venerazione; e senza le loro frondi non faceano mai sacrificio: e 'l vischio che nasceva in

23

loro, aveano per Dio. Vestansi pur come piace al pittore, purchè tutti d'una guisa. Nel quarto, gli Esseni, gente giudaica, santa, casta, senza donne, romita, e contemplatori solamente delle cose divine e morali. Questi vestono anch'essi tutti in un modo: e di state, veste d'inverno, e d'inverno quelle d'estate; le tengono comunemente, e le ripigliano in confuso; e si potria fare un loco che paresse repositorio di vesti comuni.

I vani piccioli sono tutti dentro all ornamento, siccome anco i minimi e chiamammo Piccioli, che non sono capaci se non d'una figura, e Minimi che non capiscono anco figure di naturale. I piccioli sono in tutto diciassette, ma dieci d'una sorta e sette d'un'altra. Nelli diece, che sono quelli dell'ornamento estremo, che abbracciano tutto il vano, perchè giacciono per lo lungo, farei le figure a giacere, e rappresenterei dieci grandi autori che hanno parlato della solitudine. Nelli sette, che sono dentro dell'ornamento, perchè hanno la lor lunghezza in alto, porrei ritti quelli che l'hanno messa in opera. Nel primo delli dieci farei uno Aristotile, appoggiato per lo lungo, secondo che giace il quadro; in quell' abito che lo fanno ora, o finto o vero che sia, con una tavola in mano, o fra le gambe o scritta da lui con queste parole: ANIMA FIT, SEDENDO ET QUIESCENDO, PRUDENTIOR. Nel secondo, un Catone in abito di senator romano, e di questo ci è la effigie tenuta per sua, ancora che non fosse; e nella sua tavola scriverei questo suo motto: QUEMADMODUM NEGOTII, SIC ET OTII RATIO HABENDA. Nel terzo un Euripide; ed anco di questo si trova l'effigie cavata da certi termini antichi: la tavola o la cartella sua dica: QUI AGIT PLURIMA, PLURIMUM PECCAT. Nel quarto un Seneca Morale in abito di filosofo; non sapendo donde cavar l'effigie, con questa sentenza in una simil tavola: PLUS AGUNT, QUI NIHIL AGERE VIDENTUR. Nel quinto, un Ennio, coronato e vestito da poeta, la cui tavola dicesse: OTIO QUI NESCIT UTI, PLUS NEGOTII HABET. Avvertendo che le tavole, o cartelle o brevi che si chiamino, siano diversamente tenute e collocate, per variare. Nel sesto, Plutarco, in abito pur di filosofo, che scriva, o tenga questo motto: QUIES ET OTIUM IN SCIENTIAE, ET PRUDENTIAE EXERCITATIONE PONENDA. Nel settimo farei M. Tullio, pur da senatore, con un volume all'antica rinvolto all'ombilico che pendesse, con queste lettere: OTIUM CUM DIGNITATE, NEGOTIUM SINE PERICULO. Nell' ottavo, un Menandro, in abito greco comico, con una maschera appresso, e con la tavola che dicesse: VIRTUTIS ET LIBERAE VITAE MAGISTRA OPTIMA SOLITUDO. Nel nono, un Gregorio Nazianzeno, in abito episcopale, con la sua tavola con questo detto: QUANTO QUIS IN REBUS MORTALIBUS OCCUPATIOR, TANTO A DEO REMOTIOR. Nel decimo, un s. Agostino, col suo abito da frate, e con questa sua sentenza: NEMO BONUS NEGOTIUM QUAERIT, NEMO IMPROBUS IN OTIO CONQUIESCIT.

Ne' vani piccoli alti, ponendo (come s'e detto) quelli che si sono dati alla solitudine, di tutti ne scerrei sette di sette condizioni, come sono sette i vani. Nel primo porrei un pontefice romano, e questo sarebbe Celestino, che depose il papato. Nel secondo, un imperatore, e questo farei Diocleziano; che, lasciato l'imperio, se n'andò in Ischiavonia a rusticare. E tra i moderni ci potrebbe aver loco ancora Carlo V. Per un re degli antichi ci si potrebbe metter Tolomeo Filadelfo, che ritraendosi dall'amministrazione del regno, attese agli studi, e fece quella famosa libreria. De' moderni re, Pietro d'Anglia, che, lasciato il regno, venne a Roma e visse privato in poverta. Per un cardinale, il medesimo s. Ieronimo; o de' moderni, Ardicino della Porta, cardinal d'Aleria, sotto Innocenzio VIII. Per un tiranno, Ieron Siracusano, che, caduto in infermità, chiamato a sè Simonide, ed altri poeti, si diede a filosofare. Per un gran capitano, Scipione Africano, che, lasciata la cura della repubblica, si ritirò a Linterno. Per un filosofo notabile, Diogene, con la sua botte.

Ci restano dodici altri vani minimi, tramezzati tra gli minori già detti. Ed in questi, non potendo metter figure umane, farei alcuni animali, come per grottesche, e per simboli di questa materia della solitudine, e delle cose appartenenti ad essa. E prima porrei gli quattro principali negli quattro cantoni. In uno, il Pegaso, cavallo alato delle Muse; nell altro, il Grifo; nel terzo, l'elefante col grugno rivolto alla luna; nel quarto, l'aquila, che rapisse Ganimede; essendo che tutti questi sieno significativi d'elevazion di mente e di contemplazione. Negli due quadretti, poichè sono dalle teste, l'uno a rincontro dell' altro, nell' un farei l'aquila solo, affissata al sole, che significa in cotal guisa speculazione, e per sè stessa è animal solitario; e di tre figliuoli che fa, due sempre ne gitta via, ed un solo n'alleva. Nell' altro porrei la fenice, pur volta al sole, che significherà l'altezza e la rarezza de' concetti, ed anco la solitudine per essere unica.

Vi restano ora sei vani di questi minimi che sono tondi. Ed in uno di questi farei un serpe che mostra l'astuzia, la solerzia e la prudenza della contemplazione, che perciò fu dato a Minerva. Nell' altro, un passero solitario; che col nome stesso significa la solitudine; nel terzo, un nitticorace, o gufo o civetta che sia, che ancor essa è dedicata a Minerva, per esser uccello notturno, e significativo degli studi. Nel quarto farei un eritaco, uccello tanto solitario, che di lui si scrive che non se ne ritrovano mai due in un bosco medesimo. Io non trovo ancora com' egli sia, però mi rimetto che'l pittor lo faccia di sua maniera. Nel quinto, un pellicano, al quale David si assimigliò nella sua solitudine fuggendo da Saulo: facciasi un uccello bianco, magro per lo sangue che si tragge da se stesso, per pascere i figliuoli. Alcuni dicono che questo uccello è il porfirione; e se questo è, arebbe avere il becco e gli stinchi lunghi e rossi. Nell'ultimo, una lepre; del quale animale scrivono che è tanto solitario, che mai non si posa se non solo; e per non esser trovato per indizio de'suoi vestigi, nel tempo della neve, dall'ultimo pedate, sin al luogo dove si posa, fa un gran salto.

Si sono fino a qui date le empiture a tutti i vani. Restano gli ornamenti; e questi si lasciano all' invenzione del pittore. Pure è ben d'ammonirlo, se gli paresse d'accomodarvi in alcuni luoghi, come per grottesche, istrumenti da solitari e studiosi; come sfere, astrolabi, armille, quadranti, seste, squadre, livelle, bussole, lauri, mirti, ellere, tane, cappellette, romitori e simili novelle. . . . *alli* 15 *di maggio,* 1565.

Tobias and the Angel

Così parlar conviensi al vostro ingegno,
però che solo da sensato apprende
ciò che fa poscia d'intelletto degno.

.

E santa Chiesa con aspetto umano
Gabriel e Michel vi rappresenta
e l'altro che Tobia rifece sano.

(In this manner we must speak to you because your mind only grasps what it perceives
with the senses which it subsequently makes worthy of the intellect. . . . And the holy
Church represents to you Gabriel and Michael in a human aspect and the other, who
restored Tobias to health.) Dante, *Paradiso*, Canto IV

TOBIAS and the Angel in the National Gallery in London (Fig. 23) is an unpre-
tentious painting, little suited to arouse the historian's curiosity. But once he
begins to probe, he may discover here, as always, how little may be taken for
granted.

It matters little that the painter's name is unknown. After conflicting suggestions
scholars agreed to call it 'school' or 'workshop' of Verrocchio.[1] The word 'work-
shop', at any rate, has a homely ring which fits the picture well. One of the few
things we really do know is that similar paintings of the same subject were turned
out by Florentine painters towards the middle of the quattrocento in a manner
suggesting the 'workshop' rather than the studio.[2] The London picture more or
less repeats the central group of a famous painting in the Uffizi in Florence, attri-
buted to Botticini (Fig. 24), and this in turn, has a companion piece in Turin.
There are other examples in various European collections. Many more must have
been lost. From the records of the Florentine painter Neri di Bicci we know that
he alone produced no less than nine versions of the theme for various customers.[3]
The subject was also popular with the early Florentine engravers.[4] The great fre-
quency of this theme in the Florentine Renaissance is all the more remarkable
because it occurs only very rarely in the religious art of the Middle Ages.

An attractive theory has been brought forward to explain the significance of
these pictures. The story of Tobias, it has been argued, is the story of a business
journey.[5] Young Tobias is sent by his blind father to distant Rages in Media to
recover ten talents of silver which his father had lent to Gabael, his brother in faith.
Would not this story strike a chord in the hearts of the Florentine merchants who
frequently had to send their sons to distant lands on similar errands? These pictures

This study is a slightly amplified version of the paper which appeared in *Harvest* in 1948.

were explained as *ex voto*'s commissioned by anxious parents to secure or com-
memorate the safe return of their son. This theory has found almost general accep-
tance but it rests on no documentary evidence. True, Tobias' eventful expedition
to Media was among the scriptural precedents of divine protection for travellers
invoked in the prayers of the Church. In one of the few fifteenth-century northern
paintings of the subject, Tobias and the Angel appear side by side with the three
Magi, the other travellers often referred to in prayers. But to restrict the application
of the story to the literal parallel of merchants sending their sons abroad betrays a
rationalist approach which misreads the role of the Scriptures in the life of the past.
Centuries of sermon-making had moulded the Sacred Word into an instrument of
universal application. Wherever we dip into religious tracts dealing with the Book of
Tobit we find its message interpreted to fit a different situation. St. Ambrose dwelt
at length on the fact that Tobit did not charge interest on his loan, and then
preached against usury. A German sixteenth-century Bishop, J. Hoffmann, goes
through the book section by section to append his topical comment. And who can
re-read the story now without being reminded of tales of the resistance in the
'underground Europe' of the war and post-war world?

But over and above these individual applications the story of Tobias remained
the epic of the Archangel Raphael.[6] Nowhere else in the Bible does the angel reveal
his name and nature to the mortals. His name means 'God has healed', and his
part in the drama is that of the great healer. It is he who advises Tobias on the
miraculous properties of the entrails of the fish. His advice first rid Sara of the evil
spirit who had murdered her seven bridegrooms and helped Tobias to his pre-
ordained wife and later healed Tobit from his blindness. Since he smoked out the
fiend who 'fled into the utmost parts of Egypt' Raphael was also identified by the
Church with the Angel of the Revelation (viii.3) 'who stood before the altar holding
a golden censer in his hand'.

All these facts are recalled in the Offices of the Church on occasion of the feast
of Raphael. In the ancient hymns composed for the occasion Raphael is invoked as
the physician (*nostrae salutis medicus*) who should 'lead us safely back to our father'
and let the 'blind among the congregation see the light'. Every one of these state-
ments clearly has a multiplicity of applications. The images are drawn from the
context of the Scriptures but their meaning is expanded to apply to us all.

A Florentine quattrocento picture of our subject (Fig. 25) carries an inscription
in the same vein: 'Raphael, health-giver, be with me for ever, and as thou wert
with Tobias, always be with me on my way.'[7] Again we must not only think of
physical healing and physical 'ways'. In the language of religious symbolism each
term is surrounded by a sphere of metaphorical applications. We deprive them of
their import if we cut out these overtones and take them as literal statements.

These pictures, it seems, have been consistently misunderstood. They have been

taken as illustrations of the Biblical story and have been alternately praised for the 'naïve realism' with which the incident is represented and censured for alleged inconsistencies with the text. Evidence of naïve realism they undoubtedly show. For not only must the dog, the fish and also young Tobias have been painted from nature but many other details seem to confirm the intention of the painter to reconstruct the story in all its vivid concreteness as it was done in the Mystery plays. Thus Tobias carries in his hand a scroll on which the word *Ricordo* can be deciphered. It is the 'handwriting' of Gabael, which he will present at Rages in token of his identity.

But this urge for translation of the story into visually concrete terms does not imply that the painter really imagined himself standing on the road to Media and painting the travellers as they were striding along. We need only put the idea of 'realism' in this extreme way to realize how different was the painter's approach.

It surely was not indifference to the text which made the painter treat its statements so cavalierly. He knew perfectly well that the Bible described Raphael as travelling in the guise of a human companion calling himself Azarias. He could have no doubt that the fish which frightened young Tobias was of monstrous size and he certainly realized that it had been cut up and eaten—save the healthgiving entrails—by the time the two were proceeding on the road. Why, then, did he depart from the text? The answer is simple enough. The boy carries a fish because without this emblem we would not recognize him as Tobias. Azarias is painted with wings because without them we would not recognize him for an angel. And, finally, he is accompanied by Tobias, not because the painter meant to illustrate a particular moment in the story, but simply because without the young companion with the fish we would not recognize the angel as Raphael, the healer. Tobias, in fact, is Raphael's emblem just as the wheel is the emblem of St. Catherine. Raphael grasps Tobias with his left hand and in his right he holds a golden container. It is the box for the fish's entrails which was identified as the golden censer (*turibulum*) ascribed to the Angel of the Revelation. Each Archangel draws his emblems from the situations in which he occurs in the Bible—Gabriel usually carries the lily of the Annunciation, St. Michael is represented with the sword and the dragon, or with the balance with which he is to weigh the souls on judgment day. But this symbolic identification of a sacred figure must not be confused with the purpose of realistic portrayal. Dante's reminder which serves as a motto to this paper has too often been ignored. How else can it be explained that the panel with the Three Archangels (each distinguished by his emblem) (Fig. 24) has often been described as Tobias accompanied by Raphael, Gabriel and Michael, an interpretation which is not only in conflict with the Bible but betrays a complete misunderstanding of the system of symbolism employed. It is the same misunderstanding that has led to the collective title of 'Sacra Conversazione' for paintings which show a number of

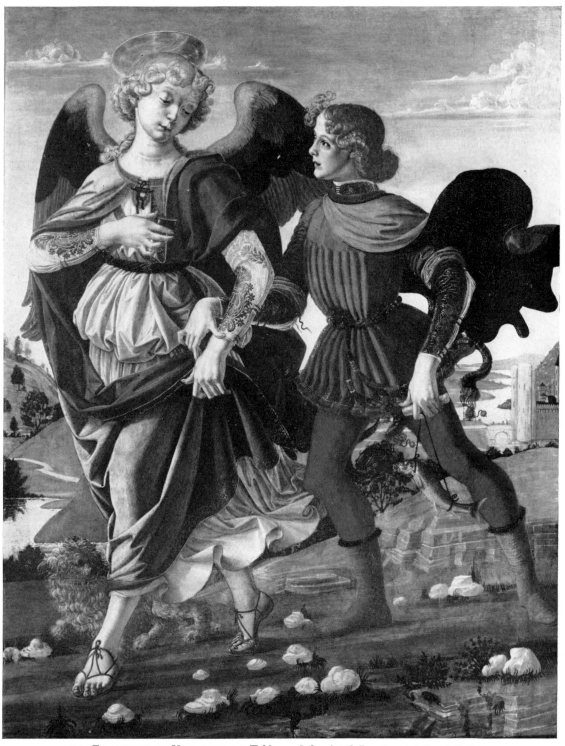

23. FOLLOWER OF VERROCCHIO: *Tobias and the Angel*. London, National Gallery

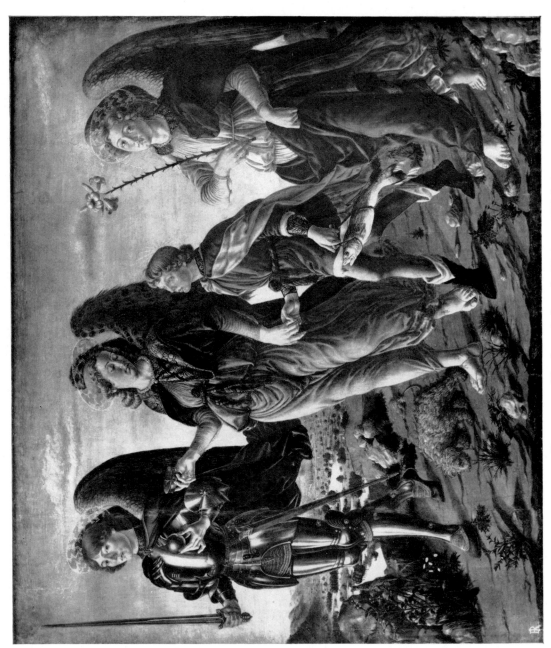

24. BOTTICINI: *The three Archangels.* Florence, Uffizi

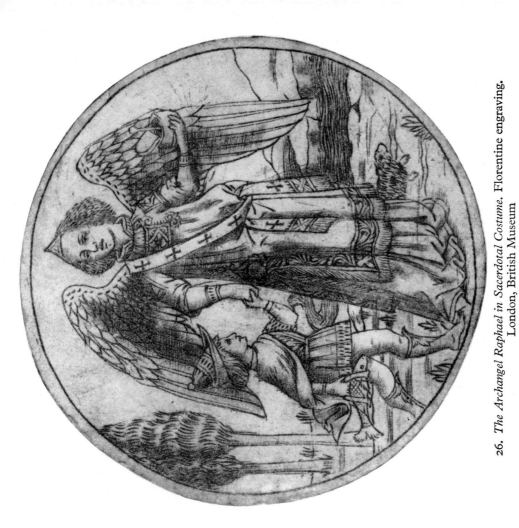

26. *The Archangel Raphael in Sacerdotal Costume.* Florentine engraving.
London, British Museum

25. FOLLOWER OF BALDOVINETTI: *Tobias and the Angel.*
San Giovanni Valdarno, S. Maria delle Grazie

27. BOTTICELLI AND ASSISTANTS: *The Trinity with St. Mary Magdalen, St. John the Baptist and Tobias and the Angel.* London, Courtauld Institute Galleries

Saints—including, sometimes, Raphael with his emblem Tobias (Fig. 27). Such paintings, to repeat, are neither conceived as representations of a real scene in Heaven nor as evocations of a particular Biblical episode. The sacred personage is portrayed or signified by several contexts in which he occurs in the sacred texts. In fact a Florentine fifteenth-century engraving (Fig. 26) shows our Archangel clad in a deacon's dalmatic and stole to allude to the passage in *Revelation* as well as to the story of young Tobias.

Here, as always, the study of meanings cannot be separated from the appreciation of forms. Those who have taken our picture for an illustration of the Biblical scene were somewhat repelled by the precious pose of Raphael, a legitimate objection if the painter had really wanted to persuade us that Azarias strode along that Median Road talking to his companion in such an affected attitude. Once we grasp the symbolic element of the picture behind the surface of illustration we read it differently. It is the Angel who is the principal figure. The painter had to display him before us in full view like any Saint represented to receive the prayers of the faithful. Here we can still discern the hieratic formula of the symbolic art of the Middle Ages. Tobias, on the other hand, was a figure from a different world. The painter was not restricted by the requirements of devotional art. Tobias' part in the story was to stride along confiding himself to his helpmate. In his person the new realism could be given free play. The problem was how to fit the two together. Our master solved the problem well by letting Raphael turn round looking down on his incense container as if to talk about the gall of the fish. He walks ahead of young Tobias and yet we feel that we can address ourselves to him before he disappears out of sight. Like Leonardo's *St. Anne* (Fig. 20) this modest workshop picture is thus the outcome of a compromise between two opposing concepts of painting, the symbolic and the representational.

It is this symbolic element, so often overlooked, which links the picture with the network of references which, to the religious mind, embrace the whole universe. In this system every symbol points beyond itself. The fish points to Tobias, Tobias to Raphael, Raphael, the healer, to the drama of salvation enacted in the universe. It is important to remember that in the mind of those who ordered and painted the picture this framework of references was not a matter of rational thought. To them meaning and effect were still inextricably intertwined. Raphael's image does not merely 'represent' the Biblical symbol. It partakes of its meaning, and hence of its power; it helps the donor to enter into communion with those forces of which it is the visible token.

It is dangerous to probe too deeply into these questions, for we so easily falsify a mode of thought by attempting to translate it into a language of a different order. But an understanding of even the formal problems of religious art may be impossible without some awareness of this background.

These are some of the questions and doubts that assail the historian as he stands before our picture. But there are more. Why was it that this theme acquired such a sudden popularity in the Florence of the quattrocento? Perhaps we shall never know for certain. But the best approach to the solution seems to be an investigation of the *Compagnia di Raffaello,* for which the Uffizi prototype of these pictures is known to have been painted and which may easily be also connected with many others.[8] This company had been founded in Florence in 1409 by a goldsmith to further religious instruction among the young. Such religious confraternities played a considerable part in the life of the community.[9] As mutual aid societies they drew their members often from the labouring classes and soon acquired political importance. In 1425 Cosimo de Medici, then struggling for power, decided to deal a blow to the most powerful of these fraternities, the *Compagnia della Misericordia.* It was forcibly merged with the rival brotherhood of *Bigallo* and thus deprived of its identity. Many of its members declined to enter the new organization and left. We know that one of the main tasks of this dissolved brotherhood had been the burying of the dead and that its patron had been 'S. Tobia', whose acts of charity towards the dead were so amply rewarded by the Lord. We know that the meeting place of the *Misericordia* had even been decorated with frescoes from the life of Tobias. The *Misericordia* remained suspended till 1475 but its memory was kept alive. When, in that year, a dead body was found left unburied in the streets of Florence, great public clamour arose. The bells were rung and a revival of the Company achieved. It was in the period between these two dates that most of the Tobias pictures were painted. Is it not conceivable that the *Compagnia di Raffaello* owed part of its popularity to the influx of the seceding members of the *Misericordia*? There is one clue which points in the same direction.

Two years after the enforced merger, in 1427, the membership of the *Compagnia di Raffaello* had increased to such an extent that Cosimo de' Medici made an effort to split it. He invited its members to found yet another fraternity '*della Purificazione di S. Zanobi, detto di S. Marco*' to which he allotted a meeting-place in his favourite monastery of San Marco. Was this an attempt to achieve by bribery what he had failed to achieve by force? Was the *Compagnia di Raffaello* little else than the *Compagnia della Misericordia* 'gone underground', a rallying-point for factions in opposition to the Medici?

Only very patient research in the inexhaustible archives of Florence might possibly turn such a wild guess into a sound hypothesis. But even the guess may not be quite futile if it serves to remind us that these paintings, in addition to their religious significance, also formed part of a social context of which we know too little.

Botticelli's Mythologies

A Study in the Neo-Platonic Symbolism of his Circle

A POSTSCRIPT AS A PREFACE

THE essay on *Botticelli's Mythologies* was conceived and written nearly 25 years ago. It proposes to show that a coherent reading of Botticelli's mythological paintings can be obtained in the light of Neo-Platonic interpretations. In order to make this case, which had not previously been made in the literature about the artist, I assembled a large number of texts mainly from the writings of Marsilio Ficino, the leader of the Neo-Platonic revival in Florence. Though I am less sure today that these tactics were sound I cannot accuse myself of having tried to prove too much. The essay emphasizes throughout that my interpretation presents a hypothesis rather than a proof.

Two students of the period accepted the hypothesis—Frederick Hartt in the introduction to a paperback volume, *Sandro Botticelli*, Amsterdam, 1954, and André Chastel in his introduction to a book on the master, London, 1959. Erwin Panofsky in his *Renaissance and Renascences in Western Art*, Stockholm, 1960, was very critical of many details but not only accepted a Neo-Platonic reading but acknowledged the relevance of the main text from Ficino, on which my interpretation had been pivoted. Edgar Wind in his *Pagan Mysteries in the Renaissance*, London 1958 (new edition, 1968), proposed yet another Neo-Platonic reading and particularly rejected my discussion of the Three Graces. In discussing the Birth of Venus W. S. Heckscher[1] stressed the medieval traditions he sees embodied in the painting. P. Francastel[2] also emphasized this element of continuity with medieval romance and pageantry. In a second article[3] he linked the Primavera even more closely with Lorenzo de' Medici's *Commento sopra alcuni de' suoi sonetti* and with the glorification of Medicean rule.

Finally the allegorical reading of these paintings was questioned by two authors who proposed a return to the earlier conception, according to which the pictures do not reflect the philosophical pre-occupation of Ficino so much as the love poetry of Angelo Poliziano, whose fragment on the Joust of Giuliano de' Medici had been felt for a long time to offer the closest literary parallel to Botticelli's imagery. Of these A. B. Ferruolo[4] still suggests at least some connection with the Neo-Platonic

This study is a revised version of the paper of the same name which appeared in the *Journal of the Warburg and Courtauld Institutes* in 1945.

philosophy of love while Charles Dempsey,[5] in a learned article devoted to the *Primavera*, regards the painting as a straightforward illustration of classical texts linking Venus with the season of spring and thus as an immediate parallel to Poliziano's later poem *Rusticus*, which draws on the same tradition.

On a counting of votes, therefore, the nays certainly far outweigh the ayes and so I naturally hesitated whether it was worth including this lengthy essay, which —to repeat—never claimed to have proven its point. What decided me to override these scruples was precisely the problem of method to which I have alluded in the introduction to this volume. Briefly it seems to me that an iconological analysis should not be confined to the search for textual sources. The literature on the *Primavera* has amply proved—if proof was needed—that there are innumerable references in ancient and Renaissance literature to the Goddess of Love, to the beauty of her garden, to Flora and the Graces, and even to Mercury. I would not deny for a moment that Botticelli's images easily come to our mind when we read these glorifications of love and of spring; indeed such associations are not confined to earlier texts; many readers of Spencer have been reminded of Botticelli by his graceful descriptions, and I have no doubt that artists and poets indeed draw on such a common stock of ideas and images which illuminate each other. Thus I would not want to disparage the learning and ingenuity of scholars who have pointed to many literary parallels I had not considered, but I feel that their very wealth tends to obscure rather than to illuminate the problem of these paintings. In the Introduction I drew attention to the principle formulated by Hirsch that any interpretation must start from a hypothesis regarding the kind or category of work we are confronting. It seems to me that my own starting point in this matter and indeed the whole principle have become somewhat blurred in the subsequent discussion. I may have been guilty myself of confusing these outlines by an excess of documentation and by an appeal to prevailing theories concerning the Neo-Platonic character of the Renaissance which courts the danger of circularity. I should therefore like to restate the problem more briefly.

At the time when they were painted Botticelli's Mythologies belonged to no established category. It is true that mythological themes were quite frequently represented in secular art, on marriage chests, caskets or on tapestries, but as far as we know Botticelli was the first to paint mythological paintings of such a monumental kind, which in their size and in their seriousness vied with the religious art of the period. What became a commonplace in the sixteenth century in the art of Correggio and Titian was certainly a novelty in the late 1470s, when the *Primavera*, the earliest of Botticelli's Mythologies, was painted. Are we entitled to see it in the light of the later development? This is what those authors have done who celebrated Botticelli as the initiator of pagan subjects in art, the first painter of a nude Venus and the mouthpiece of the pagan revival which was so often associated with the

Florence of Lorenzo de' Medici. Readers of my essay will see that I started from the assumption that this interpretation had lost much of its persuasiveness. Even for the sixteenth century Panofsky and others had proposed a new reading of the mythological genre, and attention had become focused on the Neo-Platonic conception of myth as an expression of ancient wisdom rather than of modern sensuality. There certainly is a problem of method connected with these interpretations —the fact that a given myth *can* be interpreted symbolically does not prove that it was intended in a given instance to be so interpreted. It was for this reason that I so much insisted on the hypothetical character of my Neo-Platonic reading, and I am still glad I did. But it was not on these texts that I rested my proposal but on the reconstruction of a historical situation. It was this situation which, in my view, could offer an explanation of the emergence of the new kind of painting represented by the *Primavera*. Maybe I did not make this implication sufficiently clear; at any rate not one of the subsequent discussions of these paintings even referred to my reconstruction of the circumstances which may have led to the commission of a novel kind of picture.

Both the *Primavera* and the *Birth of Venus* come from the Villa di Castello, which was owned by the cousin of Lorenzo de' Medici, Lorenzo di Pierfrancesco, who remained a patron of Botticelli. Documents show that the villa was acquired by and for him in 1478, when he was an adolescent of fifteen. This is the period into which the *Primavera* fits on stylistic grounds and so it has long been suggested that it was commissioned when the new villa was fitted out for Lorenzo di Pierfrancesco. Now it turned out that in this very year Ficino had sent the young Medici a moral exhortation couched in the form of an allegorical horoscope. It culminates in an appeal to the young man that he should fix his eyes on Venus who stood for *Humanitas*. Let him submit to the charm of this beautiful nymph, who was entirely in his power. There is evidence that Ficino attached much importance to this moral injunction. He wrote a covering note to the young man's tutors asking them to make their pupil learn it by heart.

I do not claim and cannot claim that Botticelli's painting illustrates the letter. What I propose is rather that it was intended to serve a similar purpose. We know that Ficino attached much importance to the power of sight. In particular he followed Cicero in the belief that the young were more easily swayed by visual demonstration than by abstract instruction. 'Don't talk about virtue to them', he said in effect, 'but present virtue as an attractive girl and they will fall for it.' May the beauty of Botticelli's Venus owe its existence to this pedagogic theory?

There is one aspect of this historical situation which I may have stressed insufficiently—the virtue of *Humanitas*, which Ficino commends so passionately to the young man, may have been precisely a virtue he conspicuously lacked. Throughout his life the younger Lorenzo was an irascible person and I have meanwhile found

evidence that his outbursts did not spare Lorenzo il Magnifico.[6] Thus this wealthy but politically inactive member of the Medici family did indeed present a problem to the unofficial ruler of Florence. How desirable it was to tame him and to teach him the value of Humanitas, which means not only culture but also affability. In my essay on *Icones Symbolicae*, also reprinted in this volume, I have meanwhile argued that the Neo-Platonic conception of painting approximates it to the art of music; both exert their spell and lead to lasting psychological effects. Perhaps the novel kind of painting was thought out by Ficino for the sake of this effect. It should mollify the character of the young man precisely as the influence of the planet Venus affected the character of those born under it.

If this belief existed it is natural that those who commissioned the painting of the Goddess would also be concerned with her authentic appearance. For just as an amulet is only effective if it has the right image so the picture destined to exert its beneficent spell would only work if it was correct.

In my paper I suggested that the text which was mainly consulted for this purpose was a description of Venus and her train which occurs in the *Golden Ass* by Apuleius in the context of a dumbshow of the Judgment of Paris. This hypothesis has fared badly with my critics. Panofsky in particular rejected it on both philological and intrinsic grounds and his arguments certainly deserve respect. But he grants that a 'similarity may be admitted to exist' between the description of Venus between the dancing graces and the hours scattering flowers and the picture, though 'this analogy, not very cogent in itself, is further weakened by the fact that the picture shows the number of seasons reduced to one'.[7] I still think that the scholar eager to provide the painter with an authentic description of the Venus as she was seen in antiquity may have remembered this passage, but it will be clear from what has been said so far that this detail does not much affect my principal hypothesis as to the kind of picture the *Primavera* is. However much I stressed the hypothetical character of this connection with Apuleius, I did not help matters by suggesting the possibility that the programme may have rested on a misunderstanding of the text. Granted that it may have done so, this is dangerous ground, for once we start tampering with the text to approximate it to the picture we are on a slippery slope. To sum up, I would not want to exclude Apuleius from the list of authors remembered by Botticelli's instructor, but I would agree that some of the texts adduced by Dempsey are at least as relevant.

In one respect I may always have been closer to Dempsey's anti-philosophical position than I am to those interpreters who read the *Primavera*, either alone or in conjunction with the *Birth of Venus*, as a complex philosophical allegory. The difficulties which confront the interpreter in reading any of these paintings in terms of a definite symbolic statement were in fact the subject of that section on the Three Graces to which Edgar Wind objected on philosophical grounds. I would not want

to defend its precise wording nor would I wish to deny that this particular triad is connected with a tradition also exemplified in a passage from Proclus which he adduces, but the problem of method which I raised still seems to me valid: Are pictures of this kind philosophical diagrams, comparable to the complex allegories devised by Leonardo or by later students of hieroglyphics, or are they rather to be seen as evocations of the Gods for the sake of their form and their influence? In the absence of contrary evidence, that is the impression Botticelli's mythologies give me, though in the case of the *Minerva* a slightly more explicit philosophical 'programme' would have to be postulated.

What can be argued from the proximity of Botticelli's patron to Ficino and from the circumstances which may have accompanied the first commission of this kind of mythology is that these images were seen as something more than decorations. The myth rather than the picture was seen as charged with meaning and therefore with psychological power. Whether or not we see in the *Primavera* primarily an allegory of Spring or a picture of Venus with her company, whether we regard the *Birth of Venus* mainly as a contrasting picture of the Celestial Venus or stress the literary influence of Apelles' Venus *anadyomene* and the description of such a theme in Poliziano's *Giostra* matters less than our ideas about the way these works were intended to be approached. In a passage in my paper which Panofsky quoted and endorsed I suggested that it was the Neo-Platonic approach to ancient myth which succeeded 'in opening up to secular art emotional spheres which had hitherto been the preserve of religious worship'. I think this is still a hypothesis worth entertaining. It is for this reason that I have decided to re-publish that essay.

August 1970

INTRODUCTION

The history of Botticelli's fame has still to be written.[8] In such a history the fascination which his 'pagan' subjects exerted on his discoverers in the nineteenth century would form an important part.[9] To generations of art lovers these pictures provided the back-cloth, as it were, for the stage of the Florentine *quattrocento* and the colourful drama of the Renaissance which they saw enacted on it. As this dream begins to recede, the need for a more strictly historical interpretation of Botticelli's mythologies becomes more apparent. We have become too much aware of the complex cross-currents of the late fifteenth century to accept the picture of the period which most of the books on Botticelli present to us.[10] The interpretation to be put before the reader in these pages tries to provide a hypothesis more in keeping with a more recent reading of the Renaissance. It takes its starting-point from texts which show that Marsilio Ficino was the spiritual mentor of Botticelli's patron at the time the 'Primavera' was painted and that the Neo-Platonic conception of the classical Gods was discussed in their correspondence. While it does not aspire to give 'proofs' in matters of interpretation where proofs cannot be given it suggests that a coherent reading of Botticelli's mythologies can be obtained in the light of Neo-Platonic imagery.

The many extracts from Ficino's writings quoted in support of these arguments should not obscure the fact that vast tracts of this literature still remain unexplored and that a further search may yield better and closer parallels. Though a polemic against earlier interpretations could not be wholly avoided it should not be taken to imply that anything like finality is claimed for the present attempt. There is, in fact, an important assumption which this interpretation shares with all previous theories. It is an assumption which may any day be overthrown by a lucky find: the hypothesis that Botticelli's mythologies are not straight illustrations of existing literary passages but that they are based on 'programmes' drawn up *ad hoc* by a humanist. That such programmes for paintings existed in the *quattrocento* we can infer from contemporary sources; but only one early example of this strange kind of literature has come down to us—Paride da Ceresara's detailed instructions to Perugino concerning the painting for Isabella d'Este's *Studiolo*.[11] The chance of recovering similar documents for Botticelli's paintings is, alas, extremely slight. In their absence the reconstruction of these missing links between the works of art and the modes of thought prevailing in the circles of the artist's patron will always remain a precarious venture.

THE 'PRIMAVERA'

1. *Past Interpretations*

Anyone interested in problems of method can do no better than to study the conflicting interpretations of the 'Primavera' (Fig. 28) and the discussions which centred round them.[12] We can save ourselves a detailed recapitulation as each succeeding writer has usually pointed out the weak spots in his predecessor's efforts; but the residue of these interpretations, both sound and fanciful, has come to cover the picture like a thick coloured varnish, and a brief analysis of its main ingredients is necessary for its removal.

There is, in the first place, the suggestive power of the name which Vasari conferred on the picture when he described it somewhat inaccurately as 'Venus whom the Graces deck with flowers, denoting the Spring'.[13] This has led scholars to garner from classical and Renaissance literature a number of quotations mentioning Venus and Spring,[14] forming in the end a veritable anthology of charming songs of May and Love. Then there is, secondly, the spell which Poliziano's *Giostra* has exercised over the interpreters ever since Warburg attempted to establish a connection between the poet's and the painter's modes of visualizing classical antiquity in terms of movement. In his famous doctoral thesis on the subject[15] Warburg not only argued for a connection between the 'Birth of Venus' and Poliziano's *stanze*; he also drew attention to passages of the same poem whose atmosphere and imagery were reminiscent of the 'Primavera'. In a more detailed comparison Marrai and Supino afterwards pointed out that the correspondence between the picture and the poem is really rather slight, but Poliziano's mellifluous *stanze* continued to be quoted side by side with Botticelli's painting, which was even described as an 'illustration' to the *Giostra*.[16] This intimate fusion of the picture and the poem lent support to a legend which was particularly dear to the aesthetic movement and thus formed the third ingredient of the myth which grew round the picture. It is the legend of the 'Bella Simonetta'. If the 'Primavera' is inspired by the *Giostra*, there may be no need to say good-bye to the long-cherished romance which linked Botticelli with the Swinburnian beauty who died of consumption at the age of 23 and was mourned by Lorenzo and his circle in verses of Petrarchan hyperbole. The growth of this legend, due, in part, to an erroneous note in Milanesi's Vasari edition, is less surprising than its persistence after Horne and Mesnil had pointed out that there is no shred of evidence that Botticelli ever painted the young wife of Marco Vespucci.[17] Her connection with Giuliano's Joust, moreover, must be seen within the conventions of chivalry, according to which 'ladies were as indispensable to a joust as were arms and horses' (Horne). The appeal of these

interpretations, and their heated defence in the absence of any tangible evidence, provides an object lesson in the romantic approach to the past, which regards history, not as an incomplete record of an unlimited number of lives and happenings, but rather as a well-ordered pageant in which all the favourite highlights and episodes turn up at their cue.[18] A famous picture like the 'Primavera' must be connected with the most famous patron of the age, Lorenzo il Magnifico; it must be inspired by the best remembered poem of the time, Poliziano's *stanze*; it must commemorate the most picturesque episode of the period, the famous Joust; and represent its most attractive protagonists, Simonetta and Giuliano. In its less crude form the romantic interpretation would admit that the painting does not actually *represent* the event and *illustrate* the poem. It withdraws to positions more attractive and less easily disproved such as the assertion that 'Spring' symbolizes the age of the Renaissance with its spring tide of youth and delight[19]; or that it 'expresses' the spirit of the age[20] and its 'pagan' carnival for which Lorenzo's *giovinezza* song has provided the inevitable quotation.[21]

These romantic constructions would never have been as successful as they were had it not been for certain qualities in Botticelli's art, which easily lends itself to the most contradictory interpretations. In a lecture which deserves to be better known, L. Rosenthal pointed out before the turn of the century that Botticelli's art owed its vogue—then at its height—to this very fact that it allows us to project into the strangely ambiguous expressions of his figures almost any meaning we wish to find.[22] He might have added that this haunting character of Botticelli's physiognomies not only permits but demands interpretations. These puzzling and wistful faces give us no rest until we have built around them a story which seems to account for their enigmatic expression. The literature on the 'Primavera' provides ample illustration of this interesting psychological fact. The gestures and expressions of its figures have given rise to the most varied explanations and the conviction with which these contradictory readings were put forward never deterred the next writer from putting his own musings on paper with similar assurance. The fifteen texts assembled in a note[23] show that the whole gamut of emotions from sadness to joy has been read into the pretty features of Venus (Fig. 30). Some pondered over her 'melancholy', others detected in her face the typical symptoms of pregnancy or of consumption, while others described her as 'smiling' or even 'laughing'. The gesture of her right hand was similarly made to express anything from the 'welcoming of Spring' to 'beating time to the dance of the Graces', from an expression of 'awe' to that paradox of a gesture 'half blessing, half defensive'. Small wonder, therefore, that the picture lent itself to such diverse interpretations as 'The awakening of Simonetta in Elysium', 'The Marriage of Menippean Satire with Mercury', 'The mystery of Womanhood', 'The return of the Medicean Spring', or 'Two Gods conspiring to arrange the meeting of lovers'.[24]

The conclusion to be drawn from these efforts is that the aesthetic approach of the impressionable critic is no safer guide than the romantic vision of the imaginative historian in fathoming the secret of Botticelli's art. In the best of cases expression in pictorial art remains an ambiguous language. Its elements need a context to acquire a well-defined meaning. In the case of Botticelli this general difficulty is greatly increased by his peculiar historical position. With him we lack the guidance which the fixed formulae of medieval art give us for the reading of gestures and situations, and his mastery of the intricacies of expression has not yet caught up with this new problem.[25] Botticelli may well have subscribed to Alberti's statement that only he who has tried to draw a laughing and a crying face can realize the difficulty of distinguishing between the two.[26] The beautiful pages which have been written by masters of prose on the emotional import of Botticelli's figures remain purely subjective unless the context in which these figures stand can be established by outside means.[27] The 'iconological' approach of historical scholarship has often come in for attack on the part of those who want to defend the autonomy of artistic sensibility. These attacks overlook the fact that it is only in the interaction of theme and treatment, of situation and gesture, that expression springs to life. Far from destroying the works of art of the past, these attempts to establish their concrete significance only help us to re-create their aesthetic meaning.[28]

2. *The Historical Approach: Ficino's Letter to Botticelli's Patron*

The historian's task is to establish the precise meaning of the symbols used by the artist. In the case of the 'Primavera' the attempts made in this direction have met with a difficulty not less formidable than that of establishing the precise meaning of the gestures and expressions. Warburg and his followers have shown us how manifold were the meanings attached to the classical divinities and how little is conveyed by a conventional label such as the 'Goddess of Love'.[29] To the Renaissance Venus is an 'ambivalent' symbol if ever there was one. The humanists were familiar with her conventional role no less than with the more esoteric meanings attached to her in the dialogues of Plato, who speaks of two Venuses, or in the poem of Lucretius, who addresses her as the embodiment of the generative power. Even in the popular mind Venus lived in a dual role. As a planet she ruled over merrymaking, spring, love, finery and the sanguine complexion, and in some or all of these capacities she was seen to drive through the streets of Florence in many a carnival pageant.[30] At the same time she remained the allegorical figure of chivalrous poetry, dwelling in the symbolic gardens and bowers of Romance.[31] While in the carnival songs she was praised and asked to make Florence her abode,[32] the first mention of a painting of Venus in a Renaissance setting occurs in Filarete's

imagined 'Temple of Vice'.[33] There she appears with Bacchus and Priapus some ten years before Botticelli's picture was painted, and we are left in no doubt as to her significance:

Venus, wreathed with myrtle, rising from the foam with a dove and a shell and exclaiming: All of you, rich and poor, who possess the attribute of Priapus, come into my bower, you will be well received.

Filarete adds that, to be generally understood, the speeches of these figures were added in Latin, Italian, Greek, Hungarian, German, Spanish, French, and other languages.

The question as to what Venus signified 'to the Renaissance' or even 'to the Florentine Quattrocento' is obviously still too vague for the historian to obtain a well-defined answer. It must be narrowed down to the question of what Venus signified to Botticelli's patron at the time and occasion the picture was painted. Thanks to the researches of Horne we can formulate this question even more precisely. We know with reasonable certainty for whom the picture was painted. Vasari saw it at Castello, the Villa which belonged in Botticelli's time to Lorenzo di Pierfrancesco de' Medici (1463–1503), the second cousin of Lorenzo il Magnifico.[34] The connection between Lorenzo di Pierfrancesco and Botticelli is well established by a number of documents and contemporary sources.[35] Most of these sources refer to a later period, the time when Botticelli was engaged on the Dante drawings for him and on a number of other works no longer extant. They date from the time when Lorenzo di Pierfrancesco also patronized Michelangelo, who sent his well-known account of his arrival in Rome to the Medici through Botticelli. Three of Botticelli's mythological paintings have been traced to Lorenzo di Pierfrancesco's family through their location in the sixteenth century, namely the 'Primavera', the 'Birth of Venus', and 'Minerva and the Centaur'; and though the validity of these conclusions has not remained unchallenged we hope to adduce new arguments in their support.[36] The figure of Lorenzo di Pierfrancesco remains somewhat shadowy.[37] We know that his relations with the Magnifico were not always of the best. His father, Pierfrancesco, the son of Cosimo's brother Lorenzo, had been a partner in the Medici firm and had received a great fortune when the property of the two branches was divided. There were quarrels over the share of their respective heirs in the expenses to be borne in some joint enterprises, and the friendship can hardly have improved through Lorenzo il Magnifico being compelled to borrow very large sums from his wealthy cousin, who received jewellery to the value of 21,000 gold *lire* in pledge. We know that in one of his *rappresentationi sacre* Lorenzo di Pierfrancesco deplored the lot of those 'who live under a tyrant'. He was in close contact with Charles VIII, on whose entry into Florence, when the Magnifico's son fled, he and his brother assumed the name of *Popolano* without, however, joining

the camp of Savonarola.[38] Later in life he was involved in a number of lawsuits which do not show his character to the best advantage. As the ancestor of 'Lorenzaccio' his figure became shrouded in obscurity when Cosimo established his dynasty.

Of Lorenzo di Pierfrancesco's literary and artistic interest much has to be inferred. It has sometimes been mentioned that Poliziano praised his accomplishments and dedicated one of his poems to him. But there is one source for this central figure in Botticelli's life which has not yet been tapped by any of the painter's biographers. It is the *Epistolarium* of Marsilio Ficino, in which we find a number of letters addressed to *Laurentius minor*, as he is called in contradistinction to his powerful, older relative.[39] The first of these letters provides the answer to our question as to what Venus would signify to Lorenzo di Pierfrancesco at the time when the 'Primavera' was painted for him. The letter bears no date but its content and form prove that it is addressed to a boy, 'adolescens'. Internal evidence suggests the winter 1477–8, when the recipient was fourteen to fifteen years of age.[40] This is the approximate period in which the 'Primavera' has been universally placed on stylistic grounds by Botticelli scholars, and the fact that Botticelli's patron had hardly reached his teens at the time has often seemed inconsistent with the remaining evidence. Here, too, the letter and its circumstances may provide an explanation. It is no less interesting for the fact that it may be less appealing than the love garden of Poliziano:

My immense love for you, excellent Lorenzo, has long prompted me to make you an immense present. For anyone who contemplates the heavens, nothing he sets eyes upon seems immense, but the heavens themselves. If, therefore, I make you a present of the heavens themselves what would be its price? But I would rather not talk of the price; for Love, born from the Graces, gives and accepts everything gratis; nor indeed can anything under heaven fairly balance against heaven itself.

The astrologers have it that he is the happiest man for whom Fate has so disposed the heavenly signs that Luna is in no bad aspect to Mars and Saturn, that furthermore she is in favourable aspect to Sol and Jupiter, Mercury and Venus. And just as the astrologers call happy the man for whom fate has thus arranged the heavenly bodies, so the theologians deem him happy who has disposed his own self in a similar way. You may well wonder whether this is not asking too much—it certainly is much, but nevertheless, my gifted Lorenzo, go forward to the task with good cheer, for he who made you is greater than the heavens, and you too will be greater than the heavens as soon as you resolve to face them. We must not look for these matters outside ourselves, for all the heavens are within us and the fiery vigour in us testifies to our heavenly origin.

First Luna—what else can she signify in us but that continuous motion of the soul and of the body? Mars stands for speed, Saturn for tardiness, Sol for God, Jupiter for the Law, Mercury for Reason, and Venus for Humanity (*Humanitas*).

Onward, then, great-minded youth, gird yourself, and, together with me, dispose your own heavens. Your Luna—the continuous motion of your soul and body—should avoid

the excessive speed of Mars and the tardiness of Saturn, that is, it should leave everything to the right and opportune moment, and should not hasten unduly, nor tarry too long. Furthermore this Luna within you should continuously behold the Sun, that is God Himself, from whom she ever receives the life-giving rays, for you must honour Him above all things, to whom you are beholden, and make yourself worthy of the honour. Your Luna should also behold Jupiter, the laws human and divine, which should never be transgressed—for a deviation from the laws by which all things are governed is tanta- mount to perdition. She should also direct her gaze on Mercury, that is on good counsel, reason and knowledge, for nothing should be undertaken without consulting the wise, nor should anything be said or done for which no plausible reason can be adduced. A man not versed in science and letters is considered blind and deaf. Finally she should fix her eyes on Venus herself, that is to say on Humanity (*Humanitas*). This serves us as an exhortation and a reminder that we cannot possess anything great on this earth without possessing the men themselves from whose favour all earthly things spring. Men, more- over, cannot be caught by any other bait but that of Humanity (*Humanitas*). Be careful, therefore, not to despise it, thinking perhaps that 'humanitas' is of earthy origin ('forse existimans humanitatem humi natam').

For Humanity (*Humanitas*) herself is a nymph of excellent comeliness born of heaven and more than others beloved by God all highest. Her soul and mind are Love and Charity, her eyes Dignity and Magnanimity, the hands Liberality and Magnificence, the feet Comeliness and Modesty. The whole, then, is Temperance and Honesty, Charm and Splendour. Oh, what exquisite beauty! How beautiful to behold. My dear Lorenzo, a nymph of such nobility has been wholly given into your power. If you were to unite with her in wedlock and claim her as yours she would make all your years sweet and make you the father of fine children.

In fine, then, to speak briefly, if you thus dispose the heavenly signs and your gifts in this way, you will escape all the threats of fortune, and, under divine favour, will live happy and free from cares.

The conception of the classical deities that we find in this letter from a humanist to Botticelli's young patron could hardly be more bizarre. Ficino has fused the two traditions by which the Middle Ages had transformed the ancient Olympus—the moral allegory and the astrological lore.[41] He draws up a horoscope which is really a moral injunction. Far from being the Goddess of Lust, his Venus is a moralized Planet, signifying a virtue whose complex definition is represented to us, medieval fashion, as a commentary on her anatomy. Venus stands for *Humanitas* which, in turn, embraces Love and Charity, Dignity and Magnanimity, Liberality and Mag- nificence, Comeliness and Modesty, Charm and Splendour. There are many cur- rents which unite in this transformation, and make it possible for such a symbol to be fashioned out of the classical goddess of Love. We find in the background the astrological conception in which the 'children' of the Planet Venus are of a friendly, amiable disposition, loving grace and finery,[42] but also that complex medieval ideal of temporal perfection, the ideal of 'courtesy' which dominates the code of conduct in the Courts of Love.[43] The idea of Venus as a guide to the love of men and to

all that adds dignity and grace to life could hardly have been formed without this distant background. But Ficino's language is that of the humanist. To him the supreme virtue which the young man should embrace is *Humanitas*, and the word calls up the Ciceronian ideal of refinement and culture, the virtue with which the Florentine merchants matched and outshone the courtly conventions of chivalry.[44] The enthusiasm, finally, with which this Venus is placed before the mental eye of the young Medici is Ficino's own. The author of the famous Commentary on the *Symposium* would have no difficulty in persuading himself that, for a boy, the moral principle represented by Venus, whether we call it Culture or Courtesy, Beauty or Humanity, was the proper guide towards the higher spheres.[45]

It is this notion of beauty as a gateway to the divine which explains Ficino's mode of expression, and also the importance he attached to his paedagogic effort. We know that he did not rest content with merely having written this strange epistle. He took special precaution that its lesson should not be lost on young Lorenzo. In the *Epistolarium* the letter is followed by a kind of covering note to two well-known scholars, both friends of Ficino, who appear to have been young Lorenzo's tutors at the time:

> Marsilio Ficino to Giorgio Antonio Vespucci and to Naldi: I am writing a letter to the younger Lorenzo about the prosperous fate often bestowed upon us by the stars which are outside us and also about the free happiness we acquire by our own free will from the stars within us. Explain it to him, if it should prove necessary, and exhort him to learn it by heart and treasure it up in his mind. Great as are the things which I promise him, those which he will acquire by himself are as great, if only he reads the letter in the spirit in which I wrote it.[46]

The two men to whom this letter is addressed belonged to Ficino's most intimate circle. They are frequently mentioned in his writings. Giorgio Antonio Vespucci, born in 1434, was the uncle and teacher of Amerigo. A member of a respected family, he was a humanist of considerable reputation who earned his living by transcribing classical codices and giving private lessons in Greek and Latin. He was known for his piety and integrity. Later in his life he took holy orders and entered San Marco during the priorship of Savonarola, of whom he became an ardent follower.[47]

Naldo Naldi, the other addressee of Ficino's letter, was a humanist of different moral fibre. Born in 1435, he is chiefly remembered for his poetic efforts to curry favour with the Medici and other powerful men. By his own admission, his repeated attempts to draw the attention of Lorenzo il Magnifico to his person were not, at first, well received. In fact he left Florence twice to sing the praise of princes and great men in Forlì and Venice, and not until 1484 did he receive one of the coveted salaried positions in Florence. In the literary *côterie* of the humanists his Latin poetry was warmly praised, and both Poliziano and Ficino speak highly of him.[48]

These were the two men on whom devolved the task of keeping the injunctions of the admired mystagogue before the eyes of their young scholar, who had not reached the age at which he could understand them without explanation. They were to kindle his enthusiasm for the divine beauty of *Venus-Humanitas*. In the 'Primavera' we have a picture of Venus which, from entirely different evidence, was thought to have been painted for Lorenzo di Pierfrancesco at exactly the period when this situation arose. If the 'Primavera' was painted for young Lorenzo, who had just been called upon to follow the alluring beauty of that fair nymph *Humanitas* who was Venus, can we still see the picture in the light of 'pagan' love and spring? Is it not tempting to connect the sources and to trace the origin of this commission, so momentous in the history of art, to the circumstances recorded in the documents?

We know that the Villa di Castello was bought for Lorenzo in 1477.[49] The idea of its decoration was naturally connected with such a purchase. In itself the thought of having Venus and her followers represented in the private apartments of a noble house would not have seemed far-fetched to Lorenzo's tutors or guardians. They must have known tapestries such as the fragment in Paris showing Venus and the Court of Love (Fig. 29). Warburg's researches have shown to what extent these Northern tapestries were collected and appreciated in *quattrocento* Florence.[50] Even the moral twist given to such representations was somehow prefigured in Northern art. Kohlhausen suggests that German tapestries showing a lady leading a 'wild man' in fetters are meant as a tribute to the civilizing powers of Lady Love.[51] The ground was thus well prepared for the idea of the commission, but Ficino's letter and advice must have provided the spark which kindled the flame. Through him the traditional theme would acquire a new dignity. To Ficino's circle, moreover, the role of such a picture would be of infinitely greater importance than that of the Northern tapestries with their suggestion of elegant decoration. Ficino can never tire of praising the nobility of sight and the sublimity of visual beauty as a symbol of Divine splendour. In his hierarchy of values the eye ranges before the ear as a source of enthusiasm.[52] If he was at pains to drive home to young Lorenzo the lesson which he had wished him to learn by heart, nothing would seem more natural to him than to translate it into visual reality; for Ficino's views on education are closely linked with the value which he attached to sight. His letter to Lorenzo, in which he describes the beauty of *Humanitas* in such glowing colours, is only one instance of the efforts he makes to translate his moral views into terms of visual concreteness when trying to convert the young.[53] In another letter to young Lorenzo we can watch him groping for even more effective means to make him *see* the ugliness of depravity and the beauty of goodness, and to 'point with the finger' at the sheer abhorrence of bad habits.[54] In yet another letter, this time to Lorenzo il Magnifico and Bernardo Bembo, Ficino explains his attitude to the virtue of visual experience in terms which read almost like a reference to a concrete instance:

Much do the philosophers argue, the orators declaim, the poets sing, in order to exhort man to a true love of virtue. . . . I think, however, that virtue herself (if she can be placed before the eye) may serve much better as an exhortation than the words of men. It is useless to praise a girl in the ears of a boy, or describe her with words, if you want to arouse him to love. . . . Point, if you can, to the fair maiden herself with your finger and no further word will be needed. One cannot describe how much more easily the sight of Beauty inspires love than words can do. If, therefore, we could present the wonderful aspect of Virtue itself to the eyes of men there would no longer be any need for our art of persuasion. . . .[55]

We thus have Ficino's own indirect testimony that he felt that mere words were inadequate to keep before the eyes of his spiritual ward the rousing beauty of *Humanitas* as he had described her in the letter: 'praestanti corpore nympha, coelesti origine nata, aethereo ante alias dilecta deo . . . o egregiam formam, o pulchrum spectaculum.' How much better would it be if Lorenzo's tutors were able to 'point with the finger' at this image of virtue as symbolized in Venus. Could anything suit this requirement more perfectly than Botticelli's 'Primavera'?

The unusual circumstances of its commission would appear to explain the unusual choice of subject matter which makes the picture a turning-point in the history of European art. The youthfulness of the patron, which had seemed inconsistent with the ideas usually attached to the picture, now becomes an important clue for its interpretation. Its very beauty is part of its theme. Had Ficino addressed a grown-up man, he would have spoken to him in abstract terms. Had Lorenzo been older, he might have preferred to seek a visual symbol of Divine Beauty even more concrete than a picture.[56] But for a child of fourteen or fifteen, this picture sermon on a new doctrine was just what was needed to rouse his mind to higher spheres.

That the choice of the commission fell on Botticelli fits in well with the circumstances as we know them. The young painter had been successful with such moral allegories. He had painted the 'Fortitude' in the series originally commissioned from the Pollaiuoli and he had already shown his mettle with a moral allegory in the guise of a mythological subject—Giuliano's jousting standard of Minerva and Cupid as symbols of Chastity. Moreover the Vespuccis and the Filipepis were next-door neighbours,[57] and it may well have been Giorgio Antonio Vespucci who procured him the commission.

We may also assume that it was in the circle of these three men, Ficino, Naldi, Vespucci, that the actual programme for the composition took shape. It is to a possible source of this programme that we must now turn.

3. *Apuleius' Description of Venus*

If this interpretation of the documents is right, Ficino's letter provides an explanation of the circumstances that led to the commissioning of the 'Primavera' and of

its central theme: *Venus-Humanitas*. It does not explain the whole composition. For the actual programme we must look elsewhere. That Warburg was right when he presupposed such a programme for the 'Primavera' becomes even more likely with our reading of the evidence. The philosophical ideas of Ficino could not easily be directly translated into paint. The 'Primavera' is certainly not an illustration of the philosopher's letter, nor would a moralized horoscope of this kind easily have lent itself to pictorial illustration. True, the main emphasis of the letter rests on Venus and, to a minor extent, on Mercury, both of which figure in the 'Primavera', but there is still a big gulf separating the picture and Ficino's text. This gulf has to be bridged by the hypothetical programme, of which we as yet know nothing.

Perhaps it is still possible to narrow this gap and to point to a source upon which the author (or authors) of the programme drew when they had to advise the painter as to how he should represent Venus and her train. Such a possible source is a description of the Judgment of Paris which occurs in the *Golden Ass* by Apuleius. The popularity of this tale in the *quattrocento* is well attested,[58] but it must cause something of a shock to find this predecessor of the picaresque novel connected with Botticelli's delicate vision. The context, moreover, in which this description of Venus and her train occurs, seems at first to militate against a connection between the picture and this text. A close examination, however, yields many more points of contact than are at first apparent.

The passage in question precedes the climax of the story in the tenth book.[59] Lucius the ass has been promised that he will be restored to human shape if he eats roses, the flowers of Venus, and it is high time for him to be saved as he has been singled out for the degrading spectacle of publicly embracing a doomed murderess. While he is awaiting the moment of the performance he perceives a ray of hope:

Spring had started and was already painting everything with flowering buds and clothing the meadows with a purple hue; bursting their thorny coats and breathing their cinnamon fragrance, the roses came forth which should restore me to my former self.

After an introduction the spectacle opens with a dumb show:

First there was a hill made of wood, representing Mount Ida of which Homer sang, reared up as a high structure and garnished with verdure and live trees; a gushing fountain, devised by a skilful artist, poured forth real water from the top. A number of little goatlets cropped the dainty herbage and a youth, representing the Phrygian shepherd Paris, richly arrayed in a flowing foreign costume, a golden tiara on his head, posed as herdsman. Beside him was a handsome boy, naked but for the *chlamys ephebica*, which covered his left shoulder; in his fair hair was visible a well-matched pair of linked golden wings; the caduceus and rod indicated that he was Mercury. Stepping forth like a dancer, he carried a gilt apple in his right hand and proffered it to the actor representing Paris,

indicating by his gesture what Jupiter had commanded. After that he made his exit from the scene with graceful steps.

There followed a maiden of honest demeanour; she represented the Goddess Juno, for she had a glittering diadem on her head and carried a sceptre. Then came another, whom you would have recognized as Minerva, for she wore a shining helmet covered with a crown of olive branches, and carried a shield and a spear as if about to fight.

After these there entered one of outstanding and wondrous beauty, whose ambrosian hue indicated Venus, as Venus was when she was a maiden; her naked and uncovered body showed her perfect beauty, for nothing but a flimsy silken garment veiled the lovely maiden. A prying wind now lovingly and lasciviously blew it aside so that the flower of her youth was revealed to the sight, now with a wanton breath made it cling to her, the more graphically to outline the voluptuous forms of her limbs. But the colour of the Goddess was of a twofold nature—her body was shining because she comes from heaven, her garment azure, because she returns to the sea. . . .

(There follows a description of Juno, accompanied by Castor and Pollux, and of Minerva, accompanied by Terror and Fear.)

And lo, now Venus, amidst the applause of the audience, smiling sweetly, stands right in the middle of the stage, surrounded by the gayest crowd of boys. You would have taken these round-limbed, milk-white babes for genuine Cupids who had just flown here from the heaven or the sea—for they had little winglets and arrows and the rest of their attire was in harmony with their beautiful countenances, as with burning torches they lit the path of their lady as for a marriage feast.

And then there was a new inrush of young and fair unwed maidens—here the most welcome Graces, there the most comely Horae, who paid homage to their Goddess by scattering flowers, both loose and garlanded; moving in a dance of most expert design, they blandished the Goddess of Lust with the petals of Spring. Already the melodious flutes sounded luxurious Lydian harmonies, melting the hearts of the audience with their sweetness—but far sweeter still, Venus began placidly to move with a hesitating, slow step, gently swaying her body, slightly inclining her head, and with delicate gestures responded to the voluptuous sound of the flutes; now with a tender drooping of the eyelids, now with fiery glances, she sometimes seemed to dance only with her eyes.

As soon as she had made her appearance before the judge she seemed to indicate by the movement of her arms that she promised to give Paris a spouse of outstanding beauty like herself if he would put her above the other Goddesses. . . .

It is, above all, the central group of the 'Primavera' which shows a striking correspondence to the appearance of Venus in Apuleius' dumbshow.

Venus . . . in ipso meditullio scaenae . . . dulce surridens . . . *hinc* Gratiae gratissimae, *inde* Horae pulcherrimae, quae jaculis floris serti et soluti deam suam propitiantes scitissimum construxerant chorum, dominae voluptatum veris coma blandientes.

(Venus . . . in the very centre of the stage . . . smiling sweetly . . . on the one side the most welcome Graces, on the other the most beautiful Horae who paid homage to their Goddess by throwing flowers both in garlands and singly, and wove a most expert dance, to flatter the Queen of Pleasure with the petals of spring.)

If the painter's advisers used this description for their programme, they found in it the idea of Venus standing in the centre with the Graces on one side (*hinc*) and the Horae on the other (*inde*). Their actions were distributed accordingly. The Graces were made to display themselves in their most expert dance, while the Horae on the other side would scatter the petals of Spring. True, Apuleius speaks of many Horae and many Cupids while Botticelli's picture has only one of each. Such a reduction is somewhat puzzling since the Horae are social beings, but curiously enough Botticelli submitted them to exactly the same treatment in the 'Birth of Venus'. There, too, Poliziano's text speaks of three Horae receiving the Goddess and Botticelli reduced them to one.[60] One may ascribe this freedom to 'pictorial licence',[61] but there may also be a more clearly formulated theoretical reason behind it. In his treatise on painting, Alberti had inveighed against the crowded pictures of his period, the gay throngs of Gentile da Fabriano and other followers of the international style. He laid down the law that with certain exceptions a good *storia* should not have more than nine or ten figures. With the humanist's peculiar logic, he quotes as evidence an anecdote about Varro, who preferred to dine in small company and would never invite more than nine guests.[62] Filarete in his *Sforzinda* is even more rigid and says: 'A story will not bear more than nine figures, rather should it have fewer.'[63] The 'Primavera' conforms exactly to this rule—it has nine figures or 'rather fewer' if we count Cupid as not much of a person. It was this single representative of the Horae 'dominae voluptatum veris coma blandientes' which suggested to Vasari that the whole picture represented 'Venus decked with flowers . . . , signifying Spring'; not an unnatural inference if we think of the close connection of the Goddess with the season of love.[64]

It is not only the general arrangement of this central group which tallies with Apuleius' description. The picture and attitude of Venus herself, which has caused so much speculation, also fits surprisingly well.

Venus placide commoveri cunctantique lente vestigio . . . et sensim annutante capite coepit incedere, mollique tibiarum sono delicatis respondere gestibus. . . .
(Venus began placidly to move with a hesitating slow step . . . and slightly inclining her head, she responded with delicate movements to the voluptuous sound of the flute. . . .)

Was it not the inclination of the head, prescribed in the passage, which led so many observers to find in her a pensive or melancholy look? And was it not the gesture 'responding' to music which Venturi interpreted as 'beating time to the dance of the Graces' while more fanciful observers read into it a *noli me tangere*? Whether the gesture is actually that of dancing or of Venus' promise before the judge, remains undecided—it may easily be both at the same time. Venus' whole demeanour suits the idea of dancing 'with a slow halting step' very well (Fig. 30). We need only place her next to Filippo Lippi's and Ghirlandajo's 'Salome' (Figs.

28. BOTTICELLI: *Primavera*. Florence, Uffizi

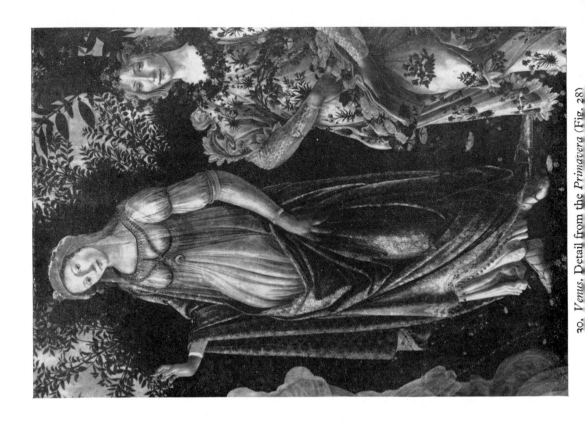

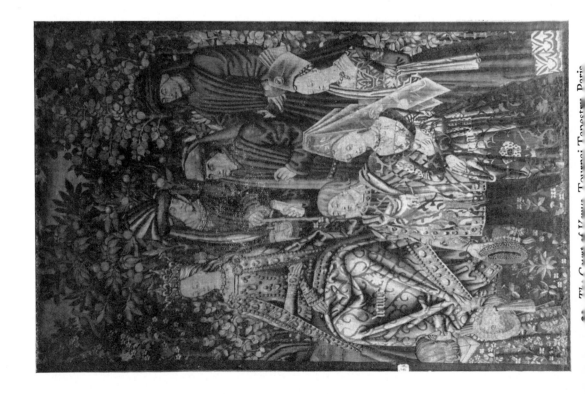

29, The Court of Venus, Tournai Tapestry, Paris

30, *Venus*, Detail from the *Primavera* (Fig. 28)

31. FILIPPO LIPPI: *Salome. Detail from* The Feast of Herod.
Prato, Cathedral

32. GHIRLANDAJO: *Salome. Detail from* The Feast of Herod.
Florence, S. Maria Novella

34. *Fides between Juno and Pallas.* Title-page of A. Assaracus, *Historiae,* Milan, 1516. See p. 210, note 80

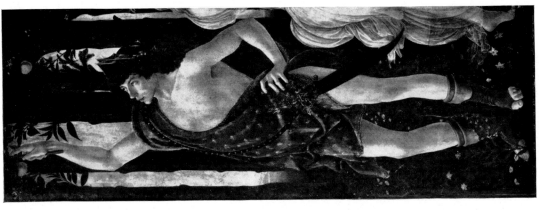

33. *Mercury.* Detail from the *Primavera* (Fig. 28)

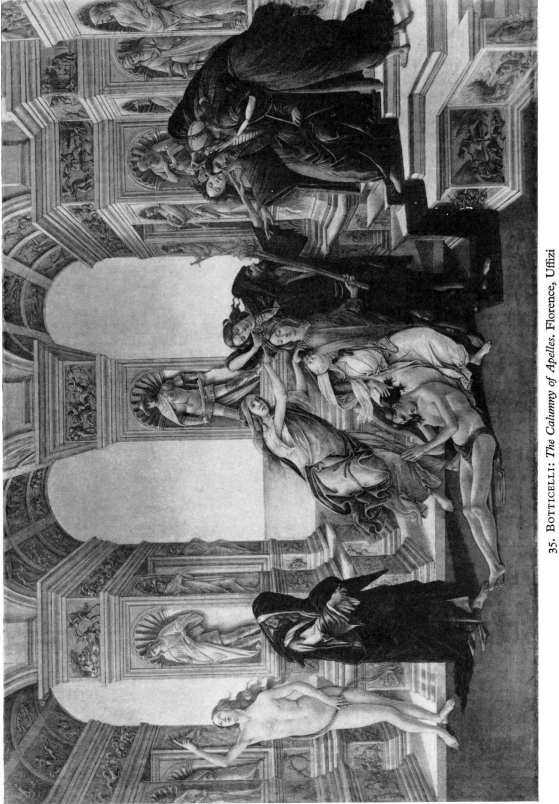

35. BOTTICELLI: *The Calumny of Apelles*. Florence, Uffizi

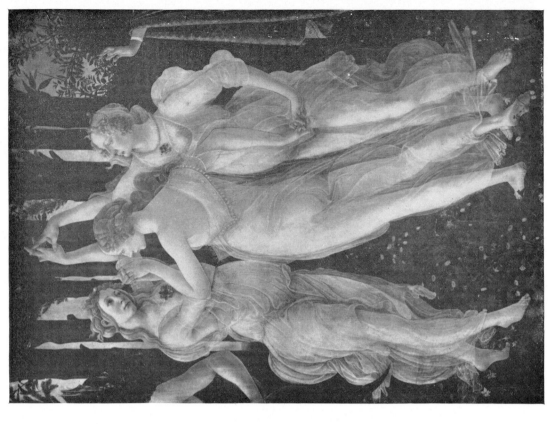

37. *The Three Graces.* Detail from the *Primavera* (Fig. 28)

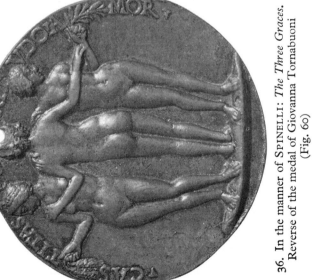

36. In the manner of SPINELLI: *The Three Graces.* Reverse of the medal of Giovanna Tornabuoni (Fig. 60)

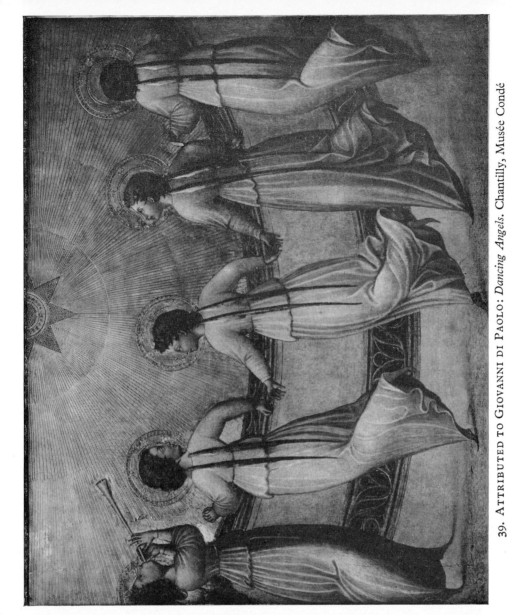

39. ATTRIBUTED TO GIOVANNI DI PAOLO: *Dancing Angels*. Chantilly, Musée Condé

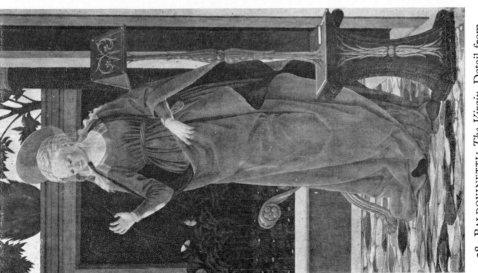

38. BALDOVINETTI: *The Virgin*. Detail from
The Annunciation. Florence, Uffizi

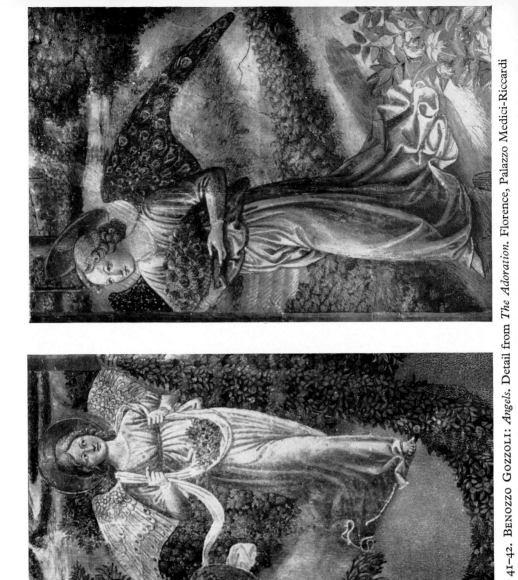

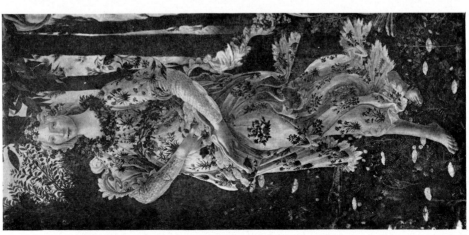

41–42. BENOZZO GOZZOLI: *Angels*. Detail from *The Adoration*. Florence, Palazzo Medici-Riccardi

40. *Flora*. Detail from the *Primavera*

31, 32)—making allowance for the wickedness of Herodias' daughter—and Botticelli's Venus seems to say: 'voyez comme on danse.'

4. *Misreadings of the Text?*

Modern editions of Apuleius make Venus move 'Leniter fluctuante spinula', 'slowly swaying her spine'. This would fit the picture quite well, but the reading is relatively recent. The *editio princeps* of 1469 has the cryptic words 'leviter fluctuantes pinnulas', a version which Boiardo translated 'battando le ale di varie penne dipinte'. Beroaldus, in his edition of 1501, tried to improve the text by suggesting 'leviter per fluctuantes pinnulas', commenting: 'Venus inter pinnatos cupidines, quorum pinnulae leviter fluctuabant, coepit incedere' (Venus began to step forward among the winged cupids whose winglets floated lightly). A similar emendation of the corrupt passage may account for the fact that Amor is in fact floating in the air over Venus in Botticelli's picture. His attire corresponds with the description of the Cupids.

illos teretes et lacteos puellos diceres tu Cupidines veros de coelo vel mari commodum involasse; nam et pinnulis et sagittulis et habitu cetero formae praeclare congruebant, et velut nuptiales epulas obiturae dominae coruscis praelucebant facibus.

(You would have taken these round-limbed, milk-white little boys for genuine Cupids who had just flown in from the sky or the sea. For both their little wings and their little arrows and the remainder of their attire conformed to their beautiful looks, and they lit the path of their lady with burning torches as if she were going to a marriage feast.)

In Botticelli's picture the single Cupid combines in fact all these attributes. He is winged with bow and arrow but his arrow is barbed with fire, is a torch. This is in itself a rare iconographic trait, which Apuleius' text would help to explain.[65]

There remain the terminal figures to the right and the left of the central group. Was the author of the programme also drawing on Apuleius' description when he advised Botticelli on their inclusion? It is a puzzling question because, though the actual correspondence breaks down, there are various features in which the text and these figures coincide. Warburg quoted a number of descriptions to show the correspondence of the typical scene of the pursuit of the nymph, which he interpreted as Zephyr following Flora, with classical models, notably Ovid's often imitated description of Apollo and Daphne. It is strange that none of these passages provides quite as close a parallel to the picture as does a paragraph in Apuleius' text.

Super has introcessit alia . . . nudo et intecto corpore perfectam formositatem professa, nisi quod tenui pallio bombycino inumbrabat spectabilem pubem: quam quidem laciniam curiosulus ventus satis amanter nunc lasciviens reflabat, ut dimota pateret flos aetatulae, nunc luxurians aspirabat, ut adhaerens pressule membrorum voluptatem graphice deliniaret.[66]

(After these there entered another woman . . . her naked and uncovered body showed her perfect beauty, for nothing but a short silken skirt veiled her shapely private parts. And this cloth was blown aside lovingly by a lascivious prying wind, now shifting it to reveal the flower of the young girl, now breathing upon it voluptuously to make it cling closely and show up the charming outlines of her body.)

The figure of the beautiful maiden covered only by a thin silken veil with which a wind plays pryingly is not a commonplace motif. The group in the 'Primavera' suits the description line by line. The way in which the flimsy veil adheres to the form of the limbs and reveals the whole form of the maiden far exceeds in its literal execution the usual formula of wind-blown garments recommended by Alberti.[67]

But here we are up against a formidable difficulty. In Apuleius this description applies to the figure of Venus and if the painter's adviser embodied it in his programme as it stands, his text must have included two Venuses, one rushing on to the scene and one beginning to dance. We have no explanation to offer for this strange procedure, only a number of conjectures which will hardly convince everyone. One possibility is that the authors of the programme were thinking of the doctrine of the 'two Venuses'. In itself such an application to pictorial art would not be isolated in the *quattrocento*. We know that Mantegna's sketches for the Realm of Comus' provided for 'two Venuses, one draped, one nude'.[68] But this solution would imply that the authors of the programme completely disregarded the context of Apuleius' description and used it exclusively for visual material. There clearly was only one Venus at the Judgment of Paris. If, on the other hand, the authors of the programme still aimed at something approximating to the scene described by the classical author, they might have deliberately applied the description of Venus and the wind, so tempting to a painter, to another figure which would fit better into the general context. In other words they might have added Zephyr and Flora to the train of Venus and adapted Apuleius' description to this pair.

There is yet another possible way of accounting for the difference between Apuleius' text, as we know it, and Botticelli's picture. The authors of the programme may have used a different version. Apuleius' style is nowhere conspicuous for its clarity. We saw how Boiardo, in his translation, made Venus 'beat the wings with various painted feathers' because he was working from a corrupt passage. What a problem any painter would have set us had he illustrated a similar emendation! We can hardly exclude the possibility that a similar crux in the text which the humanists had before them would explain our problem. We have not got such a text, but even the printed version of the *editio princeps* is sufficiently puzzling in its punctuation:

Super has introcessit alia visendo decore praepollens gratia coloris ambrosei designans venerem: qualis fuit venus: cum fuit virgo: nudo et intecto corpore. . . .

(After these there entered one of outstanding and wondrous beauty whose ambrosian hue indicated Venus: as Venus was: so was the maiden: with a naked and uncovered body. . . .)

If we can trust the testimony of the picture, Botticelli's adviser may have read 'qualis fuit Venus, Tum fuit virgo. . . .' Or else he made an emendation similar to that suggested by Beroaldus concerning the passage with Venus' wings. He read, for instance, 'Qualis fuit Venus. Cum *ea* fuit virgo.' She was Venus. 'With her (or them) came a maiden whose naked and uncovered body . . .' A similar explanation may account for the flowers coming out of the maiden's mouth. To us it is sufficiently clear what Apuleius means when he speaks of the wanton wind who lasciviously blew the garment aside so that the flower of her youth ('flos aetatulae') was revealed to the sight. But the spelling and punctuation of the first edition was again less clear:

quam quidem laciniam curiosulus ventus satis amanter: nunc lascivians reflabat: ut dimota: pateret flos etatule. . . .[69]
(which veil a prying wind lovingly: now lasciviously blew aside: thus revealing: the flower of her girlhood appeared. . . .)

Some such confused version may well have led to a literal interpretation of the 'flower' which appeared under the breath of the wanton wind. It would certainly not be the only time that a strange emendation of a classical text determined the features of a great work of art. If this one was adopted—which had much to commend it as against Apuleius' real meaning—the trend of thought might have led, even more naturally, to the identification of the Maiden pursued by the loving wind with Zephyr and Flora.

There remains the figure of Mercury, and here there are more divergencies than similarities. Mercury occurs in Apuleius, not as a follower of Venus, but in his traditional role at the Judgment of Paris. Nor does his appearance tally with the description. Despite a general resemblance the differences are marked. Mercury in Apuleius is:

luculentus puer nudus, nisi quod ephebica chlamida sinistrum tegebat humerum, flavis crinibus usquaque conspicuus, et inter comas eius aureae pinnulae cognatione simili sociatae prominebant, quem caduceus et virgula Mercurium indicabant.
(a resplendent boy, naked except for the *chlamys ephebica*, which covered his left shoulder, striking because of his fair hair in which a neat pair of little golden wings stood out, was recognizable as Mercury by the caduceus and the rod.)

The hair of Botticelli's Mercury is dark, not fair; he wears the *chlamys* over the right shoulder, not the left; his strange golden helmet differs from the wings described in the text and he carries a sword, not a rod. And yet even for this figure, the text offers a possible explanation of a perplexing trait which has so far defied

interpretation. Mercury's gesture has been interpreted in almost as many different ways as that of Venus. Some made him look for oranges or singing birds, others thought he was scattering clouds, about whose existence the iconographic meteorologists were not quite in agreement. According to Supino, he raises the caduceus to announce the coming of Venus; Count Plunkett says he points heavenwards; while Weisbach thinks he waves his hand to Mars to draw attention to the presence of Venus. If we compare him with other figures in Botticelli's work, notably with Truth in the 'Calumny of Apelles' (Figs. 33, 35), whose place in the general composition is somewhat similar, Count Plunkett's reading gains much in likelihood. Both his and Weisbach's interpretation of the gesture as a pointing or waving upwards, would fit well with Apuleius' text which describes him indicating by a sign that Jupiter sent him ('quod mandaret Jupiter nutu significans'), a gesture in which he would have to point heavenwards.

That there are serious difficulties in the way of linking Apuleius' text with the hypothetical programme for Botticelli's picture cannot be denied. Above all, the emendation and interpretation of a text to make it fit the picture which it is supposed to explain, is open to serious objections on the grounds of method. And yet there are two reasons which speak in favour of some connection between picture and text. One concerns the form of Apuleius' description, the other its context.

5. *Description and Symbolism in Apuleius*

In contrast to other classical texts which have been quoted in connection with the 'Primavera' the passage in Apuleius is not a passing reference to Venus and her train but a detailed description of unusual visual concreteness of her appearance in a mime. The lines from Lucretius (v, 737), for instance, which have been quoted as a source for the picture since J. A. Symonds drew attention to them[70] look near enough to the picture, in isolation:

> On come spring and Venus and Venus' winged harbinger marching before with Zephyr and mother Flora a pace behind him, strewing the whole path for them with brilliant colours and filling it with scent.

It is not so much the absence of the Graces and Mercury which speaks against Symonds' theory. It is rather the fact that these lines are embedded in the long philosophical disquisitions of Lucretius' poem, to be exact in a passage in which the poet enlarges on the consoling thought of the transience of all things, including the universe. Various theories concerning the phases of the moon are discussed, some hold her to be a ball, lit on one side and black on the other, the revolutions explaining the phases. Some would suppose that an entirely new heavenly body of different shape is created every night and Lucretius thinks that such a phenomenon would

not be without parallels in nature. The seasons, for instance, are likewise created anew every year in a fixed order—and it is here that the procession of spring, summer, autumn and winter with their attendant phenomena is mentioned, after which the poet plunges into an argument on the causes of the eclipse. Among all the Renaissance paintings whose sources are known, one will look in vain for such a fleeting reference to have formed the principal theme of a picture. Is it likely that one of the very first independent mythological paintings since the decline of anti-quity should have been an illustration of this type of passage?[71] Apuleius' text, on the other hand, has many features in common with the type of source which mostly inspired Renaissance artists or their humanist mentors—the classical *ekphrasis*. It is to these descriptions of pictures, real or imaginary, that the Renaissance turned in its search for new themes.[72] Alberti had made a beginning in his advice to painters to reconstruct the Calumny and the picture of the Graces. Botticelli him-self was to follow this advice concerning the Calumny (Fig. 35) into which he even inserted the reconstruction of another classical picture described by Lucian—the family of Centaurs. His 'Birth of Venus' is based on a Renaissance *ekphrasis*, closely modelled on classical examples. Titian's greatest mythologies are based on similar sources (Philostratus and Catullus), Raphael's 'Galatea' belongs to that category, not to speak of minor works by Sodoma or others. Apuleius' text is not an *ekphrasis* but from the artist's point of view it shares its advantages—it gives a description, at least as detailed as that of the ancient orators, of the disposition, appearance and gestures of the figures, which not only permits visualization but positively asks to be reconstructed in paint.[73]

It must not be forgotten that even before the descriptions of Lucian and Philo-stratus had become known, artists and their advisers used to turn to such concrete descriptions of the Gods, their attributes and their attendants, whenever it was a question of introducing them into pictures. Up to the time of Botticelli the so-called Albericus, with its concise description of the classic deities and their atten-dants, had supplied this need. Albericus' description of Venus has often been quoted:[74]

Venus was painted as a very fair maiden, naked and swimming in the sea, holding a shell in her right hand and accompanied by doves which fluttered around her. Vulcan, the God of fire, coarse and horrid, her husband, stood by her side. In front of her stood three small naked maidens, called the Graces, two of whom turned their faces towards us while the third was seen from behind; her son Cupid, winged and blindfolded, also stood by her side, shooting with bow and arrow at Apollo, after which, fearing the wrath of the Gods, he fled into the lap of his mother, who gave him her left hand.[75]

Ficino and his friends may well have rejected these potted versions of the medieval mythographer but their need of finding some equally concrete substitute was none the less great. The quest for an 'authentic' description was not merely a

question of aesthetic propriety or learned pedantry. To Ficino no less than to Albericus it was an established fact that the attributes and appearance of the Gods revealed their real essence. It was as important to establish the authentic image of a god or a planet as to find its 'true name'. In both was hidden, for those who could read the esoteric language of ancient wisdom, the secret of their being.[76] It is this impulse which lends such dramatic force to the searchings of the humanists for the genuine images and descriptions of the ancient myths. The use of an artistically inferior passage, such as Apuleius' description, for the programme of a masterpiece might lose much of its embarrassing character within such a setting.

This leads to the second reason why Apuleius and this particular part of the tale might have recommended itself to Ficino's circle. Apuleius 'Platonicus' passed as an author of esoteric wisdom whose tale concealed a profound moral truth. The mystic ending of the story lent colour to the interpretation, forcefully insisted upon in the preface to the *editio princeps*[77] of the novel as a kind of Pilgrim's Progress. In this 'Platonic' conception more than one link can be found with the conception of *Venus-Humanitas* of Ficino's letter. *Allegorice*, Lucius' story, is the tale of human degradation and salvation. The Goddess through whom Lucius' salvation is wrought, and who finally restores him to his 'humanitas', is Venus as much as Isis. As she appears to Lucius in a vision, slowly rising from the sea with the attributes of Isis, she proclaims herself:

the mother of nature, the mistress of the elements . . . whose divinity is worshipped by all the world in many forms and various rites. The Phrygians, who are the first of men, call me the Mother of Gods of Pessinus, the earth-born Athenians call me the Cecropian Minerva, the sea-girt Cyprians the Paphian Venus. . . .[78]

In the allegorical reading of the story, the triumph of Venus in the dumbshow would not be read as a mere decorative frill or a digression. It would be taken to foreshadow this final appearance of the Goddess. The Judgment of Paris itself was traditionally read in the light of moral allegory. It rivalled the story of Hercules as an example of the moral choice before man. In the commentary to Apuleius, written by Beroaldus towards the end of the *quattrocento*, the passage is explained by a reference to Fulgentius, according to whom the scene signifies the human choice between the three forms of life, contemplative, active or voluptuous. We know that Ficino accepted this interpretation, but in his bias for the Goddess of Love he contrived to give it a different twist. In a dedication of Plato's *Philebus* to Lorenzo il Magnifico—written, it is true, many years later—he commends his patron for not having drawn upon himself the wrath of any of the three Goddesses by rejecting her. Rather had he chosen all three of them, the wisdom of Minerva, the power of Juno and the grace, poetry and music of Venus.[79]

If the passage in Apuleius was read in a similar light, its selection as a source of the programme for the picture of *Venus-Humanitas* would seem quite consistent.

Ficino's letter is a plea that Lorenzo di Pierfrancesco should choose Venus. The apostrophe in the letter:

Laurenti mi, nympha tam nobilis in tuo tota arbitrio posita est; si hanc ipse tibi connubio iunxeris propriamque dicaveris, omnes tibi dulces afferet annos et pulchra faciet te prole parentem ...

(My dear Lorenzo, a nymph of such nobility has been wholly given into your power. If you were to unite with her in wedlock and claim her as yours, she would make all your years sweet, and make you the father of fine children.)

is almost echoed in Apuleius' description of Venus:

... ubi primum ante iudicis conspectum facta est nisu brachiorum polliceri videbatur, si fuisset deabus caeteris antelata, daturam se nuptam Paridi forma praecipuam suique similem.

(... as soon as she had made her appearance before the judge, she seemed to indicate by the movement of her arm that she promised to give Paris a spouse of outstanding beauty like herself if he would put her above the other goddesses.)

If our reading of the context is right, there might even be an element of illustration in Botticelli's 'Primavera'. Its programme would have described Venus appearing with her train and pleading before Paris, with Mercury pointing heavenwards to indicate that Jupiter has sent him. The ultimate consequence of this interpretation would be that it was the young spectator himself, Lorenzo di Pierfrancesco, for whom the picture was ordered, who would have completed the context. Standing before the picture, he would be the object of Venus' pleading; with him, as with Paris, would lie the fateful choice. Within the realm of poetry and pageantry such a direct address to the beholder would not seem surprising.[80] In visual art we are less accustomed to think of the beholder as drawn into the orbit of the picture. But many a *sacra conversazione* and many a blessing Christ child also addresses the worshipper directly, and the difference between this conception and the one suggested above is perhaps only one of degree.[81] We should not like to press this argument too far but it may be worth remembering that a nineteenth-century guidebook suggested for the picture the title 'The Judgment of Paris'.[82]

6. *The Graces and the Problem of Exegesis*

If the link we tried to establish between Ficino's letter to Lorenzo di Pierfrancesco and the 'Primavera' holds, we are entitled to take Venus as standing for the virtue of *Humanitas*. Our assumption that Apuleius provided a source for the programme makes it likely that the picture is also connected with the traditional moralized allegory of the Judgment of Paris, in which Venus and her train find a natural place. The texts of Ficino and Apuleius together would thus account for the main structure of the allegory and the meaning to be attached to it. But the fact that we have a

straight allegory in the Judgment of Paris does not exclude the possibility that exegesis may have been carried further and that, for instance, each of the companions of Venus may have a specific meaning. In fact if Apuleius was read as a Platonic author and if his description was chosen as an authentic revelation of the true appearance of the Platonic Venus, it is very likely that the rest of the scene was intended to carry a hidden significance. For Mercury, the moralized astrology of the letter provided a suitable explanation.[83] He could stand for good counsel and the gift of oratory. But what of the Graces (Fig. 37)?

The case is typical of the quandary in which the allegorizers place the interpreters, and a rather full discussion of the problems involved may therefore be justified. There is a famous interpretation of the Graces in Alberti's *De Pictura* which has frequently been mentioned in conjunction with the 'Primavera'. Alberti, whose source is Seneca, interprets the three sisters as 'liberality', 'one of the sisters gives, the other receives, the other returns the benefit'.[84] Warburg also drew attention to the medal of Giovanna Tornabuoni (Fig. 36) where the Graces bear the inscription 'Castitas, Pulchritudo, Amor'. Later he noted the allegorical exegesis of the three Graces in the works of Pico della Mirandola, whose medal also shows the three sisters, but this time inscribed 'Amor, Pulchritudo, Voluptas'. Among the famous 900 conclusions on which Pico invited disputation was the following:

whoever profoundly and with his intellect understands the division of the unity of Venus in the trinity of the Graces, of the unity of fate in the trinity of the Fates and the unity of Saturn in the trinity of Jupiter, Neptune and Pluto, will see the right mode of proceeding in Orphic theology.[85]

Pico would not seem to have commented on this cryptic thesis, but in a different context he offers another exegetic allegory of the Graces, to which Warburg has drawn attention:

The poets say that Venus has as companions and as her maidens, the Graces, whose names in the vulgar tongue are Verdure, Gladness and Splendour. These three Graces are nothing but the three properties appertaining to that Ideal Beauty.[86]

In a lengthy explanation, Pico tries to demonstrate that verdure indicates permanence and perfection—for do we not call a young man in the fullness of his power 'green'? The other two properties of ideal beauty are the splendour with which it illuminates the intellect; and the desire which it arouses in the will for the possession of that ineffable gladness.

As permanence is not a reflective act, one of the Graces is painted with her face towards us, as if she would go forward and not turn back; the other two refer to the operations of the intellect and the will, whose operations are reflective, for which reason they are painted with the back towards us as one who turns back. . . .

Another member of the same circle has a different exegetic allegory at hand. Christoforo Landino, in his commentary on Dante, makes the name of Grace his starting point. Commenting on Mary, Lucy and Beatrice as three aspects of heavenly Grace, he remembers that:

Hesiod writes in the Theogony that the Graces are three in number, nor does he depart from the truth. They are the daughters of Jove; which means nothing else but that from God alone proceed all graces.

Landino goes on to quote St. Paul and David in support of this and to give the three names also mentioned by Alberti and Pico. Only his interpretation differs:

... Euphrosyne means happiness, and indeed we owe our happiness to heavenly Grace; Thalia means green and flourishing, and truly heavenly Grace refreshes our souls and makes them bloom. The poets add that the two last are turned towards the first; and in fact on the splendour of Grace our souls depend for their joy and health.[87]

As we pick our way through this new type of ambiguity, a clue seems to offer itself. There is another letter by Ficino to Lorenzo di Pierfrancesco and it deals with the meaning of the Graces. True, the letter is dated 1481, that is, it was written after the completion of the 'Primavera' while Botticelli was working in Rome. But would it not help us to establish the meaning that the myth held for Ficino? It would not appear that it does; it merely helps us to gain a further insight into the exegetical methods employed by the *quattrocento*. The letter is an example of how easily a trivial occasion could serve as a pretext for a display of esoteric profundity. It constitutes no more than a polite excuse for not having written for some time, but this excuse is couched in the form of an Orphic arcanum. Ficino complains that, though full of ideas, his mind suddenly became a blank whenever he put pen to paper to write 'Marsilio salutes Lorenzo the younger'. At first he blamed the Gods, but then Minerva appeared to him and took him to task for his lack of piety. She makes a speech explaining to Ficino the reason for his curious disability:

Know first that those three Graces, whom our poet depicts as three maidens embracing each other, are among the heavenly beings essentially three planets; Mercurius Jovius (that is Mercury who receives the grace and benefit of Jupiter), Sol and Venus who are harmonious and propitious companions in the heavenly dance. Similarly those three names of the Graces, Verdure, Light and Gladness, conform excellently with these stars. These stars are, among the celestial bodies, those which most affect by their favour the human genius; and for this reason they are called the Graces of man, not of any other kind of animal. Nor are they really the followers of Venus but of Minerva, and if you ever hear the first Grace identified with Jupiter, understand that it is not so much Jupiter but Mercurius Jovius, that is Mercury aided by the aspect or some other favour of Jupiter. For it is Mercury who, with that certain vital and prompt liveliness of his, exhorts us always to research into the truth of matters. The Sun with his light makes every kind of invention apparent to all ye who seek. Venus, finally, with her most amiable beauty, always adorns and embellishes what has been found.[88]

Having thus established the connection between certain planets and the Graces as ruling over 'invention', Ficino explains that it is these planets who determine a person's daemon or genius at birth.[89] If their constellation in the nativity of two people was similar, the genius of those two people will be similar, if not identical, and so will be their will. Minerva explains that since Ficino's own horoscope coincides with that of Lorenzo on this point—the three planets being in the Ninth House, that of faith, religion, genius and wisdom—their two genii are really the same. Whenever Ficino writes 'Marsilio salutes Lorenzo' he therefore inadvertently sins against heavenly order and his 'genius' dries up. He would rather begin his letters, 'Marsilio salutes Marsilio', and his invention would then flow. With a few more variations on the theme of 'alter ego', and with greetings to his beloved Giorgio Antonio Vespucci, Ficino ends his long epistle.

Need we conclude from this letter that Ficino took the Graces to symbolize the three planets, Mercurius Jovius, Sol and Venus? It is evident that such an interpretation is not applicable to the 'Primavera'. If one of the Graces is Venus and the other Mercury, what are the real Mercury and Venus doing in the picture? The letter may possibly throw a light on the way in which Mercury's gesture, pointing towards Jupiter, was capable of interpretation through astrological exegesis, but it also shows us how unstable all these symbolic references have become. There is ample evidence that Ficino himself never meant to establish a fixed meaning by his exegetic firework on the Graces as planets. Even within the realm of astrological interpretation we find him shifting and changing the significance according to his requirements. In his book *De vita coelitus comparanda* he expounds the very theory he has been at pains to disprove in the letter: 'That the three Graces are Jupiter, Sol and Venus, and that Jupiter is in the middle of the two other Graces and in greatest harmony with us'.[90] In yet another passage, a letter about Pico, the significance has shifted to Sol, Mercury and Jupiter, now identified with wisdom, eloquence and probity. When Pico was born, Ficino says, the Graces ceased to follow Venus and joined the 'dux concordiae'.[91]

But Ficino was not tied to these shifting astrological interpretations of the Graces. In the commentary to the *Symposium* he gives them an aesthetic significance, more reminiscent of the one expounded by Pico but again differing in all details:

... we say correctly that love pertains only to knowledge, shapes and sounds, and hence that only that is grace which is found in these three ... this pleasing quality whether of virtue, shape or sound, which summons and attracts the soul to itself through reason, sight or hearing, is most rightly called Beauty. These are the three Graces about which Orpheus speaks thus: Splendour, Youth, Abundant Happiness (ἀγλαιή τε Θάλεια καὶ εὐφροσύνη πολυόλβη). He calls 'Splendour' the charm and beauty of the soul which consists of brightness of truth and virtue; 'Youth' he applies to the charm of shape and colour, for this shines essentially in the greenness of youth; and finally by 'Happiness' he means that pure, salutary and perpetual delight which we feel in music.[92]

If the context required it, Ficino was even able to link this aesthetic interpretation with the astrological exegetic in yet another *tour de force* in which he uses the astrological significations of the letter to Lorenzo di Pierfrancesco:

Venus . . . is the mother of Grace, of Beauty and of Faith. . . . Beauty is nothing but Grace, a Grace, I say, composed of three Graces, that is of three things which descend in a similar way from three celestial powers: Apollo attracts the hearers by means of the grace of musical harmonies; Venus enraptures the eye by means of the Grace of colour and shape; Mercury, finally, by means of the wonderful Grace of intelligence and eloquence, turns contemplation mainly towards himself and kindles it with the love of divine contemplation and Beauty. . . .[93]

If we approach the Graces of the 'Primavera' with these texts in mind, our difficulty is obviously, not that we do not know any meaning, but that we know too many. Though we have been careful to restrict our search only to the immediate circle of Florentine *quattrocento* sources, we have had no difficulty in collecting a round dozen of different exegetic interpretations.[94] We do not know, and we may never know, which to apply or whether any applies. Who can tell whether young Lorenzo was not presented with yet another exegetic explanation of the followers of *Venus-Humanitas* which his tutors might have construed to make some particular point which they desired to drive home?

But if we have failed to solve this problem, our quest was nevertheless not quite in vain. We have learned something about the nature of the language we failed to translate. It is a strange language indeed. There are no dictionaries in this language because there are no fixed meanings. There is an important passage in Ficino in which he is quite explicit on this point:

Just as the Christian theologians find four senses in the sacred word, the literal, the moral, the allegorical and anagogical, and follow up the one in one passage, and the other mainly in another, so have the Platonists four modes of multiplying the Gods and spirits and apply a different mode of multiplication in different places as it is fitting. I too am used in my commentaries to interpret and distinguish the deities differently as the context requires.[95]

Here we learn something about the origins of the language we are investigating. It grows out of medieval exegesis, which in turn has its roots in late antiquity. No systematic study of this language from the point of view of semiotics has as yet been made, but certain broad principles have emerged.[96] They explain the difficulty which we meet when we try to establish the significance of any symbol such as the Graces as if it were a strict system of signs. A fixed relationship between symbol and reference requires an element of rational conventionalism which is absent from this mode of thought. It is precisely because he thinks that the meaning can be 'found' 'in' the symbol that the exegetic allegorist has to rely on the rules of primitive associations. He always finds the meaning for which he searches, and his

efforts are only directed at rationalization after the event. Ficino wants to praise
the Villa Carreggi as a seat of learning—and finds in the name what he wants, an
allusion to the Graces ('charitum ager').[97] Here the link between symbol and
significance is established along a very frail bridge of sounds. In other cases we saw
the *tertium comparationis* was a colour, a number or any other attribute. There is
something of a game in the technique employed. One could imagine a board in
which the myth or figure to be 'interpreted' is placed in the centre. Round it various
concepts with their attributes are written in schematic fashion. Identical attributes
are linked. A bridge leads from the Grace whose name is 'splendour' to the
'splendour' of truth and virtue and also to the 'splendour' of the planet Sol. The
game consists in moving the counter of signification to a desired point and back to
the centre along different lines. If you have gone to 'Sol' you must go through two
other planets and find their links with two other Graces—if no direct links can be
found you may choose an intermediary stop like 'youth' which, for Pico, links the
'green' Grace with the perfection of Divine Beauty.[98]

There is an element of artistic enjoyment in these twists of exegetic ingenuity
which it is not easy for us to experience but which, at its best, may have something
in common with the discovery of new and unsought musical relationships. To find
new and unexpected links and to add new possibilities of application to a symbol
was to many generations the essence of 'wit'. On the other side the practice of
'finding' the meaning of a symbol with the technique indicated is closely allied to
the modes of thought revealed in the magic practices of astrology. In these it is the
effect of a sign that is studied on the lines of sympathetic links.[99] It is characteristic
of the mental attitude of the Renaissance philosophers that to them the meaning
and the effect of a symbol becomes so easily interchangeable. Venus 'means'
Humanitas because her effect as a planet is to engender friendliness—both meaning
and effect deriving, in the last analysis, from her character as a laughter-loving
figure. Huizinga was certainly right when he stressed the primitive element in
medieval symbolism, but he was equally justified later in elaborating its playful
features.[100] The humanist allegory frequently oscillates between the search for the
Orphic arcanum, bordering on primitive magic, and the sophisticated conceit,
bordering on parlour games.[101]

The more insight we gain into this Renaissance approach to the symbols of
classical antiquity the more likely are we to understand the spirit in which the
'Primavera' was conceived, even if the precise meaning of some of its figures eludes
us. To think of these symbols as a ready material for the construction of picture
puzzles is no less one-sided than to regard them as evidence of 'paganism'. For the
cultured visitors to Castello the Graces in the 'Primavera' must have been sur-
rounded by an aura of potential application and still-to-be-discovered meaning
which may be just as essential for their understanding as the significance they had

for the initiated. Interpretation is not only concerned with the translation of symbols into concepts—it is limited in these efforts by the presence of a definite key. It also strives to assess the quality of the imagery and the kind of its appeal. In this context the fluidity of meaning attached to the classical symbols is of equal significance for the position of the 'Primavera' as is the ambiguity of expression we found on its figures. For this fluidity Ficino provides the best illustrations. He treated the ancient myths with a freedom which may surprise one in a humanist. Where the old tales did not satisfy his needs he enjoyed inventing new ones. These mythological fables or *apologi* are among the most attractive of Ficino's writings. Modern literature has neglected them. But the imagery and spirit of some are sufficiently close to that of the 'Primavera' to justify a full quotation of an example even though it does not offer a 'key' to any figure in the picture. In the *Epistolarium* it belongs to a series appended to the letter to Lorenzo di Pierfrancesco of October 1481, an indication that it was dedicated to Botticelli's patron, who was 18 at the time:

Among the many pieces of advice which Phoebus, the light of life and author of life-giving medicine, gave to his daughter Lucilia, the main counsel was that she must never leave her father's side or else she would suffer divers grievous ills. At first Lucilia obeyed the commands of her father, forced by the rigour of the winter. But later, reassured by the happy smiles of spring, the maiden began to stray further from her father's house, and to stroll among the beautiful gardens of pleasant Venus across the gaily painted meadows; beckoned on by the charm of the fields, the beauty of the flowers and the sweetness of scents, she began to make wreaths and garlands and even a whole garment of ivy, myrtle and lilies, roses, violets and other flowers. Soon she began plucking the sweet berries and bland fruits all around her, not only tasting them but devouring them with eager mouth. Then the pride that she felt in her new ornaments made her bold; she became vain and conceited and quite forgetting her father, she entered the nearby city. But meanwhile the snakes hidden among the herbs constantly bit the feet of the dancing maiden, and the bees hidden among the flowers of her garlands stung her cheek, neck and hands; swollen with the richness of her unaccustomed food she was sorely grieved. Then the ungrateful Lucilia, who had already been seduced by pleasure to despise her father, the healer, was compelled by her great pains to return home, and to acknowledge her father, whose help she demanded with these words: 'Ah my father Phoebus, come to the aid of your daughter Lucilia, please hurry, oh dearest father, help your daughter, who will perish without your succour.' But Phoebus said: 'Why, vain Flora, do you call Phoebus your father? Stay now, you immodest wretch, stay, I tell you, I am not your father, you just go to your Venus, impious Flora, and leave me instantly.' But imploring him even more with many prayers and beseeching him not to take the life of the only maiden to whom he had given it, she promised him that she would never again disregard his paternal commands. At last her loving father forgave her and admonished her with these words: 'I do not want to heal you before you have divested yourself of those tinsel ornaments and lascivious trappings. Let it be your lesson, the lesson of your temerity, that while you stray far from your paternal home you buy a brief and slight pleasure at the cost of such long and grievous pain, and that the little honey you win by disregarding the commandments of the true healer will bring you much gall.'[102]

In this story Ficino represents the Garden of Venus as the evil principle of lust and Lucilia's appearance decked with flowers as her fall. Had it pleased him to shuffle the cards differently and to represent Venus in her positive qualities—as he did in another *apologus* of the same group[103]—we might have come even nearer to the imagery of the 'Primavera'. Perhaps it is lucky that he did not. For this might have tempted us to read a more specific meaning into the right-hand side of the picture than it may have had in Botticelli's mind. Suffice it to show that to him and his contemporaries the Garden of Venus was still peopled with symbolic beings, whose very beauty was charged with meaning.

7. *The Typological Approach*

So far we have only used literary sources for the interpretation of the 'Primavera'. We are therefore not in danger of reading out of the picture what we have just read into it. How far does the picture answer to the ideas we have derived from the texts? How far did Botticelli enter into the spirit of Ficinian allegory and the message his picture was to convey? We may feel that he did so, but can we give more concrete reasons for this feeling than did those who saw in the picture a glorification of Love and Spring? We can, by investigating the pictorial terms in which Botticelli expressed the idea.

Botticelli certainly knew the traditions of secular art which flourished both North and South of the Alps. Its main themes were drawn from the world of chivalry and courtly love.[104] The Gardens and Bowers of Love, the Fountains of Youth, the pictures of Venus and her children, the storming of the castle of Love, the occupations of the months with their charming pictures of May, in short, the whole cycle of courtly imagery with its flowery meadows and delicate maidens must have been present in Botticelli's mind when he was approached to paint a picture of Venus and her train for the Villa di Castello. He must equally have had in mind the Cassone paintings with their crowded illustrations of classical tales glorifying the great examples of ancient virtue. Yet it has always been felt that the 'Primavera' constitutes something entirely new. There may be elements in the picture connecting it with earlier works of secular art, but its spirit and emotional import are different. It is not only conceived on a larger scale but altogether on a higher plane. It is in this fact that we find a confirmation of its connection with Ficino's letter and the Platonic programme. As the artist absorbed the idea of *Venus-Humanitas* and its inspiring call, the terms of traditional secular art proved inadequate to express its meaning. This Venus was to arouse in the spectator a feeling akin to religious enthusiasm, a divine *furor* kindled by beauty. What wonder that Botticelli visualized 'Praestanti corpore nympha, coelesti origine nata, aethereo ante alias dilecta Deo' in the mould of sacred art? The nymph of heavenly origin whom God exalts by

His love has indeed her spiritual sister in Baldovinetti's 'ancilla domini' (Fig. 38). The many critics who sensed the affinity of Botticelli's Venus with his Madonnas were certainly right[105] but such a connection was less naïve or paradoxical than it seemed to them. We find a similar equation in the poems of Botticelli's contemporary Bonincontri, a friend of Ficino, in whose astrological poem the planet of the Third Heaven is quite explicitly coupled with the Holy Virgin.[106] Once he had conceived his Venus in such terms of sacred art the Bower of Love would of itself take on the appearance of Paradise. Even without an allegorical re-valuation, the imagery of the two gardens had sometimes tended to merge so closely as to arouse the protest of devout writers. Early in the fifteenth century Gerson protested against the confusion of the descriptions of earthly love and of Paradise in the *Roman de la Rose*.[107] Ficino's interpretation of Love as a symbol of the Divine had made this identification both innocuous and inevitable.[108] Thus Botticelli did not visualize the Graces like the dancing maidens that used to decorate the walls and coffers of noble Florentines; nor did he look for models among the frenzied maenads of classical sarcophagi. The rhythm of their dance is inspired by the harmonious motions of the blessed spirits in one of Fra Angelico's scenes of Paradise or of the chorus of angels in Sienese paintings (Figs. 37, 39). And so with the figure of the 'Hora', scattering the flowers of spring. Warburg connected her with a classical statue, and such a connection may well hold; but this does not exclude her relationship to a family of angels scattering flowers. The vision of that maidenly figure, her lap full of flowers, enhancing a holy presence, was prefigured in the angels of Filippo Lippi and Gozzoli (Figs. 40–42).[109] Even the figure of Flora pursued by the wanton wind could somehow be adapted to this medium. The group may retain a distant echo of the traditional group of a poor soul trying to enter Paradise and pursued by one of the devils.[110] It is not, of course, suggested that Botticelli's picture is a pastiche of various types of sacred art. But if he knew Ficino's letter and the approach of his circle to mythology, his mind would naturally set to work in the direction of beatific visions. It was this conception which enabled Botticelli to conceive the work on the scale and on the plane of religious painting. It was from this sphere that he derived the intense and noble pathos that pervades his work.

Such an interpretation would solve the apparent paradox which has attracted and puzzled so many writers on Botticelli's mythologies. On the other hand it would seem to be in contradiction with the views expounded by Warburg that it was precisely for the quality of 'pathos' that the mythological art of the *quattrocento* went to the classical models. But this contradiction is more apparent than real. Borrowing from the antique and the rise in the status of secular art are two things. Religious art had never ceased adapting classical motifs and had done so consciously ever since the Pisani.[111] What would Donatello's great 'pathos' be without classical inspiration? If Botticelli borrowed a classical motif for a movement or a drapery

he was only doing what many artists had done before him. But that he painted a non-religious subject with the fervour and feeling usually reserved for objects of worship was a departure of momentous significance. Only through such a step was it possible for secular art to assimilate and transform the pathos of classical sculpture.

If we approach Botticelli's picture with the artificial antithesis of Pagan or Christian we will only get a distorted answer. If our interpretation is right this dilemma was as unreal to Botticelli as it was to Ficino. The 'paganism' of Apuleius' description had undergone a complete transmutation through Ficino's moral enthusiasm and exegetic wizardry. A description of a show, little better than a Montmartre *Revue*, had been translated in all good faith into a vision of the bliss that comes with *Humanitas*. But the very fact that such high and inspiring thoughts could be translated into pictorial terms outside the range of religious iconography constitutes a symptom of no mean importance. The highest aspirations of the human mind were opened up to non-religious art. What we witness is not the birth of secular art—that had existed and flourished throughout the Middle Ages—but the opening up, to secular art, of emotional spheres which had hitherto been the preserve of religious worship. This step had become possible through the trans-formation of the classical symbols in the solvent of Neo-Platonic thought. Once it was made, once the boundaries had been crossed, the division into recognized spheres began to fade. Visual symbols have a way of asserting their own presence. To the next generation, the dignity and emotional import of classical themes began to equal those of religious subjects. Their exegetic meaning, however, began to pale. The image gained ascendancy over the text, Venus conquered her commentators.[112]

THE PLATONIC ACADEMY AND BOTTICELLI'S ART

Ficino and Botticelli's Patron

The kinship of Botticelli's art with the spirit of Ficino's Academy has been felt by various writers.[113] Are we then entitled to extend the findings made in the previous section and apply them to all Botticelli's mythologies or even to his art as such? The historical material, scanty as it is, would support such a hypothesis. The docu-mentary evidence of Lorenzo di Pierfrancesco's continued patronage of Botticelli is well known.[114] It is perhaps the most intimate connection between an artist and a private *maecenas* on record in the early Renaissance. The evidence for Ficino's continued intimacy with Botticelli's patron is equally strong. Not only does the *Epistolarium* testify to their constant friendship; we have a more striking proof of the closeness of this friendship in Ficino's will. In this personal document the

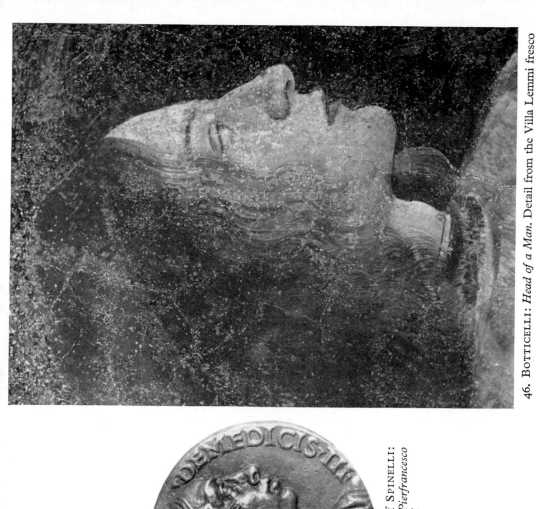

46. BOTTICELLI: *Head of a Man*. Detail from the Villa Lemmi fresco
(Fig. 58b)

44. In the manner of SPINELLI:
*Medal of Lorenzo di Pierfrancesco
de' Medici*

43. In the manner of SPINELLI:
*Medal of Lorenzo di Pierfrancesco
de' Medici*

45. Reverse of the medal Fig. 43

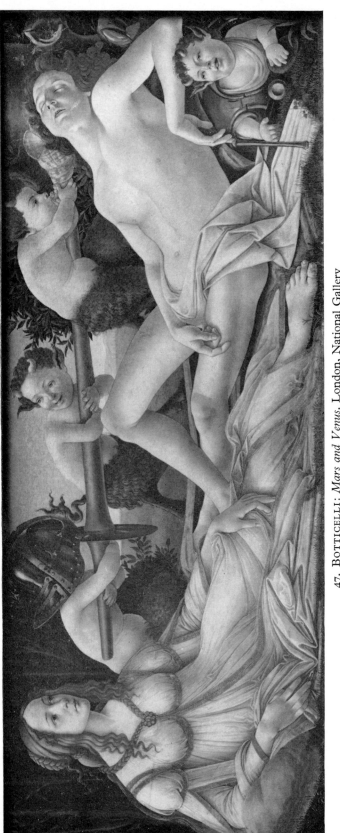

47. BOTTICELLI: *Mars and Venus*. London, National Gallery

49. The arms of
the Vespucci

51. PIERO DI COSIMO: *The Misfortunes of Silenus*. Detail.
Cambridge, Mass., Fogg Art Museum. See p. 216, note 139

50. *Wasps*. Detail from Fig. 47

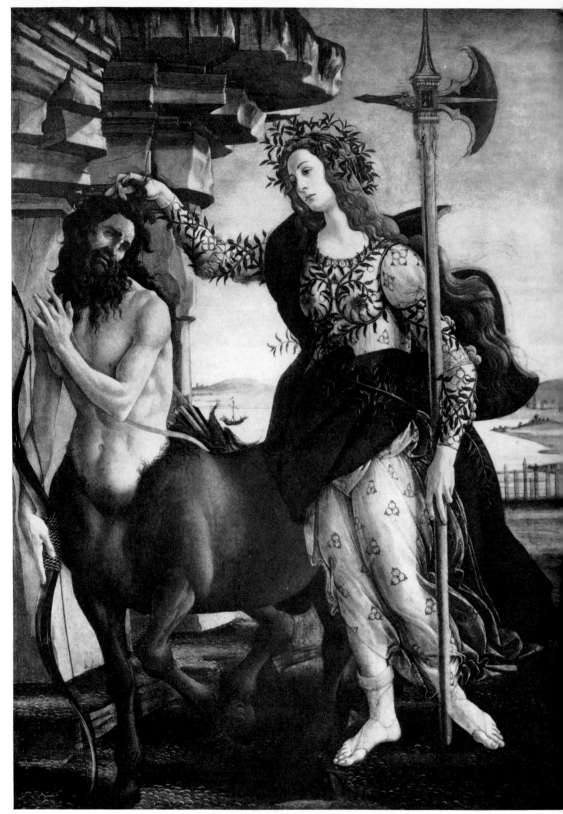

52. BOTTICELLI: *Minerva and the Centaur*. Florence, Uffizi

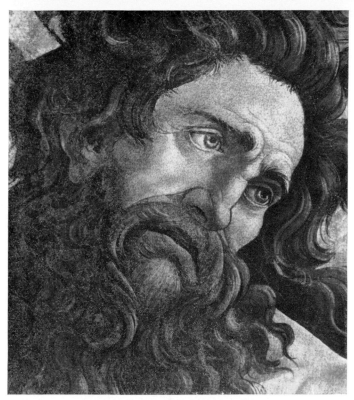

53. *Head of the Centaur.* Detail from Fig. 52

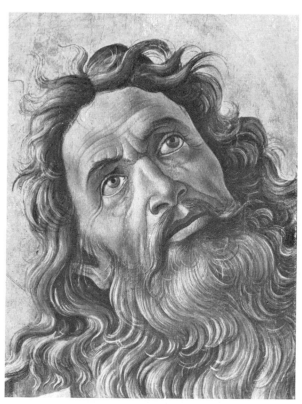

54. *Head of St. John the Evangelist.* Detail from
Botticelli's *Coronation of the Virgin.* Florence, Uffizi

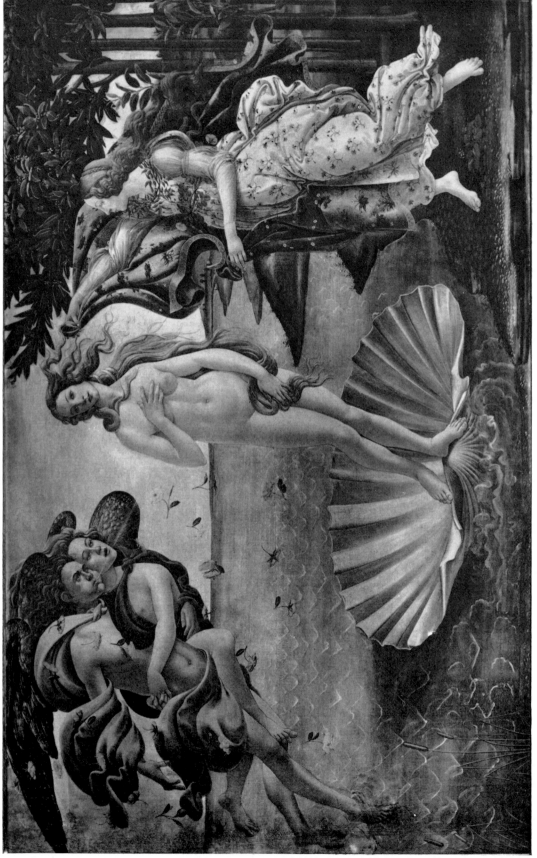

55. BOTTICELLI: *The Birth of Venus.* Florence, Uffizi

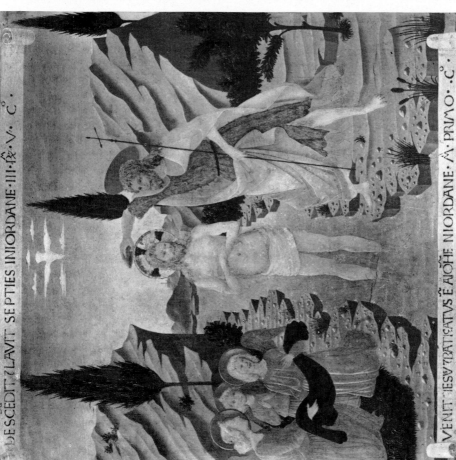

57. BALDOVINETTI: *The Baptism of Christ*. Florence, Museo di S. Marco

56. Detail of the *Tazza Farnese*. Antique cameo. Naples, Museo Nazionale. See p. 218, note 156

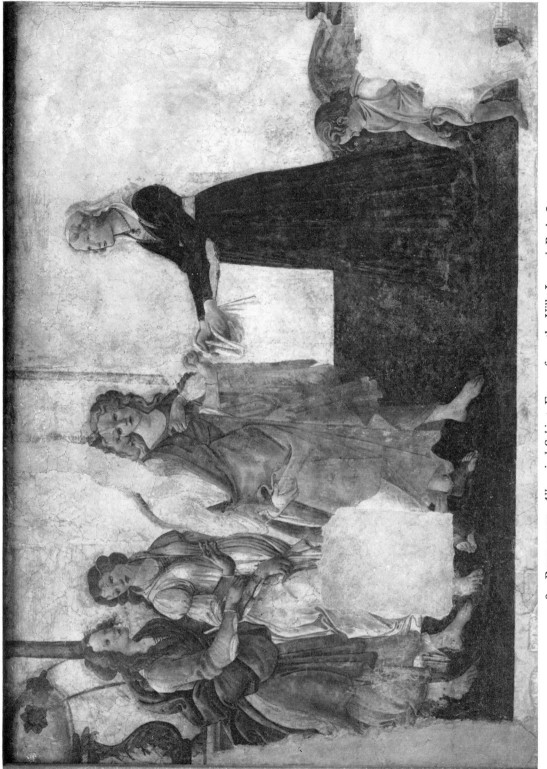

58a. BOTTICELLI: *Allegorical Subject.* Fresco from the Villa Lemmi. Paris, Louvre

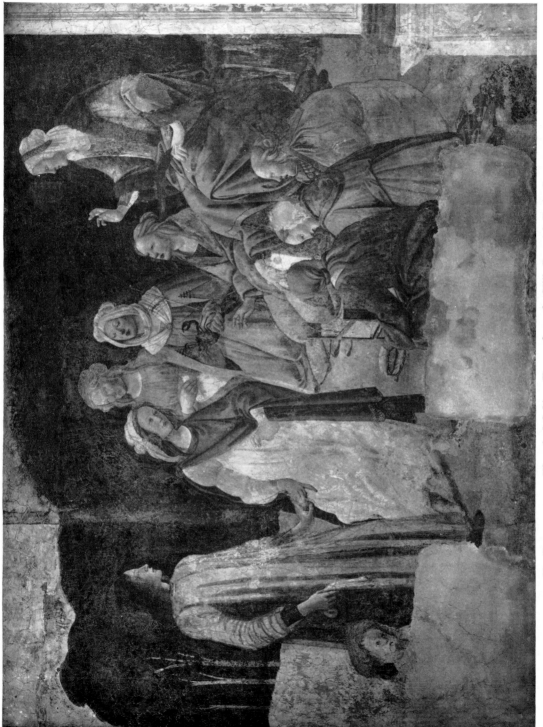

58b. BOTTICELLI: *Allegorical Subject*. Fresco from the Villa Lemmi. Paris, Louvre

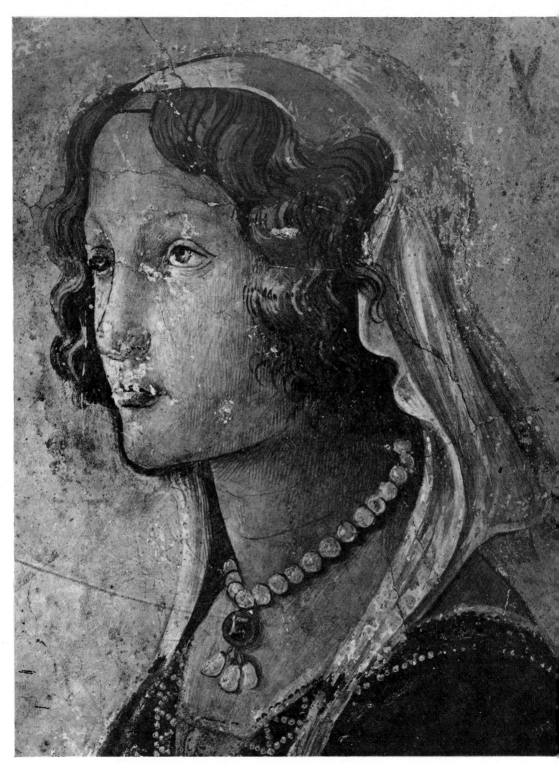

59. *Head of a Woman.* Detail from Fig. 58a

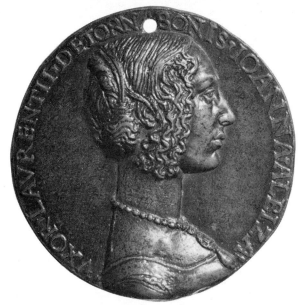

60. In the manner of SPINELLI:
Medal of Giovanna Tornabuoni

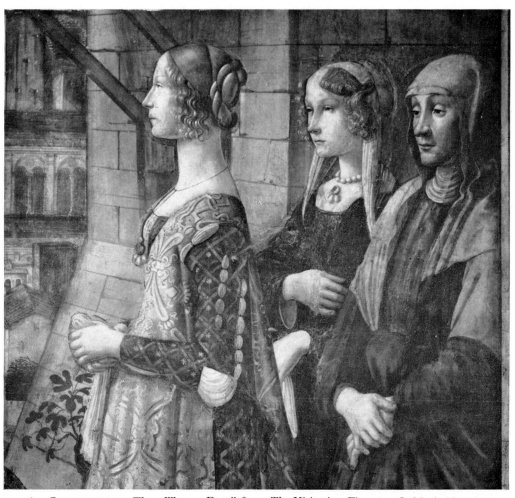

61. GHIRLANDAJO: *Three Women*. Detail from *The Visitation*. Florence, S. Maria Novella

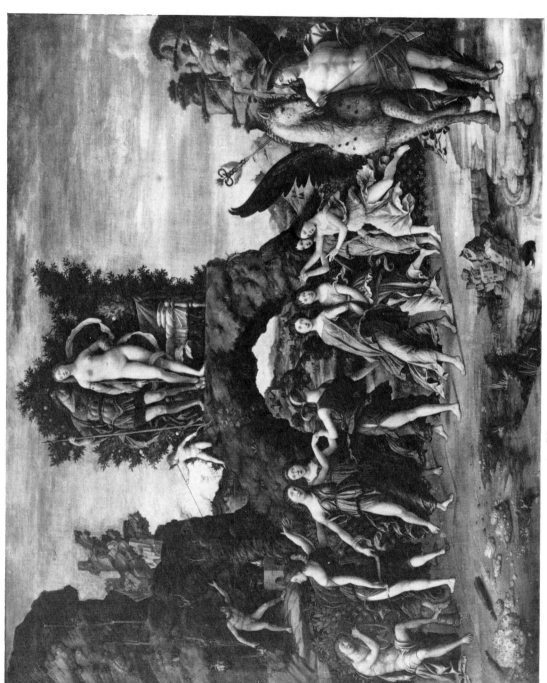

62. MANTEGNA: *Parnassus*. Paris, Louvre

philosopher charges Lorenzo di Pierfrancesco with the task of providing for his tomb and leaves him, in significant recognition of special services rendered, the treasured complete copy of Plato's Dialogues in Greek.[115] Another of Botticelli's patrons was also closely connected with Lorenzo di Pierfrancesco on the one hand and Ficino on the other. The Vespuccis, whose connection with Botticelli was traced by Horne, were Lorenzo di Pierfrancesco's business partners.[116] It was due to this connection that Amerigo Vespucci, the pupil of Giorgio Antonio and therefore fellow student of Lorenzo di Pierfrancesco, sent his sensational letter on the New World, which gave the continent its name, to none other than Botticelli's patron.[117] The relation, in turn, of Giorgio Antonio, Amerigo's uncle, with Ficino also lasted throughout their lifetime. In Ficino's will he signs as the first witness.[118]

We thus see Botticelli closely connected with a circle in which Ficino's influence was particularly strong. Perhaps it was even stronger among these men than in the more immediate entourage of Lorenzo il Magnifico and his friend Poliziano. In the early years, of course, all these belonged to one 'Platonic' circle, but one may well wonder whether it has not been taken too much for granted that this harmony lasted throughout the Magnifico's lifetime? Perhaps a more detailed analysis would reveal different groupings[119] and also growing antagonisms which expressed themselves in the political field. Or should we assume that Lorenzo di Pierfrancesco's *fronde* and his French intrigues did not start until after the Magnifico's death? He certainly maintained close relations with Charles VIII ever after his mission to France as a young man. Guido Antonio Vespucci was also for many years ambassador to France. And is it mere coincidence that when Charles VIII finally entered Florence and put an end to the supremacy of the Magnifico's line, it was Ficino who welcomed the king in terms of profuse flattery?[120]

If we assume that these groups had already started to form during the Magnifico's lifetime, we would feel less surprise at the fact that no major works by Botticelli were found among his listed possessions.[121] We might even dimly discern the social background in which Botticelli's 'second Gothic' developed in such contrast to the art of Ghirlandajo or of Bertoldo, the intimate of the Magnifico.[122]

The relations of Lorenzo di Pierfrancesco's circle to Savonarola, finally, may provide a key to Botticelli's much discussed conversion. Perhaps it was a less dramatic break than has sometimes been assumed. Giorgio Antonio Vespucci, Ficino's friend, was a follower of Savonarola. Ficino himself was never opposed to the frate's plans of reform.[123] Lorenzo di Pierfrancesco's role in the last episode of the frate's career is more ambiguous, but his first profession of allegiance to the cause of the *Popolani* need not have been insincere. Savonarola himself, of course, spoke under duress at his trial, but he may nevertheless have meant what he said when he stated that he 'had always held Lorenzo di Pierfrancesco in good account and for a worthy man'.[124]

Little though we know about Lorenzo di Pierfrancesco, as compared with our
knowledge of his more famous relation, his figure nevertheless attains an indivi-
duality of its own if we piece together all the evidence. Among the few letters from
his hand is one recommending the Greek humanist, Marullo, to Lorenzo il
Magnifico.[125] Marullo, too, whose mystical conception of antiquity stands out
against the purer humanism of his enemy Poliziano, fits into the circle of Plato-
nists.[126] It was Lorenzo di Pierfrancesco, in all likelihood, who paid for the edition
of Dante with Landino's commentary and Botticelli's engravings, and he again who
commissioned Botticelli to undertake the great work of his Dante illustrations.
Moreover, Lorenzo di Pierfrancesco took care that he should be more to posterity
than a mere name. There are two medals of his extant, both showing his head in
profile and, on the reverse, a snake biting its own tail (Figs. 43–5).[127] It was cer-
tainly not for nothing that the scion of a great family chose this symbol for his
medal. It is a hieroglyph, described by Iamblichus as signifying 'eternity', and the
aura of esoteric wisdom which surrounds it may have proclaimed to his contem-
poraries a preoccupation with mystic lore.[128] Ficino had translated Iamblichus and
discussed the sacred symbol in his writings[129] and we should like to think that it
was he who advised Lorenzo di Pierfrancesco on its adoption for the medal. The
two medals show on the obverse Lorenzo's head in profile, the one as a compara-
tively young man, the other as older, with more hardened features. Hill thought
that the portrait suggests a painted prototype and perhaps we shall not go wrong
if we ascribe this prototype to Botticelli. The similarity in conception between this
head and that in the Villa Lemmi fresco (Fig. 46) is indeed striking.[130] This medal,
therefore, may be a token of that collaboration between Ficino and Botticelli for
their patron Lorenzo di Pierfrancesco, for which we are trying to make a case.

Mars and Venus

We know no sources at present which would link other works of Botticelli with any
specific utterances of Ficino. The nature of his approach to mythology and the
kaleidoscopic character of his interpretations make it extremely hazardous to apply
passages from his works to specific pictures. Even if they fit in many details we
have no guarantee that the correspondence was intended. Our justification in
putting a number of such conjectural interpretations before the reader lies in the
method that governs all processes of 'decoding'. The solution suggested in one
instance must be tested in application to others. The greater the number of
'messages' which make sense in the light of a particular solution, the smaller is the
danger that the correspondence is merely fortuitous. If, moreover, such interpre-
tations can account for points which have puzzled previous observers, they are at

any rate worth ventilating. In the end they must be judged in the aggregate on their fruitfulness or otherwise in explaining the character of Botticelli's art.

For one of Botticelli's mythologies a Ficinian interpretation has been suggested before, though art history has not apparently taken note of the fact. In her book on the Neo-Platonism of the Italian Renaissance, Nesca N. Robb suggested that Ficino may offer the key to the picture of Mars and Venus in the National Gallery (Fig. 47). She drew attention to the passage in the commentary on the *Symposium* in which Ficino gives an astrological interpretation of the myth of Mars and Venus:

Mars is outstanding in strength among the planets, because he makes men stronger, but Venus masters him.... Venus, when in conjunction with Mars, in opposition to him, or in reception, or watching from sextile or trine aspect, as we say, often checks his malignance ... she seems to master and appease Mars, but Mars never masters Venus....[131]

This is clearly a case when a trait which has hitherto defied explanation would acquire coherence and meaning in the light of Ficino's doctrine. The contrast between the deadly torpor of Mars and the alert watchfulness of Venus has often been remarked.[132] Neither the description of Mars and Venus in Poliziano's *Giostra*, nor its apparent model, the passage in Lucretius, accounts for it.[133] It is all the more in need of explanation as it is not a feature of the classical relief which E. Tietze-Conrat has shown to have served as a model for the general attitude of the two reclining figures (Fig. 48).[134] The passage in Ficino's commentary, moreover, is by no means isolated. Ficino loved to refer to his favourite doctrine of the mutual 'temperament' of the planets, a theme which also underlies Dürer's 'Melancholia'.[135] That he was not alone in this interpretation is known to every reader of Chaucer's *Complaint of Mars*, where the elaborate interplay of astrological and mythological facts must have been intelligible to contemporaries.[136] This is what we hear of Venus' 'governance' over Mars:

> And she hath take him in subjeccioun,
> And as a maistresse taught him his lessoun, ...
> For she forbad him jelosye at alle,
> And crueltee, and bost, and tyrannye;
> She made hym at hir lust so humble and talle,
> That when hir deyned caste on hym her ÿe,
> He took in pacience to lyve or dye;
> And thus she brydeleth him in hir manere,
> With no-thing but with scourgyng of hir chere.

Verses like these are a useful reminder that the astrological interpretation of the myth does not exclude a moral application. The lordship of gentle Venus over ferocious Mars fits in well with Ficino's conception of the Goddess. It is in such passages that the borderline between effect and significance is blurred and if drawn

too clearly would probably falsify the symbol. The same may be said of the application of the astrological and moral constellation to particular instances. Chaucer's 'complaynt' was, according to old sources, a personal allusion or tribute,[137] and Ficino was equally prone to apply the general doctrine to the particular. The astrological and moral overtone of Botticelli's 'Mars and Venus' therefore is not incompatible with its having been painted for a particular occasion.

There are two indications that this was indeed the case. The first is connected with Count Plunkett's observation that the *amorini* or *satyrini*, playing round Mars and mocking his helplessness, echo another classical *ekphrasis* by Lucian; his description of the painting of Alexander and Roxana. Count Plunkett's suggestion has gradually dropped out of the literature about the picture, no doubt because it is awkward to imagine that a minor motif of this kind should have been borrowed from a recondite source and adapted to a different subject. But we are presented with the alternative either of admitting the connection or declaring the similarity to be purely fortuitous, which is not a likely solution in view of the eagerness with which the Renaissance searched for descriptions of classical paintings. The passage from Lucian runs:

> On the other side of the picture, more Loves play among Alexander's armour; *two are carrying his spear, as porters do a heavy beam;* two more grasp the handles of the shield, tugging it along with another reclining on it, playing kind, I suppose; and then *another has got into the breast plate, which lies hollow part upwards; he is in ambush,* and will give the royal equipage a good fright when it comes within reach.[138]

The use of this passage from such a recondite source is in itself a proof that Botticelli's picture is anything but a 'naïve' evocation of the classical tale. It, too, must rest on a humanist programme, and if its author included the motif from a Greek writer, he very likely did so because the interpretation Lucian gives to it is of the type which endeared the *ekphrasis* to Renaissance scholars.

> All this is not idle fancy, on which the painter has been lavishing needless pains; he is hinting that Alexander has also another love, in War; though he loves Roxana, he does not forget his armour. And, by the way, there was some extra nuptial virtue in the picture itself, outside the realm of fancy; for it did Aëtion's wooing for him. He departed with a wedding of his own as a sort of pendant to that of Alexander; his groom's-man was the King; and the price of his marriage-piece was a marriage.

If 'Mars and Venus' was a 'marriage piece', it was continuing the tradition of the *cassoni*, of which it is clearly an offspring. In the *cassoni* we can sometimes tell by the coat-of-arms whose marriage is to be celebrated. Botticelli's picture is less explicit but it also allows us a guess in this direction. In the right-hand corner, where we may expect a coat of arms, we see the conspicuous and puzzling motif of wasps swarming in and out of a trunk (Fig. 50). Perhaps the solution of this riddle is very simple. The wasps were the punning coat-of-arms of the Vespucci (Fig. 49),

whom we have already met as patrons of Botticelli.[139] Is it not likely that the picture does in fact commemorate a marriage in that wealthy house?[140]

Our interpretation presupposes a complexity of meaning in the picture which some may find hard to accept. But, retracing our steps, we find no element which contradicts the known customs and ideas of the *quattrocento*. A marriage panel in the *cassoni* tradition—perhaps for a bed, as has been suggested—a programme by a humanist who sees the story of Mars and Venus in terms of astrological lore, thus adding a gallant tribute to the spouse who 'tames' her lover, a motif from Lucian brought in because its significance is equally fitting, a classical sarcophagus to provide the typological source for the general composition, and a personal emblem built into the margin of the picture as a sign of property. All these steps seem conceivable in Botticelli's world. Can the same be said of the romantic interpretation which sees in the picture yet another glorification of Giuliano and 'La Bella Simonetta', based once more on Poliziano's *Giostra*? The relevant passage in the poem most often referred to is really a commentary on Giuliano's Jousting Standard which showed Minerva and bound Cupid, symbols of Chastity.[141] The symbol appears to Giuliano in a dream. Poor Cupid, chastised by Simonetta-Minerva, cries for help, but Giuliano is powerless, as the Gorgon head on Pallas' shield keeps him at a distance. At this moment Glory, Poetry and History come to his aid, and he sees in his vision how they divest his lady of the arms of Pallas and leave her in a white robe. It is hard to see a connection between this courtly allegory and Botticelli's picture. Someone is asleep and someone wears a white robe, but that is really all. That Giuliano de' Medici, 'Luctus Publicus' (as the commemorative medal calls him), should have been portrayed in such a shape, and that Poliziano's poem should have been illustrated on this type of panel, would be without any documented parallel in the *quattrocento*. Reality was probably both more complicated and much simpler than the romantic interpretation would have it.

Pallas and the Centaur

A similar romantic pre-occupation also stands in the way of a more natural interpretation of 'Pallas and the Centaur' (Fig. 52). At the time of its discovery the picture was taken to be a political allegory because Minerva's dress is embroidered with a Medicean emblem.[142] It was interpreted as a kind of 'serious cartoon', a super Tenniel commemorating Lorenzo de' Medici's victory over the Pazzi or over the hostile coalition against him. Some regarded it as a specific monument commemorating the victory of his shrewd diplomacy over the clumsy brutality of the court of Naples. But political allegories of this type seem to be a later development. There is again no documented parallel which would support this interpretation.

Political art presupposes a public to which its propaganda is directed, and we know that the Minerva came from the private apartments of the Medici, very likely from Lorenzo di Pierfrancesco's city palace. These external circumstances and the typological tradition point towards moral allegory.[143] It is not difficult to imagine a programme in the spirit of Ficino's imagery which would fit it better than the political interpretation.

One of the principal themes of Ficino's writings is that of the position of man between brute and God.[144] The nether parts of our soul link us with the world of the body and its senses; the exalted region of the mind partakes of the Divine; and human reason, which is man's own prerogative, stands in between. Our soul is the scene of constant strife between the fretful motion of the animal instinct and the yearnings of reason—a strife which only Divine guidance can resolve from above, bringing with it the serene stillness of heavenly wisdom.

In a letter to his fellow-philosophers Ficino develops this favourite idea with illustrations sufficiently close to Botticelli's painting to warrant quotation:

Wisdom, who is born from the exalted head of Jupiter, creator of all things, prescribes to philosophers, her lovers, that whenever they desire to grasp a beloved thing they should rather aim at the top, at the heads of things, than at the feet below. For Pallas, the divine offspring who is sent from the high heavens, herself dwells on the heights which she makes her stronghold. Furthermore she shows us that we cannot attain to the summits and heads of things before having mounted to the head of the soul, the intellect (*mens*), leaving behind us the soul's lower regions. She promises us finally that if we withdraw ourselves into that most fertile head of the soul, that is, the intellect, we will doubtless procreate from this head an intellect which will be the companion of Minerva herself and the helpmate of Jupiter the all-highest.[145]

After this introduction to the Five Questions concerning the intellect, Ficino discusses the hierarchy of faculties from the angle of the Platonic theory of motion. The body is lowest in the ladder because it cannot move by itself but is moved by the soul according to strict laws: the soul is capable of motion but finds itself moved towards its heavenly origin, where God is rest. What wonder, then, that we find no rest while we dwell in the body?

'Our brute, that is the senses' is compelled toward its aim by animal urges, as the arrow towards its target. 'Our man, that is reason' finds no satisfaction in the fulfilment of these urges. Through reason, perceiving man's higher aim, we have become restless and tormented:

This may be the significance of that most unhappy Prometheus who, admonished by the Divine Wisdom of Pallas, had received the celestial flame, that is reason; because of this very act he was fastened on the peak of a mountain, that is the rock of contemplation, and torn by the constant bites of a most rapacious bird, that is the spur of the desire for knowledge.

Or, again, we are like Sisyphus who is toiling up the steep mountainside:

We aim at the highest summit of Olympus and dwell in the abyss of the lowest vale . . . here we are detained by a host of obstacles and impediments, there deflected by the blandishments of the meadows.

Only Divine Grace can resolve the paradox of human existence. Only the immortality of the soul gives meaning to our toil on earth. While dwelling in the body, the soul cannot attain to the state of perfection and happiness for which it is destined.

Again Botticelli's picture is not an illustration of Ficino's treatise, but the points of contact are sufficient to draw up, with its help, a hypothetical programme. In such a programme 'bestia noster, id est sensus' and 'homo noster, id est ratio', would be expressed in their relationship, not through the symbol of Prometheus or of Sisyphus, but through the symbol of the Centaur, whose form partakes of both beings.[146] He is equipped with bows and arrows, emblem of animal urges,[147] and 'lives deep down in the abyss of the valley' ('habitat infimae vallis abyssum'), detained, it seems, by 'the charm of the meadows' ('pratorum blandimenta'). *Minerva-Mens*, 'born from the high head of Jove the creator' ('summo Iovis creatoris capite nata'), takes the soul by its head, which is her appropriate gesture of domination.

This hypothesis would explain a number of features which remained meaningless and even awkward within the context of earlier interpretations. The landscape setting, with its conspicuous craggy rock and smiling vistas, does not look like an ordinary decorative scenery but rather like one of the allegorical landscapes familiar from such scenes as the Dilemma of Hercules.[148] The bows and arrows may not stand in need of a particular explanation but the strange attitude of Minerva surely does. Any interpretation of the picture as a symbol of a struggle between good and evil—political or ethical—must find the action and composition rather lame and spiritless.[149] There is no struggle going on between Minerva and the Centaur, no heroic strife because the strife is taking place within the Monster 'created sick, commanded to be sound'. Once we see the picture in this light we also understand the Centaur's suffering expression and the gaze which he turns upon Minerva, the embodiment of Divine Wisdom. As she takes him gently by the head to still his fretful motion and to lead him on his way, he does not resist but abandons himself to her guidance.

> La figlia qui del gran Tonante sorga,
> che sanza matre del suo capo uscio;
> questa la mano al basso ingegno porga.[150]

(Here arises the daughter of the great Thunderer who emerged from his head without a mother, and she proffers her hand to our lowly mind.)

The type used by Botticelli for the head of the Centaur would not conflict with such an interpretation. It is probably modelled on a classical sculpture,[151] but the painter has assimilated his features, not to the stock figures of sinful brutality, but to the physiognomy of his praying Saints (Figs. 53, 54). Thus, while we cannot, of course, prove our interpretation, it seems certainly to come nearer to the spirit of the work than the story of Lorenzo's visit to the court of Naples.

The Birth of Venus

The most difficult problem confronting us is that of the 'Birth of Venus' (Fig. 55). Here there are no puzzling features demanding explanation; no picture could be more self-sufficient. The fame of Apelles' 'Aphrodite Anadyomene' and the *ekphrasis*[152] in Poliziano's *Giostra* may really explain the picture completely. But do they? Only recently a critic has stressed the exceptional character of such a subject in the *quattrocento*. 'One might call the Birth of Venus the Rebirth (*Rinascita*) of Venus, because with that picture the most wily and the most seducing of the pagan demoniac powers, one of the most beautiful and most vital personalities of Olympus, returned to European art. But Botticelli had risked too much. Fra Girolamo Savonarola declared war on that new idolatry and Sandro did bitter penance.'[153] This interpretation would certainly clash with all our previous notions. If the 'Primavera' was painted for Lorenzo di Pierfrancesco, so was the 'Birth of Venus', and if Ficino's pupil really saw the Goddess in such a sinister light, our interpretation of Botticelli's mythologies would be refuted. But there is no need for such an assumption. If Lorenzo di Pierfrancesco was taught to see in the Venus of the 'Primavera' an embodiment of *Humanitas*, Ficinian exegesis may also have initiated him into the spiritual *significatio* of the 'Birth of Venus'.

In his commentary on Plato's *Philebus* Ficino explains the myth of Venus' birth in his customary manner as a cosmogonic mystery. It stands for the birth of beauty within the Neo-Platonic system of emanations:

> The story told by Hesiod in the *Theogony* of how Saturn castrated Heaven and threw the testicles into the sea, out of the agitated foam of which Venus was born, we should perhaps under.tand as referring to the potential fecundity of all things which lies latent in the first principle. This the divine spirit drinks and first unfolds within himself; after which he pours it forth into the soul and matter, which is called the sea, because of the motion, time, and humour of generation. As soon as the soul is thus fertilized, it creates Beauty within itself; by an upward movement of conversion towards supra-intelligible things; and by a downward movement it gives birth to the charm of sensible things in matter. This conversion into Beauty and its birth from the soul is called Venus. And as in all aspects and in all generation of Beauty there is pleasure, and as all generation is from the soul, which is called Venus, many thought that Venus herself was Pleasure.[154]

After which Ficino proceeds to give a spiritualized interpretation of Pleasure.

Are we to think of this tortuous passage as we stand before the picture in the Uffizi? We need hardly remember all its twists and turns[155] but some such idea of an exalted mystery connected with the Birth of Beauty would certainly not clash with the mood of the painting. Horne, who was not given to uncontrolled rapture, says of Venus that 'she comes on with a light ineffable blitheness which savours rather of the circles of Paradise than of the heights of Olympus', and many other critics have felt the same. As in the case of the 'Minerva' the typological approach would seem to confirm this impression. Once more Botticelli fell back on a compositional scheme from religious art. The general arrangement of the figures is taken over from the traditional group of the Baptism of Christ (Fig. 57), the scene so closely connected with the manifestation of the Holy Ghost.[156]

This interpretation would not, of course, invalidate the accepted view concerning the immediate source of the composition. Poliziano's description may still have helped to evoke that vision. But if Botticelli's second thought about Venus is in any way connected with his first, the 'Primavera', it may be that it, too, embodied a motive from Apuleius. Lucius tells of his vision of the Great Goddess in the following terms:

When I had poured forth my prayers and abject lamentations, sleep again oppressed my pining mind on that same bed. I had hardly closed my eyes when, lo, from the midst of the sea there emerged a divine face of an appearance worthy of veneration even by the Gods: then gradually I saw a whole shining figure rising out of the sea and standing before me. I shall attempt to describe her wonderful appearance as far as the poverty of human speech will allow.... First her hair, most abundant in its richness, flowed yieldingly around her divine neck in slight curves, fluttering luxuriously....[157]

What follows is a description of the Goddess in her attire of Isis, but we have seen above that the Divinity herself proclaimed her identity with Venus.[158] Might it not be that the passage, for all its difference, contains the germinal idea for the second picture and that the lines 'crines uberrimi prolixique et sensim intorti per divina colla passive dispersi molliter defluebant' set Botticelli's mind working in the direction of that symphony of flowing hair which has always excited wonder and admiration?

The creative process pre-supposed by such a theory would not be more complex than that which we tried to reconstruct for 'Mars and Venus'. If Apuleius served as a source for the programme of the 'Primavera', the idea of adding a picture of the vision of the Goddess would not be far-fetched. But the idea must soon have been overlaid by other plans. It was Venus, not Isis, whom the painter was to represent emerging from the sea. This was the subject that would match the 'Primavera' and carry with it an equally exalted message. Once this programme was agreed what was more natural than to let Botticelli enter into competition with

Apelles' famous work which Poliziano had re-created in the *stanze*? To us this collection of motifs from different sources and their combination in a mosaic of quotations may seem the very negation of creative art. Renaissance artists and scholars thought differently. We need only look at one of Botticelli's undoubted sources, Poliziano's description of the Birth of Venus, to find that it, too, is such a composite product. The main action is taken from a Homeric Hymn, but to add to visual concreteness the poet has taken individual lines from Ovid and other classical authors, regardless of their original context. It is characteristic that he too showed a certain predilection for the classical *ekphrasis* which he was trying to revive. In one stanza of his description he made use of two different Ovidian accounts of fictitious works of art.

> Vera la schiuma e vero il mar diresti,
> E vero il nicchio e ver soffiar di venti

(You would have called the foam and the sea real, and real the shell and real the blowing of the winds.)

is taken from Ovid's description of Europa's sea journey as depicted on Arachne's blasphemous tapestry representing the illicit loves of the Gods:

> Maeonis elusam designat imagine tauri
> Europen: verum taurum, freta vera putares . . .

(Arachne pictures Europa cheated by the disguise of the bull: a real bull and real waves you would think.)

> (Met. VI, 103 f.)

Poliziano's description of the Horae, four lines later

> Non una non diversa esser lor faccia,
> Come par che a sorelle ben confaccia . . .

(Their features are neither the same nor different as is fitting for sisters.)

is lifted bodily out of Ovid's description of the sea Gods represented on the gates of the Palace of Sol:

> Facies non omnibus una,
> Nec diversa tamen: qualem decet esse sororum.

(They have not all the same appearance, and yet not altogether different; as it should be with sisters.)[159]

> (Met. II, 13 f.)

If we imagine that the compilers of Botticelli's programmes followed a similar technique—and they probably knew no other—the multiplicity of sources and the way in which they are combined no longer look incredible. We can then imagine how it was possible for the programmes to embody such individual traits as Venus' flowing hair from Apuleius' description of Venus-Isis, or of Mars's 'shapely neck thrown back' from Lucretius, of the playing *Satyrini* from Lucian, or of the visual

material from Apuleius' Judgment of Paris. It may well have been the pride of the authors of the programmes to make their instructions a closely woven texture of 'authentic' classical descriptions. The impulse behind this ambition would still be the search for the 'true' image of the ancient Gods which is inseparable from Ficino's concept of mythological symbolism.

The Villa Lemmi Frescoes

There is at least one work by Botticelli which we know to be a moral allegory and which is very probably connected with classical mythology. These are the frescoes which were discovered under the whitewash in the Villa Lemmi outside Florence in the nineteenth century and taken to the Louvre (Figs. 58a, b). There is no reason to doubt the traditional interpretation of one of the frescoes as Venus with the three Graces appearing to a young woman, for the presence of Cupid certainly fits this interpretation best. The figure on the other fresco who is leading the young man towards the personifications of Philosophy and the Liberal Arts has been given various names, but since she is dressed exactly like her counterpart on the other wall and is also accompanied by Cupid she must also be Venus.[160] There exists in fact an anonymous *quattrocento* poem in which Venus leads the author to an assembly of personifications which includes the Liberal Arts.[161]

If this interpretation could be sustained the underlying theme of these frescoes would indeed provide a remarkable parallel to the presumed interpretation of Venus as a symbol of *Humanitas*. We would not be far from the orbit of Ficinian allegory where Love is the 'teacher of all the arts'.[162] In this respect the paintings of the Villa Lemmi would spell out in more explicit terms the very conception of classical divinity which may underlie all Botticelli's mythologies.

Given this kinship it would be a strong argument in favour of the hypothesis here presented if it could be made likely that the young pair of the Villa Lemmi frescoes represented in fact Botticelli's patron, Lorenzo di Pierfrancesco, and his wife. Such a proof, alas, is not possible but it can at least be argued that the current identification of the pair with Lorenzo and Giovanna Tornabuoni is most unlikely to be correct. After all we know what Giovanna Tornabuoni looked like, both from her medal by Spinelli and her portrait in Ghirlandajo's Tornabuoni Chapel which so closely resembles the medal (Figs. 59–61). What is more, there is another figure in Ghirlandajo's group which corresponds exactly to the young woman in Botticelli's Villa Lemmi fresco. And it is surely impossible that both should represent the same woman. Though Thieme drew attention to this fact around the turn of the century only Jacques Mesnil among writers on Botticelli has taken note.[163]

Nor is the similarity between the portrait of Lorenzo Tornabuoni on his medal

with the young man on the fresco close enough to obviate this difficulty. In fact the young man looks at least as much like Lorenzo di Pierfrancesco on his medals (Figs. 43, 44, 46) though it must be admitted that both are types of elegant young men rather than closely observed portraits. In other words there is no evidence which would firmly contradict the possibility of the Villa Lemmi frescoes belonging to the same cycle of images to which we have traced Botticelli's mythologies.

Ficino and Art

Recent discussions on Renaissance thought have tended to reduce Ficino's stature as a philosopher considerably.[164] The 'second Plato' was no original mind; he was not even a consistent thinker. His main claim to fame, the story of his 're-discovery' of Plato, is being reduced to its just proportions;[165] the murky profundity with which he advocated superstitious practices prompted Lynn Thorndike to dub him 'Ficino the philosophaster'.[166] But while his position in the history of thought is being challenged, the sway his ideas exerted on the art and poetry of the sixteenth century becomes increasingly evident. Was it a mere freak of fashion which made his 'Platonism' the dominating ideal of a century and inspired so many great works? Ficino's writings provide the clue for works as different as Dürer's 'Melancholia'[167] and Titian's 'Education of Amor',[168] and, so we think, for Botticelli's Mythologies.

The features of his thought which would most appeal to artists and lovers of art are sufficiently known. Ficino's conception of Beauty as a symbol of the Divine and the place of enthusiasm in his system have been traced in a number of studies.[169] We have also had occasion to touch upon some of his ideas through which art and the visual image could attain a new function and a new dignity. Nothing, perhaps, is more characteristic of his philosophy than this mode of thought which allows every experience to be turned into a symbol of something higher than itself. With this magic wand, the secularization of life could at the same time be undone and sanctioned. Ficino's apology for love could look back to a long tradition which loses itself in medieval thought;[170] the apology for art which his philosophy made possible fulfilled a more vital need. It provided the spiritual tools for the artists in their struggle for emancipation from the status of 'menial' craftsmen.[171] Two ways were open to the artist to make good his claim for a higher position. He could try to demonstrate his equality with the scientist, the way to which Leonardo devoted his life; or he could stress his kinship with the poet and base his claims on the powers of 'invenzione'—and it was this approach which won the day, very much under the influence of Neo-Platonic thought.

The general trend of this development has been described by Panofsky, but a

number of references to art in Ficino's works have not yet been appraised in this important context. The first, which occurs in the *Epistolarium*, is more biographical in character but it has a bearing on our theme. Ficino speaks of a 'philosophic' painting in his own gymnasium and thus himself testifies to the fact that he patronized the arts. There was at least one *quattrocento* painting for which Ficino must have furnished the programme:

> You have seen in my gymnasium the painting of the Sphere of the World and on one side Democritus, on the other Heraclitus, one of them laughing, the other crying.[172]

We do not know who the painter was who carried out this idea and thus started an iconographic tradition which lasted up to the eighteenth century.[173] We may be pardoned the fancy that it was Botticelli.

In another incidental passage Ficino shows his live interest in the painter's art. A discussion on various modes of cause and effect in his *Theologia Platonica* provides an unexpected glimpse of a *quattrocento* painter at work:

> When Apelles looked at a field he tried to paint it with colours on a panel. It was the whole field which showed itself in a single moment to Apelles and aroused this desire in him. This showing and rousing could be described as the 'action'. . . . The act of looking and painting done by Apelles is called 'motion' because it proceeds in successive stages. First he looks at one flower then at the next and he paints it in the same way. It is the field which causes in Apelles' mind at one and the same moment both the perception of a field and the desire to paint it. But that Apelles looks at one blade of grass and paints it, and then another, at different and successive moments of time, is not an effect caused by the field, but by the soul of Apelles, whose nature it is to see and do different things one at a time and not simultaneously.[174]

In this concise description of the interaction of object and subject in art as seen by a *quattrocento* painter, we have an implicit recognition of the artists' share in the process. There are other passages which show that Ficino was not indifferent to the art of his time. He hails its achievements as a sure sign that the Golden Age had returned. It is the idea of the Renaissance, expressed as if for a textbook:

> This Golden Age, as it were, has brought back to light the Liberal Arts which had almost been extinct; Grammar, Poetry, Rhetorics, Painting, Architecture, Music and the ancient art of Singing to the Orphic Lyre.[175]

This unorthodox list of Seven Liberal arts would have pleased the artists chafing under the restrictions of the guilds. Or were they no longer chafing? Botticelli only entered his guild at the end of his active career.[176]

Ficino's most revolutionary tribute to this new dignity of art is again to be found in the *Theologia Platonica*. In this passage, which was written when Botticelli had hardly begun to work, the essential unity of all the arts is taken for granted:

> All the works of art which pertain to vision or hearing proclaim the whole of the artist's mind. . . . In paintings and buildings the wisdom and skill of the artist shines forth.

Moreover, we can see in them the attitude and the image, as it were, of his mind; for in these works the mind expresses and reflects itself not otherwise than a mirror reflects the face of a man who looks into it. To the greatest degree the mind reveals itself in speeches, songs and skilful harmonies. In these the whole disposition and will of the mind becomes manifest. Whatever the emotion of the artist, his work will usually excite in us an identical emotion, a mournful voice often compels us to weep, an angry one to become furious, a sensual one to be lascivious. For the works which pertain to vision and hearing are closest to the artist's mind.[177]

Such a passage points the way to a 'mundus novus' of the mind, as exciting as the one which Amerigo Vespucci's letter to Botticelli's patron had put on the map. If the talk on art in the Villa di Castello turned on such subjects we can understand something of the character of Botticelli's art. If our reconstruction of the atmosphere in Lorenzo di Pierfrancesco's circle is not entirely fanciful, it was there, again, that Michelangelo was initiated into the mysteries of Neo-Platonic thought during his most formative years.[178] It was this doctrine which entitled the painter to step beside the poet and the humanist and to say, in the words of Poliziano: 'I express my own self.'[179]

Appendix:

Three unpublished letters by Lorenzo di Pierfrancesco de' Medici[180]

1. Lorenzo di Pierfrancesco to Lorenzo il Magnifico, 4 September 1475 (Archivio Mediceo avanti il Principato, filza 32, 541)

Magnifice vir et tanquam pater honorande etc.

Quando fui con voi a dì passati per vostra humanità mi richiedesti volavate venissi con voi a Pisa quando vi andassi, et così vi promissi, perchè credetti potervelo atenere (*sic*). Di poi fui con mio padre et domandandogli la licenzia, mi disse chè per questa volta voleva che io fussi contento starmi quassù con Mona Ginevra, perchè è pur di tempo et starebbe troppo sola senza un di noi, et anchora gli pareva cha l'aria fusse chalda, et dubitava non pigliassi una di quelle febbre pisane. Ma era ben contentissimo da questo mese in là che l'aria sara rafreschata, et Mona Ginevra sara condotta in Firenze che a Dio piaccia sana e salva, che io vengha sempre con voi in tutti quegli luoghi che a voi parrà et piacerà. Et pertanto io vi priegho mi habbiate per schusato questa volta, et anchora che siate contento quando vi anderete più da questa volta in là vi piaccia menarmi con voi perche el mio desiderio è esser sempre apresso di voi et maxime in quegli luoghi che io non sono stato de' quali sono desideroso vedere. Ne altro per questa a vuoi mille volte mi rachomando, et priegho idio che mi vi ghardi lungho tempo sano et salvo et in felicissimo et buono stato. Vostro a Trebbio a dì 4 settembre 1475.

Lo sparviere che io hebbi da Prato, la strozzo; se lo volete, mandate per esso.

Lorenzo di Pierfrancesco

Magnifico viro Laurentio de Medicis tamquam patri honorando florentiae.

Illustrious Sir, to be honoured like a father, etc.

When I was with you a few days ago, you were so very kind to ask me to come with you to Pisa when you went there, and I promised you because I believed I would be allowed to. Then I saw my father and asked his permission and he told me that for this occasion he wanted me to be satisfied with staying here with Mona Ginevra because the season is not right, and she would be too lonely without one of us, and he also thought it would be hot, and he was worried I might catch one of those Pisan fevers. But he would be quite happy in a month's time when the air would be cooler and when Mona Ginevra would be taken to Florence, God willing, safe and sound, that I should go with you anywhere you choose and would like. And thus I beg you to excuse me for this time and also that you should be willing to take me along if you go there more than just this once, because I always want to be near you, and particularly if you go where I have not yet been, and which I should like to see. This is all except that I commend myself to you a thousand times and pray to God that you should be preserved to me for a long time, safe and sound, happy and well.

Yours from Trebbio, 4 September 1475.

I intend to kill the sparrow hawk which I had from Prato; if you want it, send for it.

Lorenzo di Pierfrancesco

To the illustrious Lorenzo de' Medici to be honoured as a father, Florence

2. Lorenzo di Pierfrancesco to Lorenzo il Magnifico, 2 September 1476 (Archivio Mediceo
 avanti il Principato, filza 33, 741)

<div align="center">Magnifice vir et pater honorande etc.</div>

Dipoi vi partisti da noi madonna Ginevra et io pensamo le parole vostre, et quello che
cci dicesti del podere d'Andrea della Stufa a Chastello, che siamo cierti non ci consigleresti
di chosa che fusse contro a noi et che cci avessi a nuocere per verso nessuno, ma tutto per
farci honore et utile. Il perchè abbiamo diliberato attenerci al vostro consiglio er parere
et in ogni modo comperarlo, et per questa chagione vi scrivo che tiriate inanzi il farne
conclusione quando vi pare il tempo, che aquanto farete saremo contentissimi.

ex Trivio die secundo settembris 1476.

<div align="right">Voster filius Laurenzius petri francisci de medicis.</div>

Magnifico viro Laurenzio de medicis patri meo plurimum honorando.

<div align="center">Illustrious Sir, to be honoured like a father, etc.</div>

After you had left us, Mona Ginevra and I thought over your words and what you had
told us about Andrea della Stufa's estate at Castello; we are certain you would not advise
us in any manner contrary to our interests and that you have no reason to harm us, but
would do everything to honour and be of service to us. For this reason we have decided
to follow your advice and wishes, and by all means to buy it, and so I am writing to you
to ask you to expedite the transaction when the time seems ripe. Whenever you do it we
shall be very pleased.

From Trebbio, 2 September 1476,

<div align="right">your son, Lorenzo di Pierfrancesco de' Medici.</div>

To the Illustrious Lorenzo de' Medici to be much honoured like a father.

3. Lorenzo di Pierfrancesco de' Medici to Sandro di Piero Pagagnotti (Archivio Mediceo
 avanti il Principato, filza 84, 104)

Egli è stato qua su a me Amerigho per quella lor facenda; ora io credo che la sia a mal
partito perchè Lorenzo mi pare non sia volto aiutarla. Si che confortate Messer Giorgian-
tonio a patientia. Entendete la volontà sua quale ella sia et offeritegli per nostra parte ogni
et qualunque cosa et ditegli che in mentre che noi aremo roba non gli mancerà nulla, chè
per la gratia di Dio noi abiamo tanto che a dispetto di chi non vuole e' sarà sempremai
uno huomo da bene.

Menate con esso voi Giovanni Cavalcanti che anche lui lo conforti.

Messer Giorgiantonio vorrebbe che ser Antonio andassi a partito; non credo che i
consoli se ne contentino; pur se v'andrà non credo vinca perchè la cosa e ferma. Niente-
dimanco fate quel che vuole per mia parte.

Non vengho costì perch' io non credo giovare, chè si e' credessi giovare alla cosa verrei,
se bene i credessi farne dispiacere a Lorenzo.

Non vi vengho in fine perchè io mi sento collerico in modo che io direi cose che
dispiacerebbono a qualcuno; per[ò] se vuol, verrò.

<div align="right">Lo.</div>

Amerigo has been up here with me in connection with their affairs; now I think that things are going badly because it seems to me that Lorenzo is not inclined to help. So comfort Messer Giorgiantonio that he should be patient. Find out what he wants, whatever it is, and offer him on our behalf everything whatever it may be, and tell him that while we possess anything, he will want for nothing, and that through God's grace we have so much that he will always be well off despite him who wishes otherwise.

Take Giovanni Cavalcanti with you that he may also comfort him.

Messer Giorgiantonio would like Ser Antonio to stand for election; I do not think that the consuls will accept this; moreover if he stands I do not think he will win because the matter is closed. Nevertheless, do what you like on my behalf.

I am not going there because I do not believe I can be of use, but I should like to help if you think I could, although in doing so I think I would displease Lorenzo.

In short I am not coming because I feel so choleric that I would say things which would displease somebody; however, if you wish it, I shall come.

Lo.

While letters 1 and 2 are self-explanatory, the references in letter 3, which is undated, are still obscure. It is clear, however, that the opening section refers to Amerigo and Giorgio Antonio Vespucci and shows Lorenzo di Pierfrancesco once more as their powerful protector (see above pp. 43 and 65). Giovanni Cavalcanti is listed as *priore* in May/June 1488 and in March/April 1495. Whatever the precise issue may have been in which Lorenzo tried to intervene, it is amusing to reflect that it caused Lorenzo to promise he would always look after Amerigo—we may thus be conceivably at the beginning of the strange chain of events that led to the name of 'America'.

The personage referred to in the second part of the letter is harder to identify, since Professor Rubinstein informs me that there were at least four notaries with the Christian name Antonio. The reference to consuls indicates that the candidature concerned a guild. My reason for publishing this document lies of course in the twice expressed hostility to Lorenzo il Magnifico. Indeed, in the light of this outburst even the two earlier letters may be construed to show at least an ambivalent attitude towards the writer's powerful cousin.

An Interpretation of Mantegna's 'Parnassus'

IN her negotiations with Giovanni Bellini, Isabella d'Este laid down what we might call her 'minimum conditions' for a painting that was to go into her *Studiolo*. It could be any story, an ancient fable or a fresh invention, provided only that it 'represented a classical subject with a beautiful meaning'.[1] It is easy to see in what way Mantegna's so-called 'Parnassus' (Fig. 62) fulfils the first of these conditions, but what of the second? What *bello significato* can be found in the hilarious comedy of Mars and Venus trapped by Vulcan for the amusement of the gods? Ever since Foerster first stressed the essentially humorous character of the story, discussion has centred on this difficulty.[2] Did Isabella (or her adviser) read the tale in the spirit of Homer's minstrel in the *Odyssey*, who entertains the Phaeacians with this spicy story[3] or did they prefer to forget it for the sake of a more general significance, such as the glorification of Isabella and her martial husband in the guise of the Goddess of Love and the God of War? Perhaps these alternatives are not mutually exclusive. For there is a classical text which explicitly chides those who cannot see beyond the immoral surface of Homer's story and fail to grasp its beautiful significance. It occurs in the allegorization of Homer, a defence of the poet against Plato's strictures, attributed in the Renaissance to the philosopher Heraclides Ponticus but now to an otherwise unknown rhetorician of the first century A.D. called Heraclitus.[4] This text was first printed in Venice in 1505 but a good many manuscripts, which could easily have been accessible to Isabella's advisers, exist in Italian libraries.[5] Moreover, the passage concerned is also quoted in some, at least, of the scholia to the *Odyssey*[6] which would have been eagerly scrutinized by any humanist trying to fulfil Isabella's requirement.

> Let us now leave all other things aside and turn to the defence of that crime with which the slanderous informers plague us—for they never stop making a song and dance with their loud accusation that the loves of Mars and Venus are a blasphemous invention. They allege that this carries lust into heaven and that Homer is not ashamed of attributing to the gods a crime such as adultery, which is punished with death among men:
>
>> I sing of the love of Ares and Aphrodite of the fair crown
>> How they first lay together in the house of Hephaistos. . . .
>
> Then the trap, the laughter of the gods and Poseidon's intervention with Hephaistos are censured. For if these vices occur among the gods it would be unworthy to punish them among men.
> I think, however, that though this story was sung among the Phaeacians, a people enslaved by pleasure, it still contains a philosophical message. For the passage confirms the doctrine of the Silicians and of Empedocles that Ares is the name of strife, Aphrodite

This study appeared in the *Journal of the Warburg and Courtauld Institutes* in 1963.

that of love. Homer tells how these two ancient enemies were reconciled. Thus it is fitting that from the two is born Harmony, which reduces everything to concord and tranquillity. Thus the gods laugh and rejoice out of gratitude that the accursed strife is over and transformed into unanimity and peace.[7]

Heraclitus goes on to offer an additional allegory interpreting the myth in a way which foreshadows the alchemists, with Mars standing for iron, Venus for fire and Vulcan for water, and the whole story symbolizing the art of the armourer. We need not follow him there, for the interpretation quoted above appears to provide all that is needed for the understanding of Mantegna's composition. What more 'beautiful meaning' could be found for this classical subject than the birth of Harmony from the union of Mars and Venus and the rejoicing of the gods at the establishment of peace and concord? And how could this meaning have been better symbolized than by the joyful dance of the nine Muses to the song of Apollo? Incidentally, this meaning may explain the puzzling fact that the first description of the picture, the 1542 inventory of Isabella d'Este's possessions, calls the singer 'Orpheus' and the Muses 'nymphs'.[8] The writer remembered the *bello significato* better than he identified the *cosa antiqua*.

There is no reason, in this reading, to underplay the cheerful character of the subject, typified by the figure of Cupid who seems to aim his blow-pipe at Vulcan in a distinctly naughty way.[9] For the surface of the story is humorous, its deeper meaning joyous.

What, then, of Hermes and Pegasus accompanying the scene? In Homer it is banter between Apollo and Hermes (both agreeing that they would gladly change places with Ares) that provokes the laughter of the gods. Hermes' presence, more-over, would equally fit the idea of the birth of Harmony if he is linked with oratory and the arts.

This is the role in which Mercury appears in company with Apollo, the Muses and Venus in the beautiful opening lines of Pontanus's *Urania*, which were written in the same years when Mantegna painted his picture.[10] I do not want to suggest, of course, that there is any direct link between the poem and the painting. Pontanus does not write about Mars and Venus. But the great poet's enchanting vision of the joyous concourse of the gods comes so close in spirit to Mantegna's evocation of divine harmony that word and image illuminate each other even though they were conceived independently.[11]

> Qui coelo radient ignes, quae sidera mundo
> Labantur tacito, stellis quibus emicet ingens
> Signifer, utque suos peragant errantia cursus . . .
> Dic, dea, quae nomen coelo deducis ab ipso
> Uranie, dic, Musa, Iovis clarissima proles,
> Et tecum castae veniant ad vota sorores.

Dum canitis resonatque cavis in vallibus echo . . .
Ipse chori pater ac princeps et carminis auctor,
Phoebe, adsis, noctisque decus latonia virgo,
Dique deaeque omnes, quorum sub numine coelum est.
Tuque adeo, comes Aonidum, dux optima vatum,
Alma Venus (teneros nati sat lusimus ignes), . . .
O mihi si Charites spirent, si blanda canentis
Gratia mesopio contingat labra liquore
Tu vero, nate, ingentes accingere ad orsus
Et mecum illustres coeli spatiare per oras;
Namque aderit tibi Mercurius, cui coelifer Atlas
Est avus et notas puerum puer instruet artis. . . .

(You who take your name from the heavens themselves, Urania, divine Muse, renowned child of Jupiter, tell of the fires that shine in the sky, of the constellations that move while the world is silent; tell with what stars the great zodiac shines forth, and how the Planets run their wandering courses; and let the chaste sisters join you in your hymn. And while your song echoes in the hollow valleys, lead Phoebus, you who are the father and ruler of the chorus, the leader and originator of song, and Diana the adornment of the night, and all the gods and goddesses who hold sway over the heavens, yes, and you, mother Venus, the companion of the Muses and excellent guide of the poets (we have sung enough of the gentle fires of your son . . .). Oh, if the Charites inspire me, and if favouring Grace touched the lips of the singer with inspiring liquor, and you, Cupid, begin the great undertaking and traverse with me the shining confines of the heavens, for Mercury, whose ancestor is Atlas who carried the heaven, will be with you, who as a boy should teach the boy the foundations of the art.)

Raphael's Stanza della Segnatura and the Nature of its Symbolism

O N his arrival in Rome . . . Raphael 'began in the *Camera della Segnatura* a painting of how theologians harmonize Philosophy and Astrology with Theology, where all the sages of the world are shown discussing in various ways.'[1] These opening words of Vasari's account of Raphael's fresco cycle in the first Stanza of the Vatican naturally set the key for the interpretation of these frescoes for centuries to come.[2] Not only did Vasari establish the conviction that the subject of this cycle was meant to be of profound philosophical import, he also enforced this interpretation by isolating the individual frescoes from their intellectual and decorative context, and treating them as illustrations of particular philosophical and theological activities. We now know the source of this error: Vasari worked from engravings after the frescoes, either to refresh his memory or simply because access to these Papal apartments was not easy at that time.[3] It has long been acknowledged that this makeshift led Vasari into astonishing errors. He placed the Evangelists among the Greek philosophers simply because some of these groups had been adapted by Agostino Veneziano in engravings of these Saints.[4] Nevertheless the method and the tendency persisted. In 1695 the learned antiquarian Giovanni Pietro Bellori published his *Descrizione delle Imagini dipinti da Raffaello d' Urbino nel Vaticano* as a show piece of philosophical criticism. Bellori had an axe to grind. The partisan of academic classicism and the friend of Maratta, who had just restored or ruined the frescoes, he was out to stress the importance of *invenzione* in art and to exalt the frescoes as the most sublime inventions of modern painting. There are those, he exclaims, who decry such powers of invention in a painter and prefer him to be uncultured and ignorant, merely luxuriating in fine pigments. How different was Raphael, whose erudition Bellori now proceeds to document in his description and identification of all the figures in the cycle.[5] His example was followed by Passavant in his pioneer biography of Raphael[6] and though scholars failed to agree on any one interpretation the conviction persisted that there was a key to these frescoes which must be in accord with the philosophical and humanistic ideas of the sixteenth century. Indeed, in the nineteenth century this interpretation of a work which was seen as the culmination of Renaissance art reacted back on the arts of the time. Ambitious intellectual programmes like that

This essay is based on a lecture given at the Warburg Institute in 1956 and reworked for the Initial Address to the Anglo-American Conference of Historians on 9 July 1970.

of Overbeck's *Triumph of the Reformation* or the statuary of the Albert Memorial might be described as attempts to emulate the *Stanza della Segnatura*.

Writing in 1883 the great art historian Anton Springer hoped to reduce this game *ad absurdum* by tabulating all the identifications that had been made of the figures in the 'School of Athens' (Fig. 74).[7] But the most radical reaction was represented by Franz Wickhoff, whose work was in so many respects influenced by the aesthetics of Impressionism. In his article of 1893[8] he brushed aside all previous interpretations of the Stanza like so many cobwebs and proposed to start from scratch, that is from the inscriptions and the sources of the period. Unfortunately his article is vitiated by the theory that the Stanza must have been the Papal Library—an unlikely hypothesis since we know from Albertini's contemporary description that the library of Julius II was decorated with pictures of planets and constellations.[9]

Be that as it may, Wickhoff's paper was hailed as a 'liberation' by Wölfflin, who proclaimed in his 'Classic Art'[10] that no historical knowledge was needed to appreciate the Stanza and proceeded to analyse the four walls in terms of formal harmonies. Characteristically, however, Wölfflin, too, betrays his dependence on reproductions of the individual walls, in fact he discusses at some length the merits of these engravings, which, as he tells us, every traveller to Rome took home as a souvenir. The change of approach came or should have come when Wickhoff's pupil Julius von Schlosser published an article of tremendous sweep and learning in 1896,[11] in which he at last placed the purified Stanza into a historical setting that should have made any further isolation of these compositions impossible. The paper on 'Giusto's Frescoes in Padua and the forerunners of the Stanza della Segnatura' has the weight and length of a book tracing the medieval tradition of associating the Personifications of individual Arts or Virtues with certain typical representatives or authors, Geometry being associated with Euclid or Justice with Trajan. The uncovering of this tradition, which reaches back to the porches of the French Cathedrals and is epitomized in an Italian fourteenth-century illustration to a legal text[11] (Fig. 75), disposed once and for all of the notion that the presence in the Papal apartment of famous Greeks and Romans was symptomatic of Renaissance 'paganism'. But it did more, it showed why the isolation of the individual walls completely falsifies not only the intellectual, but also the artistic interpretation of Raphael's decoration.

For the cycle of the *Stanza della Segnatura* is so organized that its composition must be read from the ceiling downwards, but the room is so small that no photograph can take in part of the vaulted ceiling and walls at the same time. We have to rely on rather unprepossessing nineteenth-century engravings (Figs. 72, 73) to convey even this principal feature of the cycle. Basically it shows four allegorical figures enthroned on the ceiling, and underneath, on earth as it were, assemblies of people (Figs. 63–71). For instance, there is the personification of Poetry and below her the

fresco we call the Parnassus with Apollo, the Muses and a group of poets, the foremost one carrying an inscribed scroll that marks her as Sappho (Figs. 66–67).

Such schemes of personifications enthroned with representative figures assembled below them were very much common form at the time when Raphael set to work. We do not know exactly when the Stanza was first planned—it was completed in 1511—but we know that late in 1507 Julius II expressed the wish to move out of his predecessor's apartment in the Vatican because he could no longer stand the ubiquitous sight of the Borgia bull on its walls and ceilings.[12] He obviously had nothing against the general ideas expressed on its walls by Pinturicchio, for basically the new Stanza repeated the scheme of the Room of the Seven Liberal Arts painted some ten years earlier in the Borgia apartments (Fig. 76). The similarity of these enthroned figures such as Dialectic (Fig. 77) with its group of orators underneath with Raphael's scheme would always have been obvious if the ceilings and the walls of the Stanza could have been reproduced together.

We know from Schlosser that the series of the Liberal Arts was not the only group of personifications traditionally coupled with famous exemplars. Indeed, Fig. 75 shows them side by side with the other popular series, the Seven Virtues, each with their typical opponent, whom they trample underfoot.

It so happens that the tradition of personified virtues grouped with exemplars from history had also been applied in a famous fresco cycle which must have been known to Raphael and to Julius II. Perugino's *Cambio* in Perugia (Fig. 79) had been planned at the very time when Raphael was closest to Perugino, at the turn of the century, and completed about 1507, not more than a year before both Perugino and Raphael left for Rome to take up work in the apartments of the Vatican the Pope wished to have decorated.[13]

The *Cambio*, the Public Exchange, was decorated with the enthroned figures of the four cardinal virtues Prudence, Justice, Fortitude, and Temperance, aloft in the sky and three representatives of each arranged below (Figs. 80a, b); thus under Justice we see three exemplars of the virtue from antiquity, Camillus, the Emperor Trajan and Pittacus. It has been suggested that the remaining three scenes were intended to symbolize the three theological virtues, Faith, Hope and Charity, the assembly of Prophets and Sibyls signifying Hope, the Nativity Charity, and the Transfiguration Faith.

Be that as it may, the kinship of this scheme with that of the Stanza della Segnatura cannot be emphasized too strongly. There is that same mixture of Christian themes and pagan examples which puzzled the nineteenth century but should not have caused any surprise to anyone who knew the habits of medieval moralists or indeed of St. Augustine. The parallelism goes much further. The cardinal virtue of Prudence in the *Cambio* (Fig. 80a) is accompanied by verses composed by the humanist Maturanzio, who makes her say: 'Scrutari verum doceo,

causasque latentes' (I teach to search for truth and hidden causes). The second of her disciples on earth is a very Italianate Socrates. One of the four personifications on the ceiling of the Stanza della Segnatura is accompanied by the inscription 'Causarum Cognitio' (the understanding of causes), and underneath her we find the assembly of philosophers which a French seventeenth-century guidebook first called by the somewhat misleading name 'The School of Athens'. Among its personages we see Socrates engaged in argument, his classical Silenus mask serving instead of the *titulus*. Even an echo of the Virtue of Prudence is still to be found on its wall in the figure of Minerva (Fig. 65).

It is this kinship with accepted schemes of decoration which serves to remind us the Stanza will not stand fragmentation without complete disruption of its symbolic and artistic significance. For if we fail to read these compositions from the ceiling downwards we miss the type or class of work with which we are confronted and having thus lost the point of entry we get confused by details. For in this class of composition the enthroned personifications are not mere allegorical labels for the representations underneath. On the contrary the walls must be seen as expositions or amplifications of the ideas expressed by the personifications on the ceiling (Fig. 63). We may do well to remember that except for a few nominalist outsiders the ecclesiastics of the Papal Court had learnt and accepted the view that *universalia sunt ante rem,* that the things of this earth are only embodiments, however incomplete, of general ideas or principles. This thought, which is so alien to our view of the world, must have come natural to generations who conceived of the whole universe as of a hierarchy of principles emanating and descending from on high. *Causarum cognitio* is more real as an idea than are the individual philosophers, who merely exemplify instances of this eternal notion. We may even go further and say that this assembly of men is governed by Philosophy just as the so-called children of planets are governed by the star which determines the laws of their being, their character and their profession; here, too, there was an example of such a juxtaposition close at hand in Pinturicchio's Borgia apartment where, for instance, the children of Sol are shown as Bishops and clergymen in whom the influence of the celestian principle of sunniness is manifest (Fig. 78). Maybe it was this example which led Pinturicchio to abandon in his room of the Seven Liberal Arts the traditional method of showing identified representatives of the various disciplines and rather illustrating an anonymous assembly of people engaged in the appropriate activities. This, in its turn, determined Raphael's theme.

What becomes manifest from all high in the *Stanza della Segnatura,* is shown in the inscriptions—it is knowledge and virtue as expressions of the divine.

These inscriptions accompanying the personifications must indeed form the starting point of any interpretation. They are, to recapitulate, *causarum cognitio* with the group of philosophers we call the School of Athens, *numine afflatur* con-

stituting the claim of Poetry to divine origin, exemplified in the Parnassus, *Divin-arum rerum notitia* (knowledge of things divine) pointing towards the group of sacred personages which has become known as the *Disputà*, and *Ius suumcuique tribuit* (each his due), which is the motto of Justice, under whom we see two scenes exemplifying the promulgation of justice, the establishment of civil law through the pandects under Justinian and of canon law through the decretals under Gregory IX.

The name *Stanza della Segnatura* refers to the Papal court which held its sessions in this room and though it cannot be proved that this had been its purpose from the beginning the scheme of decoration makes this very likely. One can but admire the ingenuity by which the two precedents of decorative schemes were adapted without being actually repeated. It so happens that Justice is both one of the four cardinal virtues and the presiding personification of legal studies. In the stanza she is coupled with the three remaining virtues but also fitted into the scheme of disciplines or faculties which derives from the tradition of the liberal arts. Instead of the seven we now have four, Law, Theology, Poetry and Philosophy.

And just as the scheme of decoration merely varied a current usage so the choice of these disciplines reflected conventional ideas about the various paths through which knowledge comes to mankind. In looking for the historical context in which these ideas took shape we need not go far afield. It was in the universities that knowledge was organized and transmitted and thus it is in texts concerned with university teaching that we find a great many echoes of the intellectual themes of Raphael's fresco cycle.

It was the custom for university teachers to give formal inaugural lectures not only once in their career, as is done today, but at the opening of any course.[14] In these they had to advertise their subject by praising its dignity and its pre-eminence. In reading these formal orations we feel transported into the atmosphere that pervades the Stanza. They show that the subject of this scheme of images fits no less perfectly into the intellectual tradition of the age than it harmonized with its artistic conventions.

Thus one of the disciples of the great humanist Guarini, Giovanni Toscanella, introduced his course in rhetoric at the University of Bologna in c. 1425 with a speech in which many of the commonplaces and tags of the Stanza are anticipated.[15]

To begin with the poets what should we say about their divine minds, what about their ancient lineage? My learned audience need not be told that it is not easy to encompass the praise of poets in a brief oration since poets are also frequently historians and often deserve rightly to be called renowned orators and philosophers, lawgivers and interpreters of the law as well as physicians and mathematicians. . . . Truly it was the poets who first proclaimed of themselves that a God existed and who affirmed that God saw everything and ruled over everything. This, as we know, was felt by Orpheus, whom the ancients

also considered a theologian, this by Homer and this by Hesiod among the Greeks but among us Virgil and Ovid proclaimed it quite openly in many passages. It was also the poets who most copiously and eloquently praised virtue in their poems through various fictions. In truth Basilius, an excellent and most erudite man, claims to have heard from a learned man, considered to be most gifted for the investigation of the mind of the poets, that the whole of Homer's poetry amounted to a praise of virtue. Why otherwise does Father Ennius call the poets sacred but because they are touched by a divine spirit and afflatus? (*quod divino videlicet spiritu afflatuque tanguntur*).

(The speaker now proceeds to a praise of the ancient historians, Herodotus, Thucydides, Livy, etc.)

Let us now pass to philosophy, a gift rather of the immortal Gods than of men. Since it must truly be divided in three parts, the cause and nature of things, the subtlety of speech, true judgement and the reason for desiring or shunning things, it is everywhere so rich in fruit that if we desired to express our opinion and our judgement fully we would have to say that it is the greatest of the gifts which the immortal Gods bestowed on mortal man. For what is there more beautiful than to know the nature and the cause of everything? (*cuiusque rei naturam causasque*). What more admirable than to be able to judge between truth and falsehood, the correct and the absurd? What finally could be more desirable than to be able to understand the reasons for what is honest or vile, useful or useless. Those among the ancients who excelled in these matters were first considered and called wise men but since this appellation appeared to be too proud and arrogant they began later to be called philosophers instead and it is said that Pythagoras of Samos was the first to have adopted this name. Do you not see that whatever we call them, whether wise men or philosophers which means lovers of wisdom they are singled out for an illustrious appellation? For philosophy as Cicero says is nothing but a study of wisdom but wisdom as it was defined by the ancient philosophers is the science of the divine and the human and of the causes which are comprised by these things. (*rerum divinarum et humanarum causarumque, quibus hae res continentur, scientia.*) It was this which Plato who had heard Socrates, this which Aristotle, the disciple of Plato, this which Xenophon, the Socratic, and many others pursued with great zeal and industry. But the one that teaches the reasons for desiring or avoiding things bears the largest and most wonderful fruits. Its father was Socrates.

(The speaker now proceeds to the praise of oratory and concludes:)

Come, therefore, most excellent and most learned man, let us make use of that divine and heavenly reason and intellect, take hold of these subjects of humane learning, these liberal arts with all possible zeal, work and industry; be alert in daytime and wakeful at night so that your mind, that divine gift, should not sink into earthly mire, but always gazing at the higher and the divine, should think nothing and desire nothing but the way to fulfil the heavenly and divine tasks. If you do this you will also live in fame after your death.

Startling as some of the parallels between Toscanella's speech and the themes of the Stanza may look at first sight, it is obvious that this old *pièce d'occasion* cannot have been one of the sources of Raphael's scheme. Only the praise of poetry and of

philosophy even recalls the Stanze, while a room illustrating Tuscanella's eulogy would have to have its remaining walls dedicated to History and historians and Rhetoric and orators.

But the interest in Toscanella's very conventional eulogy lies less in the choice of disciplines than in the reasons for which he lauds them. It clearly is a commonplace for him that the dignity of all knowledge is derived from its link with the Divine. All intellectual disciplines somehow partake of the revelation of higher truth. Some indirectly and obscurely, some directly and radiantly. God had spoken implicitly through the mouth of inspired poets and philosophers and openly through the Scriptures and the Traditions of the Church, though even these messages have to be expounded if they are to be understood. We see again that the juxtaposition in the Stanza of poets and philosophers on an equal footing with theologians has nothing to do with Renaissance secularism. If anything, the tradition on which Toscanella draws was not out to profane the sacred but to sanctify the profane. The respect paid to ancient poetry and philosophy could only enhance the importance of *divinarum rerum notitia*, the knowledge of things divine represented in the so called *Disputà* (Figs. 68–69).

The name is derived from Vasari's description, who speaks of Saints disputing about the host on the altar.[16] It has often been pointed out that this interpretation (which may have come natural to Vasari in the post-Reformation period) tends to obscure the meaning of the composition. Here, as always, it must certainly be read from the ceiling downwards, from God to man. Once we see it in this all-embracing context, we perceive 'the knowledge of things divine' coming down to earth in the Incarnation. In this unusual configuration of the Trinity the dove of the Holy Ghost is seen descending below the figure of Christ and flanked by the four gospels hovering over the altar, around which the Fathers of the Church expound the message to mankind in their inspired writings (Figs. 66–67).

In terms of these broad outlines there is indeed no difficulty in interpreting any of the frescoes. The so-called *Parnassus* is a perfect visualization of *Numine Afflatur*, the divine inspiration of poetry with Apollo glancing ecstatically upwards as does blind Homer, and with the Muses and the poets directly handing on their supernatural knowledge to the people gathering in the Stanza.

Within the context of the Stanza the general import of the so-called '*School of Athens*' again presents no difficulty. *Causarum Cognitio* is shown enthroned holding two volumes marked *Moralis* and *Naturalis*, the main divisions of philosophy. Of these natural philosophy is embodied below by Plato, who holds the *Timaeus*, the dialogue concerned with the creation and the nature of the Universe. His famous upwards pointing gesture may refer to the knowledge of causes rather than to any doctrinal contrast with his disciple Aristotle, who holds the *Ethics* the moral philosophy he imparts to us.[17] We may expect the other philosophers also to

exemplify the search for causes in natural and moral philosophy and this, no doubt, is the theme of the groups assembled under Minerva, the goddess of Wisdom, and Apollo, the teacher of Ethics (Figs. 64–65).

Was it also intended to exemplify in these men the theme of the Seven Liberal Arts from Pinturicchio's earlier scheme? Springer's suggestion is appealing,[18] and it is certainly possible to recognize Geometry in the group assembling around a demonstration and Music in the corresponding display of a tablet with the system of harmonies; Astronomy presents no difficulty, for there is the King with the globe traditional for Ptolemy (the astronomer having been confused with the ruler). But even Arithmetic, the fourth of the *Quadrivium*, is less easily identified, and when it comes to the Trivium of Grammar, Rhetoric and Dialectic the choice becomes yet more arbitrary. Moreover, one may legitimately doubt whether *Trivium* could be subsumed under the idea of *causarum cognitio*. Are the arguing people grouped around Socrates not rather concerned with that Moral Philosophy of which he was reputed to be the founder while those which recall the *Quadrivium* represent Natural Philosophy or Science?

In any case there is no reason to think that the manifold activities of the philosophers must have been intended to tabulate a discrete number of 'arts'. On the contrary, the same university tradition which gave rise to Tuscanella's speech habitually insisted on the essential unity of all human disciplines. Cicero had called Philosophy the procreator and mother of all the praiseworthy arts[19] and had expressed his faith in the unity of all humane learning in a memorable passage: 'All arts that relate to culture have a common link and are bound together by some affinity' (Omnes artes quae ad humanitatem pertinent habent quoddam commune vinclum et quasi cognatione quadam inter se continentur).[20]

Not unexpectedly there exists an inaugural lecture on this theme,[21] even among the few of the genre collected and printed by Karl Müllner in his invaluable anthology. Gregorius Tiphernius, who taught in Rome under Nicolaus V, patiently leads us in his speech through the list of the arts, each time pausing to prove that they could not be torn or separated from the others. The Grammarian as a student of language will have to study all the other disciplines using language. Dialectic occurs in the arguments used in the *Quadrivium*, and Rhetoric, which demands the mastery of words and things, must merge into all the others. Poetry is linked to Arithmetic since prosody requires counting, not to forget that poets frequently deal with such mysteries as Astronomy or Philosophy. It really fuses with Music which, in its turn, adjoins Geometry. The doctrine of the Pythagoreans linked Music to Philosophy but Music is also concerned with moral philosophy through its power over the affects. That Astronomy itself stands in need of other arts goes without saying, indeed the ancients were right, as the speaker reminds us, when they depicted the arts as maidens linked in a dance. Nor should students of Law be

ignorant of the arts since Law itself originates from the inner recesses of Philo-
sophy. Of Medicine, of Philosophy, and of Theology, the Queen of them all,
Tiphernius assures us that he could also speak at length but on this occasion he
forbore.

Once more we see how familiar the arrangement of the Stanze would have looked
to men brought up in this tradition of learning; it happens to accord well with
Raphael's cycle that the speaker thought fit in his peroration to link Philosophy
with the study of Law before he bowed to Theology.

In the Stanza, of course, the fourth wall celebrates Justice both as one of the
Cardinal Virtues and as a Discipline which is passed on to mankind in the Pandects
enshrining civil law and the Decretals codifying canon law. Nor is it hard to docu-
ment the way in which legal studies could be fitted into the scheme of divine gifts
to mankind. Cicero had called the Law the invention not of man but of the Gods.
Embroidering on this theme a humanist such as Poggio Bracciolini[22] was able to
compose an eulogy of legal studies in which he asserts the pre-eminence of his
subject over all the rest.

Rightly had the ancient Romans placed concern for Law before all other concerns.

For poetry began much after the inscribing of the Twelve Tables. Philosophy, too, and
the other disciplines known as the Liberal Arts were the last to be received by the Romans
into their state. These wise men, therefore, believed that no norms of civil life, no liberty,
no fruit of their labours should exist in their city that was not upheld by the best laws.[23]

After enumerating famous Roman jurists Poggio finds no difficulty in making a
transition to Plato and Aristotle, both of whom were concerned with Law. Without
Law, we hear again, there could be neither Philosophy, Dialectic, Astrology or
any other art. Once more we are told about Pythagoras being the first who called
himself a philosopher and about Socrates, who initiated moral philosophy and
brought philosophy down from heaven to earth. Astrology was said to come from
the Chaldeans if Zoroaster was not its inventor. And so we are back to the list of
inventors of the arts paying passing tribute to Orpheus, Linus and Musaeus,
inventors of Poetry, till we arrive at Moses the lawgiver before the speaker pulls out
all the stops in a final *laudatio*:

O what an enormous and outstanding protection was here granted by God Almighty
to the human race! For what better, what more useful, what more sacred gift could be
bestowed on us than that heavenly bounty by which our minds are guided towards the
good life, by which virtue is fortified, a quiet life achieved and by which we ascend to the
very heaven?

Thus the trained churchmen and lawyers who assembled in the *Stanza* would
find themselves surrounded by familiar imagery as they listened to counsel's
speeches in which, no doubt, similar Ciceronian tags would make their frequent

appearance. They were comfortably ensconced in the well-ordered universe of Disciplines through which Divine principles were translated into the speech and the actions of mortal men. If they were in a serious mood, they might even have hoped or felt that the divine spark was indeed passing from the venerable figures on the walls to the assembly, which could thus become the embodiment and the mouthpiece of the heavenly knowledge radiating from above.

Were they content thus to be reassured and comforted as one must assume they were when attending a solemn service or, indeed, a ritualistic university function, or did they scrutinize the images on the walls for fresh insights? To put it in more general terms, should we look to such a symbolic cycle for a re-statement of conventional beliefs or for some more specific and recondite message?

To ask this question need not imply that the kind of texts so far adduced must offer the key to all details of the Stanza. They certainly do not. We know for instance that the personifications on the ceiling (Fig. 63) are flanked by episodes which Passavant interpreted as linking the various faculties—the Fall as between Theology and Justice, the Judgment of Solomon between Justice and Philosophy, 'Astronomy' or the contemplation of the Universe (Fig. 84) between Philosophy and Poetry, and the Flaying of Marsyas between Poetry and Theology, assuming that Dante's prayer to Apollo can thus be interpreted. There are also the grisailles with further *exempla* under Justice and the scenes under the 'Parnassus', some of which are not very clear and have been variously interpreted. Finally, of course, there is the question of portraits of imaginary and real persons on the walls. Some of the figures are clearly marked by inscriptions (such as Sappho), others like Socrates, Homer or Dante could be expected to be recognized. Nor need we doubt that Raphael incorporated in these groups portraits of contemporaries, for we know that he did so not only with Julius II, who is portrayed as Gregory IX, but that he also painted young Federigo Gonzaga, who was kept as a hostage at the Papal Court—though we can no longer identify him.[24]

But surely in this question of portraiture we come up against that notorious crux of interpretation, the question of the 'meaning of meaning'.[25] It is one thing for an artist to use a particular individual, an apprentice or a personage at the court as a model, another to do so with the intention of him being recognized for all times. The 'in-group' might have had their pleasure in seeing familiar faces looking at them from these walls but is this part of the fresco's 'meaning'? We might go further and ask whether the intended meaning could have included even a long list of ancient poets or philosophers whose identification has proved so difficult?

It is worth here pointing to a startling contrast between the critic's reaction to Pinturicchio's frescoes and those of Raphael, for whom they certainly served as a model. Surely the groups assembled beneath these earlier personifications of Arts are similar enough in character and function, but no-one has felt moved to give each

of these figures a local habitation and a name in intellectual history. They remain an anonymous crowd, though there is no reason why Pinturicchio, too, might not have incorporated portraits of friends or contemporaries in these groups.

Take the striking figure of the old man in Raphael's School of Athens who bends down to draw a geometrical demonstration for a group of admiring disciples (Fig. 81)—he is usually called Euclid, and Vasari, who identifies him with Bramante, has rarely been contradicted. But what portrait intended to commemorate a friend has ever been taken from such a disadvantageous position from which only the bald pate is visible? Is it not much more likely that the geometer means no more and no less than the similar figure in Pinturicchio's cycle who has a similar crown of white hair (Fig. 83)?

Such questions are more easily asked than answered for it is obvious that the absence of a particular meaning can never be proved—*negativa non sunt probanda* as the lawyers say.

It is unlikely that a further study of Renaissance texts would here fulfil the hopes which are so often pinned on this kind of source. In a sense there are too many texts to choose from. The problem is not really to find more literary sources in which Plato and Aristotle, Homer and Orpheus, Theology and Justice are mentioned and related. It would be harder to point to a book from the period where these notions and commonplaces do not occur. The real question of method raised by the interpretations of the Stanza lies on a different plane; in iconography no less than in life, wisdom lies in knowing where to stop.

It is in the nature of things that no conceivable method can ever be a cut and dried answer to this question. No sign or symbol can refer to itself and tell us how much it is intended to signify. All signs have a characteristic which Karl Buehler called 'abstractive relevance'.[26] The letters of the alphabet signify through certain distinctive features but in normal contexts their meaning is not affected by their size, colour or font. The same is true of the images which interest the iconographer, be they coats of arms, hieroglyphs, emblems or personifications traditionally marked by certain 'attributes'. In every one of these cases there are any number of features which are strictly speaking without a translatable meaning, and only a few which we are intended to read and translate. But while we can easily identify those in the case of codified signs, the limit of significance, what Buehler called the 'sign limit', is much more open in the case of symbolic images. Take the personification of *Causarum Cognitio* on the ceiling of the Stanza (Fig. 64). Care has been taken for us to know the meaning of the books she holds, for they are inscribed. Nor need we doubt that the decoration of the throne was intended to signify an aspect of Philosophy—the many-breasted Diana stands traditionally for Nature. Now Vasari also tells us in some detail that the colours of her garment, from the neck downward, are those of fire, air, earth and water, and are therefore symbolic. He

may be right, but what of the garments of the other personifications? He does not tell us, but even if he did, we could always ask further questions. Are the configurations of the folds significant? Are the positions of the fingers?

But though it is obvious that the limits of signification are invisible when looked upon from outside, as it were, when we are confronted with any particular image, the situation changes dramatically when we look at the problem from the other side, when we consider a text which is to be translated into an image. The reason is simple. Language operates with universals, and the particular will always slip through its net, however fine we may make its meshes. It is because language is discrete and painting continuous that the painted allegory cannot but have an infinity of characteristics which are from this point of view quite devoid of meaning.

Of course what is allegorically meaningless is not, thereby, without significance of some other kind. If it were, the image would be a pictogram and not a work of art.

Take another of Raphael's personifications, Poetry (Fig. 66), or better still his ravishing drawing for that figure (Fig. 85). From one point of view it is a pictorial sign with the obvious and enumerable attributes of the wings, the lyre and the book. But this vision not only signifies *numine afflatur*, it also displays or expresses it. The sign limits are blurred. The upturned gaze may still be a conventional sign for inspiration, carried by the tradition of art from ancient times, but the tense beauty of the figure is Raphael's own, and not even he could quite transfer and repeat it, for it may well be that the finished image is a little less convincing as an embodiment of the Divine afflatus though it has an added laurel wreath.

Elsewhere in this volume the history of the distinction has been traced between the symbol and the allegory.[27] The allegory was felt to be translatable into conceptual language once its conventions were known, the symbol to exhibit that plenitude of meaning that approaches the ineffable.

But the same study has also suggested that historically speaking the distinction is falsely drawn. Personifications were not simply viewed as pictographs denoting a concept by image rather than by label. They were rather true representations or embodiments of those superior entities which were conceived as the denizens of the intelligible world. It is here, again, that the intellectual tradition embodied in the Stanza met the artist half-way. Indeed the orator who selected these universals as objects of praise could appeal to the visual imagination to clothe them with flesh and blood.

Here, too, we can draw on the conventions of 'epideictic oratory' collected in Müllner's handy anthology. In 1458 Giovanni Argyropoulos, the Byzantine humanist naturalized in Medicean Florence, wound up a lecture on Aristotle's Physics in words which call to mind Raphael's radiant vision of Astronomy (Fig. 84).

Immortal Gods, how great is the nobility of that Science, how great its perfection, how great its force and power, how great also its beauty. Concentrate your minds on this,

63. RAPHAEL: Ceiling of the *Stanza della Segnatura*, Vatican Palace

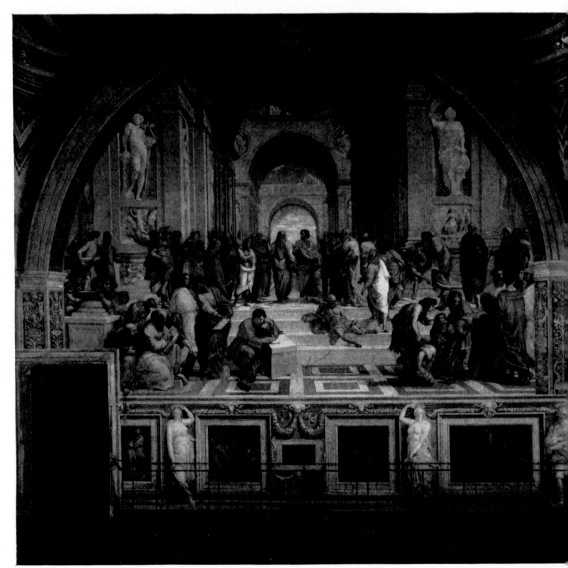

64–65. RAPHAEL: *The Knowledge of Causes*: 'Philosophy' and 'The School of Athens'. Stanza della Segnatu

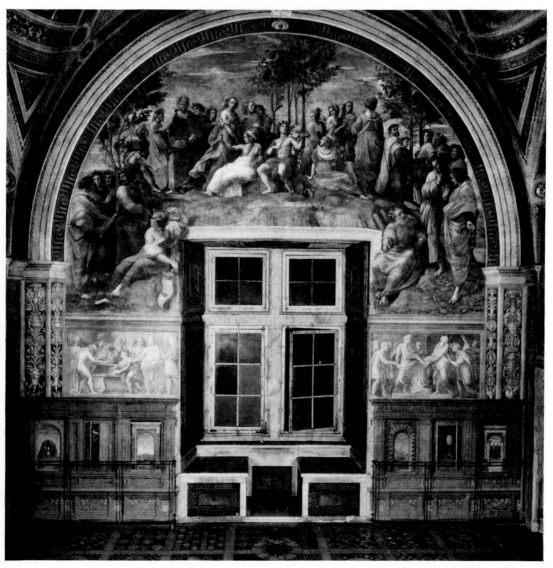

66–67. RAPHAEL: *Divine Inspiration*: 'Poetry' and 'Parnassus'. Stanza della Segnatura

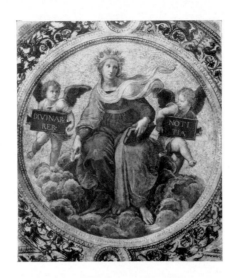

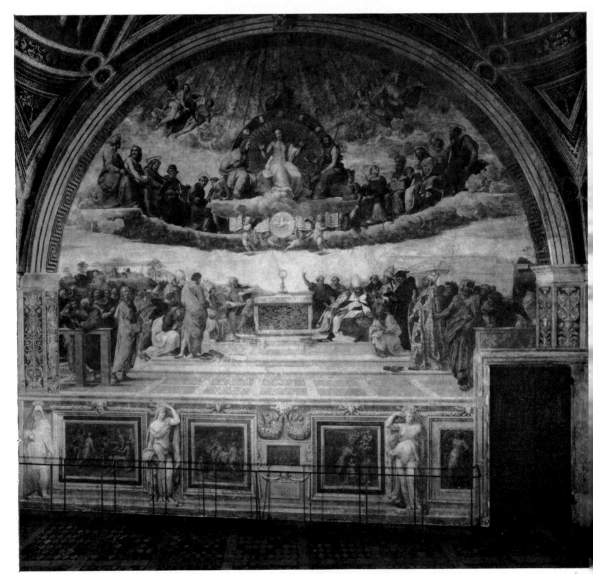

68–69. RAPHAEL: *Knowledge of Things Divine*: 'Theology' and 'Disputa'. Stanza della Segnatura

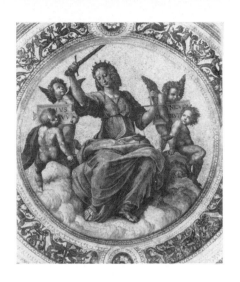

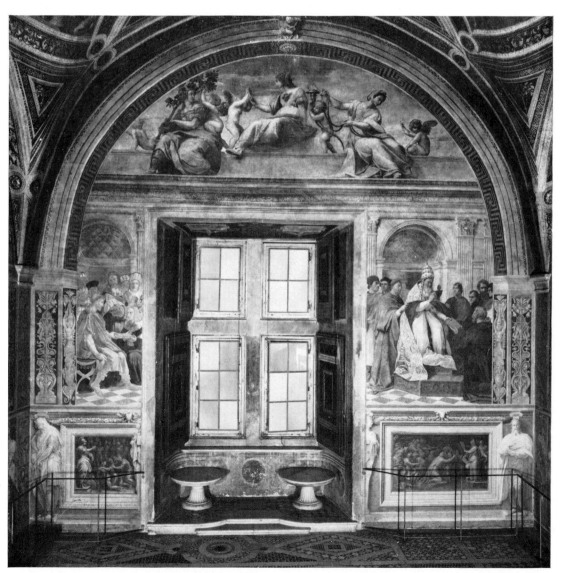

70-71. RAPHAEL: *To Each his Due*: Justice, Prudence flanked by Fortitude and Temperance, and 'The Institution of Civil and Canon Law'

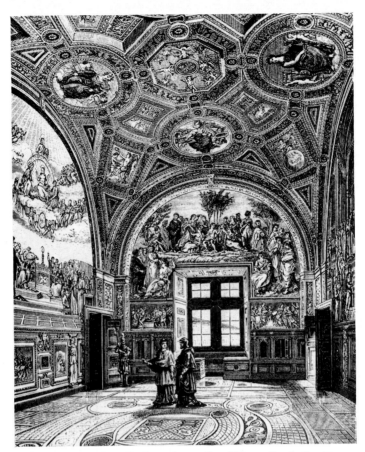

72. The Stanza della Segnatura, after Müntz, *Raphaël*, 1881

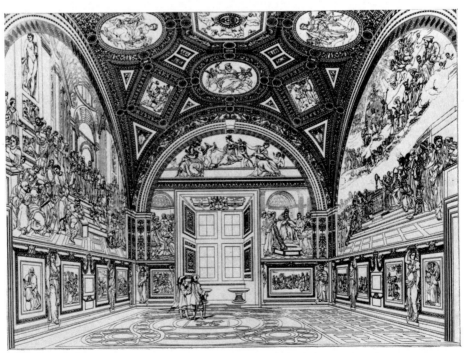

73. The Stanza della Segnatura, after Letarouilly, *The Vatican and St. Peter's*, 1882

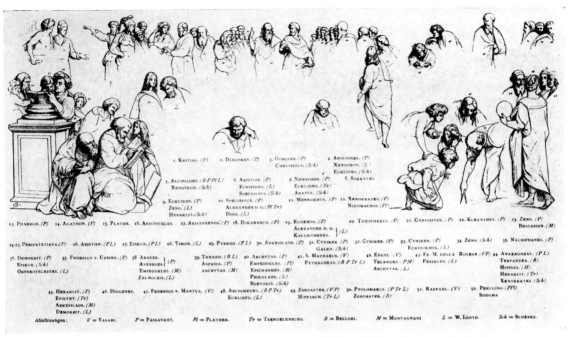

74. Tabulation of 'identifications' in 'The School of Athens' (Fig. 65), from A. Springer, *Raffaels Schule von Athen*, 1883

75. NICOLÒ DA BOLOGNA: *The Virtues and the Arts*, from Giovanni Andrea's *Novella super libros Decretalium*, 1355, Milan, Ambrosiana MS. B. 42 inf., fol. 1

78. PINTURICCHIO: *Planet Sol and his Children.* Vatican Palace,
Borgia Apartments, Sala delle Sibille

77. PINTURICCHIO: *Dialectica.* Vatican Palace, Borgia Apartments,
Sala delle Arti Liberali

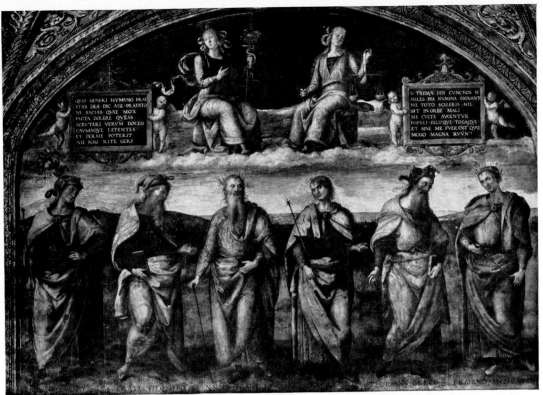

80a. PERUGINO: *Prudence (with Fabius Maximus, Socrates and Numa Pompilius),*
Justice (with F. Camillus, Pittacus and Trajan). Perugia, Cambio

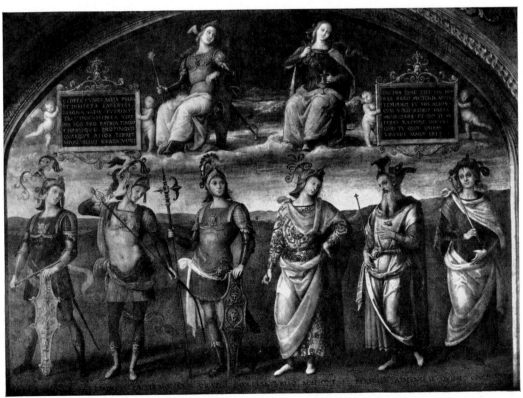

80b. PERUGINO: *Fortitude (with L. Sicinius, Leonidas and Horatius Cocles),*
Temperance (with L. Scipio, Pericles and Cincinnatus). Perugia, Cambio

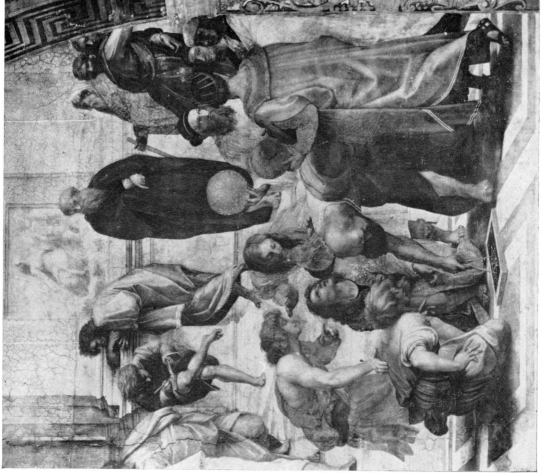

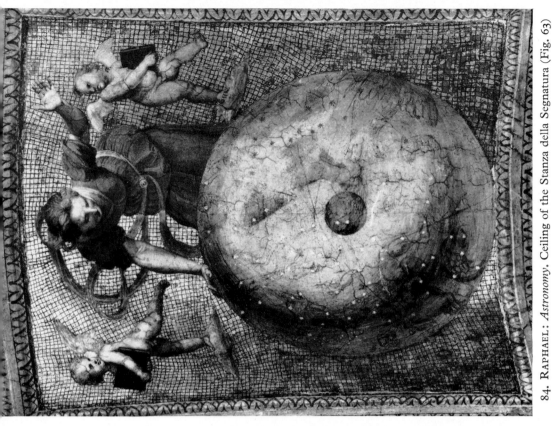

84. RAPHAEL: *Astronomy*. Ceiling of the Stanza della Segnatura (Fig. 63)

83. PINTURICCHIO: *Geometry*. Vatican Palace, Borgia Apartments,
Sala delle Arti Liberali

85. RAPHAEL: *Poetry*. Drawing.
Windsor Castle, Royal Library

86. RAPHAEL: *The Trinity*. Perugia, S. Severo

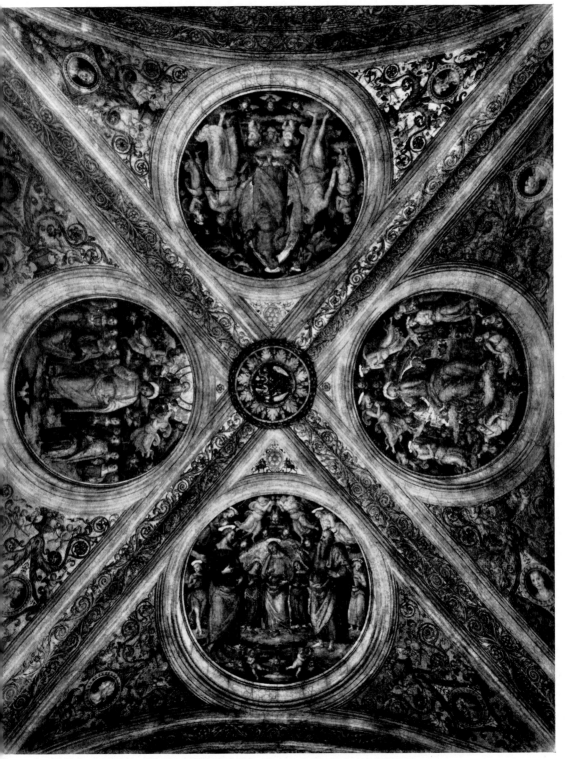

87. PERUGINO: Ceiling of the Stanza dell'Incendio. Vatican Palace

88. FRA BARTOLOMEO: *The Last Judgement*. Florence, Museo di S. Marco

89. RAPHAEL: Study for the 'Disputa'. Windsor Castle, Royal Library

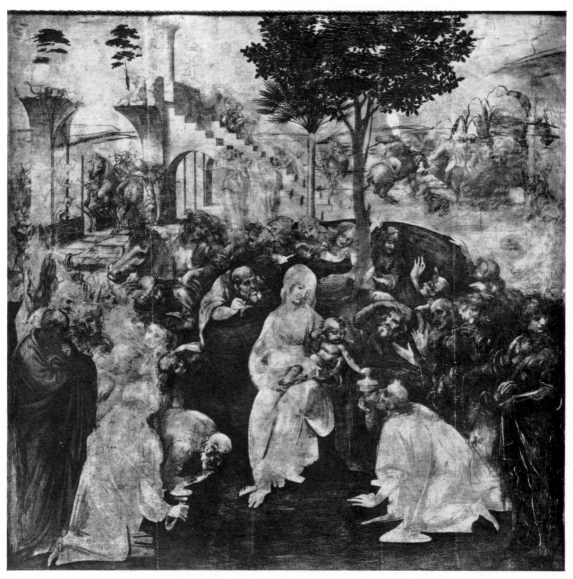

90. LEONARDO DA VINCI: *The Adoration of the Magi*. Florence, Uffizi

92. LEONARDO DA VINCI: Detail from *The Adoration of the Magi*
(Fig. 90)

91. RAPHAEL: Detail from the cartoon for 'The School of Athens'.
Milan, Ambrosiana

93. FILIPPINO LIPPI: *St. Thomas Confounding the Heretics*. Rome, S. Maria sopra Minerva

94. BOTTICELLI: *The Temptation of Christ*. Vatican Palace, Sistine Chapel

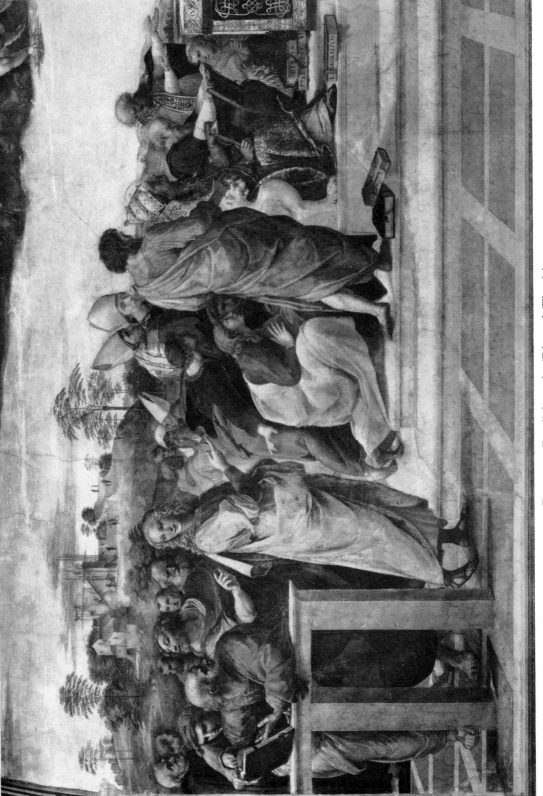

95 · RAPHAEL · Detail from the 'Disputa' (Fig. 60)

96. RAPHAEL: Study for the 'Disputa'. Frankfurt, Staedel Institute

98. RAPHAEL: Study for the 'Disputa'. Oxford,

97. RAPHAEL: Venus, Drawing, Florence, Uffizi

99. RAPHAEL: Study for the 'Disputa'. London, British Museum

101. SCHOOL OF RAPHAEL: Copy after Donatello (Fig. 82).

100. RAPHAEL: Study for the 'Disputa' (verso of Fig. 98).

concentrate it, I implore you, and do what I tell you. Imagine—for your minds are free and so are your thoughts, so that you can easily form an image in your mind by the use of reason, as if it were real—imagine, therefore, and place before the eyes of your mind Science herself in the guise and appearance of a maiden; gather in it all the ideas comprised in Science, does she then not truly look to you like the Helen of Zeuxis or rather like Helen herself, like Pallas, like Juno, like Diana, like Venus? Without doubt she will by far excel the beauty of all these, and her comeliness, which can be perceived by the mind, cannot in any way be described in words. O what loves would she then arouse, what ardours, what desires, indeed, if I may say so, what lusts, to approach, to embrace, to cherish her, if she were seen by the mind as she really is and could be seen in that sphere. . . .[28]

Needless to say, there is no more reason to assume that Raphael or his advisers knew this particular text than that they knew any of the other specimens of the *genre* quoted above. All they had to convey to the young artist was the conviction that beauty is an attribute of the Divine. Not that an artist of Raphael's stamp would have to be told of this belief. The tradition of Christian art and indeed of Christian poetry would not be imaginable without this anchorage.

If Raphael conceived his task in this light he may not have needed much further verbal instruction of how to translate the idea of the divinity of knowledge into a cycle of images. Perhaps he required no more detailed guidance than the composer of a solemn text ever needed to set it to music.[29] We cannot claim to know exactly what the text was on which Raphael thus set to work, but there is one type of evidence which virtually rules out the assumption that it can have been either very long or very detailed.

It is the record of his working procedure preserved in the many drawings for the Stanza which O. Fischel has sifted and discussed in such a masterly fashion in his monumental work on *Raphaels Zeichnungen*.[30] Though little can be added to his analysis, it is still relevant to review this evidence, which will never cease to startle and challenge any student of the creative process.[31] For briefly we shall see that it was not only the scheme as a whole which resulted from a fusion and modification of recent cycles known to Raphael, but that this whole perfect symphony of forms owes its degree of coherence and articulation to the artist's systematic use and modification of existing compositions which he embodied and transfigured in his masterpiece.

The record is most complete for the assembly under *Divinarum rerum notitia*, the so-called *Disputà*. Its central conception comes surprisingly close to another composition of Perugino, whose *Cambio* so obviously influenced the whole scheme. It is to be found on the ceiling of the very room adjoining the *Stanza della Segnatura*, today Raphael's *Stanza dell'Incendio* (Fig. 87). It is not known when Perugino painted this ceiling, but it seems it was in 1508 just before work on our Stanza began. As in the *Disputà* we see the descent of the Holy Ghost in the form

of a dove spreading its wings beneath the figure of blessing Christ. So similar is the basic conception of the two works, that one cannot help wondering whether they are not also historically connected.

May not the twenty-five-year-old Raphael originally have been called to Rome to assist his aged master, who had just completed the *Cambio* in Perugia, and may not Julius II (perhaps prompted by Bramante) subsequently have decided to place the young genius in charge of the neighbouring room, where Sodoma had been at work? These may be idle speculations, but we know that, when Raphael first planned the wall, he made use of another formula he had recently employed in a joint work with Perugino, the Trinity of San Severo (Fig. 86), where a row of Saints are arranged in a semicircle around Christ enthroned on clouds. Basically Raphael appears to have planned to compose the upper half of the fresco along the lines of a Last Judgment with Christ in the centre, flanked by intercessors and Judges. The composition by Fra Bartolomeo (Fig. 88), an artist to whom Raphael owed so much, has often been quoted as his inspiration.

But looking at the beautiful sketch at Windsor which appears to embody Raphael's first complete plan (Fig. 89), we observe an even stranger dependence. The group on earth, linked to the heavenly apparition by a lovely figure pointing upwards in the way of the traditional representation of Hope, turns out to be closely modelled on Leonardo's unfinished *Adoration of the Magi* (Fig. 90). The figure of the dignified old man who stands wrapped in his cloak and sunk in meditation serves the same compositional purpose in Raphael as he does in Leonardo— to anchor the group while other members bend and surge forward.

But somehow Leonardo's beautiful compositional motif did not suffice to provide a basis for the long wall Raphael had to cover, and so he gave up his original idea of combining themes from Fra Bartolomeo and Leonardo. But he was far too circumspect an artist to part for that reason with the group he obviously admired, and when he removed it from his plan of the *Disputà* he shifted it to the opposite wall, turning some of its elements into a group of the writing sage with others peering at his writing. The Cartoon of the *School of Athens* (Fig. 91) proves this dependence beyond any reasonable doubt and shows that Raphael had no compunction even in copying an individual type (Fig. 92), if it suited his purpose.

Having thus found a use for the Leonardo he was left without a model for the terrestrial group of theologians. But he did not have far to go for another exemplar, no further than across the corridor to the Sistine Chapel. It does not appear to have been noticed that the basic grouping of the *Disputà* on the lower left-hand side (Fig. 95) is modelled on Botticelli's fresco of the *Temptation of Christ* (Fig. 94), which, in its turn, may owe something to Leonardo's contemporary *Adoration*. The dependence is even closer in the first sketches for the composition, notably the drawing in Frankfort, which may be a copy (Fig. 96). Like Botticelli's group it

shows a surge of movement towards a centre, arrested in the middle, and a counter-movement of men debating among themselves.

Raphael retained this group of separatists even in the final version, and the question has been much discussed whether they are meant to be heretics. We may never know, but what we do know is that even this possibility could have been suggested to Raphael not by a learned theologian but by the tradition of his art. He cannot but have seen Filippino's recent masterpiece of St. Thomas routing the heretics in S. Maria sopra Minerva (Fig. 93). Here, too, he used what he could assimilate, such as the *putti* with the *tituli,* the books which litter the steps of the centre and the upraised arm of one of the Cardinal Virtues.

But contrary to first appearances Raphael was not simply a magpie, making a pastiche from recent frescoes. He was a great artist who knew how to fuse these elements of the tradition into a novel work of superior organization and complexity. It is here that the drawings provide the most telling and moving evidence.

In the Botticelli no less than in Raphael's Frankfort drawing there is a gap between the movement towards the centre and the counter-movement towards the periphery. In Raphael's finished fresco the gap is triumphantly closed by a turning figure which links the two groups. Once more we can admire Raphael's economy of means, for he took that figure from the first Windsor drawing, where it links the lower with the higher order. But the drawings also reveal the care Raphael took to adjust it to the changing function; there are studies (Lille) in which he works on the exact degree of turning, but the most astonishing of these is another document which shows the use Raphael could make of tradition—his drawing in the Uffizi, where the image of a classical Venus is used to clarify this all-important posture of grace and apparent simplicity (Fig. 97).

If one gap was now closed, there remained another hiatus in the composition where the forward movement came up against the sitting figures of the centre. Once more Raphael needed a figure to take up the movement and carry it forward, a turning figure. There is a rapid pen drawing in the British Museum with fragments of a sonnet, a sketch for two arguing figures among the 'heretics', a foot, and a graphic record of Raphael's thoughts permitting us to watch him turning the figure around in space (Fig. 99). From there we can follow the invention taking shape, first it seems to belong to a group like those on the School of Athens watching or reading, but then on a drawing in Oxford (Fig. 98) which also contains ideas for the Parnassus the solution is almost achieved, and all that remains is to clothe the figure in that majestic drapery which, on a further charcoal drawing, (Fig. 100) gives it that weight or *gravitas* that is demanded by its artistic function. This does not exclude, of course, that the figure was also given a name in some larger system of thought, but all the evidence points to the conclusion that if it happened it must have happened as an afterthought.

There are fewer drawings to document the growth of the assembly exemplifying *Causarum Cognitio*, the Search for the Knowledge of Causes, but there is equally little evidence that Raphael here wanted to give, or was instructed to give, a rigid system of Philosophy. Indeed there is again one small but decisive piece of evidence against the existence of a very detailed programme. The strange group on the extreme right (Fig. 81) is known to have been taken over from one of Donatello's reliefs in the *Santo* (Fig. 82), copied in a sketchbook from Raphael's circle (Fig. 101).

Wölfflin, who discussed this borrowing in his *Classic Art*, was sufficiently startled to suggest that it might have been incorporated in the composition by way of a joke.[32] At any rate, he said, it should not be taken as an indication of any poverty of invention on Raphael's part and should not be taken 'too tragically'. He was addressing readers steeped in the cult of originality. But we have seen that this approach can never do justice either to Raphael's methods of creation nor indeed to the composition of the Stanze. The group was for Raphael an instance comparable to a musical modulation—the way to give a composition with a strong central accent a counterbalancing movement towards the edge. But in transplanting the group into the lofty hall he also transformed Donatello's anxious old spectator into a mysterious sage and the woman rushing out into a man with an enigmatic errand. If no written programme is likely to have included the group he found in Donatello, it follows by no means that we should only look at it as a mere formal flourish.

Wölfflin himself, who has so often been invoked as a champion of 'formal analysis', was the last to have advocated such an impoverishment. The very last sentence of *Classic Art* tries to forestall such a misreading. 'In no way do we want to have pleaded for a formalistic appreciation of art. It certainly needs the light to make the diamond sparkle.'[33] Wölfflin saw very clearly that the dichotomy between form and content, beauty and meaning is inapplicable to works of the High Renaissance. Raphael and his friends would certainly not have understood such a separation. They were brought up in that atmosphere to which allusion has been made so often in this paper, the tradition of rhetoric. It is true that we tend to think of rhetoric as a hypertrophy of form over content, but that is not how the Renaissance regarded it. They naturally accepted the theory of Decorum, the doctrine demanding that a noble content should be matched by noble forms. The choice of such noble words, images and cadences to do justice to the greatness of a theme was indeed the core of that branch of rhetoric called 'epideictic'. There can be few even among twentieth-century scholars who can read these compositions with the same attention and appreciation with which they were probably listened to at the time, for we have come to believe that a speech should convey information or a cogent argument. What the Renaissance meant by wit, by the epigrammatic play with metaphors and images, may appeal to us more readily because the use of paradox and of esoteric allusions sets the mind a puzzle. There was also

a kind of visual image that corresponded to this second approach, the emblem, the hieroglyph or the device. These were packed with meaning, without being therefore very profound. In any case there is no reason to think that a cycle such as the *Stanza* was intended to contain this kind of *acutezza recondita*.[34]

In asking an artist to celebrate Justice and the Knowledge of Things Divine, the Search for Causes and the Divine Afflatus, in a room of the Papal apartments one would not have thought in terms of emblems and epigrams so much as in terms of *amplificatio*, the restatement of the meaning in ornate examples and beautiful periods, which orchestrate the idea of knowledge as a gift from all high.

For an artist of Raphael's genius that meant that the visual realization of this idea had to be infused with his own kind of harmony and beauty, his own melodious groups and formal cadences. They all contributed to the celebration of the exalted theme. Seen in this light every group, every gesture and every expression of the *Stanza* is indeed charged with significance, and is the appropriate form for a solemn content.[35]

But art, like music, certainly does more than simply restate the intellectual message. In clothing it with forms it also modifies and articulates the thought. Once we grasp the general message we are led to find fresh metaphors and symbols in the rich configurations which surround us. We learn to see and to understand something of the numinous quality which Raphael and his contemporaries saw in Knowledge, and there must have been many who gained a more intense picture of what was meant by Theology, Poetry or Philosophy through these frescoes.

No wonder that so many admirers of Raphael's art also felt prompted to rationalize this response by trying to translate the meaning they felt to be present in the cycle into a profound philosophical statement. They were aroused to this confident search precisely by the beauty and complexity of the composition. Pinturicchio's cycle left them cold; they could pass it by and just take in the routine list of the Liberal Arts. It was Raphael's greatness as an artist who knew how to bring the whole tradition of pictorial composition to bear on this task that ultimately caused this feeling of an inexhaustible plenitude. This plenitude is no illusion, even if it should turn out that the instructions the artist received contained no more than the current commonplaces of the school.

Hypnerotomachiana

I

BRAMANTE AND THE *HYPNEROTOMACHIA POLIPHILI*

THERE is a passage in Vasari's Life of Bramante which seems to have escaped the attention of Karl Giehlow when he prepared his classic paper on hieroglyphic studies in the Renaissance.[1] It tells us that Bramante had planned to adorn the 'Belvedere' with an inscription in hieroglyphs proclaiming the name of the founder and of the architect and that he was prevented from doing so by Julius II.

> The fancy took Bramante to make, in a frieze on the outer façade of the Belvedere, some letters after the manner of ancient hieroglyphics, representing the name of the Pope and his own, in order to show his ingenuity; and he had begun thus: 'Julio II, Pont. Max.', having caused a head in profile of Julius Caesar to be made, and a bridge with two arches, which signified 'Julio II, Pont.', and an obelisk from the Circus Maximus to represent 'Max.'. At which the Pope laughed, and caused him to make the letters in the ancient manner, one braccio in height, which are still there to this day, saying that he had copied this folly from a door at Viterbo. There one Maestro Francesco, an architect, had placed his name, carved in the architrave, and represented by a St. Francis (*Francesco*), an arch (*arco*), a roof (*tetto*), and a tower (*torre*), which interpreted in his own way, denoted 'Maestro Francesco Architettore'.[2]

In recording this incident some sixty years after the event, Vasari seems to have missed some of its implications. The most ambitious hieroglyphic inscription 'deciphered' in the *Hypnerotomachia Poliphili*[3] (Fig. 102) recalls Bramante's intended frieze; it reads *Divo Julio Caesari semper Augusto totius orbis gubernatori ob anim clementiam et liberalitatem Aegyptii communi aere s. erexere.* (To the Divine Julius Caesar, always Augustus, ruler of the whole world, for his qualities of Mercy and Liberality, the Egyptians erected me at public expense.) The eye stands for *divus*, the ears of corn for *Julius*, the sword for *Caesar*, the circle for *semper*, the flails for *Augusto*, etc.[4] The similarity between the two inscriptions can hardly be fortuitous.[5]

Why did Julius II object? Was he ignorant of the aura of mystery surrounding the hieroglyphs? Did he really confuse this method with the rebuses and canting devices of which Rabelais was to make fun some time later?[6] There would indeed

This is a revised version of the study which appeared in the *Journal of the Warburg and Courtauld Institutes* in 1951.

have been grounds for this confusion, for Giehlow has shown how much the hieroglyphic fashion drew on the heritage of medieval symbolism. Moreover, Bramante's proposed inscription had certain weaknesses (e.g. the two-arched bridge for *Secundus Pontifex*) which invited such ridicule. However, as Julius II quoted an example from Viterbo as a warning instance of hieroglyphic fatuity, there may be another reason for his aversion to this type of game, for Viterbo plays an interesting part in this history of hieroglyphic research. It was the patriotic historian of that town, Fra Giovanni Nanni da Viterbo, who tried to establish the claims of his native city as a cradle of civilization by misreading or, if necessary, forging ancient monuments in precisely the fashion Julius II parodied.[7] Moreover, it was this curious scholar who inspired the 'Egyptological' programme for Pinturicchio's frescoes in the Appartamento Borgia in the Vatican.[8] According to contemporary evidence, it was the sight of the emblems of his hated predecessor that drove Julius out of these apartments to another floor in the Vatican and thus led to the creation of Raphael's *Stanze*.[9] He had therefore every motive to resist Bramante's attempts to glorify his own name with the methods imported from Viterbo.[10]

It might be idle to speculate on this incident were it not that another clash has been recorded between Bramante and Julius II over the same issue, but on a much higher plane. Significantly enough we owe a report of this conflict to another scholar from Viterbo, the great General of the Augustines Egidio da Viterbo, who was probably introduced to orientalist studies by his less reputable compatriot.[11] In his *Historia viginti seculorum* Egidio tells of another plan of Bramante which was thwarted by Julius II.[12] The architect had suggested turning the axis of St. Peter's to run from south to north instead of, as previously, from west to east, for then the famous obelisk of the Vatican[13] (Fig. 103) would have come to stand in front of the church. The importance which Bramante attached to this arrangement can be gauged from the fact that he proposed for its sake to shift the tomb of the Apostle over which the ancient Basilica had been erected. Against the objections of the Pope he urged how fitting it would be that the forecourt of the temple erected by Julius should be marked by the monument of Julius Caesar. Moreover, it would add to the religious atmosphere if the minds of those who entered the church were first attuned by the stirring sight of this vast monument. Having received this preliminary shock they would much more easily prostrate themselves before the altar.[14] It was much easier to shift the earth round the tomb—which would not be upset at all—than to uproot the obelisk.[15] Julius II, however, remained adamant. He would not have the tomb of the Apostle touched. What suited the obelisk was Bramante's concern. He himself would always place the sacred before the profane, religion before pomp.

In this instance the objections of the Pope are hardly in need of explanation. It is Bramante's insistence which presents the historical problem. Was it only a passion

for the hieroglyphic allusion from Julius Caesar to Julius II which prompted him to put forward such a bold plan? Egidio da Viterbo's account suggests an additional interpretation. To Bramante the obelisk was a religious symbol, worthy to stand in the forecourt of the most sacred church in Christendom (Fig. 105). Only by contemplating this symbol could the mind be properly attuned to respond to the mystery that awaited the pilgrim within. Once more such a conception strongly recalls the atmosphere of the *Hypnerotomachia* with its feeling of religious awe surrounding the symbols of Egyptian wisdom and its stages of initiation marked through obelisks and sacred buildings. Indeed the obelisk of the Vatican is quoted in such a context when Colonna describes a fantastic structure of his dream:

This very tall obelisk, in truth I know of no other like it: not the Vatican one, nor the one from Alexandria, nor that of the Babylonians. In itself it contained such a store of wonders that I stood and contemplated it in an insensible stupor. And much more on account of the immensity of the work, and the surpassing subtlety of its opulence and the rare skill, great care and exquisite diligence of the architect. What boldness of inventive power! What human strength, art, device and incredible enterprise was needed to raise up into the air such a weight, rivalling the sky. . . .[16]

Thus it seems that Colonna's curious romance provided Bramante not only with a little *capriccio* to be used in the inscription on the Belvedere but that his whole conception of architecture was influenced by it. Had he found favour with his plan of turning St. Peter's 90 degrees, he would in truth have created a complex of buildings that filled the mind 'di stupore insensato'. For then the obelisk would have come to stand in front of the gigantic church, almost—if not quite—in line with the main axis of the Belvedere.[17] The studies of R. Wittkower[18] and J. Ackerman[19] have revealed Bramante's 'ultima maniera' in a fresh light. The centralized plan of St. Peter's was not a mere aesthetic exercise; it served a symbolic purpose. The Belvedere was not only a Renaissance Palace, but also an evocation of ancient Rome. The two stray fragments of historical records discussed above fit into this new picture of the architect.

Behind the figure of the ruthless planner and *rovinante* we now dimly perceive the utopian dreamer from the North Italian *ambiente*, a Bramante who hoped to transform the capital of Christendom into a classical city, conceived in the image of Francesco Colonna's mystery-laden fantasies.[20]

II

THE BELVEDERE GARDEN AS A GROVE OF VENUS

Passing through Bramante's *exedra*, whose classical character has been analysed by J. Ackerman,[21] the visitor to the Belvedere would find himself in a small garden

DIVO IVLIO CAESARI SEMP. AVG. TOTIVS ORB.
GVBERNAT. OB ANIMI CLEMENT. ET LIBER ALI
TATEMAEGYPTII COMMVNIA ER E. S. EREXER E.

102. *Divo Iulio.* Woodcut from the *Hypnerotomachia Poliphili*, 1499, fol. vi verso

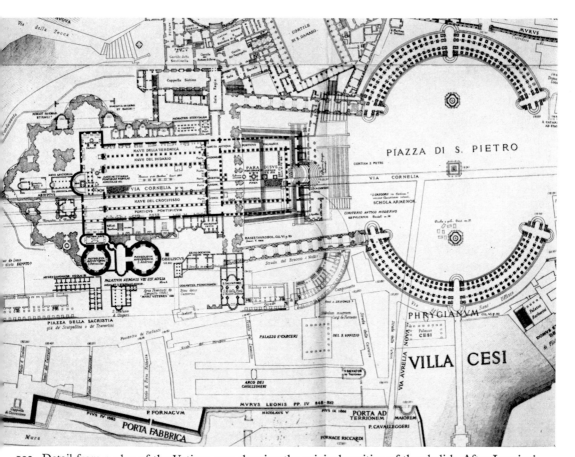

103. Detail from a plan of the Vatican area showing the original position of the obelisk. After Lanciani

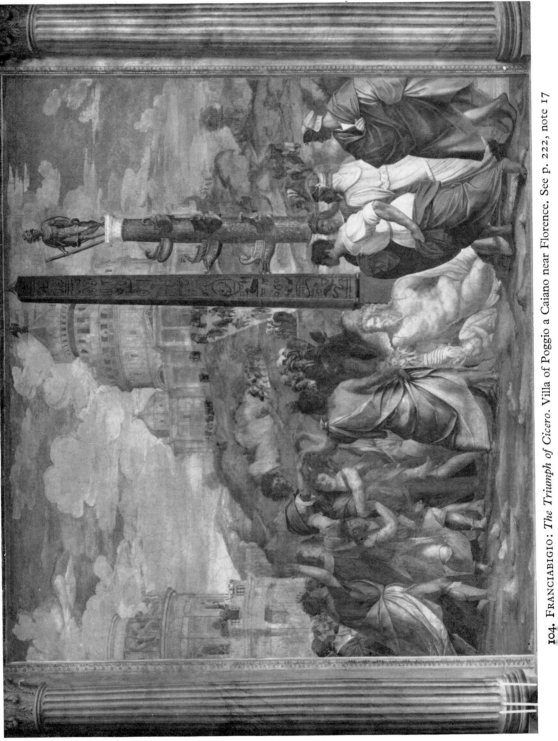

104. FRANCIABIGIO: *The Triumph of Cicero.* Villa of Poggio a Caiano near Florence. See p. 222, note 17

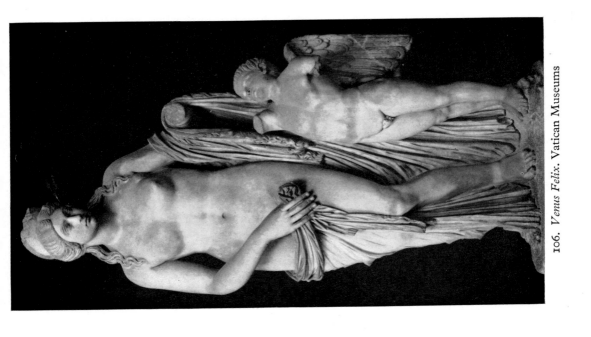

106. *Venus Felix*. Vatican Museums

105. MARTEN HEEMSKERCK: Drawing showing the Vatican obelisk in its original position. Berlin, Kupferstichkabinett

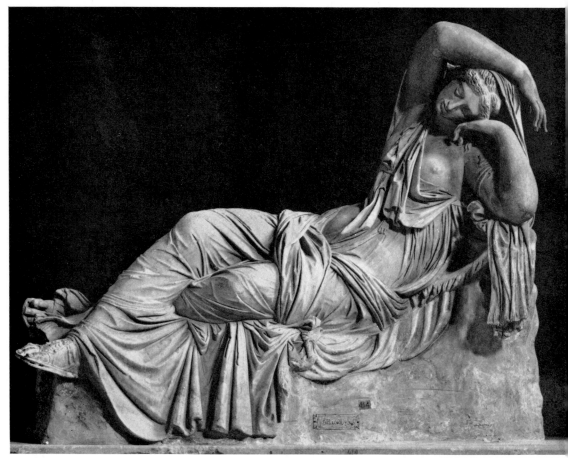

107. *Ariadne.* Vatican Museums

108. A Roman general and barbarians. Sarcophagus, second century A.D. Vatican Museums

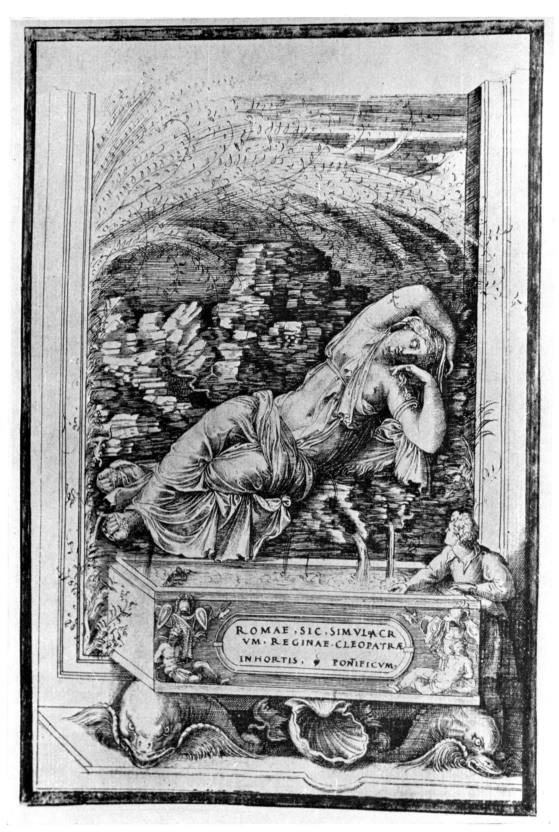

ROMAE . SIC . SIMVLACR
VM . REGINAE . CLEOPATRÆ
IN HORTIS . ◊ PONTIFICVM

109. Francisco da Holanda: Drawing of the *Ariadne*. Escorial

110. Giulio Romano: Wall of the Sala di Psiche with *Venus and Mars*, Mantua, Palazzo del Te

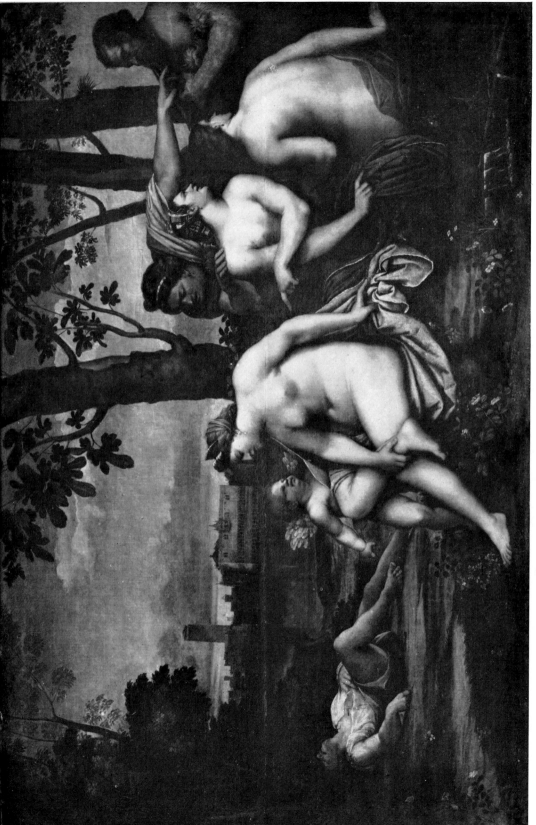

III. SEBASTIANO DEL PIOMBO: *The Death of Adonis*. Florence, Uffizi

112. *Monument to Adonis.* Woodcut from the *Hypnerotomachia Poliphili*, 1499, fol. z vii recto

112a. HEINDRICH VAN CLEEF: View of the Vatican. Detail. Catton Hall, Derbyshire, Col. Anson, M.C.

full of classical statues, still visible on sixteenth-century paintings (cf. Fig. 112a).
Archaeologists such as Michaelis have used contemporary descriptions and draw-
ings with much success and have thus reconstructed the growth and arrangement
of this unique collection and identified its pieces.[22] But is it right to think of this
famous viridarium, which Bramante laid out under Julius II, as merely the nucleus
of a Museum of antiquities? Would it not share in the deliberate evocation of a
classical atmosphere which was apparently Bramante's aim, and confirm the
influence of the *Hypnerotomachia?*

There is at least one contemporary description—so far overlooked by archaeo-
logists—which suggests such an interpretation. True, its author was not an unbiased
and detached observer, nor was he an ordinary visitor. It was Giovanni Francesco
Pico della Mirandola, the unhappy nephew of the famous Count of Concordia, like
his uncle a Neo-Platonic mystic and an ardent follower of Savonarola.[23] This
younger Pico lives in history mainly as the author of a courageous speech *de refor-
mandis moribus* delivered before Leo X in 1517, the year of the Reformation.[24] But
his critical attitude towards the *Curia* goes back much farther. He had even spon-
sored the fantastic adventure of setting up an anti-Pope against Alexander VI in
1502.[25] In 1512 the vicissitudes of a turbulent political career had brought Giovanni
Francesco to Rome. Having been deprived of his dominion of Mirandola by his
brothers, the keys of the fortress had been handed to him by Julius II after its
dramatic siege and conquest in the preceding year, but he had lost it again to
Gianiacobo Trivulzi. During the anxious negotiations of these days he must have
spent many hours in the Papal residence, appealing, soliciting and waiting. In these
tense moments—so we may infer—the statues of the gods in the Belvedere Garden
seemed to assume an uncanny life. They looked to him like idols, placed on altars
—but he at any rate would not sacrifice to them. The group of Venus and Cupid,
above all, which the Pope had but recently brought into the garden—it was the
Venus Felix[26] (Fig. 106)—became to him a symbol and embodiment of all that
moral corruption in Rome which he abhorred. And so he composed a kind of
Psychomachia, *De Venere et Cupidine expellendis*, which recalls the motif of Man-
tegna's Minerva, driving Venus and her train of vices into the swamps.[27] It is the
letter to his friend Lilius Gyraldus, printed with the Rome edition of this poem
and dated August 1512, which shows the Belvedere Garden in this unexpected
light:

Lilius, do you know Venus and Cupid, the gods of those vain ancients? Julius II,
Pontifex Maximus has procured them from Roman ruins, where they were recently
discovered and has placed them in that most fragrant citrus grove, paved with flintstone,
in whose midst stands also the colossal image of the Blue Tiber. Everywhere, however,
antique statues are placed, each on its little altar. On the one side there is the Trojan
Laocoon, sculptured as he is described by Vergil, on the other you see the figure of Apollo

with his quiver as he is pictured by Homer. And in one of the corners you also see the image of Cleopatra, bitten by the snake, from whose breasts, as it were, the water flows in the manner of the ancient aqueducts and falls into an antique marble sarcophagus on which the deeds of the Emperor Trajan are related.[28]

The purely archaeological value of the passage is slight, as all the monuments enumerated by Pico are known to have been in the Belvedere garden by the end of Julius II's pontificate. However, the description of the 'Cleopatra'—in fact the Ariadne (Fig. 107)—does reveal that the sarcophagus which formed the trough of the fountain (Fig. 108) was thought to represent scenes from the life of Trajan. The sarcophagus also appears in a drawing by Francisco da Hollanda (Fig. 109), but a cartouche has been substituted for the main relief.

More interesting is the question of the general arrangement of the fountain group. Pico's description strongly suggests a passage from the *Hypnerotomachia* where Colonna describes 'The very beautiful sleeping nymph, lying comfortably on a stretched out cloth . . . the arm below her drawn back and her free hand placed on her cheek and supporting her head. . . . From the nipples (almost like those of a virgin) of her breasts flowed a stream of the freshest water from the right, and from the left warm liquid. These twin streams cascaded into a porphyry vessel.'[29] But if Pico was reminded of 'ancient aqueducts' may not Bramante himself have been guided by the memory of this description?

Pico's letter continues:

As I often turned to this grove, not in order to meditate on philosophy, as I had often done in the past in the shade of the plane trees by the murmuring waters of the Ilissus rushing between coloured pebbles, even less, though, to pray or sacrifice cattle, as the followers of futile rites used to do, but rather for serious business, concerned with issues of peace and war, with my return to power over my dominions or my continued exile, it seemed to me not useless to escape the torpor of inactivity, when, what I desired most was not offered immediately . . . to begin or work out anything worthy of man and above the beasts.[30]

The Roman hills and particularly the Vatican appeared to be swarming with brutes, some of a species unknown to the great zoologists of the past and ferocious beyond measure. Finding himself among all these brutes in the grove of Venus and Cupid (*venereo cupidineoque nemori*) he composed the poem on the expulsion of these gods—not from the grove, for that was beyond his power, but from the minds of the beasts. For the brutes had once been men and could be restored to human stature just as Lucius was in Apuleius' Golden Ass, when he ate the roses. No wonder, indeed, there were so many of them, for there were myriads of Circes and Sirens about.[31]

The poem itself which accompanies the letter is deservedly forgotten. It is little more than a pastiche of the conventional themes of Platonic love and of the *remedia*

amoris known from Lucretius and Ovid, culminating in a devout exhortation to Christian chastity.[32] It is only the letter to Gyraldus—omitted in the Strasbourg edition of the same poem[33]—which gives it its topical twist. For it implies that Venus in the Vatican was experienced by Pico as a sinister presence. Maybe we should dismiss this interpretation as the mere expression of Savonarolean prejudice. But is it not also possible that the philosopher's eyes, sharpened as they were by critical hostility, saw deeper? Can we exclude the possibility that Bramante was really trying to construct a kind of pagan grove behind the tremendous structure of the Belvedere, encouraged as he might have been by the equivocal religiosity of the Hypnerotomachia with its talk of 'Sancta Venere'?

Perhaps the question is not capable of a cut-and-dried answer. We no longer use the term 'Renaissance Paganism' with a good conscience for we have become aware of the immense complexity and delicacy of the whole issue. Everybody in twentieth-century London would understand if a modern Pico were to write a poem on the Expulsion of Eros from Piccadilly. But does this make Londoners into pagans? The scenes of joy when Eros returned to his place at the end of the war would suggest one answer, a questionnaire another. Eros has become a symbol—a focal point for feelings which otherwise would have remained less articulate.[34] Perhaps the answer to the problem lies in a similar direction. There exists a number of documents to indicate that in Bramante's environment the figure of Venus had really become such a symbol, a crystallizing point not indeed for a belief but for a playful suspension of disbelief. They show that the interest which members of this circle could take in a statue of Venus was not purely archaeological. In this sense the implications of Pico's description are confirmed by the famous letter written by Bembo to Cardinal Bibbiena under the eyes of Raphael, Bramante's successor.

Raphael had planned to place a statuette of Venus in Bibbiena's bathroom but the niche proved unsuitable and so he encouraged Bembo to ask for it on loan. Bembo writes that he wants to place this Venus in his study 'between Jove and Mercury, her father and her brother'

that I may gaze at her ever more pleasurably day by day, which you are unable to do because of your unceasing commitments. . . . So, my dear Sir, do not deny me this boon. . . . I anticipate a favourable reply from your Lordship, and I have already prepared and decorated that part, that corner of my bedroom where I can set up the Venus. . . .[35]

But the strongest justification of Pico's plea to expel Venus from the Vatican may be found in a *moresca* that was danced before Leo X in 1521. Here, in the topsy-turvy world of the carneval, the old theme of the Psychomachia was reversed. First eight hermits attacked and disarmed Cupid as Pico would have urged them to do, but then Venus appeared to vanquish and unfrock them.[36]

When Pope Hadrian VI entered the Vatican two years afterwards he caused consternation among the lovers of antiquity by passing the Laocoon in the Belve-

dere Garden with the words 'sunt idola antiquorum'.[37] Shortly afterwards Raphael's pupil Giulio Romano was turning away from Rome to seek refuge at the court of Federigo Gonzaga of Mantua, the same who had spent his formative years as the favoured hostage of Julius II. It was here that the idea survived of constructing a sanctuary to Venus and even in this venture the memory of the Hypnerotomachia lingered on.

III

GIULIO ROMANO AND SEBASTIANO DEL PIOMBO

Towards the end of the Hypnerotomachia the lovers find themselves in a sacred grove dedicated to Venus. In its centre stands a sarcophagus or trough with marble reliefs commemorating an event that had taken place at that very spot: Venus had taken a bath in the midst of a rosebower and had run barefooted to the aid of Adonis, who had been attacked by jealous Mars. She had pricked her foot on a rose thorn and her blood, collected by Cupid in a shell, had transformed the rose into the red flower we now know. Colonna must have taken this story from a Greek textbook of Rhetoric, Aphthonius' 'Progymnasmata' where it serves as an example of concise narration.[38] The woodcut illustrating the memorial in the Aldine edition of Colonna's Romance (Fig. 112) is familiar to students of Renaissance iconography as the probable source of one of the reliefs on the marble trough on Titian's so-called Sacred and Profane Love.[39] But Titian was not the only painter of the period who tried to translate the awkward representation of the woodcut into a genuine classical idiom: the same scene appears also on one of the walls of Giulio Romano's Sala di Psiche in the Palazzo del Te (Fig. 110). On the left-hand side we see Venus taking her bath, presumably with Adonis, though the figure has usually been taken for Mars. On the right-hand side we see Mars pursuing Adonis and Venus hurrying to hold him back. Once we know the text it is easy to recognize the Cupid who points to the rose on the ground which is about to prick her foot. One wonders what Colonna would have said to this coarsened version of the tale, created less than a generation after the publication of his book. And yet the very conception of a shrine of Venus deriving, as it does, from the spirit of the allegorical Romance, can not have been far from the mind of those who commissioned the Sala di Psiche.[40]

Sebastiano's famous painting in the Uffizi (Fig. 111) combines the story of the Death of Adonis with this episode from Aphthonius: we see in the foreground how the blood trickling from the foot of Venus coloured the roses red.[41]

The Sala dei Venti in the Palazzo del Te

W HEN Giulio Romano built and decorated the Palazzo del Te in Mantua, he was apparently instructed to select for his fresco cycles themes relating to the dynastic symbolism of the Gonzaga. Among these fashionable *imprese*, which were intended to express the aspirations of the ruling house, the image of Mount Olympus was accorded a special place. As such it forms the centre of the ceiling of the small, but exquisitely decorated, 'Sala dei Venti'.[1]

An inscription over the door of the room: DISTAT ENIM QUAE SYDERA TE EXCI-PIANT,[2] indicates that here the Olympian theme is given an astrological turn. A scrutiny of the astrological texts which enjoyed most authority in Renaissance humanist circles reveals the source of the sixteen medallions arranged under the twelve signs of the zodiac (Figs. 113, 114). They are based on a doctrine propounded in the fifth book of Manilius' famous *Astronomica* which ascribes an influence not only to the zodiacal signs themselves but also to the various constellations which rise together with these signs—or, more exactly, which astrologers located (often quite arbitrarily) north and south of the thirty degrees of the ecliptic to which each sign of the zodiac is allocated.[3] This doctrine was familiar to the Renaissance not only through the poem of Manilius but also through the large prose handbook of judicial astrology compiled by the late antique author Firmicus Maternus under the title *Matheseos Libri VIII*,[4] the last book of which contains a conveniently codified catalogue of these constellations and their influence on human destiny.

In most of the passages to be discussed, the texts of Manilius and Firmicus run so closely parallel that it would not be easy to decide which of them was chosen for illustration—but in two or three cases Firmicus has added an interpretation of his own which we find represented on the walls of the Sala dei Venti. While it is thus clear that we must take Firmicus as our guide, it seems that on occasion the author of the programme has also referred back to the more detailed descriptions of the Augustan poet.[5]

Unlike Manilius, Firmicus always gives the position of each constellation discussed within the thirty degrees of the 'sign' in question and describes the variations which the 'rays' of the planets may effect on the horoscope of those born when this part of the heavens appears over the horizon:

In the fourth degree of Aries . . . (on the right-hand side) there rises the Ship (*Navis*).

This study appeared in the *Journal of the Warburg and Courtauld Institutes* in 1950.

Anyone born when that part of the heavens rises ... will be a ship's mate, a pilot, or skipper, that is one who will wish all his life to engage in seafaring. (VIII, 6, 1)

If we turn from this description to the roundel under Aries (Fig. 115), we may be disappointed. It is true that there are three ships in the background but the text does not explain the main scene. For some reason or other this roundel turns out to illustrate the effects of two constellations, not only that of the Ship, but also that of the Dolphin.[6] Fortunately it is the only one of the sixteen medallions in which such a 'contamination' has taken place. I shall return to it later.

After describing the fate of those born under *Orion* in the tenth degree and under *Auriga* in the fifteenth degree of Aries, Firmicus continues:

In the twentieth degree of Aries, on its Northern side, rises the Goat (*Haedus*) carried by *Auriga*. Those born when this constellation rises will be of deceptive appearance, hiding their true character. They will be of austere countenance, with flowing beards and stubborn foreheads in the manner of Cato. But all this is deceit and counterfeit. For by nature they are wanton, lascivious, always the prey of depraved and voluptuous passions and consumed with love's desire. They will also be quite devoid of virtuous ambition, timid, stupid, mortally afraid of the perils of war. Frequently they fall victim to their vicious lusts and are forced to kill themselves, engaged in stupid love affairs. Under this star are also born shepherds whose pipe brings forth sweet measures of rustic songs. (VIII, 6, 4)

It is this last passage which is illustrated in the roundel oblique under Aries (Fig. 116) with its three piping shepherds—while Giulio has glozed over the 'wantonness' of the lovestruck couples by gracefully combining elements *all' antica* with a contemporary pastoral.[7]

Under Taurus, Firmicus enumerates only one constellation, the *Pleiades*, which rise in its sixth degree. But as if to make up for this scarcity of images he adds an account of what will become of those born under a specific star of the constellation Taurus itself. This is one of the passages for which there is no parallel in the poem of Manilius.

If the horoscope was in the parting of the hoofs of Taurus (*in fissione ungulae Tauri*) and an equal amount of malignant and beneficent rays are cast on this spot they will produce a painter, but one whom this pursuit will ennoble through fame and honoui. If, however, only malignant rays are menacingly directed at this spot without the presence of benevolent stars, famous gladiators will be born, who, however, after many prizes and countless victories will die by the menacing sword in their fights, amidst the great applause and acclaim of the spectators. (VIII, 7, 5)

This, then, is the destiny illustrated in the roundel under Taurus (Fig. 117) with its grandly conceived (though poorly executed) figure of an old gladiator dying in the foreground.

The only constellation rising with Gemini is the Hare (*Lepus*) in their seventh degree.

Those who are born when this star rises will be so lightly built that if they start to run they will seem to surpass the birds in speed. If Mars is in aspect it will produce stadium-runners . . . if Mercury, jugglers. (VIII, 8, 1)

In Giulio's fresco in the roundel under Gemini (Fig. 118) the swift runners are identified with Hippomenes and Atalanta.

In the first degree of Cancer rise the Asses (*Jugulae*):

Whoever is born when they rise will be irreligious and perfidious but will show a great aptitude for every type of hunting. He will catch animals in nets, trap them in pits, hunt them with various snares and irons or search the secret recesses of the woods with dogs in pursuit of game. Even a woman born under this star will follow the same or a similar calling with man-like courage but this she will do only when Mars with benevolent stars casts any kind of rays at that spot. If, however, Saturnus does the same they will show aptitude for every kind of fishing and will also catch sea animals in carefully planned fishing expeditions. (VIII, 9, 1-2)

The medallion with the hunting scene directly under Cancer in which a man and two women are chasing after various kinds of game (Fig. 119) thus refers to those born under the Asses. Giulio has somewhat assimilated this scene to the classical representations of the Caledonian boar hunt with Meleager and Atalanta—maybe he was instructed to do so, for if we turn from Firmicus to his model, Manilius (v, 174 ff.), we find the mythological hunters mentioned.

A reference back from Firmicus to the poet's text is also possible in the case of the adjoining medallion—round the corner but equally under Cancer—which represents a fishing scene (Fig. 120). For here, as usual, Manilius (v, 193) gives more details and describes how the fishermen 'sift the running rivers with inserted nets'—a passage which would fit the illustration well.

The dog-star (*Canicula*), which rises in the fifth degree of Leo, is described as another very evil constellation making those born under it equally feared and hated by all men.

If Mars, however, looks at this spot . . . they will never fear the secrets of the woods but with headlong courage will despise the bites of all animals and often incur dangers from wild beasts and fires. (VIII, 10, 3)

In the roundel under Leo (Fig. 121) this, the only positive quality of the 'children' of the dog-star, is illustrated with characteristic verve.

In the fifth degree of Virgo rises the Wreath (*Corona*). Whoever is born when this constellation rises, will be engaged in various voluptuous pleasures, intent on the study of womanly arts, an inventor of flowers and wreaths, a lover of gardening, passionately craving for scents, ointments and perfumes. . . . (VIII, 11, 1)

The idyllic scene in the roundel under Virgo (Fig. 122) again stresses the more pleasant aspects of the constellation, the wreath-binding and gardening, though

the presence of Cupid hints at 'voluptuous' inclinations and the reclining girl in the foreground seems intent on inhaling the sweet odours of the flowers.[8]

In the eighth degree of Libra rises the Arrow (*Sagitta*). Whoever is born when this constellation rises will be a hurler of arrows who transfixes the birds in their flight with a specially constructed device, or fearlessly spears the fishes of the deep with the trident or harpoon. (VIII, 12, 1)

In the roundel under Libra (Fig. 123) the hurling of arrows by means of a specially constructed device (*speciali artifici moderatione*) is interpreted as the use of the modern crossbows while the harpooning fishermen are shown to use a trident of classical shape.

In the first degree of Scorpio rises the altar (*Ara*). Those born when this constellation rises with benevolent stars in presence will become priests, prophets, temple wardens and heads of any most sacred religion explaining every kind of divine practice by skilful interpretations. (VIII, 13, 1)

In the twelfth degree of Scorpio rises the Centaur (*Centaurus*). Whoever is born under this constellation will be a charioteer or a feeder and breeder of horses. . . . (VIII, 13, 3)

Here, as in the case of Cancer, the zodiacal sign in the corner is co-ordinated with two medallions under it—one representing a sacrifice *all' antica* with the priests at the altar (Fig. 124), one a charioteer (Fig. 125).

The correct order is slightly upset in the next two roundels, both of which refer to a constellation under Sagittarius above them.

In the fifth degree of Sagittarius rises *Arcturus*. Whoever is born when this constellation rises will be one of those who can keep a friend's secret in faithful silence. To those are entrusted the treasures of Kings, national finances and public buildings. But if malignant stars cast their rays on that spot they will either be burdened with public responsibilities or become janitors of regal buildings or those who are entrusted with the office of admitting and welcoming visitors to the palace.

If, however, that sign (*Arcturus*) is found setting, and if Saturnus with Mercury are present with any type of ray, it produces people whom envy drives to grave crimes and who are delivered into the public dungeons fettered in chains, there to die in miserable torments. (VIII, 14, 1-2)

The order of the two illustrations is here inverted. The prison scene in the centre, under Sagittarius (Fig. 126), refers to the unfortunates in whose horoscope Arcturus is setting. The roundel beside it represents the guardians of regal buildings (Fig. 127). It is indeed one of the pleasures of a successful interpretation that it allows us to see details which are otherwise easily overlooked. The 'regal building' of the medallion has often been regarded as a view of a vanished garden front of the Palazzo del Te.[9] There is now less reason for this assumption. It may just represent any 'palace' of Giulio's fancy and the accent lies on the two figures on each side of the entrance, the 'janitors' who welcome the guests.

113. Diagrammatic scheme of the Sala dei Venti,
Mantua, Palazzo del Te, by C. Redfield

114. GIULIO ROMANO: Ceiling and medallions on the Sala dei Venti, Mantua, Palazzo del Te

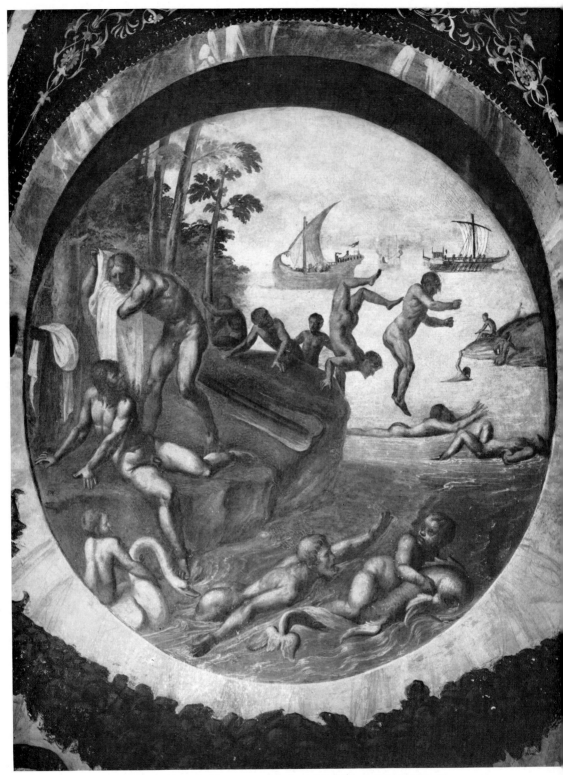

115. GIULIO ROMANO: *Navis and Delphinus*. Sala dei Venti

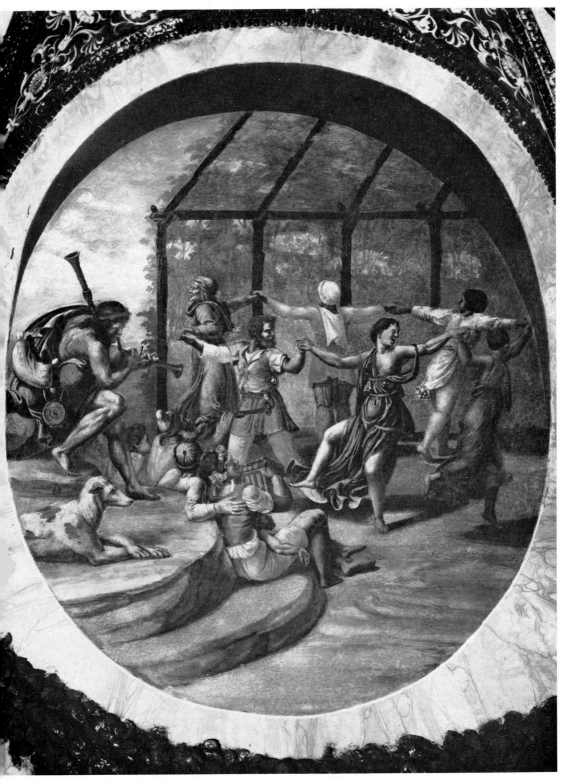

116. GIULIO ROMANO: *Haedus*. Sala dei Venti

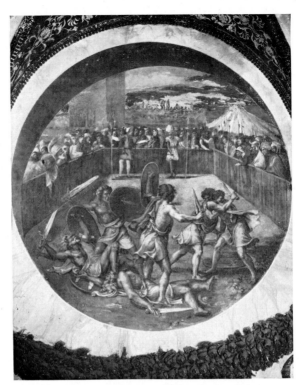

117. GIULIO ROMANO: *Fissio Ungulae Tauri*.
Sala dei Venti

118–119. GIULIO ROMANO: *Lepus*; *Jugulae 1*. Sala dei Venti

120. GIULIO ROMANO: *Jugulae 2*. Sala dei Venti

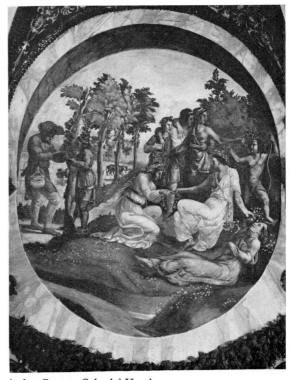

121-122. GIULIO ROMANO: *Canicula*; *Corona*. Sala dei Venti

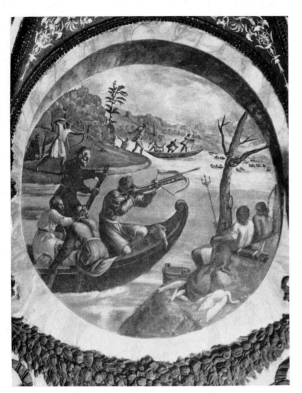
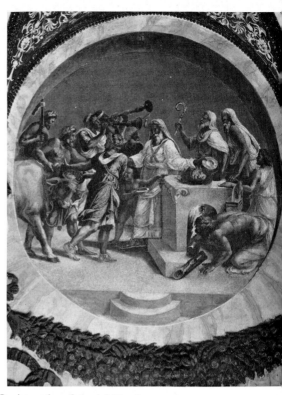

123–124. GIULIO ROMANO: *Sagitta*; *Ara*. Sala dei Venti

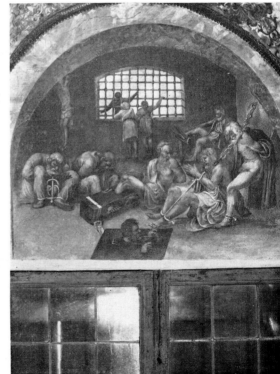

125–126. GIULIO ROMANO: *Centaurus*; *Arcturus 1*. Sala dei Venti

127–128. GIULIO ROMANO: *Arcturus 2*; *Ophiuchus*. Sala dei Venti

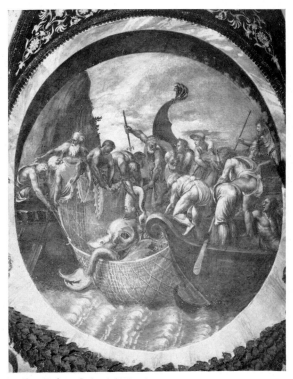

129–130. GIULIO ROMANO: *Aquila*; *Belua*. Sala dei Venti

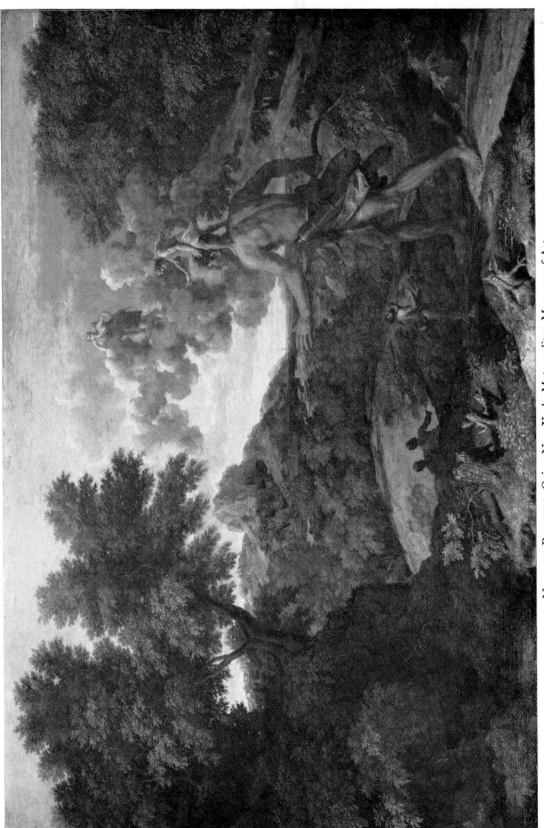

131. NICOLAS POUSSIN: *Orion*, New York, Metropolitan Museum of Art

The next roundel is again in the right sequence:

In the first degrees of *Capricornus* rises the snakeholder (*Ophiuchus*). Those born when this constellation rises will be *Marsians* who charm poisonous snakes by sleeping spells or charmed herbs. (VIII, 15, 1)

The roundel under Capricorn, as Warburg has shown,[10] represents one of the 'theriac vendors' who had taken over the role of the *Marsians*, the ancient snake charmers as sellers of antidotes against snake bites (Fig. 128).

In the twelfth degree of Aquarius rises the Eagle (*Aquila*). Those born when this constellation rises will make their living through robbing and killing people. They will also catch and tame animals. Furthermore they will be courageous soldiers whose virtue and leadership allays the fear of war . . . if benevolent stars are in aspect with propitious rays they will liberate their country, will found new cities and will triumph, having vanquished and subjected nations. (VIII, 16, 1–2)

The medallion under Aquarius again presents the most favourable interpretation of this text in its illustration of a victorious general surrounded by trophies and captives (Fig. 129).

Pisces, like Aries, accompanies many constellations, of which the last was selected for illustration:

In the last degrees of *Pisces* on their left hand side, rises the Whale (*Belua*). . . . Those born when this constellation rises will be fishermen but of large fishes. . . . (VIII, 17, 5)

The medallion under Pisces with the catchers of large fishes (Fig. 130), which Goethe considered an illustration from Philostratus,[11] may also draw some details from Manilius' more graphic description of whaling.[12]

This influence of Manilius becomes a certainty in the medallion under Aries (Fig. 115). The ships in the background must refer to the Ship, which as we have seen, rises as the first constellation under Aries. But the scene in the foreground is clearly imported from another zodiacal sign. It illustrates the qualities of those born under the Dolphin (*Delfinus*) which rises under Capricorn—to which in fact, as a 'corner sign', two roundels should have been allotted.

Here Firmicus contains only bare statements:

In the eighth degree of *Capricornus* rises the Dolphin (*Delfinus*). Whoever is born when this sign rises will be devoted to the pursuit of swimming but when Saturn is present he will be a diver. . . . (VIII, 15, 2)

In Manilius, however, Giulio's adviser would have found a description particularly suggestive to the illustrator; the seventeenth-century translation is sufficiently faithful to preserve the spirit of this gay picture:[13]

> But when the *Dolphin's* Fires begin to rise
> With Stars like Scales, and swim in Liquid Skies;

It shall be doubtful which shall most Command
The Inclination for the *Sea* or *Land*:
Both shall conspire, and in one Mass combind,
Now this way draw, now that way force the Mind:
 For as the *Dolphin* mounts, now dives again,
Now turns, now leaps, and figures all the Main:
So those that shall be born shall now divide
With wide strecht Arms, and beat the swelling Tide;
Now thrust them downward, and with secret Oars
Their Bodies row, and visit Foreign Shores;
Now tread the Water, with their Feet maintain
Themselves Erect, and wade the deepest Main,
As t'were a shallow; like the firmest Field,
The Floods shall bear them, and refuse to yield:
Now on their Backs or Sides securely keep
One constant place, and lie upon the *Deep*:
No Oar to Boy them up; but Floods forget
Their natural yielding, and sustain the Weight:
Or they shall dive, through boundless Oceans go,
And visit *Nereus*, and the *Nymphs* below;
 Or take up Shipwracks, Merchants Spoils restore,
And rob the greedy Ocean of its Oar.
 To these joyn those, who from an Engine tost
Pierce through the Air, and in the Clouds are lost;
Or poize on Timber, where by turns they rise
And sink, and mount each other to the Skies
Or leap through Fire, and fall on hardest Ground
As on soft Seas, unhurt, and safe from Wound:
Tho' void of Wings, their Bodies boldly rear,
 And imitate their *Dolphin* in the Air. . . .

Was it Giulio himself who was tempted to include this scene, so attractive to the Renaissance painter, in the foreground of the *Navis* illustration in the roundel under Aries, or was there some deeper reason for this choice?

Even apart from this displacement of the 'children' of the Dolphin the principle of selection that governed the choice of these images is not quite easy to determine. All except one illustrate the fate of those who are born when a constellation rises—the one exception being the grim dungeon destined for those born when *Arcturus* sets.

In the case of nine out of twelve signs, simply the first or the first two constellations described by Firmicus are selected for illustration: Gemini (*Lepus*), Cancer (two *Jugulae*), Leo (*Canicula*), Virgo (*Corona*), Libra (*Sagitta*), Scorpio (*Ara, Centaurus*), Sagittarius (*Arcturus*), Capricorn (*Ophiuchus, Delfinus*), Aquarius (*Aquila*). In most of these the opening words of each section are used, but in two of the above-mentioned thirteen medallions the most positive interpretation of the

text has obviously been chosen—the animal fighter and not the criminal under *Canicula*, the general and not the robber under *Aquila*. In the case of Taurus (*Fissio ungulae*) and Pisces (*Belua*) the last constellation mentioned was selected, in that of Aries the first (*Navis*) and the fourth (*Haedus*) in its optimal interpretation, whereas in that of Sagittarius (*Arcturus* rising and setting) the positive evaluation was bypassed, possibly because a faithful friend is less easy to illustrate than a janitor, but possibly for reasons still obscure.

This distribution excludes the possibility of a specific horoscope—either that of Federigo Gonzaga or of the Palazzo del Te—forming the dominating idea of the series, for it goes without saying that only one constellation can rise and one set in any individual horoscope. The series is therefore more likely one of general didactic character, reminding the beholder of the manifold influences to which man is subject, the many stars that may yet 'lay hold of him' as the inscription says, and leading his mind to the contemplation of cosmic regularities in the spirit of the introduction of Firmicus' eighth book, from which the roundels were selected:

Regard the heavens, my glorious Mavors, with open eyes, and may your mind always dwell on the beautiful artistry of this divine creation. For then our soul, moulded by its own greatness, will be freed from the depraved vices of the body, cast off the impediments of mortality and hurry towards its creator . . . for this knowledge gives us at least a minute insight into the workings of divine wisdom and leads us towards the secret of our own origins. For always engaged in divine reasoning and applying our minds to the heavenly powers, initiating it into divine ceremonies we shall be rid of all depraved desires. And this will lead to the great achievement that we will despise all that is considered bad or prosperous in the human lot. (VIII, 1, 6–8)

Given such an interpretation there is nothing 'pagan' in the contemplation of the heavens and its laws. Like the more popular series of 'planet children' the frescoes illustrate a scientific doctrine which need not be in conflict with the faith as it only concerns matters mundane, the fate here beneath of those born under certain constellations. In the medallions of the Sala dei Venti this pseudo-scientific doctrine is stated in pictorial forms which deliberately seem to avoid the humdrum and the obvious, again in the spirit of Firmicus Maternus, who stresses the esoteric character of the revelations he makes:

. . . the nature of Godhead conceals itself behind many veils so that it should not be easy of approach nor the majesty of its origins thrown open to all. We, too, in this book have contrived to make its reading clear to the faithful while it will be for ever denied to the profane and sacrilegious, to avoid the venerable words of the ancients being polluted through sacrilegious publication. (VIII, 33, 2–3)

Whoever devised the programme for this room was quite successful in this purpose of creating a mystery[14]—though the method he used was not entirely new. The turn from the 'vulgar' planetary astrology to the more esoteric 'wisdom' of

Manilius, at any rate, is already pre-figured in the famous astrological cycle of Ferrara, the home town of Federigo's illustrious mother.[15] In both cycles, too, the planets which are usually co-ordinated with the zodiacal signs are replaced by the twelve Olympian gods, each of whom is allotted a sign by Manilius.[16] A glance at the ceiling of the Sala dei Venti shows that here, as in Ferrara, the sequence given by Manilius is preserved even though the co-ordination with the zodiac is somewhat upset by the necessity of fitting the series into the available space (Fig. 114).[17]

If we start with the beginning of the calendar year, that is with Aquarius in the south-western corner of the room, and proceed along the zodiac we find Juno correctly over Aquarius, Neptune over Pisces, Minerva over Aries. Continuing parallel with the walls of the room we follow the correct sequence of Venus, Apollo, Mercury, Jove and Ceres, though for reasons of geometry the series has fallen out of step with the zodiacal signs. Having completed one tour of the room we discover that the remaining four signs are strung up in the right order along the central axis of the ceiling: Vulcanus (in gilt stucco), Mars, Diana (with Actaeon), and finally Vesta (again in stucco).

The series of the Olympian Gods was cramped into this odd shape because the twelve lozenges directly adjoining the zodiacal signs were reserved for representations of the twelve months. This, indeed, follows the correct order, January standing besides Aquarius, February between Aquarius and Pisces, March between Pisces and Aries, and so all round the year. This arrangement even has the advantage over the usual co-ordination that it takes account of the fact that Aries, for instance, does not rise on the first of March and that each month has a share of the two signs between which it comes to stand.

Thus, while cycles of zodiacal signs combined with images of the months belong, of course, to the stock-in-trade of medieval calendar illustrations, Giulio's adviser has again shown his desire for originality. This intention makes itself particularly felt in the actual representations of the months. Instead of the familiar series[18] we find a rather bewildering display of classical learning designed, no doubt, to recover the authentic appearance of these images. Whoever devised this cycle must have had access to all the classical calendar lore, such as it is discussed in Ovid's *Fasti*, in Macrobius' *Saturnalia* and other more recondite sources. The humanists and astrologers of the sixteenth century had in fact begun to collect and collate this material with great thoroughness—and one of their most characteristic representatives, Lucas Gauricus, may provide the key to most of these representations.[19]

Januarius, of course, is represented by Janus 'biceps', holding the key (according to Ovid, *Fast.*, I, 99 he should have it in his left hand). By his side is the hieroglyph of eternity, the snake biting its tail, so dear to Renaissance philosophers. *Februarius* takes the form of a Faun with two torches, no doubt an allusion to the *Lupercalia* 'Fauni sacra bicornis' (Ovid, *Fast.*, II, 268). 'And for twelve days in February the

whole nation was engaged in sacrifices with waxen torches.'[20] *March*, of course, is represented by Mars which, we hear, is a derivation favoured by many, though not by all.[21] *April* is illustrated by the Birth of Venus, for according to Macrobius one interpretation derives the name from the Greek word for the foam from which the goddess rose.[22] For *May* another of Macrobius' many suggested etymologies is chosen in the representation of Maia, the mother of Mercury[23] (who is seen on her arm, holding the *caduceus*). For *June*, too, Giulio's adviser preferred the derivation from Juno to the other etymologies which might have presented greater obstacles to illustration.[24] For *July* and *August*, of course, the choice of Julius Caesar and Augustus was obvious.[25] But from here onwards the selection of suitable and intelligible images clearly presented some difficulty—for how should the simple numerals embodied in the names from September to December, which hide no mysteries, be represented? It seems that for *September* and *October* the compiler of the programme could still take some comfort from Macrobius and other texts. For we read that various attempts were made in classical antiquity to bestow names of Emperors on these two months. Tiberius, Domitianus, Antoninus Pius and Commodus all were accorded such transient honours—and one of them is probably intended by the Emperor that fills the place of September.[26] A similar solution may have suggested itself for October, for both Domitianus and Commodus attempted to usurp this month for their immortalization.[27] For November and December, however, no such way out was open. It seems, therefore, that recourse was taken to a translation of the traditional occupations of the month into the *maniera antica*. What kind of text underlies the gay scene of *November* occupations performed by winged putti it is hard to guess. For *December* one might think of a rather far-fetched allusion to be found in the above-mentioned writings of Lucas Gauricus, who identifies that month with the Egyptian month of Choeac, 'the fruit-bearing'.[28] But one could wish for a better reason why this month was represented by 'putti who gather the fruits of an olive tree' as a contemporary document says.[29]

It is not from these many cycles of paintings, however, that the room derived its original name in contemporary documents, but from the gilt stucco masks of sixteen winds which blow into the room from over each medallion and mark off the serene sphere of the heavens from the troubled scenes on earth. Are these sixteen winds[30] really the dominating feature of the room or were these masks, like the eagles in the adjoining room, just the first part of the decoration to be carried out, and did this convenient name adopted in the early documents merely outlast the painted decorations?

Too much store should hardly be set on this name, for another contemporary document speaks of the 'camera delli pianetti et venti'[31]—and unless we assume that the planets were added in a series of tapestries of which no trace has been preserved we must add this reference to the large volume of evidence that the secrets

of Renaissance iconography fulfilled their purpose of remaining secrets remarkably well.

Still, there were, no doubt, exceptions. When Charles V visited the Palazzo del Te in 1530, he greatly admired this room, which served at the time as the Marchese's dwelling-room. We are told that he spent an hour there in conversation with Cardinal Cibò, that he desired a minute explanation of all its features and had high praise for the room, its designer and its inventor.[32]

Who was the inventor? In the absence of documentary evidence we can only venture a guess. It may have been that same Lucas Gauricus in whose writings we found the key to many of the representations of the months. Even without this evidence, which alone is hardly conclusive, he would be a strong candidate for being considered the astrological adviser of Federigo Gonzaga. We know that this famous astrologer entertained the closest relations with the Gonzagas.[33] He was the author of a prognostic poem on the future of Mantua,[34] he spent several years in that city,[35] and he included a special advice to Federigo in a prognostic for the year 1526—warning him that in the month of June special danger threatened him from two of his favourite occupations—horses and love affairs.[36] What is more, we know that in the spring of that year, the year when the Palazzo del Te was being planned, Gauricus was in correspondence with the Marchese and probably also went to Mantua.[37] In any case he presented Federigo with the first printed edition of Bonincontri's *De Rebus Coelestibus* and praised him in the dedication as a second Alexander, Caesar, Augustus, Hector and Achilles. Maybe Pietro Aretino had reasons for dedicating, in his turn, a satirical prognostic for the year 1527 to Federigo Gonzaga in which he makes fun of Gauricus and his astrological predictions.[38]

It was at this time that Aretino gained his astonishing ascendancy over the Marchese by promising to satisfy his craving for personal glory and his predilection for erotic works of art.[39] Is it too fanciful to see the spirits of these two men, representing, as they do, two contrasting aspects of the age, struggling for predominance in the strangely oppressive dream-world of the Palazzo del Te?[40]

The Subject of Poussin's Orion

This was the vision, or the allegory:
We heard the leaves shudder with no wind upon them
By the ford of the river, by the deep worn stones,
And a tread of thunder in the shadowed wood;
Then the hunter Orion came out through the trees,
A tree-top giant, with a man upon his shoulder,
Half in the clouds. . . .

<div align="right">Sacheverell Sitwell: 'Landscape with the Giant Orion.'[1]</div>

BELLORI tells us that of two landscapes Poussin painted for M. Passart one represented 'the story of Orion, the blind giant, whose size can be gauged from that of a little man who stands on his shoulders and guides him, while another one gazes at him'.[2] It is to Professor Tancred Borenius that we owe the identification and publication of this masterpiece, which is now at the Metropolitan Museum at New York (Fig. 131).[3] The strange tale of how the gigantic huntsman Orion, who had been blinded for an attempt to violate the princess Merope at Chios, was healed by the rays of the rising sun, would appear to be a tempting subject for illustration. And yet Poussin seems to have been the first—if not the only—artist to paint it.

Perhaps the story did indeed appeal to him—as Sacheverell Sitwell suggested —'because of its poetical character, and because of the opportunity if afforded him to make a study of a giant figure, half on earth and half in the clouds, at the moment of sunrise', but the idea of making it the subject of a painting was nevertheless not his own. It was apparently first conceived not by a painter but by a man of letters, by that fertile journalist of late antiquity: Lucian.

In his rhetorical description of a Noble Hall, Lucian enumerates the frescoes which adorn its walls:

On this there follows another prehistoric picture. Orion, who is blind, is carrying Cedalion, and the latter, riding on his back, is showing him the way to the sunlight. The rising sun is healing the blindness of Orion, and Hephaestos views the incident from Lemnos.[4]

There can be little doubt that this passage is the immediate source of Poussin's painting. Like Botticelli's *Calumny of Apelles* or Titian's *Bacchanal* it thus owes its origin to that curious literary fashion of classical antiquity, the *ekphrasis*, which fired the imagination of later centuries by the detailed description of real or imaginary works of classical art.

This was an article in *The Burlington Magazine* in 1944.

But, although the passage from Lucian may serve to explain Poussin's choice of the subject matter, it does not appear to have been the only literary source on which he relied when he began to reconstruct the classical fresco described by the Greek author. For in one point, at least, Poussin's picture does not exactly tally with Lucian's description: Hephaestos is not represented as 'watching the incident from Lemnos'—he is seen advising the guide he gave Orion and pointing the way towards the East where the sun is about to rise. The role of the spectator has been filled by another divinity, Diana, who is seen quietly looking down from a cloud. The same cloud on which she leans also forms a veil in front of Orion's eye and thus suggests some kind of connection between the presence of the goddess and the predicament of the giant. Félibien must have felt this connection when he described the picture as 'un grand paysage où est Orion, aveuglé par Diane'[5]—quite oblivious of the fact that no classical version of the myth conforms to this description. It was not Diana who blinded Orion, however often the story of the hunting goddess may have been interwoven with that of the hunting giant. It was said that he loved her in his youth, attempted to violate her, was slain by her for his crime (or else for his boasts that he would kill all the animals in the world), and was finally changed by her into that mighty constellation on the night sky in which his name lives on. No classical version of the tale, however, connects Diana with the episode of Orion's blindness. Indeed it is her intriguing appearance as 'a silent stone statue in the open sky' that inspired Mr. Sacheverell Sitwell in his highly imaginative poetical interpretations of the painting which centre round the poet's impression that 'she will fade out of the sky as soon as Orion recovers his sight'. However, the presence of the goddess becomes perhaps less mysterious if we turn from classical authors to the reference books Poussin may have consulted, when trying to deepen his acquaintance with the myth to which Lucian alluded.

A few lines in a satirical verse by Marston provide a neat enumeration of some of the most popular reference books in vogue with the poets and artists:

> Reach me some poets' index, that will show
> *Imagines Deorum*, Book of Epithets,
> Natalis Comes, thou I know recites,
> And makest anatomy of poesy.[6]

The modern reader who turns to works like *Natalis Comitis Mythologiae* will find it difficult to associate this bewildering farrago of pedantic erudition and uncritical compilation with the serene Olympian world of Poussin.[7] The most apocryphical and outlandish versions of classical and pseudo-classical tales are here displayed and commented upon as the ultimate esoteric wisdom. The very subtitle of Comes' book: '*Explicationis fabularum libri decem; in quibus omnia prope Naturalis et Moralis Philosophiae dogmata in veterum fabulis contenta fuisse perspicue demonstratur*', (Ten books of explanations of fables, clearly demonstrating that all

the doctrines of Natural and Moral Philosophy were contained in the fables of the ancients) shows it to be part of that broad stream of tradition which kept alive the belief that, to the initiated, the old fables reveal themselves as symbolical or allegorical representations of the 'arcana' of Natural History or Moral Philosophy.[8]

The principal method of this strange art of hermeneutics is a fanciful etymology which so stretches the sound and meaning of words and names that they are made to yield their pretended secrets. Weird and abstruse as these 'interpretations' read today, it can hardly be denied that they satisfy at least one of the principal requirements of any successful interpretation: the most disparate elements of a myth are, through this method, reduced to one common denominator and even the most contradictory episodes can be made to appear as different symbols and manifestations of one 'hidden truth'. In his interpretation of the Orion myth, Natalis Comes chose to consider its various episodes in the light of a slightly repulsive apocryphal story which tells of the giant's joint procreation by Neptune, Jupiter and Apollo, a story which, to Comes, clearly signifies that Orion stands for a product of water (Neptune), air (Jupiter) and sun (Apollo). Armed with this clue and a fanciful 'scientific' interpretation of meteorological phenomena he proceeds boldly to interpret the whole legend as a veiled symbol of the interaction of these elements in the origin and natural course of the stormcloud:

. . . through the combined power of these three Gods arises the stuff of wind, rain and thunder that is called Orion. Since the subtler part of the water which is rarefied rests on the surface it is said that Orion had learned from his father how to walk on the water. When this rarefied matter spreads and diffuses into the air this is described as Orion having come to Chios which place derives its name from 'diffusion' (for *chéein* means to diffuse). And that he further attempted to violate Aerope[9] (*sic*) and was expelled from that region and deprived of his lights—this is because this matter must pass right through the air and ascend to the highest spheres and when the matter is diffused throughout that sphere it somehow feels the power of fire languishing. For anything that is moved with a motion not of its own loses its power which diminishes as it proceeds.

Orion is kindly received by Vulcanus, approaches the sun, finds his former health restored and thence returns to Chios—this naturally signifies nothing else but the cyclical and mutual generation and destruction of the elements.

They say that he was killed by Diana's arrows for having dared to touch her—because as soon as the vapours have ascended to the highest stratum of the air so that they appear to us as touching the moon or the sun, the power of the moon gathers them up and converts them into rains and storms, thus overthrowing them with her arrows and sending them downwards; for the power of the moon works like the ferment that brings about these processes. Finally they say that Orion was killed and transformed into a celestial constellation—because under this sign storms, gales and thunders are frequent. . . .[10]

In this strange 'interpretation' Diana—the Moon and her power—does indeed form an integral part of the same process that is also symbolized in the episode of Chios: the drama of the circulation of water in nature.

But reading Natalis Comes' text in front of Poussin's picture it appears to explain more than the mere presence of Diana on the scene. The long-stretched stormcloud through which the giant is striding, that conspicuously rises from under the trees, expands through the valley, gathers up in the air and touches Diana's feet, this cloud is no other than Orion himself in his 'real' esoteric meaning. We cannot but admire the ingenuity with which Poussin has contrived to represent the exoteric and the esoteric aspect of the myth in one picture. To the uninitiated the stormcloud appears as a happy pictorial solution, a rational trick which helps to illustrate Orion's blindness as a transitory phase which will be over when he has passed the mist and approached the rising sun. To the circle of scholars who were accustomed to see 'the teachings of Natural and Moral Philosophy hidden in the fables of Antiquity', the cloud rising in the grandiose scenery represented the whole myth again on a higher plane: the eternal drama of the 'mutual generation and destruction of the elements'.

Trained, as we are, in a predominantly visual approach to the arts, we may at first find little to commend in such an intellectual and even sophisticated trick of illustration that embodies a learned commentary into a representation of a classical myth. Indeed—had this trick remained purely on an anecdotal plane the connection with Natalis Comes' erudite compilation might just as well have remained forgotten. It constitutes the true achievement of Poussin's genius that he succeeded in turning a literary curiosity into a living vision, that his picture *expresses* in pictorial terms what it *signifies* in terms of allegory. Without the aid of any rational 'key' to its emblematic language the picture has always imparted its inner meaning to sensitive observers. It was of this 'Landscape of Poussin' that Hazlitt wrote, with strange intuition, in his *Table Talks*: 'At his touch, words start up into images, thoughts become things';[11] and Professor Borenius, the rediscoverer of the painting: 'the use made of the terms of land sea and sky suggests the drama of nature for which the mythological terms are but symbols'.[12]

Reading the passage from Natalis Comes there can be no doubt that this quite literally describes Poussin's approach to mythological landscape painting. An artist like Poussin can only have made use, in his reconstruction of Lucian's 'ekphrasis', of the humanist's allegorical reading of the myth because he accepted this approach as a whole. He too conceived the ancient tale of violence and magic as a veiled and esoteric 'hieroglyph' of nature's changing course. Thus the landscape became more to him than the scene in which a strange and picturesque story was enacted. Its deeper significance lifted it beyond the sphere of realistic scenery or Arcadian dreams—it became fraught with the meaning of the myth; a vision *and* an allegory of Nature herself.

Icones Symbolicae

Philosophies of Symbolism and their Bearing on Art

INTRODUCTION

WRITING on allegorical painting in 1748 Abbé Pluche made a remark which many students of this branch of art may have felt prompted to endorse: *'Puisqu'un tableau n'est destiné qu'à me montrer ce qu'on ne me dit pas, il est ridicule qu'il faille des efforts pour l'entendre. . . . Et pour l'ordinaire, quand je suis parvenu à deviner l'intention de ces personnages mystérieux, je trouve que ce qu'on m'apprend ne valait guère les frais de l'enveloppe.'*[1] The learned Abbé was here pleading for clarity in the devising of allegories in accordance with eighteenth-century taste. He wanted to confine allegories to images which could readily be understood. Nineteenth-century critics went further.[2] They regarded allegorical paintings as a kind of pictograph in which conceptual language is elaborately translated into conventional images and they consequently disapproved. The most frequent epithet applied by them to a personified abstraction was 'pale' or 'bloodless' and who wants an art which is either?

Brought up, as I was, in Austria, these epithets have always sounded puzzling to me. For the personifications which crowd the ceilings of countless baroque churches and staterooms, perched in gay profusion on radiant clouds, look anything but bloodless (Fig. 132). It was in studying these sumptuous compositions of which the exact programme is so often known that I first began to doubt the status usually assigned to personifications before the onset of the Age of Reason.[3] Were they really no more than decorative pictographs? Might they not have been conceived as true representations of the heavens in which Platonic ideas were seen dwelling with the angels? Thus it was with considerable excitement that in turning the pages of Graevius' *Thesaurus Antiquitatum* I came across a text of the seventeenth century which appeared to confirm this interpretation. It was a speech or sermon entitled *Icones Symbolicae* by a Barnabite teacher of rhetoric, Christophoro Giarda, in praise of the representation of sixteen 'Disciplines' or Liberal Arts (Figs. 133–6) adorning the reading room of the newly erected College Library.[4] Before explaining the emblems and attributes of these images Giarda delivered a eulogy of the art of devising symbolic images. Despite its baroque bombast it proves to present a

This is a much amplified version of the study which appeared in the *Journal of the Warburg and Courtauld Institutes* in 1948.

coherent and explicit doctrine which confirms that to Giarda in 1626 the personi-
fications are not simply translations of words into images, a kind of picture writing
to tease and exasperate the impatient visitor. 'We owe it to them,' he claims, 'that
the mind which has been banished from heaven into the dark cave of the body, its
actions held in bondage by the senses, can behold the beauty and form of the
Virtues and Arts, divorced from all matter and yet adumbrated, if not perfectly
expressed, in colours, and is thus roused to an even more fervent love and desire
for them.'[5]

In the first version of the essay which is now in front of the reader, I attempted
to show that Giarda really meant what he said and that he thus confirmed my
surmise that these images were conceived as representations of Platonic Ideas.[6] To
my knowledge this interpretation has not been contradicted, and I have even found
some further texts which appear to strengthen it. But looking once more at the
problems raised by the question of Abbé Pluche I feel that Platonism is only one
of the causes which account for the ubiquity of personifications in Western art,
poetry and rhetoric. I had not wholly neglected the others in the original essay,
which devotes a few words both to the Aristotelian conception of the didactic
image and to the continued impact of mythology on art; it should be possible,
however, to present these alternatives a little more clearly with the help of relevant
texts and thus to arrive at a better understanding of the conflicting and interacting
currents of thought that can be shown to have influenced ideas about symbolism
down to our present day.

One thing is clear. We cannot tackle this kind of question at all unless we are
ready to abandon the assumptions about the functions of the image we usually take
for granted. We are used to making a clear distinction between two of these func-
tions—that of representation and that of symbolization. A painting may *represent*
an object of the visible world, a woman holding a balance, or a lion. It may also
symbolize an idea. To those conversant with the conventional meanings attached to
these images the woman with the balance will symbolize Justice, the lion Courage
or the British Empire or any other concept conventionally linked in our symbolic
lore with the King of Animals.[7] On reflection we may be prepared to grant the
possibility of another kind of symbolism, not conventional but private, through
which an image can become the expression of the artist's conscious or unconscious
mind. To van Gogh the orchard in bloom may have been a symbol of his return-
ing health.[8] These three ordinary functions of images may be present in one
concrete image—a motif in a painting by Hieronymus Bosch may *represent* a
broken vessel, *symbolize* the sin of gluttony and *express* an unconscious sexual
fantasy on the part of the artist but to us the three levels of meaning remain quite
distinct.

As soon, however, as we leave the ground of rational analysis we find that these

neat distinctions no longer hold. We know that in magical practice the image not only represents an enemy but may take his place (the very word re-present still has this dual meaning). We know that the 'fetish' not only 'symbolizes' fertility but 'has' it. In short, our attitude towards the image is inextricably bound up with our whole idea about the universe. Any student of the religious function of images knows how complex this attitude may be: 'Between the belief of the peasant, who took the animation of the idol in its most gross realistic sense, and the belief of the educated man, who regarded the ceremonies of worship as only expressing in a symbolic way that there was some unseen power somewhere, who liked to receive the homage of men, there may have been any number of intermediate shades ... we realize more today than was realized before how the mind of man is on various levels, and how, beneath an articulate intellectual theory, a belief inconsistent with that theory, closely connected with unavowed feelings and desires may still subsist.' These words by Edwyn Bevan on the attitude of Horace and his time to the question of 'idols' apply to the whole field of our investigation.⁹ For where there is no clear gulf separating the material, visible world from the sphere of the spirit and of spirits, not only the various meanings of the word 'representation' may become blurred but the whole relationship between image and symbol assumes a different aspect. To primitive mentality distinction between representation and symbol is no doubt a very difficult one. Warburg described as '*Denkraumverlust*' this tendency of the human mind to confuse the sign with the thing signified, the name and its bearers, the literal and metaphorical, the image and its prototype.¹⁰ We are all apt to 'regress' at any moment to more primitive states and experience the fusion between the image and its model or the name and its bearer. Our language, in fact, favours this twilight region between the literal and the metaphorical. Who can always tell where the one begins and the other ends? A term such as 'a heavy burden' may be a dead metaphor, but it can be brought to life with the greatest ease by an orator or cartoonist.¹¹ When Marx opened the *Communist Manifesto* with the famous sentence: 'A spectre is haunting Europe, the spectre of Communism', he did not want people to believe in spectres or ghosts, but he contrived by this old rhetorical device to make the idea more vivid. It so happens that Indo-European languages tend to this particular figure we call personification, because so many of them endow nouns with a gender which makes them indistinguishable from names for living species.¹² Abstract nouns in Greek and Latin almost regularly take on the feminine gender and so the way is open for the world of ideas being peopled by personified abstractions such as *Victoria, Fortuna* or *Iustitia*. Before we probe them too pedantically, should we not remember that civilization has created a special zone in which we are forbidden to ask this very question—the zone of 'fiction' which is also the zone of art? We cannot enter this realm without entering into that compact which Coleridge described as the 'willing suspension of

disbelief'. It may indeed be argued that our experience of art is entirely independent of what we hold to be true. Meteorology and the kinetic theory of gases are unlikely to enter our mind when we read Shelley's *Ode to the West Wind*. What matters here is whether the poet can make us believe in the West Wind as 'breath of Autumn's being' who can respond to the summons 'O hear!'. To the modern critic, in other words, the problem of personifications and indeed of all symbolism in art is an aesthetic rather than an ontological problem. What interests him is what the symbol expresses rather than what it signifies. He may dismiss Bartholdi's Statue of Liberty as a 'pale abstraction' but find in Delacroix's *Liberty leading the People* a perfect expression of the struggle for freedom (Fig. 137).

In contrast to the aesthetician the student of subject matter is interested in naming an individual personification rather than in the question of its reality or fiction. Our question does not concern him either. Few historians, to my knowledge, have puzzled their heads over the strange way in which Western literature and art has preserved the peculiar habits of the ancient world to 'hypostasize' abstract concepts, fewer even have asked whether similar modes of thought exist outside this tradition.[13] This essay attempts to enquire into the intellectual background to this development. Even so it may be better not to plunge into these abstract and abstruse discussions without reminding the reader of the artistic potentialities of the genre which flourished so luxuriantly at the very time when *letterati* such as Ripa and Giarda were intent on its philosophical justification.

I

THE PERSONIFICATION OF IDEAS

There are not very many great works of the genre to which the artist himself has given us the key. One of the few is a painting by Rubens of 1637/8 in the Palazzo Pitti known under the name of *The Horrors of War* (Fig. 138). It was painted for the Grand Duke of Tuscany and the artist described its content from memory in a letter to the painter Justus Sustermans, who had apparently asked for a detailed explanation:

The principal figure is Mars—writes Rubens—who, leaving open the Temple of Janus (which it was a Roman custom to keep closed in times of peace), advances with his shield and his bloodstained sword, threatening the nations with great devastation and paying little heed to Venus his lady, who strives with caresses and embraces to restrain him, she being accompanied by her Cupids and lovegods. On the other side Mars is drawn on by the Fury Alecto, holding a torch in her hand. Nearby are monsters, representing Pestilence and Famine, the inseparable companions of war; on the ground lies a woman with a broken lute, signifying harmony, which is incompatible with the discord of war; there is also a Mother with her babe in her arms, denoting that fecundity, generation and

charity are trampled underfoot by war, which corrupts and destroys all things. In addition there is an architect, lying with his instruments in his hand, to show that what is built for the commodity and ornament of a city is laid in ruins and overthrown by the violence of arms. I believe, if I remember aright, that you will also find on the ground, beneath the feet of Mars, a book and some drawings on paper, to show that he tramples on literature and the other arts. There is also, I believe, a bundle of arrows with the cord which bound them together undone, they when bound together, being the emblem of Concord, and I also painted, lying beside them, the caduceus and the olive, the symbol of peace. That lugubrious Matron clad in black and with her veil torn, despoiled of her jewels and every other ornament, is unhappy Europe, afflicted for so many years by rapine, outrage and misery, which, as they are so harmful to all, need not be specified. Her attribute is that globe held by a putto or genius and surmounted by a crest which denotes the Christian orb. This is all that I can tell you.[14]

At first sight one may hesitate to classify this composition among 'allegorical' paintings. Is it not rather a mythology?

The principal figures, after all, are denizens of the ancient Olympus, Venus, the Goddess of Love, and Mars, the God of War. Should we not therefore rather describe the picture as an illustration in which fictitious beings, once believed to have a real existence, are represented in their imaginary form as they are in so many other mythologies? But we know that even in antiquity no real distinction can be made between the Gods conceived as demonic beings and their role as personifications and metaphors. Cupid is not only the 'God of Love', he stands for Love much as Minerva can stand for Wisdom. Rubens' composition does indeed recall such a symbolic evocation of the Gods. Lucretius, the very poet who propounded Epicurean atomism as an antidote to the fear of the Gods, opens his poem with an appeal to Venus, the embodiment of Nature's fertility, to lure Mars to her embrace and thus to bring peace to the Romans. Rubens had only to invert that image and show us a Mars unwilling to be thus subdued and spreading the horrors of war among the nations. In doing so, of course, he was drawing on the conventions of allegorical compositions which had long been developed in the contexts of political pageants and paintings. Thus in 1578, sixty years before the Rubens painting, Tintoretto had expressed a similar thought in a painting for the Palazzo Ducale in Venice (Fig. 139), where it is Minerva who keeps Mars away from a pair of personifications whom Ridolfi describes as Peace and Abundance.[15]

The subjects, the librettos of the two paintings are indeed similar, but they differ —and not only in style. Tintoretto's figures act and behave like personifications rather than like convincing beings. Rubens knew how to turn the thought into a human drama. Steeped as he was in classical lore he could fuse the message of Lucretius with a situation derived from the story of Venus. Venus had pleaded with one of her lovers not to leave her for more dangerous pursuits and this story of Venus and Adonis, who was subsequently killed when hunting the boar, had been

painted by Titian and by Rubens himself (Fig. 140). It is this touch which adds verisimilitude to the scene Rubens unfolds before our eyes. It is a real Venus who pleads with a real Mars, and this degree of fictitious reality also enables the painter to exploit one of the most important artistic potentialities of the genre—he can characterize both of the protagonists in a way that conveys to us with real immediacy what he feels about the blessings of peace and the horrors of war. His Mars is not a heroic warrior, he is a brutal butcher, rather stupid in bearing and physiognomy —and who would not be stupid to allow the Fury Alecto to drag him away from the embraces of Venus? The Fury is a demon. Is she therefore 'real'? More so, or less so than the terrified women who cower under the onslaught, one of them described by Rubens as 'a mother with her babe in arms, denoting that fecundity, generation and charity are trampled underfoot by war, which corrupts and destroys all things'. We also remember the architect with his instruments who lies prostrate to show the ruins of war. He, surely, is a real human being standing for a symbolic meaning, just as his book and the drawings which Mars is seen to trample underfoot are both real and symbolic.

What then of the 'lugubrious matron' who is unhappy Europe? What is her ontological status? We call her a personification, but in antiquity she might just as well have passed as a divinity. The *Tyche* or embodiment of cities, provinces and realms such as *Roma* were certainly not conceived as mere abstractions. Temples were built to them and sacrifices performed. As far as Mars or Alecto could be believed in, Europe too could claim a similar status. It is precisely the strength of the tradition on which Rubens drew that divinities who are imagined as human and even all-too-human, shade over into personifications who are far from 'bloodless'.

No-one would have been prepared to say whether Pestilence and Famine are Gods who could be propitiated by sacrifice, demons to be dreaded and exorcized, or mere abstractions. Yet Rubens represents them as 'the inseparable companions of war' and he precisely followed ancient practice in such matters. Homer tells us that Flight is the companion of Panic (Iliad IX, 2) and Panic the son of Ares (Iliad XIII, 299).[16] While we tend to think of a divinity as a being with an independent existence, and of a personification as a symbolic figure marked with distinctive emblems to make her recognizable, Rubens in accordance with the tradition ignores this distinction. Not only can he turn Gods into vivid personifications and personifications into demons freely interacting with real human beings such as architects or mourning mothers, he can even mix real objects such as books and drawings with emblems originally conceived as 'attributes' or personifications. We remember 'the bundle of arrows with the cord, they, when being bound together, being the emblem of Concord, and . . . beside them, the caduceus and the olive symbol of Peace'. The emblem of Concord, of course, derives from a demonstration of the

strength of a bundle, in other words from a simile or comparison, the caduceus is the wand of Mercury while the olive branch as a symbol of Peace is a conventional association.

It surely does not need any special pleading to bring it home, in such a case, how perfectly the intellectual message is here transposed into visual form. Those who see only 'what meets the eye' may also enjoy the drama and even sense the horror of the scene; but to read the Rubens letter in front of the picture enables even the eye to take in more. Benedetto Croce, we find, erected a formidable obstacle in the way of perceiving the arts of the past when he insisted on divorcing rhetoric from art.[17] It is precisely the point that ancient theory did not know this distinction. Poetry could be didactic, and teaching or preaching poetic. The painting by Rubens is a splendid illustration of this fusion. It teaches and preaches the blessings of peace and the horrors of war by placing the contrast between the two before our eyes.

It was this conception of art that kept the tradition of ancient mythology and personification alive through the Christian centuries. It enabled and even enjoined the poet, the orator or the artist to cultivate the mythopoeic faculty and to conjure up the vivid presence of any notion which to the logical mind appears as a 'concept'. This expressive evocation of a concept could also contribute to its explanation, just as the explanation in its turn could aid the imagination in arriving at a more perfect expression.

There is one form of art which conveniently illustrates this kind of aesthetic interaction—that of music in its relation to the text. The same libretto, or the same words of the liturgy set to music by different composers may remain inert or come to life. Small wonder that music lovers sometimes think that the words are a matter of indifference and that it is the music which carries the meaning. But we may do well to remember the slippery character of that much abused term. It is best to confine its application to statements or propositions in 'discursive' speech where the word 'meaning' can be handled with confidence. The prayer 'Dona nobis pacem'—to remain close to the message of Rubens's picture—has a meaning which can be discussed and translated. Beethoven did precisely this when, in his *Missa Solemnis*, he entitled the prayer as 'Bitte um inneren und äusseren Frieden' (a request for inward and outward peace). He brought out the implications of these meanings when (developing an idea of Haydn) he introduced martial music which is interrupted by a cry of anguish. But this dramatic invention, like that of Rubens, can only come to its artistic consummation through our understanding of the content and the context of the message.

To be aware of this necessary interaction need not make us less responsive to music without words any more than an awareness of the subject matter of Rubens's canvas need make us blind to the splendours of his landscapes. Whether or not

'absolute music' or landscape painting could have reached the same heights without the schooling of symbolic art is perhaps a moot point. In what follows we must be concerned with the traditions and ideas which provided opportunities for art much as liturgy and librettos provided opportunities for composers. But perhaps the journey along that arduous road will still help us to see the achievement of the masters more in the round.

II

THE DIDACTIC TRADITION

The Society of Concepts

The simplest way in which art and rhetoric could exploit the mode of personification is still intimately linked with mythology. We have seen that Homer calls Panic the son of Ares, and kinship has remained one of the basic metaphors for the expression of relationship between concepts. The Muses are the daughters of Memory and painting and poetry are called the Sister Arts. Mozart (speaking of librettos) demanded that the text must be 'the obedient daughter' of music.[18] Truth, as we know, is the daughter of time, and Caution, according to a German proverb, the mother of wisdom.[19]

The love of system, characteristic of medieval didacticism, has led to the drawing up of whole family trees to illustrate the mutual dependence of logical concepts. In the 'Tree' of the Vices Pride is the root of all evil, while the corresponding set of the virtues stems from Humility (Fig. 141).[20] Such illustrations come closest to the didactic diagram, the personifications are totally subservient to the idea and can easily be replaced by mere verbal labels.

It is one of the fascinations of this mode of thought that it demonstrates the affinity between abstract thought and artistic visualization. The very word 'affinity' I have used shows how our expository discourse is still steeped in metaphor: I could have spoken of 'kinship' instead—or of a 'link' or a 'spectrum' between the two, I could have invoked the spatial metaphor of 'proximity' or the paler formulation of 'a close relationship'; in every one of these cases I would still have suggested a concrete image to communicate to the reader that personification is the joint offspring of thought and imagination.

We must leave it to future explorers to map out the kinship systems of this strange tribe, and the way the image of the family can be replaced by other social models of co-ordination or subordination to explain the relation between concepts. 'Language', said Karl Kraus, 'is the mother, not the handmaiden of Thought.'[21] Both companionship and servitude are indeed as frequent in the society of concepts

as are terms of kinship. We remember that for Rubens Famine and Pestilence are the 'inseparable companions' of War, and two thousand years earlier a Greek vase painter represented Aphrodite with her companions or handmaidens and servants (Fig. 142), inscribed as Eros, Harmonia, Peitho (Persuasion), Kore (Maiden), Hebe (Youth) and Himeros (Longing).[22]

Unlike Rubens, though, the Greek painter has made little effort to place these concepts before our eyes. In fact it has been suggested that some of the inscriptions are misplaced; since the other side of the Vase represents the marriage of Alcestis, the composition may have been intended to represent the nuptials of Harmony, who would be the seated woman, and that the names of Kore and Peitho should be changed round so that 'Persuasion' is seen talking to Harmony. Even so the picture could stand for any wedding. Without labels it would remain mute. It needs the text more than Rubens does.

The same was probably true of the earliest composition of this kind of which we have knowledge in Greek art, the so-called Chest of Kypselos, which Pausanias described as standing in the Temple of Hera in Olympia and which is believed to have dated from the seventh century B.C.[23] Characterization can not have been very vivid in this period of archaic art, but if we can trust the author the meaning was conveyed not only by inscription but also through the appearance of the personification:

On the second zone of the chest . . . a woman is represented holding a white sleeping boy on her right arm, on her other arm a similar black boy . . . the captions say, and indeed one might have told so without captions—that it is Death and Sleep and Night, the foster-mother of both.

A beautiful woman drags an ugly one along, throttling her with her right hand, while hitting her with a stick she holds in her left. This is Justice fighting Injustice.

Here we have the earliest example of a syntactical form even more widespread than that of kinship and amity. The opposition of concepts has been expressed time and again by their personifications which are shown to be in conflict as in a physical fight. The Middle Ages inherited this mode through the *Psychomachia* of Prudentius, in which the Virtues and Vices fight a number of set battles, but neither Prudentius nor his medieval illustrators (Fig. 146) went much beyond naming and labelling the protagonists of his fights.[24] True, the virtues are more dignified and perhaps more beautiful than their wicked opponents—a contrast already remarked by Pausanias—but the whole epic is still closer to a diagram of moral theology than to the dramatic embodiment of psychological conflicts.

That masterpiece of criticism, C. S. Lewis's *The Allegory of Love*,[25] makes it unnecessary to discuss this aspect of the medieval tradition, which is in any case more relevant to the history of literature than it is to that of art. Not that artists were not called upon time and again to represent personifications in conflict. The

point is rather that in this particular tradition the label or the scroll could rarely be dispensed with.

Even so it would be interesting to explore the resources of this symbolic language for the expression of relationships more complex than those of simple kinship, friendship or hostility. Petrarch used a succession of triumphs to establish a hierarchy of values, with triumphant Love triumphed over by Chastity, Death, Fame, Time and Eternity in their turn (Fig. 143). Rubens reminds us that a dramatic action can express even richer ideas, such as Venus trying to restrain Mars, whose progress causes Europe to mourn. But even Rubens, it will be remembered, could not quite dispense with that other resource of symbolic art, the emblem or attribute, witness that bundle of arrows lying broken and useless since concord had disappeared.

The Attributes

Like the other characteristics of personifications the 'attributes' have their roots in mythology. Jove wields the thunderbolt and Minerva the shield with the Gorgoneion. These marks of recognition may be described as residues of illustration. Zeus is imagined in the act of the Thunderer, Athene had triumphed over the monster. It looks as if the need to intellectualize the attributes has arisen together with the desire to rationalize mythology. For as soon as the myths were interpreted as fables which both concealed and revealed the truth about nature, the demand must have arisen to explain not only the action but also the appearance of the gods in symbolic terms. It may even be that this demand reaches further back into a time when the meaning of certain ancient cult images had been forgotten and when the local priests felt the need of explaining their appearance to the inquisitive pilgrim or tourist. Be that as it may, the symbolic explanation of the attributes carried by a god gave rise to a genre of poetry the importance of which for our topic cannot be overrated. Rudolf Pfeiffer[26] has brilliantly reconstructed one of the archetypes of this genre from a fragmentary papyrus containing a poem by Callimachus. He has shown that a set of questions and answers which is found there relates to the image of the Delian Apollo. The god is asked for the reason of his attributes and answers himself: 'Why dost thou hold, Oh Cynthius, the bow in thy left hand, but in thy right hand thy comely Graces?' He replies, according to Pfeiffer's reconstruction, that in order to punish fools for their insolence he holds the bow 'but to the good people I stretch out my hand with the Graces. In the left hand I carry the bow because I am slower to chastise mortals, but the Graces in the right hand, as I am always disposed to distribute pleasant things.' Pfeiffer has shown how remarkably tenacious this type of interpretation remains. Swift describes an image of Justice in his Voyage to Lilliput 'with a bag of gold open in her right hand, and

a sword sheathed in her left to show she is more disposed to reward than to punish'. But more important even than the tenacity of this individual conceit is the persistence of the method by which the attributes of gods and personifications are explained.

Thus Propertius, in a much imitated elegy, explains the essence of Love by describing the image of Cupid, thus fusing the mythical image with the personification of a psychological force:

> Quicumque ille fuit, puerum qui pinxit Amorem
> nonne putas miras hunc habuisse manus?
> is primum vidit sine sensu vivere amantes,
> et levibus curis magna perire bona.
> idem non frustra ventosas addidit alas,
> fecit et humano corde volare deum:
> scilicet alterna quoniam iactamur in unda,
> nostraque non ullis permanet aura locis.
> et merito hamatis manus est armata sagittis,
> et pharetra ex umero Gnosia utroque iacet:
> ante ferit quoniam, tuti quam cernimus hostem,
> nec quisquam ex illo vulnere sanus abit. . . .

(Whoever he was who first painted Amor as a boy, surely you must agree that he had a marvellous hand. He it was who first saw that the life of lovers lacks reason and that great goods are lost through their small worries. He, too, gave him wings for good reason and made him fly about the hearts of men, for we are in fact tossed by the rolling waves and the wind that drives us is never steady. Deservedly also his hand is shown armed with barbed arrows and the Cnossian quiver hangs from his twin shoulders. For he strikes from afar when we think we are safe from the foe, nor does anyone go scatheless from the wound he deals.)[27]

The playful tone of this meditation on love need not contradict the serious purpose of the genre. Propertius praises the 'marvellous hands' of the artist who first invented this picture of the God of love. The visible characteristics are so many metaphors of the nature of love, its childishness, its restlessness, its wounds. In a way they are the secret language through which the God himself makes his essence known to the initiate.

What is here implied is made more explicit in another famous epigram on an image, one which represents a being from the very twilight realm between divinity and abstraction, *Occasio* or opportunity. Both in its dialogue form and in its content this poem by Ausonius is a close imitation of a Greek epigram on *Kairos*, the right moment of time.

Whose is this work?—it is by Phidias, who made the statue of Pallas and also that of Jove. I am his third masterpiece; I am the goddess known to the few as Opportunity.— Why do you stand on a wheel?—Because I cannot remain in one place.—Why do you

wear winged sandals?—I am volatile. Whatever Mercury makes prosper I take away, if I like.

You cover your face with your hair.—I do not want to be recognized.—But why are you bald on your hindhead?—So that I cannot be held when I flee.—Who is your companion?—Let her tell you.—I ask you who you are?—I am the goddess whom not even Cicero named, the goddess who imposes punishment for what is done and not done so that regret follows, hence I am called Remorse.—So tell me how it is with you?—Wherever I fly she remains, they whom I pass by keep her and you also while you ask your questions and linger in conversation will find that I have escaped from your hands.[28]

Description and Definition in Medieval Art

The history of literature, of art and even of political propaganda and of pageantry in Europe would have been different without the heritage of this technique developed in antiquity. Most of all it appealed to the teacher and orator who could dwell on the characteristic of any idea or topic by means of a fictitious description. That most influential book of the late antiquity, The *Consolations of Philosophy* by Boethius, provided the model of the personification seen in a vision, Philosophy who comes to admonish and console the author:

... methought I saw a woman stand above my head, having a grave countenance, glistening clear eye and of quicker sight than commonly Nature doth afford: her colour fresh and bespeaking unabated vigour, and yet discovering so many years, that she could not all be thought to belong to our times; her stature uncertain and doubtful, for sometime she exceeded not the common height of men, and sometime she seemed to touch the heavens with her head, and if she lifted it up to the highest, she pierced the very heavens, so that she could not be seen by beholders; her garments were made of most fine threads with cunning workmanship into ever-during stuff, which (as I knew afterward by her own report) she had woven with her own hands. A certain duskishness caused by negligence and time had darkened her colour, as it is wont to happen when pictures stand in a smoky room. In the lower part of them was placed the Greek letter *Pi* and in the upper *Theta*, and betwixt the two letters, in the manner of stairs, there were certain degrees made, by which there was a passage from the lower to the higher letter: this her garment had been cut by the violence of some, who had taken away such pieces as they could get. In her right hand she had certain books, and in her left she held a sceptre.[29]

The passage not only illustrates the method of arousing curiosity through certain mysterious features which the reader has to ponder, it also explains why much of the method remained for a long time confined to verbal descriptions. The elusive character of the figure who seems to grow and shrink like Alice in Wonderland could not be represented; artists could do little more than show a matron with the ladder between the mysterious letters standing for practice and theory woven into her garment.[30] It was similar with that other passage from the *Consolations* in which Philosophy denounces the blind and fickle 'monster' Fortuna. It was only the peroration which crystallized into an image:

Endeavourest thou to stay the force of the turning wheel? But thou foolishest man that ever was, if it beginneth to stay, it ceaseth to be fortune.[31]

That vivid image of the Wheel of Fortune could be detached from the personification and show the instability of worldly life in diagrammatic fashion.[32] By and large personifications in medieval art are relatively unencumbered by attributes beyond those distinctive symbols they are made to display for the purpose of identification. Before the fourteenth century, in fact, the predominance of the word in medieval allegory is unchallenged. The inscribed diagram and the labelled figure were considered more effective than the purely visual embodiment of an idea. It was only towards the end of the Middle Ages that the potentialities of these elaborate illustrations were fully re-discovered and that still in a literary context.

Thus the English friar John Ridevall composed a moral treatise in which he used the 'images' of the ancient gods as starting points for the classification and definition of Virtues and Vices.[33] One extract must suffice to show the continuity of this typical medieval text with the ancient tradition briefly outlined above. Jupiter, for instance, stands in his system as the personification of Charity or 'Benivolencia', presumably because of the 'benevolence' of the 'Jovial' character. The distinctive features of his image are first enumerated in a little rhyme obviously destined for easy memorizing:

Of the poetic picture of Charity under the image of the God Jupiter we can say that Jupiter is painted in the following way

> He is horn-faced, in deserts placed
> With eagles laced, with palm leaf mazed,
> With gold veil graced
> His countenance bright, its colour light
> The thunder he grips, from a horn he sips.

These are the nine parts of the image of Jove to which correspond the nine properties of Benevolence and Love. For Jove is painted horned-faced, because he is painted with the head of a ram. And this is indeed well in accordance with the virtue of Benevolence and Love which virtue stands at the head as the first among the other virtues. For the Ram (Aries) is called after the Greek word Ares which in Latin means virtue. And thus the head of that virtue is ram-like (*arietinum*) to signify the excess of dignity and perfection which belongs to Charity in the rank of all other virtues, a dignity about which Augustine treats in various places such as 15. *De Trinitate.* . . .

The second part of the picture concerns the location of Jupiter. For the poets call him Amon, that is the sandy one (*arenosum*) whence the poets sing: 'This most powerful Jupiter is worshipped in the sands of Lybia, where there is a majestic temple dedicated to Amon, that is to Jove, as Lucanus mentions in his poetry.' And this belongs indeed to the essence of true Love and Benevolence that it should show itself in the place and time of need and hardship, for a friend in need is a friend indeed, as Cassiodorus says in his book *De Amicitia*.

Hence the sand is the place of adversity, for in the sand (arena) the gladiators used to fight among the ancients and kill each other, whence the place of true friendship is placed by the poets in the sands of the arena. Therefore Seneca says significantly in one of his epistles, that he is mistaken who looks for a friend in the halls of the mighty. Much could be added on this topic of what the scriptures say, as appears in Proverbs, Ecclesiasticus and elsewhere.

The third part of the picture concerns the way Jupiter is served. For the poets pretend that the eagle is the squire (*armiger*) of Jove, and therefore he is pictured by the poets as surrounded from all sides by eagles, as a great Lord used to be surrounded by his squires. In what way, however, this applies to Charity is beautifully shown by the authors. For we learn from Pliny's *Historia Naturalis* that at the sight or sound of the eagle all other birds are frightened and that all the birds which are birds of prey are so frightened that they stop hunting. Applying this, then, to the virtue of Charity Hugh of St. Victor teaches in his *Expositio super regulam beati Augustini* that the demons, which are occasionally referred to in the Scriptures as birds and the winged creatures of heaven . . . fear nothing more in people than charity. If we were to distribute all we have among the poor this the devil does not fear, for he himself possesses nothing, if we fast, he is not afraid, for he consumes no food, if we watch he does not dread it, for he never sleeps, but if we are bound in charity he is wholly terrified, for we keep here on earth what he refused to cultivate in Heaven. . . .[34]

However close this technique may come in its form to the tradition of explaining the mysterious images of the gods and of personifications in the light of moral theory, it is clear that the purpose and procedure in Ridevall aims at the opposite: he wants to construct an image of a god that would sum up and crystallize all the qualities of a Virtue that are discussed in moral theology. His picture is really no more than a pedagogic device to hold the definition together, each attribute becomes a 'peg' on which to hang a meditation on Benevolence.

It is most unlikely that Ridevall ever wanted his verbal picture translated into an actual image,[35] and indeed there is only one comparatively late attempt of such a translation (Fig. 147) in a fifteenth-century German MS of remarkably poor artistic quality. And yet it is hardly fortuitous that Ridevall and his more influential follower Robert Holcot favoured this pedagogic device of fictitious description. The reason has already been alluded to: it lies in the tradition of the 'art of memory' so brilliantly explored by Frances Yates.[36] In this technique, cultivated in the schools of rhetoric and among preachers, the student was enjoined to construct mental images of a striking and memorable nature which he should arrange in a permanent framework preferably represented by a familiar building. A ram-headed figure surrounded by eagles would be just the kind of image that would impress itself on the memory and would enable the preacher to enumerate the qualities of Benevolence in the context of a lengthy sermon. There was no need to have it actually painted, as long as the student learned to 'picture' it in his mind.

We all know the use of *versus memoriales* condensing the names of the Muses or

some grammatical rule into a simple rhyme. The reader can test the identical power of pictorial condensation in the accompanying illustration which sums up the astrological doctrine of the relation between the signs of the Zodiac and the parts of the human body (Fig. 144).[37] The relation, which had a bearing on the barbers' practice of bloodletting, was usually represented diagrammatically with lines connecting the zodiacal signs with their organic correlates. A drawing in a MS in Vienna fuses the signs with the human body (Fig. 145), turning, once more, the head into that of a ram, the arms become *gemini*, and so on down to the fishes, which form the feet. It is a picture which easily stays in the mind even though we may never want to apply this knowledge.

Small wonder, therefore, that attempts were made to translate the bizarre images 'pictured' in the writings of Ridevall, his follower Robert Holcot and other theologians into actual representations for edification and instruction. Two early fifteenth-century manuscripts of this kind were published and discussed in a fundamental article by Saxl,[38] who also showed how these inventions were taken up and spread by the new art of the woodcut. It is true that these humble craftsmen sometimes got their message muddled, but the monster representing the Seven Deadly Sins all rolled in one (Fig. 148) can still be deciphered through its antecedents: she stands on a ball to symbolize that same idea of instability that we know from Ausonius. Her head is crowned with peacock feathers, symbols of pride, she offers the chalice of greed, her breasts are unchastity, her heart is inhabited by a dog and another creature intended for Wrath and Envy, her belt filled with coins (though leaking) is Avarice, her left hand, hanging limp, is Sloth; a dragon is gnawing at the one leg on which she is perched so insecurely—the leg is the life of man and the dragon death.[39]

None other than Leonardo da Vinci used this kind of monstrous image for the exposition of a moral truth. With his love of intricacy and his scientific interest in problems of interaction he constructed pictographs which no iconologist could ever unriddle (Fig. 149) were it not for Leonardo's notes and the more detailed authentic exposition which Pedretti has identified in Lomazzo's text.[40] Its very complexity justifies full quotation.

Among the bodies which cannot exist one without the other, there is pleasure and displeasure, one a most beautiful youth with a face of fine and delightful appearance, with blond hair falling in ringlets, the other old, sad and looking mournful. They are painted together because one is never without the other, and they are back to back because they are such contraries. They are painted skilfully attached from behind by their shoulders to one body which joins their bodies from there downwards. And this is done to show that they have both the same foundation; for the foundation and origin of pleasure is effort linked with displeasure, while on the other hand the foundation and roots of displeasure are the vain and lascivious pleasures. Therefore one is painted with a reed in the right hand, which is empty and without fruit, precisely as pleasure is. In the right hand of

displeasure are placed a large number of caltrops to signify the sharp and poisonous wounds with which it stabs the heart, letting some fall on the ground on which it rests. But in the left hand pleasure holds a large number of coins in front of displeasure, some of which it lets fall on the ground, to show how displeasure lies in those mundane vanities which pleasure holds out to it, while displeasure in its turn holds in front of pleasure those arrowheads without which it cannot be born. In the left hand displeasure holds a branch of a bush with the thorns of roses, demonstrating that just as no rose ever grows without thorns, so it retains only the thorns while the roses, that is pleasure, wither. A stem of roses with thorns, therefore, can only signify that fragile pleasures are soon lost and that confidence in the present leads to troubles and heartaches. Furthermore the right leg of that body rests on a bundle of hay, the left one on a tablet of gold, to show their difference; one of the legs, that is the affect of worldly pleasure, is low, weak and soft; the other, that is the affect of displeasure, on the golden tablet, is firm, strong and hardened through pain like the arrowheads.

This monster is also painted on a bed, to allude to the various dreams of pleasure and displeasure which here come to us during the night, and to our wasting a large part of our lives here, spending much time particularly in the morning when the mind is clear and rested and the body ready for new labours, and altogether the many vain pleasures which are taken here by the mind, imagining impossible things or enjoying things in the body which are frequently the cause of its death.[41]

As an invention Leonardo's twin monster is as unique ih form and content as any of the master's creations, but the accumulation of attributes to the point of monstrosity has its parallels in the North, where the definitions and distinctions of scholastic teaching gave rise to a new imagery of bizarre and startling inventions. Thus the figures of Virtues, familiar as personifications since the time of Prudentius, were made to display in their attributes all the aspects that were customarily discussed in moral theology with reference to the authorities of Cicero, Macrobius and others.[42] Temperance is represented in what Emile Mâle called the *New Iconography* in a most unbecoming guise (Fig. 152) which is explained in the accompanying lines:

> Qui a l'orloge soy regarde
> En tous ses faicts temps garde
> Qui porte le frein en sa bouche
> Chose ne dict qui a mal touche
> Qui lunettes met à ses yeux
> Près lui regarde sen voit mieux
> Esperans mentrent que cremeur (creinte)
> Font estre le josne homme meur
> Au moulin qui le corps soutinent
> Nul exces faire n'appartient

(He who pays heed to the clock, considers time in all his actions. He who wears the bridle in this mouth, says nothing pertaining to evil. He who puts glasses to his eyes, sees more clearly things close to him. The spurs show that respect teaches manners to the young, and the windmill which supports her, shows that she is party to no excess.)[43]

What is remarkable in this invention is its modernity. Though the ideas and definitions it illustrates have been shown by Rosamund Tuve to go back over many centuries, the 'attributes' cannot. Clocks, spectacles and windmills are acquisitions of the late Middle Ages and even spurs did not exist in the ancient world.

Paradoxically it is this modernity which rendered the *New Iconography* so rapidly old-fashioned with the coming of the High Renaissance. The humanists remembered the kinship between personifications and the ancient gods, and just as the Olympians were restored to their ancient form and beauty, so the allegorical image had to appear in a classical guise. However much the sixteenth century admired the bizarre and the enigmatic, monsters such as those constructed by Leonardo would not have been easily acceptable. Even less would it have been possible to equip personifications with newly invented devices, for the appearance of an image '*all' antica*' had to be kept up. Both the form and the symbolism of the personification had to bear the stamp of ancient authority. The very first sentence of the standard encyclopaedia of Personifications, Cesare Ripa's *Iconologia* of 1593, formulates this principal rule which put both Leonardo's monster and the new Temperance out of court:

The images made to signify something different from what the eye can see have no briefer and no more general rule than the imitation of the records to be found in the books, the coins and the marbles of the artful Latins and Greeks or of the earlier peoples who invented this artifice. Hence it can generally be seen that those who labour without regard for this imitation err either through ignorance or an excess of pride, two blemishes much abhorred by those who strive for some recognition. . . .

Ripa and the Aristotelian Tradition

It is all the more interesting to see some of the classically draped figures of Ripa's illustrations revealed as medieval inventions. His allegory of *Amicitia* is a case in point (Fig. 150). Erna Mandowsky[44] has shown that it is based on one of Holcot's Moral 'Pictures' which was illustrated in so different a manner in an early fifteenth-century manuscript (Fig. 151):

Fulgentius tells in a certain book on the Deeds of the Romans (writes Holcot) that the Romans described true love or true friendship in the following way, that is that the image of Love or Friendship was depicted in the shape of a very beautiful youth dressed in green. His face and his head were uncovered and bare and in front of it was the inscription 'Winter and Summer'. His side was open so that his heart could be seen, inscribed with the words, 'Far and Near'. On the hem of his garment was written 'Death and Life'. Likewise the image had bare feet.

The story is expounded as follows:

The image was represented in the shape of a young man to signify that true love and

sincere friendship must never age and must therefore never fail in times of need but must always be rejuvenated and remain equally constant in the beginning and in the end.

The image was shown with its head and face uncovered to signify that true love and sincere friendship cannot remain for long hidden in the heart but come out into the open as St. Gregory says: 'The proof of love is in the demonstration of the works.'

The inscriptions 'Winter and Summer', that is, 'Adversity and Prosperity' signify that true friends must disclose to each other the secrets of their hearts and tell each other of all their needs.

And thus it is written in the heart: 'Far and near' to signify that the friend must be loved as much when he is far as if he were near.

It was written on the hem of the garment: 'Death and Life' to signify that true love and the sincere friend must be persevering not only in the present life but also in death which is symbolized by the hem.

The green garment indicates that friendship must always remain green and sweet and never cool off through length of time but remain evergreen like the ivy which clings to the friend at all times and everywhere inseparably.[45]

Ripa's picture, as we have seen, looks very different but his text is only a slightly more elegant paraphrase of Holcot, garnished with some classical detail.

Friendship

A woman clad in white, but coarsely, who shows almost her whole left shoulder and breast bare; with her right hand she shows her heart on which is written a motto in letters of gold as follows: LONGE, ET PROPE. And at the end of her garment there is the inscription: MORS, ET VITA. She is bare-headed and wears on her head a garland of myrtle and flowers of pomegranates wound together; on her forehead is the inscription: HIEMS, AESTAS. With her left hand she holds a withered elm surrounded by a green vine.

Friendship according to Aristotle is an unchanging manifest and mutual benevolence guided by virtue and reason among men who have something in common in their nature and their temperament. The white and coarse garment is the simple candour of mind by which true love can be told from afar and distinguished from all kinds of make-believe and artificial veneer.

Her left shoulder and breast are bare and her heart shows the motto 'Far and Near' because the true friend, be he present or absent from the person he loves always leaves his heart behind and even though times and fortunes may change he always remains the same, ready to live and die for his friendship and it is this which is indicated in the mottos inscribed on the garment and the forehead. But an insincere friendship can be seen to dissolve immediately like the slightest mist at the ray of the sun if even the smallest change of fortune occurs. The bare-headedness and the myrtle wreath with its flowers of pomegranates shows that the fruit of harmonious friendship and true union spreads the sweet scent of exemplary and honourable deeds and that without any of the vanities of empty display which so often hides flattery, the enemy of that virtue.

She is painted barefoot to show her solicitude or readiness to serve since one must not shun discomfort to help a friend; as Ovid shows in The Art of Love: Si rota defuerit, tu pede carpe viam. (Should you have no carriage, you must go on foot.)

Finally she embraces a withered elm surrounded by a green vine to make it clear that a friendship formed in prosperity must always last and that friendship must always come

first among our concern remembering that no friend can ever be so useless that he could not find a way in some manner to meet the obligation of friendship.[46]

Wearisome as the example may be, it still demonstrates an important point— the way in which Ripa's Iconology grew out of medieval didacticism. For Holcot the story of the ancient Roman image of love or friendship was no more than the starting-point for a moral homily on the nature of these virtues. The picture was less intended to be illustrated than to serve as an aid for the preacher's memory. It allowed him to explain and exemplify the commonplace that 'a friend in need is a friend indeed', not a 'fair-weather friend', but 'a man for all seasons'.

Clearly Ripa's text could also be read in this way. The personification serves as a reminder of all the qualities which must go into the definition of the concept.

Perhaps in this case the Abbé Pluche could still be forgiven if he objects that such an image cannot tell him anything he did not know before.[47] But there are other examples in Ripa more apt to demonstrate that his painted definitions tell us more than the mere name of the concept could. Take the picture of *Severity* (Fig. 153), which happens to have been added in a later edition.[48] To us 'Severity' is hardly a very desirable quality, but the image with its text informs us immediately that before the humanitarian revolution severity was a very positive notion and as such represented as 'an old woman, clad in regal habits and crowned with a laurel wreath'.

She is painted old, severity being a quality of the old, having as its object not to allow itself to be moved for any reason whatever, and having as its end gravity, not to give in to frivolity or vanity whatever the circumstances. She is clad in regal habits, because severity becomes royal personages and men of grand affairs. *Severitas regem decet, maiestatem praestat, dignitatem auget,* (severity suits a king, enhances majesty and increases dignity) as Francesco Patrizzi says in *De Regno,* Book 8, Chapter 6.[49]

And now the text proceeds to explain and justify the 'attributes' he proposes the figure of Severity should be shown with: 'She is given the laurel wreath to denote the Virtue and Grandeur that belong to Severity, for Emperors and illustrious, grave and severe men were crowned with laurel.'

The attributes, of course, amplify and refine the definition by providing further comparisons, metaphors or symbols (the words here are interchangeable) of the central concept:

She holds a cube in her left hand to demonstrate that just as the cube signifies firmness, because it stands firm on whichever side it is placed, (its parts being all in equal balance which other figures do not exhibit to the same perfection) so Severity is constant, stable and always of firm mind, persevering with one and the same purpose without swaying to one or the other side.

The bare dagger fixed in the middle of the cube signifies Severity to be a Virtue, in-

flexible with regards to the afflictions of pain if right reason so demands it, as St. Thomas says, *Summa Theol.* II/2, qu. 157, art. 2.

She holds in her right the sceptre with a commanding gesture, since severity is nearly always true, for it is meet for Judges and Kings who wield the sceptre and rule that their words must always be true, constant and immutable, as Francesco Patrizzi says in the eighth book of *De Regno*.

At her side is placed a tiger, since that animal is by nature ferocious and will not allow itself to be governed by anybody. In the same way Severity does not yield to prayers nor to any other acts, aiming, as it does, not to degenerate in any way from its natural disposition, about which we read in Vergil's Aeneid 4: '*Mens immota manet, lachrimae volvuntur inanes.*'[50]

Ripa himself has tried in his Preface to explain the principles underlying this method of visual definitions. As a cook or caterer at the courts of the mighty he was not a trained thinker, but he does his best to bring his method within the orbit of Aristotelian Logic and Rhetoric. From the Logic he derives the technique of definition, from the Rhetoric the theory of metaphor.

Let us remember first that for Aristotle definition is closely connected with classification. For him the structure of the whole world resembles the structure of the Animal Kingdom, which we still classify in his way according to *genus* and *species*. Thus both the species of the lion and of the cat belong to the *genus felis*, which is part of the family of mammals. Man, in Aristotle's famous definition, is an animal, but of a special kind, *i.e.* a rational animal, rationality here being the *differentia specifica* that distinguishes man from other animals. In the same way 'three' can be defined as belonging to the *genus* of numbers but within that *genus* there is the narrower *species* of odd numbers and the still narrower one of prime numbers.[51]

The task which Ripa has thus set himself is to devise a method of visual definition which corresponds to this procedure of systematic subdivision. To do so he first explains what classes of concepts he is concerned with. He is primarily interested in the representation of moral concepts (such as Friendship or Severity), because the world of nature, 'the processes of generation and corruption and the disposition of the heavens', do not, in his opinion, stand in need of a special visual vocabulary, since they have been adequately symbolized from time immemorial by the images of the gods and the illustrations of myths.[52] He also wishes to exclude from his task the pictographic rendering of propositions 'which assert or deny', for these belong to a different art, that of the *imprese* which will still engage our attention.

The category of images which . . . are the subject of this discourse . . . corresponds to the definition . . . which can conveniently be expressed by means of the human figure. Because just as man is always a particular man in the same way as a definition is the measure of the defined, so the accidental form which appears external to him can be the accidental measure of the qualities to be defined. . . .

What Ripa tries to say in his scholastic terminology is simply that the *genus* of his abstract concepts is best signified by a human figure, because human figures can be so easily characterized and subdivided by what he calls 'accidents',[53] that is to say by the many qualities and characteristics we find in human beings. Each of them can be used as a defining or distinctive feature—marking off the concept of Friendship from that of Severity or Fortuna.

But how are we to account for the fact that the same concept can be represented in so many different ways, as Ripa himself was anxious to demonstrate in his book? We are referred to Aristotle's distinction of four types of definition, corresponding to his four types of causes, the material, the efficient, the formal and the final. The deviser of visual definitions is equally free to characterize a concept according to any of these approaches, illustrating, say, the cause or the effect of Friendship.

When, by this method, we have become distinctly aware of the qualities, the causes, the properties and the accidents of a definable concept on which the image can be based, we have to look for the similitudes that exist between these concepts and material things and which function as substitutes for the words as used in the images and definitions of the orators.

It is here that Ripa draws on Aristotle's theory of metaphor[54] as expounded in the *Rhetoric* and the *Poetics*. We have seen that the 'attributes' can indeed be interpreted as illustrated metaphors, the cube standing foursquare being an apt image for Severity just as a revolving wheel is a suitable simile for the fickleness of Fortune.

Among Aristotle's classes of metaphors there is one called 'metaphor of proportion', as when the cup is called the shield of Bacchus or the shield the cup of Mars. Clearly the shield is to Mars what the cup is to Bacchus and so we can take the one for the other. Ripa is anxious to make his attributes fit this kind of metaphor, explaining for instance, that the column may be used to characterize the concept of Strength, for the column is to a building what strength is to man. He prefers this method to the simple comparison as when Magnaminity is symbolized by a lion 'because in the lion this quality is largely found'.

Both procedures, however, are admissible because both define 'essential' qualities of the concept. What is inadmissible in his view, is to concentrate entirely on 'contingent qualities' as when Despair is represented by a man who has hanged himself[55] or friendship by two people embracing each other. These, he implies, are illustrations of particular events and thus lie outside the realm of definition. True, within the definition such 'accidental' features are allowed and even welcomed. Melancholy would clearly have to show different physiognomic characteristics from Joy. However it would be a mistake to represent Beauty simply by an image that is supremely beautiful, 'for this would merely be explaining *idem*

per idem'. He has therefore represented Beauty with her head in the clouds and 'similar corresponding particulars'.

The whole tenor of Ripa's preface makes it clear that for him the art of devising personification belongs—as he would have said—to the *genus* of rhetorical devices. Some images 'persuade through the eye, others move the will by the use of words'.

If questioned he might have appealed to the old pedagogic tradition which insists that demonstration *ad oculos* has a more lasting effect than any verbal instruction.[56] It is summed up in the famous lines from the *Ars Poetica* of Horace

> segnius irritant animos demissa per aurem
> quam quae sunt oculis subiecta fidelibus.

(What enters through the ears stirs the mind more feebly than what is placed before the trustworthy eyes.)

In all these respects, therefore, Ripa's approach can easily be fitted into the Aristotelian framework. But there is one motive which cannot be so readily reconciled with this rational purpose—it is his attitude to ancient tradition. We have encountered it in the opening of his book, and Ripa returns to it at the end of his Introduction where he traces back his art to the 'abounding wisdom' of the ancient Egyptians. He compares the method of devising images to a sage who had dwelt naked in the desert for many years but puts on fine garments when returning among the people so that the splendid exterior should attract them to a splendid soul. Pythagoras had learned this skill of dressing up wisdom from the Egyptians and so had Plato; had not even Christ clothed His wisdom in Parables?

Thus the wisdom of the Egyptians was like a man repellent and badly dressed whom experience taught to adorn himself, since it was wrong to hide the indications of hidden treasures, so that all who make an effort could achieve a degree of happiness. This dressing up signified the composition of bodily images in colour in a great variety of proportions with fine attitudes and exquisite *finesse* . . . so that there can be no-one who is not moved at first sight by a certain desire to investigate the reason why they are represented and arranged in this particular manner. This curiosity is even strengthened by seeing the names of the things written under these Images, and I think the rule of writing the names underneath should be always observed except when a king of Enigma is intended, for without knowing the name it is impossible to penetrate to the knowledge of the signification except in case of trivial images which will be recognized by everyone thanks to usage.

It will be seen from these words that Ripa wavers in his attitude. Having insisted at first that it is a rule of the game not to use any attributes which cannot be documented from ancient authority, he ends somewhat lamely by tracing not the individual symbols but merely the art of symbolism to the ancient Egyptians. For the historian it is easy to see why Ripa found it hard to rationalize the need for ancient

authority in the devising of symbolic images. This, as we shall see, was an echo of the Neo-Platonic doctrine of the Hieroglyph which had come to rival the scholastic Aristotelian doctrine represented by Ripa. It is in Giarda's speech that we shall find the more articulate explanation of this link between the esoteric tradition and *Icones Symbolicae.*

<p style="text-align:center">III</p>

NEO-PLATONISM:
GIARDA AND HIS ANTECEDENTS

By the year 1626, when Christophoro Giarda composed his speech in praise of Personifications, no less than eight editions of Ripa's best-selling handbook had appeared in the 33 years of its existence. He obviously knew the book and probably valued it highly. Indeed his technique in expounding the attributes of the sixteen personifications of Liberal Arts follows that of Ripa so closely that not much purpose would be served in quoting and analysing these explanations of very undistinguished images at length. Even in his introductory eulogy Giarda can be seen to pick up motives from the conclusion of Ripa's introduction that has just been quoted. But here the difference is noticeable. Spurred by the occasion that demanded a setpiece of 'epideictic' oratory, Giarda knew how to exalt the special character of visual images in terms which immediately introduce us into a different intellectual atmosphere.

'Before the invention of symbolic images [he tells us], the arts and sciences went about as strangers and pilgrims in the habitations of men. No-one could have known them by appearance, hardly even by name—mentioned again and again, sometimes as the nomenclature of a philosophic school, sometimes of a department of learning and other studies, but hardly pronounced they had vanished like a shadow. Nor could any-body have kept any record of them in his mind (save the learned, whenever indeed it might engage them) had not this heavenly institution of expression through Symbolic Images fixed the most noble nature of these arts more clearly in the eyes and minds of all and had not the demonstration of their sweetness aroused the eager study even of the unlearned. For, by the faith of heaven and of man, is there anything which could demonstrate the power of these excellent faculties more convincingly, which could serve as sweeter recreation and move us more profoundly than this very learned use of Symbolic Images with its wealth of erudition?

The other modes of demonstration which might be mentioned in great numbers are not devoid of virtue, but they all require a very acute intelligence to be understood. The Symbolic Images, however, present themselves to contemplation, they leap to the eyes of their beholders and through the eyes they penetrate into their mind, declaring their nature before they are scrutinized and so prudently temper their humanity that they appear to the unlearned as masked, to the others however, if they are at least tolerably

learned, undisguised and without any mask. How pleasantly they perform this, Sweetness herself, if she could speak, could hardly describe.'

For first every image and likeness, whether framed in words or expressed in colours, has this quality that it greatly delights hearers and spectators. Hence we find that the wisest of poets and orators to whom it was given to mix in their speech sweetness with usefulness are often using poetical and rhetorical images. Furthermore the greatest amount is added to our delight if this image is of a person or object which is most dearly beloved by us—for then it functions, as it were, vicariously and we tacitly accept it instead of what is absent. Finally, were it not for the fact that images are to the greatest extent endowed with the power of rousing the mind of those who behold them to love and emulation of what they represent, would the Greeks or the Romans, the wisest of all nations, have filled their public and private edifices with the images of their most outstanding men? Or would the members of ruling houses who have marriageable daughters send their carefully worked portraits to other princes?[57]

Superficially there is nothing in the passage quoted that would as yet indicate that Giarda regards his *Icones Symbolicae* as more than pedagogic devices to impress the ideas and definitions of the arts onto the minds of students. But the emphasis on love as a spur towards the apprehension of a higher truth points to the tenets of Platonism.

The Platonic Universe

There was, of course, no sense of incongruity for a theologian in falling back on this element in Christian thought. For Christianity had inherited from Platonism an essential argument in the justification of Symbolism—what might be called the doctrine of the two worlds. Our world, the world of the senses as we know it, is in this interpretation no more than an imperfect reflection of the intelligible world, the world of the spirit. In one of his many attempts to explain this foundation of his doctrine Plato also provides a first adumbration of the need for symbolism. The myth told in the *Phaedo* is in itself a beautiful illustration of the use of the symbolic mode. It is the passage where Socrates explains in his last hour that we do not really live on the surface of the earth, facing the purity of heaven, but somewhere underneath:

We do not perceive that we live in the hollows, but think we live on the upper surface of the earth, just as if someone who lives in the depths of the ocean should think he lives on the surface of the sea, and, seeing the sun and the stars through the water, should think the sea was the sky, and should, by reason of sluggishness and feebleness, never have reached the surface of the sea, and should never have seen, by rising and lifting his head out of the sea into our upper world . . . how much purer and fairer it is than the world he lived in. Now I believe this is just the case with us; for we dwell in a hollow of the earth and think we dwell on its upper surface; and the air we call the heaven, and think that is the heaven in which the stars move . . . if anyone should come to the

top of the air or should get wings and fly up, he could lift his head above it and see, as fishes lift their heads out of the water ... so he would see things in that upper world; and if his nature were strong enough to bear the sight, he would recognize that that is the real heaven and the real light and the real earth. For this earth of ours, and the stones, and the whole region where we live, are injured and corroded, as in the sea things are injured by the brine, ... and there is ... nothing perfect there ... but the things in that world above would be seen to be even more superior to those in this world of ours.[58]

In explaining the perfection the denizens of that upper world enjoy, Socrates once more takes recourse to what might be called illustration by proportion: 'What water and sea are in our lives, air is in theirs, and what the air is to us, ether is to them.'

Socrates, moreover, makes it clear that his description itself is no more than an adumbration of the truth that cannot be told in earthbound terms. For as we also know from Plato, 'discursive speech' is altogether an inferior tool for the revelation of truth. Those who can rise up to the intelligible world can there apprehend the truth directly, in a flash, without the need of words and arguments. These crutches of dialectical reason can and will be discarded in the realm of the ideas, the realm of pure spirit, to which the poet, the seer and the lover aspire.

In the words of St. Paul which enshrine this teaching for the Christian world: 'For now we see through a glass, darkly, but then face to face; now I know in part; but then I shall know even as also I am known.'[59]

This doctrine of the two modes of knowledge is the correlate of the doctrine of the two worlds. Those who dwell in the world above are not imprisoned in the body; they see what we can only reason out. Thus seeing becomes by virtue of its speed and immediacy a favoured symbol of higher knowledge.

It is well known that Plato himself was anxious not to have this higher sight confused with the deceptive reports of the senses, and that he rejected art for the very reason that it pandered to these lower reaches of the soul. The paintings of his time appeared to him no better than conjuring tricks.[60] But it was different with the ancient images of the wise Egyptians. Their immutable forms and traditions obviously did not deserve the same strictures, for they embodied changeless wisdom. And though Plato never says in so many words that they were therefore closer to the intelligible world of ideas, he certainly made them appear so.

In any case it is through intellectual intuition alone that the Ideas which dwell in the suprasensible world can ultimately be grasped. And in whatever form Plato imagined them—if he pictured them in any form—it may be natural that they began to be visualized in terms of those personifications of abstractions which anyhow had been conceived as the companions of the immortals.

It may not be easy to say when and where this fusion began, but it is well advanced in the writings of the Neo-Platonists and above all in those of the

Christian Gnostics. The idea of Wisdom, Sophia, becomes in the Gnosis a female spirit capable of being seen in a vision.[61] In fact the Neo-Platonic conception of the hierarchy of beings which links the idea of the Godhead with the sensible world in an unbroken chain of beings could readily absorb the Platonic ideas and allot them a place in the supra-celestial spheres. There was nothing in this vision which Christianity could not accept, and so St. Augustine makes the Platonic ideas dwell in the mind of God.

The Christian Interpretation

In one respect, of course, the Christian doctrine differed more radically from the Platonic tradition. In Plato himself there is certainly no hint that the higher world wishes to be known by us dwellers in the dark. It is we whose longing is aroused by the reflections of the higher world we discover in this life. It is true that in Neo-Platonism the Goodness of the One and All wells over, as it were, and sends down its emanations along the chain of beings, but even here the higher does not actively communicate with the lower.

It was Christianity that thus linked the two worlds through the mystery of the Incarnation and the doctrine of Revelation. The Logos became flesh and God speaks to man not only through the Scriptures, but through the whole of Creation and the whole of History. Symbolism, as we read in Giarda, is this form of Revelation that God in His mercy created to make the Ideas that dwell in His mind known to Man:

In the rich mind of the Godhead there flourished, ere the memory of centuries began, there still flourish and will continue to flourish as His daughters, yet not distinct in any way from their mother, the fairest Virtues, Wisdom, Goodness, the effective Power of things, Beauty, Justice, Dignity and all the rest of this kind. They were all most worthy to be much known and beloved. And yet, because of the exceeding radiance of their nature they could not be known and thus, unknown, they could not be loved in any way. What, then could God, their Father, do? It was not fitting to allow such illustrious daughters to remain for all Eternity secluded with Him in the light, separated and far removed from the notice of man. But how could he bring them to the notice and before the eyes of mortals when the outstanding radiance of the Divine virtues on the one side, the dullness of our understanding on the other was such a great obstacle?

He spoke—and with a word all the elements, and within the elements all the species of things, all the animals on earth, all the kinds of fish in the water, all the variety of birds in the air, all the prodigies in the fiery sphere, all the stars in heaven and its lights—these He turned into so many Symbolic Images, as it were, of those perfections and made and designed them all at once and presented them in the Library of this Universe, or if you prefer so in this theatre, to the contemplation of man.

Let them go, then, the mortals, let them only ask, and deny, if they can, that the easiest access to the contemplation of Things Divine is open to them, when all things, which can be perceived by the senses are the images of those, imperfect, it is true, but yet

sufficiently suited to infer from their appearance and operation the dignity of Divine matters.[62]

What Giarda here expounds may be called the doctrine of multiple revelation. God reveals Himself in everything, if we only learn to read His signs. Earlier in this volume[63] I have alluded to this doctrine of the meaning of things in connection with Biblical exegesis. The divine language of things differs from the language of words as being both richer and more obscure. Giarda had the authority of this tradition to claim that 'all the animals on earth, all the fish in the water, all the birds in the air' etc. together form the book of Nature which, rightly read, confirms and supplements the Scriptures. The Pelican pre-figures Christ and His Charity, the Pearl the Virgin birth. It is important to realize the potentialities inherent in this tradition. A thinker of Aristotelian schooling might interpret it rationally by recommending the Pelican as a suitable *metaphor* for Christ. But the Neo-Platonist could at any time revive the popular conception which presupposes the idea that God Himself pre-figured and represented His Charity in the habits of the Pelican.

What goes for the Book of Nature also goes for the mythological lore of the past. The Middle Ages had inherited the view from late Antiquity that, rightly understood, the fables and myths of the poets must yield up the same meaning as the contemplation of nature.[64] Those who accepted this belief had no intention of minimizing the value of the Bible as the chief instrument of Divine revelation. On the contrary. They were convinced that the pagan lore could only hide the same truth which God had made manifest through the Scriptures. For God had not only spoken to Moses. The first men in the Golden Age had been so close to the act of creation that they had still known the secrets of the universe. But these sages of the mythical past had hidden the truth in mysterious tales and images to prevent it from being prematurely profaned.

Something of this belief still lingers as an undercurrent of European thought. We are familiar with the doctrine of an esoteric tradition which reaches back to the mysterious origins of time and which is both revealed and concealed in the Wisdom of the East. The writings of the Florentine Neo-Platonists belong to this current of thought. Those who expect there to find the serene world of classical beauty will soon be disappointed. We are constantly referred to the mythical sages of the East, to the Egyptian Priests, to Hermes Trismegistos, to Zoroaster, and, among the Greeks, to those who were believed to have been in possession of this secret lore, to Orpheus, to Pythagoras and last but not least to Plato, whose use of myths and whose reverence for Egypt fitted in well with this picture of an unbroken chain of esoteric tradition.[65]

Giarda, as we shall see, is careful not to detach this tradition wholly from the Christian Revelation. He chooses for his account the story from Josephus, according to which pre-Lapsarian Adam or Seth had written down all knowledge before the

Flood on two indestructible pillars, from which the Egyptians derived it; they in their turn, taught it to the Greeks.[66] Thus the language of symbolism is as directly derived from God as is the language of the Scriptures:

This arcanum was understood from the beginning of the nascent world by the wisest men of the primal age and it was from them that first this usage of forming these images derived, having been handed down through all the intervening centuries through nearly all literatures and finally to our own age. Who, well versed in antiquities, does not know of the memorable two columns, one made of brick to resist fire, the other of marble to resist water, on which all the arts were depicted and engraved so that they could be transmitted to future generations?

For from these the Egyptians borrowed the excellent doctrine of the hieroglyphs which we admire so much. The Greeks followed in their footsteps and left no Art or Science unadorned by Symbolic Images. What kind of stone or metal is there in which they did not express the forms of the sciences? What shade or colour which they omitted in their representation? It was no thing to be relished by vulgar erudition but one whose singular majesty filled them with ineffable delight.[67]

Philosophically it should be clear why the Christian Platonist had to lay such stress on this interpretation of symbolism as a code derived from God and handed down in history: In the Platonic interpretation of symbolism the symbol is the imperfect reflection of the higher reality which arouses our longing for perfection. In Plato, of course, this longing is explained by the doctrine of reminiscence; we had seen perfection before our soul was banished into the body, and once our memory of this higher state is revived the soul embarks on its quest for its true home. Christianity debarred the philosopher from fully accepting this central view of Platonism according to which all knowledge is reminiscence; since God creates every soul on conception there is no place in its world picture for the *anamnese* of former states. Those who wanted to remain Platonists, therefore, were more or less driven to replace the memory of the individual by a theory of the memory of mankind. It was mankind that had enshrined in the traditions of symbolism the memories of that knowledge God had vouchsafed Adam before the Fall. The only other source of knowledge was through revelation in the Scriptures. In the Scriptures, too, God spoke to us not only directly but also through symbols and these symbols, rightly read, still revealed a Platonic or rather a Neo-Platonic Universe.

Dionysius the Areopagite

The text or texts that mediated this transition from Platonism to Christianity were the writings claiming the authority of Dionysius the Areopagite, a pagan philosopher said to have been converted by St. Paul's sermon in Athens.[68] Thus the ideas of late antique Neo-Platonism achieved entry into Christian theology. It was in the

light of pseudo-Dionysius's commentaries on the Celestian Hierarchies that Revelation was studied and the twin functions of symbolism were established which lastingly influenced Western thought on these matters.

At the outset of the Commentary the Areopagite defends the Sacred Scriptures against the accusation of having used a gross and inappropriate symbolism for the revelation of spiritual truth. There are two ways of approaching the Divine. Through affirmation (*kataphasis*) and negation (*apophasis*).[69] Revelation makes use of both ways. It represents spiritual entities by way of analogy through such dignified concepts as Logos or Nous or through the image of Light. But there is a danger in this kind of symbolic language. It may lead to the very confusions the religious mind must avoid. The reader of the Scriptures might take it literally and think that the heavenly beings are really 'god-like men, radiant figures of transcending beauty, clad in shining robes . . . or similar figures through which the Revelation has given a sensible representation of the heavenly spirits'.[70] It is to avoid this confusion that the holy authors of the revealed writings have deliberately used inappropriate symbols and similes so that we should not cling to the undignified literal meaning. The very monstrosities of which they talk, such as lions and horses in the heavenly regions, prevent us from accepting these images as real and stimulate our mind to seek a higher significance. Thus the apparent inappropriateness of the symbols found in the Holy Writ is in effect a means through which our soul is led on towards spiritual truth. To the profane these enigmatic images conceal the holy arcanum of the supernatural; to the initiate, however, they serve as the first rung of the ladder through which we ascend to the Divine.

The Two Ways

There is a certain ambivalence towards the symbol in this interpretation, which remained potent in the tradition of the Western world. The analogical symbol, at least, has its dangers if it leads the mind to take the reflection for the reality. In the rational thought of the Latin Church these dangers are often stressed, lest the fusion between image and prototype leads to idolatry or at least to that kind of image worship which became such an issue in the Eastern Church. According to the famous pronouncement of Pope Gregory I images are permissible only to teach the illiterates the Sacred Word. Strictly speaking, care should be taken that they are never taken for more than pictographs.

A document from post-Reformation Italy shows how sensitive people had become to this danger from visual representation through the revival of iconoclastic movements in the Protestant North.

Referring to his conflict with the confraternity of Santa Maria della Steccata in Parma, Giulio Romano writes in 1541:

I have also heard that I have been blamed for having painted God the Father, Who is invisible. I answer that outside of Christ and the Madonna, who are in Heaven with glorified bodies, all the rest of the Saints and Souls and Angels are invisible, and yet one is used to paint them, and to your Lordships it would not be new that paintings are the scriptures of the vulgar and ignorant. . . .[71]

Is the figure of God the Father then purely a conventional sign, like the letters of the alphabet? It was certainly possible to adopt such a radical view, but it was not necessary if you followed Dionysius and other exegeticists. For the symbols of the Bible are not 'conventional'. If the Holy Spirit after Christ's Baptism was seen 'like a dove', it was this form that the Holy Ghost had assumed. The same, of course, must also apply to the appearance of God the Father, the Giving of the Laws or the Vision of Ezekiel. These are theophanies in which God Himself chooses the form in which He wishes to appear to man. In a wider sense the whole of the Scriptures can be interpreted as such a theophany, the images and words through which the Divine makes its nature known. It is to this language of the Divine, then, that Dionysius' analysis should really be applied.

There are two contrasting ways in which God speaks to man in symbols: either representing like through like or like through unlike. The result in our terms is either Beauty or Mystery. Both these qualities are or can be a token of the Divine.

Not that the two are mutually exclusive. No reader who has followed Dante's ascent to the climax of the Beatific Vision is likely to forget both the beauty of this vision and its unfathomable and ineffable mystery. What Dante saw was both like and unlike the Divine presence—a radiant enigma.

But for the purpose of exposition it may still be helpful to distinguish between the two ways of the Areopagite, that of symbolizing the higher world through the analogies of beauty, light and gold, and the apophatic way of mysterious monstrosity.

Analogical Symbolism

Both these conceptions were discussed and applied by the leaders of the Neo-Platonic revival in Florence. In the philosophy of Pico della Mirandola that image of the three worlds we saw Socrates apply as an adumbration of an ineffable truth becomes almost a description of the layered Universe of the Neo-Platonists. The Universe in this conception is a vast symphony of correspondences in which each level of existence points to the level above. It is by virtue of this interrelated harmony that one object can signify another and that by contemplating a visible thing we can gain insight into the invisible world. In his commentary on the opening chapters of the Bible, the *Heptaplus*,[72] Pico applies the methods of Dionysius's exegesis systematically to his doctrine of three worlds, the terrestrial, the celestial

132. MAULBERTSCH: *Allegory of The Progress and the Fruits of Science*. Ceiling of the Library,
Monastery of Mistelbach (Austria), 1760

SACRA THEOLOGIA

RHETORICA

133–134. *Sacra Theologia*; *Rhetorica*. Engravings from C. Giarda, *Icones Symbolicae*, Milan, 1626

HISTORIA

MATHEMATICA

135–136. *Historia*; *Mathematica*. Engravings from C. Giarda, *Icones Symbolicae*, Milan, 1626

137. DELACROIX: *Liberty Leading the People*. Paris, Louvre

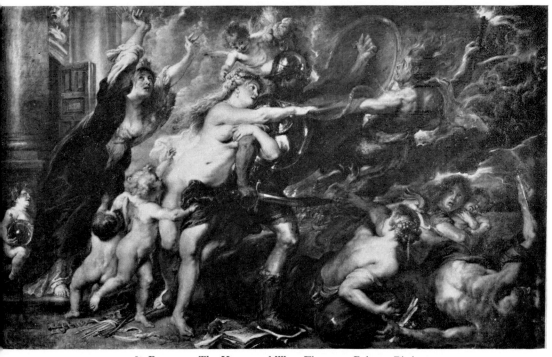

138. RUBENS: *The Horrors of War*. Florence, Palazzo Pitti

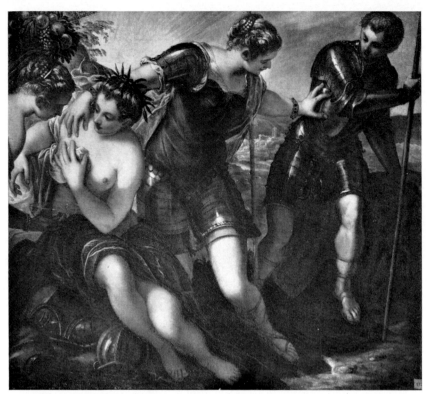

139. TINTORETTO: *Minerva Restraining Mars*. Venice, Palazzo Ducale

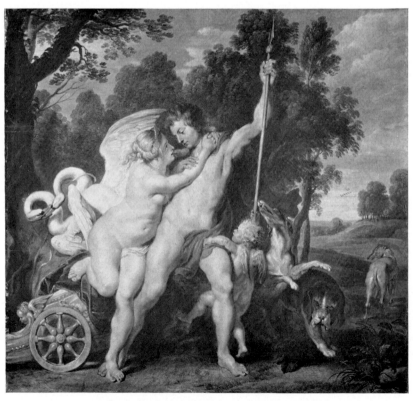

140. RUBENS: *Venus and Adonis*. Leningrad, Hermitage

141. Trees of Virtues and Vices. From *De Fructibus carnis et spiritus*. Salzburg, Stadtbibliothek. 12th century. MS. Sign. V. 1, H. 162, fol. 75v. and 76r.

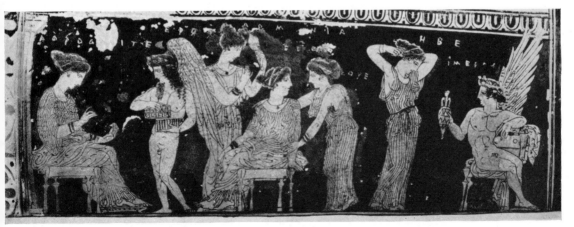

142. *Aphrodite and her Companions*. Epinetron by the Eretria Painter. Athens, National Museum

143. *Six Petrarchan Triumphs* (Love, Chastity, Death, Fame, Time, Divinity). Florentine 15th-century engraving. London, British Museum

147. *Jupiter*. From *Fulgentius Metaforalis*. German 15th-century MS. Vatican Library, MS. Palat. 1066, fol. 224

144–145. *Zodiac Man*. Shepherd's Calendar, 1503, and Vienna, Nationalbibliothek, Cod. 11182

146. *Pudicitia and Libido*. From an 11th-century illustrated Prudentius manuscript. London, British Museum, MS. Add. 24199, fol. 6r.

148. *Sin.* German 15th-century woodcut.
London, British Museum

149. LEONARDO DA VINCI: *Allegory of Pleasure and Pain.* Drawing. Oxford, Christ Church Library

150. *Amicitia.* From C. Ripa, *Iconologia*, 1603, p. 16

151. *Amicitia.* Early 15th-century MS.
Rome, Biblioteca Casanatense

152. *Temperance*. Paris, Bibliothèque Nationale, fonds français 9186, fol. 304

153. *Severity*. From Ripa, *Iconologia*, 1645, p. 568

154. RAPHAEL: *The Sistine Madonna*. Dresden, Gallery

155. LANFRANCO: Frescoed cupola of S. Andrea della Valle, Rome, 1621

156. ROTTMAYR: *The Transfiguration of St. Benedict*. Melk Monastery (Austria), 1716

157. SACCHI: *Divina Sapientia*. Engraving in H. Tetius, *Aedes Barberinae*, Rome, 1642

158. RAPHAEL: *The Vision of Ezekiel*.
Florence, Palazzo Pitti

159. *Cominus et eminus.* From Bargagli, *Imprese,*
1589, p. 44

160. *Per te surgo.* From Bargagli, *Imprese,*
1589, p. 266

161. *Ut quiescat.* From Camilli, *Imprese Illustri,* 1586, p. 16

162. *Livor ut ignis alta petit.* After Cousin, *Liber Fortunae*, 1568, no. 86

163. *Hinc clarior.* From Ruscelli, *Imprese Illustri*, 1566, p. 363

164. *Semper festina lente*. Woodcut from the *Hypnerotomachia Poliphili*, 1499, fol. d vii r.

165. The Three Worlds within the World. *Geheime Figuren der Rosenkreuzer*, Altona, 1785

166. 'Mönchskalb.' From a
pamphlet by Luther, 1523

167. Reverse of a coin of Augustus. From Montfaucon,
Antiquité, 1719, iv, pl. 23

168. *Touch, Imagination, Understanding, Invention.* From George Richardson,
Iconology. A Collection of Emblematic Figures, vol. 1, 1779, pl. 28

169. BLAKE: Engraving of the Laocoon group, c. 1820

170. Cover design of the posthumous edition of Beethoven's piano music published by Tobias Haslinger

and the supracelestial, all of which reflect each other and all of which are mirrored in the 'small world' which is man.

> Everything which is in the totality of worlds is also in each of them and none of them contains anything which is not to be found in each of the others . . . whatever exists in the inferior world will also be found in the superior world, but in a more elevated form; and whatever exists on the higher plane can also be seen down below but in a somewhat degenerate and, so to say, adulterated shape. . . . In our world we have fire as an element, in the celestial world the corresponding entity is the sun, in the supracelestial world the seraphic fire of the Intellect. But consider their difference: The elemental fire burns, the celestial fire gives life, the supracelestial loves.

This is the method of analogy we remember from Plato. But the purpose and status of symbols is yet subtly transformed through the influence of Christianity. In Plato light and beauty are also reflections of the Divine. The earthly love kindled by earthly beauty is the lowest rung of the ladder that leads the soul upwards to the contemplation of Beauty as such. In Pico this doctrine of analogy is systematized and generalized. Everything in the higher world can be grasped through its lower counterpart in this world. All we have to do is earnestly to study the tradition in which this code was preserved for our use.

> The ancient fathers could not have represented one image by another, had they not known the occult affinities and harmonies of the Universe. Otherwise there would have been no reason whatever, why they should have represented a thing by one image rather than by an opposite one.[73]

We have seen that Giarda subscribed to this view of the importance of tradition, and he makes it amply clear that he also subscribed to the interpretation of the symbol as a grosser material form of an invisible entity: The ideas in the Mind of God would either elude or dazzle us. It is through the admixture of grosser matter that they become visible.

> Just as fire, when it is nourished by grosser matter, can be seen, but when it returns to its proper abode it eludes, by its purity, the power of human vision, so the most noble Arts and Disciplines, as abstracted from the senses, are less apprehended by us the clearer they become in themselves; but made concrete by some medium accommodated to our minds, through the excellent admixture of colours, they can be grasped more easily. . . .[74]

Not only grasped, but loved. For Giarda shares the Platonic faith in the power of Love to lead to Cognition.

> For Love embraces Cognition as a blood-relation who will never bring forth the fairest offspring of love in any mind unless she be wedded in intimate union to the beautiful and the good. What, however, was wrought more beautifully by Nature or created as a greater good by God immortal than the very Virtues and Sciences? If only they could be seen by human eyes as other things they would truly kindle such amazing love for themselves

in all hearts that all men would spurn lust, forget the craving for power, quell their desire for riches and would flock together to pursue them.

Now, however, the Sciences, the rulers and queens over all fields of knowledge and the judges and arbiters of all actions, although, by their nature, they not only outshine with their light the minor stars but would even dim the sun by comparison, can nevertheless not be seen by the human mind, enclosed as it is, in the night-like dwelling of the body, as it could not sustain their immense radiance without turning away the eyes. For the mind is the eye of the soul. . . .

For all the wisest men are agreed that it is impossible to love what cannot be apprehended either by reason or by the senses. As nothing can be apprehended by the senses that is not somewhat corporeal, nothing can be understood by our mind in its depressed condition that has not the appearance of a body. Who, then, can sufficiently estimate the magnitude of the debt we owe to those who expressed the Arts and Sciences themselves in images and thus achieved it that we can not only know them but look at them, as it were, with our eyes, that we can meet them and almost converse with them about a variety of matters?[75]

Giarda's hyperbolic language should not blind us to the importance of his views for the student of art. Classical Platonism, as we know, had spurned art. It is true that Neo-Platonism had mitigated this position, but so far the influence of this tradition has mainly been studied in connection with a new aesthetics. We are familiar since Panofsky's famous history of this current with the development of the artist's claim to see beyond the dross of matter and to apprehend that Beauty that dwells in the intelligible world.[76]

Giarda reminds us that this claim need not necessarily lead to the autonomy of art. The artist's power could be harnessed to the mission of the Church, if his images could not only convey knowledge to the illiterate but arouse Cognition through Love. For whatever the warnings of the Areopagite, no man of ordinary devotion would surely doubt that the heavenly realms of the intelligible world were of surpassing beauty. Wherever the Divine had revealed itself in a vision, whether to the prophets, to Saints or to poets such as Dante, beauty and radiance was of the essence of the experience. Even though the theologians of the Tridentine Council steered clear of this issue, the artist's prophetic powers to see beauty could, if rightly guided, help the faithful to see the spiritual realm.

In this respect, it may be argued, the contrast between the various periods and styles of Ecclesiastical Art has sometimes, perhaps, been overdrawn. When Raphael painted the Sistine Madonna appearing as in a vision (Fig. 154) he surely wanted to use his innate power of discerning the Idea to clothe the Queen of Heaven in Beauty. It was Giovanni Bellori in the second half of the seventeenth century who formulated the metaphysical aesthetics of the Academic, that is the Platonic creed in his speech on the *Idea*, but this same Bellori also left us an ecstatic description of what we would call a typical Baroque version of heaven—Lanfranco's cupola of S. Andrea della Valle in Rome (1625–8) (Fig. 155).

After describing the figure of the Assunta and of Christ receiving her from above, and enumerating the other figures of Saints and Patriarchs, Bellori pulls out all the stops to evoke the centre of the choirs of angels surrounding the Lantern of the cupola:

In alternate intervals of air and of light, there opens the paradise of rosy radiant clouds with a gay and harmonious glory of angels who press towards the centre in choirs of youths and children who sit bathed in sparkling splendour, producing sounds and songs with flutes, viols, timpani and a variety of musical instruments. In the summit the smaller circles recede among brighter gilded lights and sweetly fade in an ultimate radiance where heads of Cherubim shine with such elusive outlines that the sweetness of the colour makes us hear the heavenly music in the silence of the painting. . . . Certainly the harmony of such a stupendous painting carries us upwards to heaven and in gazing at it the eye and the thought never tire of traversing its vast expanse.[77]

Nobody who reads this description in its entirety can doubt that Bellori's reaction is not merely an aesthetic one. Lanfranco has offered him a vision of heaven, a glimpse of Paradise. Nowhere does the artist or the critic seem to be worried by the dangers of confusing the splendid symbol with the greater reality.

There exists indeed a good deal of evidence that this particular problem did not worry the post-Tridentine Church as much as the Tridentine decisions might have led one to expect. The rational distinction between symbol and reality, between subjective vision and objective fact, appears almost deliberately to be blurred in the great Baroque ceiling paintings. The one in the Benedictine Monastery of Melk in Austria provides a good example of these ambiguities (Fig. 156).

The painter was asked to represent the reception of St. Benedict in Heaven.[78] This kind of apotheosis was by then almost the rule for the ceiling of churches, but what distinguishes the programme from many similar ones is that care was to be taken to show the objective truth of the event here represented: according to the legend two monks at widely separated places were granted this vision at the very moment when St. Benedict had died in Monte Cassino. Both were to be painted surrounded by angels in different parts of the ceiling watching the Saint's ascent into the angelic sphere. What interests us in particular is that this event attested by independent witnesses includes personifications: Religion assists and Idolatry cannot prevent the Saint's triumphal progress in which he is accompanied by Chastity and Penitence, his outstanding virtues. They were as visible to the two monks as were the Saint and the Angels.

No doubt, if the learned theologian who wrote this programme in Latin had been pressed, he would have used the same kind of argument as Giarda did: the true event in heaven eludes representation, but the images seen by the visionary and painted by the artist are at least valid reflections or adumbrations of the higher reality. The glimpse into the open heaven where the personifications keep company

with the angels is in itself an analogue to the grasping of a higher reality. These entities can no more be represented by symbolic images than they can be described by other means, but such images can at least illustrate the hierarchical structure of the world which is still akin to the layered world of Plato.

Both on the Jesuit stage and in countless paintings, therefore, the events on this earth are accompanied and reflected on a higher stage by abstractions in which, say, the destruction of an idol by a particular Saint is re-enacted as the victory of Religion over Idolatry. It is this reflection on the higher plane which gives meaning to the action below.

How deeply this habit had become ingrained in the seventeenth century, and how closely it had become linked with art, is shown vividly in another text referring to a Baroque ceiling painting: H. Tetius concludes his description of Sacchi's famous ceiling painting of *Divina Sapientia* in the Palazzo Barberini in Rome (Fig. 157) by recounting a moment when the symbol came to life for him. One day, so we hear, Urban VIII visited the palace and sat at table under the fresco when, quite by accident, a text on Divine Wisdom was chosen for the lesson. All present were struck by this mysterious coincidence.

At last we were able to behold Divine Wisdom, which we had never seen before except darkly and, as it were, covered by a veil, openly and without a vizor so that every one could contemplate her: her Divine and lucid Archetype (*archetypam*) in the Holy Writ, her prototype (*protypam*) in Urban and her representation (*ectypam*) in the painting. What light, what splendour was thus infused into the room and revealed to all who surrounded the exalted Prince. In truth even the very walls seemed to leap with joy (*parietes ipsi gestire videbantur*) and to congratulate themselves on this high honour. We, however, were filled with joyful confidence and felt transported to the very presence of Divine Wisdom (*quasi in ipsam Sapientiam Divinam rapti*) so that in future nothing obscure, nothing impenetrable could ever occur to us.[79]

The three accounts of paintings here quoted—Bellori's description of Lanfranco's cupola, the programme of the Melk ceiling and the experience of Tetius in the Palazzo Barberini—have one element in common: the emphasis on ecstatic visionary states. It was in Neo-Platonism above all that a consistent philosophical explanation of these states could be found. It is based on Plato's distinction between three modes of knowledge, to which allusion has already been made.

The lowest of these forms is of course the knowledge gained by our fallible senses which deserves no more than the name 'opinion'. The higher form is derived from reasoning which proceeds step by step in the dialectical process. As long as the soul is imprisoned in the body we are really thrown back on these two imperfect guides, the senses and reason which can never grasp the whole of truth at once but must use the crutches of the syllogism. The highest mode of knowledge is thus normally denied to man, for this is the process of intellectual intuition of ideas or

essences not mediated but direct, 'face to face'. For Plato we had this knowledge before we were born, and we shall recover it once we cast off the deadweight of the body and return to the realm of Ideas. In our lives—and this is the aspect which Neo-Platonism elaborated—we can only hope to achieve this true knowledge in the rare moments when the soul leaves the body in a state of *ek-stasis*, such as may be granted us through divine frenzy. Hence the importance which the Florentine Neo-Platonists attached to the working of the *furor* in love, in poetry, and in prophecy, and hence, also, the efforts of the Renaissance painters to claim for their own pursuits the same state of divine *afflatus* that antiquity had granted to the poet.

Their efforts were certainly crowned with success. Indeed, it is interesting that in the late Renaissance the claims of a great poet to prophetic status is made in analogy to the artist, at least to the special kind of artist with whom we are concerned, the deviser of visual symbols. Torquato Tasso in an important section of his treatise *Del Poema Heroico* combines an exposition of the Platonic theory of knowledge with an explicit reference to Dionysius Areopagita's conception of symbolism.[80]

The Mystical Image

The poet, he pleads, should not be classed with the sophist as a maker of 'idols' (as Plato had done).

I should rather call him a maker of images in the manner of a speaking painter, and in this he is similar to the sacred Theologian who fashions or commissions images . . . the poet is almost the same as the theologian and the dialectician. But sacred philosophy, as we may call Theology, has two parts, each corresponding to one part of the mind. For not only Plato and Aristotle, but also the Areopagite say that the mind consists of a divisible and an indivisible part. . . . It is to this indivisible part, which is the purest intellect, that the more occult Theology belongs which is contained in signs and has the power to make us perfect. The other, that is striving for Wisdom, which works by demonstration, he attributes to the divisible part of the mind, which is much less noble than the indivisible one. Thus it is a much nobler operation to lead the mind to the contemplation of things divine and to arouse it in this manner by means of images, as does the mystical Theologian, than to instruct it by way of demonstration which is the task of the scholastic Theologian. Thus the mystical Theologian and the poet exceed all others in nobility. . . .

What is it, Tasso asks, that the true poet imitates? Is his object the visible world of ours or rather the intelligible world? It must be the latter, for Plato had denied the status of being to visible things.

Hence the images of the Angels described by Dionysius exist more really than any human thing, and so is the Winged Lion, the Eagle, the Ox and the Angel which are the images of the Evangelists and thus do not belong to the imagination . . . for the imagination

belongs to the divisible part of the mind. Unless, that is, there is another imagination, beyond that which is a power of the sensitive soul, one which is like the light in illuminating matters and in showing itself, which is more a property of the intelligible imagination.

Important as is this astonishing claim for the poetic imagination which anticipates Baudelaire's designation of the 'Queen of the Faculties', we are more concerned here with the implications of Tasso's emphasis on the role of the symbol in the Platonic-Dionysian tradition. For if the previous texts illustrated the way of analogy from the experience of Beauty to the vision of the Divine, Tasso is obviously concerned with those mysterious images which exhibit no likeness but 'rouse the mind to contemplation'. Unlike the picture of a radiant paradise, the four symbols of the Evangelists derived from the vision of Ezekiel (Fig. 158) are more real than visible reality and must be apprehended neither by the senses nor by discursive reason, but by the undivided intellect.

Tasso's appeal to the example of the *pittore parlante*, the artist or painter who fashions symbolic images, can serve as a pointer to that other stream of Neo-Platonic thought which continued to influence the art and thought of post-Renaissance Europe. In this interpretation the capacity of the visual symbol to be apprehended in one flash serves by itself as an analogue to the way the higher intelligences apprehend the truth. It was Plotinus himself[81] who had introduced this argument in the very context in which he discussed the higher mode of knowing:

It must not be thought that in the Intelligible World the gods and the blessed see propositions; everything expressed there is a beautiful image.

The wise Egyptians, Plotinus tells us in this connection, did not use letters descriptive of words and sentences:

they carved one picture for each thing in their temples. . . . Thus each picture was a kind of understanding and wisdom and substance, given all at once, and not discursive reasoning and deliberation.

For the Christian Neo-Platonist who had to rely for the knowledge of truth on the forms of revelation found in the Scriptures or in the esoteric tradition, this commendation of the ancient Egyptian mode of writing must have held a particular fascination. For the hieroglyph was in any case reputed to reflect that 'ancient wisdom' that was either inherited from pre-lapsarian Adam or otherwise divinely inspired. Both its form and its context thus reflected a higher knowledge.

This is the background to the famous brief passage in Marsilio Ficino which was one of the foundation charters of the Renaissance art of emblematics.

When the Egyptian priests wished to signify divine mysteries, they did not use the small characters of script, but the whole images of plants, trees or animals; for God has know-

ledge of things not by way of multiple thought but like the pure and firm shape of the thing itself.

Your thoughts about time are multiple and shifting, when you say that time is swift or that, by a kind of turning movement, it links the beginning again to the end, that it teaches prudence and that it brings things and carries them away again. But the Egyptian can comprehend the whole of this discourse in one firm image when he paints a winged serpent with its tail in its mouth, and so with the other images which Horus described.[82]

The reference is to the only coherent text about hieroglyphs the Renaissance possessed, the *Hieroglyphica* by Horapollo, a late and fantastic compilation which enjoyed an undeserved prestige.[83] Actually his treatise assigns a different meaning to that typical mystical symbol, the serpent biting its own tail, which, by the way, is not winged in his version. He explains it as the symbol of the Universe, the scales suggesting the stars in heaven, its weight earth and its smoothness water. Its shedding its skin is interpreted as age and rejuvenation, its devouring itself signifies that whatever things are generated in the world by Divine Providence are received back into it by diminution.

The divergence between Ficino's interpretation and that found in Horapollo may be fortuitous, but it reminds us of an important fact. Where symbols are believed not to be conventional but essential, their interpretation in itself must be left to inspiration and intuition. The reason is not far to seek. Conventions can be learned, if necessary by rote. The symbol that presents to us a revelation cannot be said to have one identifiable meaning assigned to its distinctive features. All its aspects are felt to be charged with a plenitude of meanings that can never be exhaustively learned, but must be found in the very process of contemplation it is designed to engender. Elsewhere in this volume the logical and psychological problems of what is there called the 'open sign' are discussed in other contexts.[84] What matters here is that the very experience of meaning after meaning which is suggested to our mind as we contemplate the enigmatic image, becomes an analogue of the mode of apprehension in which the higher intelligences may not only see one particular proposition as in a flash, but all the truth their mind can encompass—in the case of the Divine Mind the totality of all propositions.

Thus the mysterious hieroglyph of the monster devouring itself sets the mind a puzzle which forces it to rise above the image. Not only can we not think of the sign as representing a real creature, even the event it represents transcends the possibility of our experience—what will happen when the devouring jaws reach the neck and the jaws themselves? It is this paradoxical nature of the image that has made it the archetypal symbol of mystery. We are certainly not tempted to confuse the painted enigma with its manifold meanings. The serpent does not represent either time or the Universe, but precisely because it is inexhaustible in its significance it shows us so much 'in a flash' that we return from its contemplation as from

a dream we can no longer quite recount or explain.[85] This, on the highest level, was Dante's experience and something analogous should be felt in the presence of such venerable and mysterious signs.

Unlike the image of beauty, then, the image of mystery will not arrest the mind in its ascent to the intelligible world. The serpent biting its own tail is not a 'representation' of time, for time is not part of the sensible world and so it cannot appear to our bodily senses. The essence of time is accessible only to intuition, and it is this intuition which is symbolized in our response to the image which both demands contemplation and spurs us on to transcend it.

This doctrine of the function of visual symbols may hardly be capable of completely rational exposition, because it is by the nature of the argument an irrational doctrine. Yet it is clear that in and through it the distinction between the representational and the symbolizing function of the image becomes blurred. Ficino does not accept the image of the serpent as a mere sign which 'stands for' an abstract concept. To him the essence of time is somehow 'embodied' in the mysterious shape. By contemplating the ancient symbol in which those endowed with superior knowledge laid down their insight into the nature of time he will himself arrive at an increasingly profound understanding of time, he will 'see' it here on earth as he hopes to see it when the body no longer dims his apprehension.

<div align="center">IV</div>

THE CONFLUENCE OF TRADITIONS

The Philosophy of the Impresa

Ficino's discussion of the hieroglyph provides the background to the intellectual fashion that produced a flood of books on emblems, devices and *imprese* during the sixteenth and seventeenth centuries. This vogue has recently attracted a good deal of attention on the part of historians of art and literature, and deservedly so, for we have here an art form that fascinated many generations, only to fall into disrepute and oblivion in subsequent periods.[86] The fitting together of words and music is still intuitively intelligible to us, the joining of a picture with a tag and poem (as in the emblem) or with a brief motto (as in the device or *impresa*) needs an effort of the historical imagination to become intelligible. As in the case of personifications, it may be objected that the philosophical arguments used in the learned introductions to these fashionable volumes were little more than rationalizations of a pleasure that had its psychological roots elsewhere. The investigation of these roots, as I hope to show, leads deeply into the subsoil of language and thought; but clearly the problems presented by such basic features as metaphor, image and comparison could only be expressed by these scholars in the terms they derived

from classical tradition, be it from the Platonic or the Aristotelian current if not from a combination of both.

Thus Père le Moine, in his *De L'Art des devises*, Paris 1666, sums up the Platonic position, albeit with a cautionary *captatio*, when he writes:

Were I not afraid of rising too high and of saying too much I should say that there is in the Device something of those universal images given to the Higher Spirits which present in one moment and by means of a simple and detached notion what our minds can only represent in succession and by means of a long sequence of expressions which form themselves one after the other and which more frequently get into each other's way rather than help each other by their multitude.[87]

But though such allusions to Ficino's mystical doctrine are far from rare, Robert Klein was no doubt also right in stressing the role which Aristotle's rational theory of metaphor plays in these discussions.[88] Indeed at the very time when Père le Moine thus put forward his Neo-Platonic praise of the Device, Emanuele Tesauro published his *Cannochiale Aristotelico* or Aristotelian telescope,[89] with which he scans the firmament of rhetorical 'ingenuities', images, metaphors, emblems, symbols and the like for the practical use of preachers, orators, composers of programmes, inscriptions, and devices. Many of his chapters take the form of an exposition of Aristotle's rhetoric with examples taken from a variety of fields. The core of the book, both in bulk and importance, applies Aristotle's theory of metaphor to the classification of figures of speech, images and symbols. An appendix uses it for the analysis of the art of Imprese in 31 'Theses'. The first and 'fundamental' one reads 'The perfect Impresa is a Metaphor.' This, we learn, follows from the definition of a metaphor as 'signifying one thing by means of another' and is applied by Tesauro to his paradigm of the *genre*, the Device of King Louis XII of France, a porcupine with the motto '*cominus et eminus*' (near and far) (Fig. 159). Had the King said 'I shall strike my enemies near and far' this would be normal and literal language, but to signify that conceit he shows us the image of a porcupine which pricks what is near and launches its spines far away. . . .

Hence arise the delights which *Imprese* give us, because a thing called by its proper name does not teach us anything but itself, but calling it by a metaphor teaches us two things at the same time, one within the other: The King in the porcupine and the arms in the spines, striking in the pricking, and to the human mind which is naturally desirous of knowing much without effort this is very pleasant. . . .[90]

Tesauro is anxious to show that his paradigm is indeed a perfect *Impresa*; it represents the most perfect of metaphors, the one also extolled by Ripa, that is the 'metaphor of proportion', for just as the porcupine wields its spines so the King wields his arms. It also expresses an 'heroic', that is a martial, sentiment, but not a cruel one, for Tesauro reminds us that the spines of the porcupine have also been said to heal the wounds they inflict, and the King will similarly succour the

oppressed. But the author would not be a teacher of rhetoric if he were not also capable of turning round and arguing the opposite case. Nothing is ever perfect and so the *impresa* also exhibits the flaws which belong to all human inventions. Strictly speaking it is not based on an ideal metaphor of proportion, for spines and swords are too much alike; moreover it is not very dignified to compare a king to a porcupine, which, after all, is a kind of pig.

In this rational and sober dissection of the symbolic image Tesauro merely summed up the rival tradition of the *impresa* which had found a most able defendant in the sixteenth-century author Scipione Bargagli.[91] Bargagli explicitly turns against the identification of the *Impresa* with the hieroglyph or other mystical symbols. It is nothing but an illustrated metaphor or comparison and this comparison, in Bargagli's view, should always be based on qualities objects really possess rather than on some fabulous or mystical association which would be unintelligible to the *mezzana gente* (average people) whom the *impresa* wishes to address. By these standards, of course, the fabulous porcupine is out; and indeed in turning the pages of Bargagli's collection we find most frequently everyday objects and instruments which are used as metaphors. A typical example (Fig. 160) is the simple image of the hand with a whip associated with a top, and the motto '*per te surgo*'. The application is obvious: the blows of fortune will not get me down, on the contrary, they make me rise. But would this or any other such simile, however apt, explain the enthusiasm which the art aroused?

One sample from the English version of Henry Estienne's *Art of Making Devices* may stand for many:

Bargagli saith with good reason that a Devise is nothing else but a rare and particular way of expressing oneself; the most compendious, most pleasing, most efficacious of all other that humane wit can invent. It is indeed most compendious, since, by two or three words it surpasseth that which is contained in the greatest volumes. And as a small beame of the Sun is able to illuminate and replenish a cavern be it ever so vast, with the rays of its splendor: So a Devise enlightens our whole understanding and dispelling the darkness of Error fills it with a true Piety and a solid Virtue. It is in these Devises as in a Mirrour, where without large tomes of philosophy and history we may, in a short tract of time and with much ease, plainly behold and imprint in our minds, all the rules of Moral and Civil Life. . . .[92]

Now it is certainly true that some devices display that concentration so much commended by the authors of the time. Camillo Camilli includes in his book[93] the *Impresa* of the Crotta family (Fig. 161) which shows a schematic picture of the spheres with a flame rising upwards and the motto '*ut quiescat*'. The flame that tends towards its 'natural place' up in the Empyreum becomes the symbol of the soul's natural longing for God, alluding to St. Augustine's beautiful lines 'Fecisti nos in te, et cor nostrum inquietum est, donec requiescat in te'. It is in this way

that any natural fact, as Giarda reminded us, can be used as a symbol of a moral truth, and it is precisely the task of what the Renaissance called 'wit' to find the apt but unexpected application. Thus the same natural tendency of the flame to rise upward could form the subject of a very different meditation: *Livor, ut ignis, alta petit* (Fig. 162). Envy seeks the heights like the flame, it is because I stand high that I am envied. I can now see and grasp what formerly I had to reason out.[94]

For in some sense the *impresa* is more like a demonstration than a metaphor. It applies the lesson of a particular observation to a rule of life. Its power lies less in the comparison than in its capacity to be generalized. Though I know of no author who has explicitly drawn this conclusion it is implicit in the way these images are treated in the collections to which I have alluded.[95] The comment does not rest content with one application. The author uses his wit to draw out as many such applications as the patience of the reader will bear.

These products of what has been called the Courtier's Philosophy are even less likely to appeal to twentieth-century taste than are Ripa's learned compositions of personifications, but we have to take cognizance of this approach to the symbol to get closer to the way the changing potential meanings of an enigmatic image were evidently appreciated by a meditative reader much as a music-lover enjoys listening to variations on a theme. Thus Ruscelli[96] sets out to describe or expound the *Impresa* of one Count Pompilio Collalto in five closely printed pages. It shows a sun behind clouds (Fig. 163) with the motto *hinc clarior* ('hence brighter') and 'seems to promise more than one fine meaning to have been intended by its author'.

First . . . it serves to demonstrate the natural property of light which increases in splendour the more it is gathered up in itself. . . . Thus it may be that by means of this very fine philosophical observation the author of the Impresa . . . intended a beautiful allusion to some fair Lady he loved and who, either because she was widowed, or for some other reasons, was dressed all in black and had her face veiled . . . wanting to say that in this way she appeared . . . all the more beautiful. . . .

Here Ruscelli thinks of a poem on a related theme and quotes eight stanzas in *ottave rime* on the conceit of the Sun complaining to Jove about a Lady outshining her in beauty. Jove sends a dark cloud, which turns into a veil, but in vain, the sun has to yield pride of place to the Lady.

. . . But leaving these lines of poetry and thought of Love, it may be that this high-minded Lord had intended by his *Impresa* to set before his mind . . . the true glory of God . . . which he intended to convey through the splendour of the sun. Hence the clouds would have been intended to signify the obstacles and troubles . . . which, in the normal course of things always come athwart illustrious ideas and deeds, as Petrarch says: 'It is rare that exalted enterprises are not opposed by injurious Fortune.'
But apart from all this, since the said Lord who devised this *Impresa* is known for his fine mind, one might propose a very different interpretation, which would certainly also

be most fitting: Despite the fact that the majority of poets and other secular writers generally attribute a bad meaning to clouds it can be seen that in the Holy Writ they are on the contrary taken for the most part to have a very good significance. Nearly all the great works which God wrought among us have been performed by His infinite mercy either in clouds or in fire. [Ruscelli here cites ten scriptural examples.]

There is one reason ... for which we may believe that the Divine and ineffable Goodness shows itself nearly always ... enclosed by clouds: it is to teach us ... how to raise ourselves up to God by contemplation and by deeds. For just as the world receives from the air the great boon of ... rain ... so angelic minds, which are like the clouds in relation to the central Sun that is God, bestow on our minds the ... rain of grace. ...

Beyond this ... we can see that this is done by God's infinite mercy who ... wants to accommodate to our nature and condition which can never proceed from one extreme to another without some intermediary that partakes of the nature of both one, and the other. ... Such an intermediary between our own earthly sight and the object of the heavenly light ... are the clouds which in some manner partake of the qualities of opacity and of splendour. ... In this way the Holy Writ also intends to present us the clouds as guides ... to God, and of this we have anagogical and mystical evidence in the column of the cloud that led the Chosen People ... to the Promised Land. [More biblical quotations.]

And even beyond the Holy Writ it will be found that the philosophers, and particularly the Platonists have also expressed this beautiful idea. ... Perhaps it was with the intention of showing us that our mind is unable to raise itself up and unite with God immediately of its own without some veil that shades, protects and preserves it from so much light, that the poets devised the allegory of ... Semele. Now if we want to combine with this the first idea of which we spoke ... we might say that taking the cloud to mean the corporeal beauty of the Lady, the author may have wanted to convey by this *Impresa* the *hinc*, that is to say, that from this corporeal beauty my mind lifts itself up to the beauty of her soul, heavenly and divine ... and from that heavenly beauty it is then carried upwards to the divine mind, the supreme life, whence it becomes even more serene and bright.

And beyond all this ... one can and must add yet another interpretation that may have been in the author's mind ... that is the love and desire for Glory which has its origin in our mundane concerns and ultimately comes to rest in God. And by way of confirming my idea that this Lord may have wanted to refer to this splendour and this glory ... it seems appropriate to put on record that the house of Collalta has been a most noble family for many years and has produced ... men of the greatest valour. ... [The achievements of Count Tolberto in the Venetian wars against the Turks and Count Pomponio's loyalty to the Venetians are then discussed in some detail.]

But since I am unable to state precisely in what phase of his life this Lord had devised his *Impresa* ... whether in his early youth and with an amorous intention ... or perhaps later with the other moral and military meaning ... it may also be the case that he adopted it in later years, when he experienced a variety of strange blows of Fortune ... which he was seen to resist with such marvellous goodness, prudence and patience, that grounding his hope on the inscrutable goodness of God, he can have confidence that he will emerge more resplendent in the sight of his masters. ...

And these interpretations presented here by me, and many others which we believe

the author to have in his mind, show this *Impresa* to be most beautiful and graceful in all its aspects.

The attentive reader who had the perseverance to join in this exercise will have noticed that the interpretations of the image unfold in a sequence reminiscent of the life of Castiglione's Renaissance courtier. The symbol adapts itself to the young lover, to the mature warrior and to the aged seeker of God. In every stage and in many other real or imaginary ones it means something different and yet it points to one common and unvarying truth—the contrasts of the clouds surrounding the sun which either enhance the splendour or lead us towards it.

We are reminded of Shakespeare's Prince Hal:

> I know you all, and will a while uphold
> The unyoked humour of your idleness:
> Yet herein will I imitate the sun,
> Who does permit the base contagious clouds
> To smother up his beauty from the world,
> That, when he please again to be himselfe,
> Being wanted, he may be more wonder'd at,
> By breaking through the foul and ugly mists
> Of vapours that did seem to strangle him . . .
> And like bright metal on a sullen ground,
> My reformation, glittering o'er my fault,
> Shall show more goodly and attract more eyes
> Than that which has no foil to set it off.[97]

But Shakespeare's verbal imagery, which is so akin in spirit to the metaphorical art of the Renaissance symbolists, must, through the nature of discursive speech, be tied to a particular meaning or application. The *impresa*—*hinc clarior*—may have been felt to be so illuminating precisely because it is a free floating metaphor, a formula on which it allows us to meditate. Somehow such an image reveals an aspect of the structure of the world which would seem to elude the ordered progress of dialectic argument.

The Function of Metaphor

Perhaps we may here come a little closer to a characterization of the metaphor which allows us to account for this feeling more rationally than Aristotle's theory can.

Aristotle, it will be remembered, sees in the metaphor just one of the 'figures of speech', the one which 'transfers' the meaning from one object to another (the shield is the cup of Ares). To him words were names either of individuals or of classes of things, and, in theory at least, all classes had such a name which could be used in non-metaphorical or 'literal' language. Metaphor, in this view, is only a

decoration, an embroidery which is enjoyed as we have heard, because it teaches us to see unexpected similarities, but which can easily be dispensed with.[98] In this respect Cicero's theory of metaphor is perhaps more perceptive. He thought that metaphor 'sprang from necessity due to the pressure of poverty and deficiency, but it has been subsequently made popular by its agreeable and entertaining quality'.[99] In other words he realized that language does not necessarily contain names for every individual and species and that 'when something which can scarcely be conveyed by a proper term is expressed metaphorically the meaning we desire to convey is made clear by the resemblance of the thing that we have expressed by the borrowed word'.[100]

What needs to be added to Cicero's account is only that this is a permanent and continuous process, without which language could never have served us. The real problem, as Professor George Boas once put it to me, is not so much 'what is a metaphor?' as 'What is a literal statement?'[101]

Probe almost any word or turn of phrase and you will at least find what is called a 'dead' metaphor, one, that is, which has been incorporated into the language. Strangely enough, however, Aristotle's illusion is still rather widespread. We still tend to think that language offers us an almost complete inventory of reality, and that what cannot be named cannot be important. There is a school of modern linguistics which radically reverses the relation between language and reality and insists that it is we who, through our language, create the categories and even the stable objects of our experience.[102] In other words, there are no 'natural classes' in Aristotle's sense, these classes are created by linguistic categories which for instance make us distinguish between things and processes because language offers us nouns and verbs. From this radical point of view a metaphor would not represent a transfer of meaning but a restructuring of the world. Aristotle's example would indicate that we can after all call a cup a shield and a shield a cup, just as a child can turn the one into the other in a game. Even in Aristotle's other example, 'Achilles is a lion', we simply extend the category of what we call lions to brave people and exclude, perhaps, cowardly felines, and when we speak of 'lion hunters' we extend the category from the safari to the salon. Such a radical interpretation would dissolve the notion of metaphor precisely because there is no privileged literal statement or language. There are good arguments against such an extreme proposal, simply because language is a social institution that has evolved along lines of utility. It is this function of language as a tool which explains that certain serviceable categories occur in all languages. It is likely for instance that all communities need a word for 'head'. It is different with less tangible categories and thus we find that a large number of words current in one language have no exact equivalent in another. It is here that the distinction between 'literal' and 'metaphorical' usage becomes particularly apparent. The category 'head' can be ex-

tended in English to the 'head of state', the 'head of a ship', or the 'head of a river'. The first of these corresponds to German usage, the second would be intelligible though not idiomatic, while the third may make a German pause to consider whether the head of the river lies in the direction of the source or the mouth.

Sometimes, of course, a category created by one language is found so useful that it is taken over by other communities, either by translation or simple borrowing, and having learnt to apply it we may wonder how we ever got along without it.

A metaphor which is still felt to be one may be described as a temporary or tentative category. It is precisely because our world is comparatively stabilized by language that a fresh metaphor can be felt to be so illuminating. We almost have the feeling as if it gave us a fresh insight into the structure of the world by piercing the veil of ordinary speech. It is this experience, so it seems, that underlies the illumination of which we hear in the literature on *imprese*. For though our spoken languages are comparatively rich in names for things and qualities, they tend to be poor in words describing processes and relationships. We all know how much easier it is to represent such relationships by means of a diagram than by verbal description. The linear character of language makes it hard to hold in mind a description such as 'the wife of a nephew of my father-in-law' and to make sure that it means the same as 'the wife of my wife's first cousin' but draw a diagram and the identity can be seen at a glance.

This may be one of the psychological reasons for our instinctive equation between seeing and understanding. Even to 'grasp' an idea sounds less immediate than to 'see' it. This special appeal of the immediacy of sight was also known to Cicero, who remarked on the power of the linguistic image based on vision.

> Every metaphor, provided it is a good one, has a direct appeal to the senses, especially the sense of sight, which is the keenest: for while the rest of the senses supply such metaphors as 'the fragrance of good manners' or 'the softness of a humane spirit', 'the roar of the sea' and 'the sweetness of speech', the metaphors drawn from the sense of sight are much more vivid, almost placing before the mind's eye what we cannot discern and see.[103]

Combine this vividness with the explanatory power of the diagrammatic exposition and it becomes understandable that the emblem seemed to offer an escape from the limitations of discursive speech.

We have seen how Leonardo used a device somewhere in between a personification and an emblem to express the mutual dependence of pleasure and pain in an image which demonstrates the complexity of such interaction. Bargagli's example of the top that rises when whipped is a similar instance of a surprising relationship between cause and effect. It is easy to imagine how he would have extended his repertoire of illuminating examples if he had lived today. Most of us have first

learned the principle of what engineers call 'feedback' by the example of the heater equipped with a thermostat that switches the heater off when the temperature has reached the required level and on again when it sinks. Most of us have also learned to see similar 'feedback' relationships in psychological or social processes which we were formerly unable to describe or even identify. Perhaps Bargagli would have constructed an *impresa* with such an apparatus and the motto *quod me calfacit me refrigerat* (what heats me, cools me).

We have seen in fact in the example of Ruscelli how such an unexpected relationship like 'hinc clarior' is used to scan the world for processes or events to which it might apply. It is this element of discovery that accompanies the enrichment of our repertory of symbols that accounts for the feeling of illumination. It helps to explain what we mean when we describe a saying or a symbol as 'profound'—its depth is the power of penetrating to new and unexpected categories of experience.

It is hardly an accident that no type of utterance strikes us more easily as 'profound' than a paradox, or 'oxymoron'. At first sight it seems to defy the rules of logic and of language, at second thought it reveals its applicability over a wide area. The paradox becomes a sample of the ineffable mystery that is hidden behind the veil of appearances.[104]

Even such a comparatively trivial saying as 'Festina Lente' (hurry slowly, or 'more haste, less speed') thus partakes of the aura of profundity that attracted the makers of devices, all the more as it was attributed to the Emperor Augustus, who was said to have expressed it in the image of the swift dolphin and the stable anchor (Fig. 164): what appears to be mutually exclusive in language is not so in fact.[105] Who knows how often this may be true?

The Paradox and the Transcendence of Language

It is this effort to transcend the limitations of discursive speech which links the metaphor with the paradox and thus paved the way for a mystical interpretation of the enigmatic image.

The relevant doctrine is adumbrated in Pseudo-Dionysius in a passage of crucial importance:

The higher we rise, the more concise our language becomes, for the Intelligibles present themselves in increasingly condensed fashion. When we shall advance into the Darkness beyond the Intelligible it will no longer be a matter of conciseness, for the words and thought cease altogether. When our discourse descends from the higher to the lower, its volume increases, the further we move from these heights.[106]

It is one of the unquestioned assumptions of Platonic philosophy that unity is always superior to multiplicity. Thus Marsilio Ficino can describe the ascent of the mind to the apprehension of the Divine as a return of the soul to its original

unity. He links this passage from sensing to believing, from believing to reasoning and from reasoning to direct intuition with the doctrine of the Divine frenzies, the varieties of the ecstatic experience:

Divine frenzy is a certain illumination of the rational soul by which God draws the soul, that has fallen from the higher regions to the lower, back from the lower to the higher. The fall of the soul from the highest point of the universe down to the region of bodies passes through four zones, the Intellect, Reason, Opinion, and Nature. Hence, since there are six rungs of the hierarchy of things, from the peak of divine unity to the bottom of the body and four in between them which have been named, it follows that whatever falls from the highest to the lowest falls through these four intermediate ones.

That divine unity is the end and measure of all things, without confusion and without multiplicity. The Angelic Intellect is a certain multitude of ideas but a multitude that is stable and eternal. The Reason of the Soul is a multitude of notions and arguments, a multitude that is mobile but orderly. Opinion, which is below reason, is a multitude of images which are confused and mobile, but it is a unity in one substance and one point. For the soul in which opinion resides is a substance which does not occupy any particular place. Nature, that is that nutritive power that derives from the Soul and also the vital complexion is in a similar condition, but is diffused throughout the body. The body, however, is an indeterminate multitude of parts and accidents, subject to movement and divided into substances, moments and points. Our Soul is concerned with all these zones, through them it descends, and through them it mounts upwards. . . .[107]

Ficino describes the role which the four 'frenzies' play in this upward journey.[108] Briefly they help the soul to attain that unity it has lost in its descent into matter. First music must awaken the sleeping mind and turn discord into harmony. Even harmony, though, is a type of multiplicity; thus the 'Bacchic' frenzy must administer rites and purgations so as to direct all the parts of the soul towards the Intellect with which God is adored. Once all the parts of the mind are reduced to one Intellect it may be said to have become a kind of whole. Now the third *furor* can come into operation to reduce the Intellect to that unity that is the head of the soul; it is the gift of Apollo that allows the Soul to rise above the Intellect to the Unity of the Intellect and thus to foresee the future. 'Finally, when the soul has thus been made into one which really corresponds to its essence it must still be brought back to that unity that dwells beyond the essence, that is to God.' This, Ficino tells us, is the gift of the heavenly Venus through the mediation of Love and the desire for Divine Beauty and the ardour for the Good.

For Ficino here the ascent to unity leads to the apprehension of Beauty as an analogue of the Divine. It is precisely the point of the mystical tradition, however, that the true Divine lies beyond these categories, for it transcends them all. The Christian dogma of the Trinity must always have kept the importance of this doctrine before the eyes of the faithful. In the skeptical words of Mephistopheles in the Witches' Kitchen 'a perfect contradiction is as mysterious to sages as it is to fools'.[109]

But if the mystery resists by its very nature any formulation in discursive speech it can still be hinted at through the mediation of analogies. For as we have seen, the hierarchy of realms through which the soul has to rise towards God is a hierarchy of analogies. One need only present Ficino's account in form of a diagram to see the power of such demonstrations. The microcosm as well as the macrocosm must be envisaged as a series of concentric circles surrounding the ineffable unity in ever widening distance. Thus a relationship that is palpable below is more contracted or condensed nearer the centre. The proportion a:b will equal a′:b′ and a″:b″ in each of the spheres, but in the centre all are one and all are equal.

God, in the famous words of Nicolaus Cusanus, is the *coincidentia oppositorum*. It is this kind of mystery that is 'condensed' into the image of the serpent biting its own tail which is a metaphor not only of time but of the inscrutable enigma of the universe that can only be expressed through contradictions. It does so precisely because the sense of sight provides an analogue to the non-discursive mode of apprehension which must travel from multiplicity to unity.

<p style="text-align:center">V</p>

MEANING AND MAGIC

To explore the full implications of this tradition we must turn from the study of illustrated metaphors in emblems and hieroglyphs to the tradition of esoteric mysticism and magic.[110] In Goethe's *Faust* we have a famous and authentic description of the transition from seeing to intuition, from intuition to transformation,

of the unity of mystic significance and magic effect. When Faust opens the mysterious book of Nostradamus he sees in and through the 'Sign of Macrocosmus', the Universe unriddled in the exaltation of the *vita contemplativa*.

> Ha, welche Wonne fließt in diesem Blick
> Auf einmal mir durch alle meine Sinnen!
> Ich fühle junges, heil'ges Lebensglück
> Neuglühend mir durch Nerv' und Adern rinnen.
> War es ein Gott, der diese Zeichen schrieb,
> Dir mir das innre Toben stillen,
> Das arme Herz mit Freude füllen
> Und mit geheimnisvollem Trieb,
> Die Kräfte der Natur rings um mich her enthüllen?
> Bin ich ein Gott? Mir wird so licht!
> Ich schau in diesen reinen Zügen
> Die wirkende Natur vor meiner Seele liegen.
> Jetzt erst erkenn ich, was der Weise spricht:
> 'Die Geisterwelt ist nicht verschlossen;
> 'Dein Sinn ist zu, dein Herz ist tot!
> 'Auf, bade, Schüler, unverdrossen
> 'Die ird'sche Brust im Morgenroth.'
>
> *(er beschaut das Zeichen)*
>
> Wie alles sich zum Ganzen webt!
> Eins in dem Andern wirkt und lebt!
> Wie Himmelskräfte auf und nieder steigen
> Und sich die goldnen Eimer reichen!
> Mit segenduftenden Schwingen
> Vom Himmel durch die Erde dringen,
> Harmonisch all' das All durchklingen!
> Welch Schauspiel! aber ach! ein Schauspiel nur. . . .

> (Ha! What a river of wonder at this vision
> Bursts upon all my senses in one flood!
> And I feel young, the holy joy of life
> Glows new, flows fresh, through nerve and blood!
> Was it a god designed this hieroglyph to calm
> The storm which but now raged inside me,
> To pour upon my heart such balm,
> And by some secret urge to guide me,
> Where all the powers of Nature stand unveiled around me?
> Am I a God? It grows so light!
> And through the clear-cut symbol on this page
> My soul comes face to face with all-creating Nature.
> At last I understand the dictum of the sage:
> 'The spiritual world is always open,
> Your mind is closed, your heart is dead;

Rise, young man, and plunge undaunted
Your earthly breast in the morning red.'

(*He contemplates the sign*)

Into one Whole how all things blend,
Function and live within each other!
Passing gold buckets to each other
How heavenly powers ascend, descend!
The odour of the grace upon their wings,
They thrust from heaven through earthly things.
And as all sing so *the* All sings!

What a fine show! Aye, but only a show!)[111]

Was Faust's 'Sign' a representation of the Universe, a picture with angels going up and down passing each other the golden ewers, or was it an abstract symbol, a magic rune of the kind which Goethe might have known from Rosicrucian literature (Fig. 165)?[112] The very fact that this question remains undecided proves how far removed the esoteric conception of the visual symbol is from these rational categories of representation and symbolization. The magic sign 'represents' in the literal sense of the word. Like the name it gives not only insight but power. The Neo-Platonic theory has indeed accepted this consequence. For if the visual symbol is not a conventional sign but linked through the network of correspondence and sympathies with the supracelestial essence which it embodies, it is only consistent to expect it to partake not only of the 'meaning' and 'effect' of what it represents but to become interchangeable with it.

The Symbol's Power

We can hardly understand the Renaissance attitude towards the visual symbol without at least taking cognizance of this most extreme position in which not only the distinction between symbolization and representation is removed but which threatens even the distinction between the symbol and what it symbolizes. Ficino expressed his belief in the magic potency of the image quite openly. In his book *De Vita coelitus comparanda* a number of chapters are devoted to astrological practice and amulets.[113] He treats at length *de virtute imaginum, Quam vim habeant figurae in coelo atque sub coelo, Quales coelestium figuras antiqui imaginibus imprimebant, ac de usu imaginum* (On the virtue of imagery, what power pertains to the figures in the sky and on earth, which of the heavenly configurations were impressed on images by the ancients, and on the use of images). Ficino wavers a little in his attitude. He does not think that images on amulets can achieve everything but he shows himself convinced that the right image engraved on the right stone

may have a very potent effect on health. It is not the fact that Ficino took over this superstitious belief from the 'esoteric tradition' which is important in our context but the argument which he uses to rationalize this belief. These arguments are based on the same Neo-Platonic literature, on Plotinus and Iamblichus, from which Ficino's other views on the virtue of the visual image are derived. They are, in fact, an extension of the same doctrine.

Ficino uses a number of interesting examples to make his meaning clear. Just as one lute resounds by itself when the strings of another are plucked, the likeness between the heavenly bodies and the image on the amulet may make the image absorb the rays from the stars to which it is thus attuned. The argument provides an instructive instance of what Warburg called *Die Schlitterlogik* of the astrologer. For rationally there is of course no likeness whatever between the image Ficino bids us to engrave and the star as a 'heavenly body'. What he means is the image of astrological tradition, of Saturn with his falx or Mars with his sword. These images, then, are not to be regarded as mere symbols of the planets nor are they simply representations of demonic beings. They represent the essence of the power embodied in the star. If we give these symbolic images the 'right' form of which we find the record in that ancient Eastern lore which the Neo-Platonists held to be divinely inspired, if we design them in the proper way so that they embody the 'essential' attributes of the planetary deities, they must, of necessity, receive something of the power they 'represent'. Saxl[114] has drawn attention long ago to the connection existing between the importance attached to the correct 'form' of the Gods in the sixteenth century and the belief in the magic efficacy of images. He has shown how far these ideas were removed from our rational division between 'form' and 'content'. In Ficino this magical doctrine is linked with the whole body of neo-Platonic aesthetics in the following argument:[115]

The objects in our sublunar world have different qualities, some, like heat and cold, dryness and moisture, are elemental and thus wedded to the world of matter. Others, like brightness, colours and numbers—that is proportion—appertain both to our sublunar world and to the celestial sphere. These mathematical shapes and proportions, then, belong to the higher order of things. Shapes and proportions, therefore, have the most intimate connection with the Ideas in the World Soul or the Divine Intellect. (*Imo et cum idaeis maximam habent in mente mundi regina connexionem.*) What goes for numbers and shapes also goes for colours, for colour is a kind of light which is itself the effect and image of the intellect.

If anybody should doubt these sympathetic links Ficino asks him to consider the power of images as a matter of common observation. How easily does a figure of a mourning person move us to pity, how profoundly does the image of a charming person—*amabilis personae figura*—affect the eye, the imagination and our humours! Ficino then appeals to the age-old belief according to which an unborn child is

affected by the images seen by the mother during pregnancy and by the parents' mental images during conception. We need not follow him further to see where his argument leads. It leads to the conclusion that in the Neo-Platonic theory of art image-making had surprising affinities with that of music.

In musical theory we are more familiar with the metaphysical Platonic doctrine that all harmony reflects a heavenly harmony and that the effects of music on the mind are somehow due to this power derived from cosmic laws. 'What passion cannot music raise and quell?' In the Neo-Platonic theory of music so wonderfully epitomized in Dryden's hymn no clear line is drawn between what we call expression in music and the magic effects achieved through harmonies. The Platonic theory which banned certain modes of music because of their effects on the mind must be seen in the context of the medical and physiological effects ascribed to music and these, in turn, were believed to be on the same level as magic phenomena and as the physical law of resonance invoked by Ficino. The result of this belief was, in fact, very similar in the sphere of music and in that of art. We see the Renaissance Platonists searching eagerly for the tradition of the 'music of the ancients'[116] which must have embodied the laws of the Universe and which was therefore reputed to have produced such miraculous effects:

> Orpheus could lead the savage race;
> And trees uprooted left their place
> Sequacious of the lyre;

It was of course out of these efforts to reconstruct the music of the ancients which moved the passions that grew, almost as an accidental by-product, the Opera of Monteverdi.

The parallelism with Ficino's theory of the image is suggestive. He thought that the numbers and proportions of a thing preserved in the image reflect the idea in the divine intellect and therefore impart to the image something of the power of the spiritual essence which it embodies. Moreover the effect of images on our minds can be considered a valid proof of this type of magic effect. In other words, the Neo-Platonic conception favoured not only a removal of the distinction between the representational and the symbolizing functions of the image, but also the confusion of these two levels with what we have called the expressive function. All the three together are not only seen as various forms of signification but rather as potential magic.

If we step with these notions in mind before a painting such as Botticelli's 'Birth of Venus' (Fig. 55), we feel how all these influences unite in it as rays in a burning-glass.

Whatever the actual 'programme' was that underlies this commission we know that it is the result of passionate efforts to re-evoke the 'true' image of the goddess

of love such as it had been created by the ancients. This 'true image' is the form which the heavenly entity hidden in the myth of Venus assumes when appearing before the eyes of the mortals. It both hides and proclaims her spiritual essence. The effects which such an image exerts on our senses in every meaning of the term would not have been considered incompatible with any spiritual or allegorical interpretation. On the contrary—this effect of the image on our passions and emotions would have been accepted as a proof of its true correspondence to the heavenly idea, a natural outcome of its magic efficacy. The patron who had it in his room for contemplation would surrender to its influence and would find in it a true guide to the supra-sensible principle of love or Beauty, of which Venus is but the visible embodiment and revelation.

Effect and Authenticity

We need not assume that these philosophical ideas were explicitly held by the patrons and artists of the period. But their potential presence in any speculations about the nature of symbolic images cannot but have reinforced those dreamlike reactions to the image which always lurk on the fringe of our consciousness. Any painter who is confronted with the task of portraying the virtue of Justice for a council chamber cannot but ask himself what the virtue would look like if he encountered her in the flesh. A Renaissance painter could more easily rationalize this desire instead of dismissing it as an idle fancy.

There exists, in fact, a little Latin dialogue by the Renaissance humanist Battista Fiera[117] in which Mantegna figures precisely in such a quest. He had been commanded by the Pope to paint Justice and had gone to the philosophers to consult them on the way she should be represented. He is exasperated at the conflicting advice he received. One had told him that Justice 'should be represented with one eye, the eye being rather large and in the middle of the forehead; the eyeball, for sharper discernment, deep-set under a raised eyelid', another wanted her 'standing, with eyes all over her as Argus was of old, . . . and brandishing a sword in her hand to ward off robbers'. There is much mild satire in the dialogue conducted by Momus which should not be read as a source about art but rather as a disquisition about Justice somewhat on the model of the hunt for Justice in Plato's Republic. In fact, just as Plato's search ends in the proposition that Justice resides in the harmony of all citizens so Fiera introduces a learned Carmelite who propounds the teaching of St. Thomas Aquinas according to which Justice is identical with the Divine Will and cannot therefore be represented. All Mantegna could do, the dialogue concludes, was to represent Death, for death is the great leveller.

But though the dialogue thus turns away from art it still suggests that the possibility of representing a Virtue as she dwelt in the intelligible world had

occurred to artists and their advisers. After all, the conception of the hierarchy of Beings which, in the Neo-Platonic picture of the Universe, links the idea of the Godhead with the sensible world in an unbroken chain of gradations could readily allot the Platonic ideas a definite place in the supra-celestial spheres. Thus St. Gregory, under the influence of the Areopagite, tentatively identified the Virtues with certain ranks of Angels.[118] If Angels could be represented, so could Virtues. Lomazzo in his handbook makes no difference between these two entities[119] and we have seen that the same ambiguity prevailed in Baroque art.

But since we are normally unable to perceive spiritual beings, we must obviously take Mantegna's road. If we only burrow deep enough into ancient and recondite lore we may find there an allusion to one of the images in which the ancient sages of the East hid their deep insight into the essence of Justice.[120] It was Plutarch, for instance, who reported in *De Iside et Osiride* that the mythical Priest of Egypt represented Justice blind. To paint her blindfolded was thus to reveal a true attribute of the idea of Justice. Unlike the Carmelite in Fiera's dialogue a Neo-Platonist may even encourage him to go one step further and to assume that those whose eyes rest on the figure really do behold the visible form of Justice and therefore their behaviour may or must be affected by what they see.

This attitude would explain the immense care and learning which was spent on the 'correct' equipment of figures not only in paintings but also in masques and pageantries where nobody but the organizers themselves could ever hope to understand all the learned allusions lavished on the costumes of figures which would only appear for a fleeting moment. Perhaps the idea was under the threshold of consciousness that by being in the 'right' attire these figures became genuine 'masks' in the primitive sense which turn their bearers into the supernatural beings they represent. Justice welcoming the King at the city gate during a 'Glorious Entry' was perhaps conceived as more than just a pretty girl wearing a strange costume. In and through her Justice herself had come down to earth to greet the ruler and to act as a spell and an augury.[121]

Apparitions and Portents

There is no weirder aspect of our problem than the evidence which suggests that to the Renaissance not only allegory and pneumatology but even demonology had a common frontier. Pico's nephew Giovanni Francesco not only defended the belief in witchcraft and the persecution of witches with the most learned arguments from the classical authors—he applied the same technique which a Ripa was to use for the interpretation of allegorical figures to the explanation of the physical appearance of evil spirits.[122] His unfortunate witch volunteers the information that the Evil One had appeared to her in human guise but with the feet of a goose,

turned backwards. Pico's interlocutors then discuss over many pages of the dialogue why Satan should have chosen to assume this particular shape.

God does not permit him to express and assume the whole true likeness of man so as to prevent him from deceiving man with the human countenance. But the reason why his feet are different from the other fictitious effigy of man may be that in the mystical sense of the Scriptures the feet are made to signify the affections and desires and that is why he carries them backwards because his desires are always directed against the will of God and turned against well doing. But as to the reason why he rather chose to assume goosefeet than those of any other being I plainly confess that I do not know unless there is some hidden quality in the goose which can be adapted with equal ease to malice.

Ovid, Pliny, Aristotle and Herodotus are then ransacked in search for these 'hidden qualities'. The watchful goose easily disturbs the quiet of the Night, whose patron is Diana. Perhaps, then, the Evil Demon wanted to signify to his nefarious followers that they should likewise remain awake and do without sleep when they go to the Witches' Sabbath. The speed of the geese may be compared to the flight of the witch and Pliny says that geese walked on foot from Belgium to Rome. Some (un-named) writers tell that certain organs of the goose have aphrodisiac qualities, which would again fit in well, and so the argument is developed at leisure. What matters to us is not these abstruse details, nor, in fact, the striking similarity of method between this interpretation and those of the allegorical handbooks but the theory which would link the two. We find it in the passage which stresses that the Devil assumes the shape to indicate his essence to the witches. In other words the younger Pico did not think of demons in the primitive way as visible spirits. He held the correct Neo-Platonic view that the spirits belong to the supra-sensible world and only assume visible form to enable them to have commerce with human beings. It is precisely this doctrine which informs the whole Neo-Platonic argument concerning the true nature of visual symbols. They are the forms which the invisible entities can assume to make themselves understood to the limited human mind. In other words, the Idea of Justice—be it conceived as a member of the celestial Hierarchy or as an abstract entity—is inaccessible to the senses. At best we can hope to grasp it in a moment of ecstasis and intellectual intuition. But God has decreed in His mercy (as Giarda reminds us) that these entities may accommodate themselves to our understanding and assume visible shape.[123] Strictly speaking these allegorical images neither symbolize nor represent the Platonic idea. It is the Idea itself, conceived as an entity, which through these images tries to signal to us and thus to penetrate through our eyes into our mind. Put in this form this conception sounds admittedly abstruse if not absurd. Yet it is only the explicit formulation of an idea which is implied in the whole Neo-Platonic approach to the symbol. The very position which regards the symbol as existing 'by nature' rather than by 'convention' is only understandable, as we have seen, if we accept the

assumption that the higher orders reveal themselves to our limited mind through the sign language of nature. It is not we who select and use symbols for communication, it is the Divine which expresses itself in the hieroglyph of sensible things. To rational analysis this doctrine may reveal one more semantic confusion. It is the confusion between the two meanings of the word 'sign'—the sign as part of a language and the natural sign, or indication. Nothing is more natural than the confusion of these two meanings. For in human intercourse the two merge in fact imperceptibly. There is no clear borderline between blushing as an indication of embarrassment and a frown as a sign of anger. But we have no difficulty in keeping the two apart as soon as we approach nature. We realize that lights on the horizon may be flash signals as communications, signs of distress, or sheet lightning, signs of electrical discharges, indications of approaching storms. To the mind, however, which sees the skies peopled by higher intelligences this distinction is less clear. The lightning on the horizon may be a sign in both meanings of the term, an omen through which an unseen power announces to us an impending disaster. It is therefore less surprising to notice that the sixteenth century did not always distinguish clearly between man-made symbols and supernatural omens. It is well known what importance was attached in the Reformation period to the 'signs of the time', to the miraculous births like the *Papstesel* or the *Mönchskalb* (Fig. 166). Both Luther and Melanchthon applied the subtleties of allegorical or 'hieroglyphic' interpretation to the individual features of these natural symbols: The ears of the *Mönchskalb*, for instance, were said by Luther to denote 'the tyranny of aural confession'. The theoretical justification of this divinatory technique is given by Luther in a little rhyme accompanying a picture of one of these portents:

> Was Gott selbs von dem Bapstum helt,
> Zeigt dis schrecklich bild hie gestelt.

(What God himself believes of Popery is shown in this dreadful picture.)[124]

It is a far cry from Pico's ghosts and Luther's monsters to the creations of allegorical art but in one respect they may rest on a common philosophical foundation. If the forms of spirits and portents can be conceived as signs from God it is only consistent that the forms of visual symbols, too, can be conceived as signs of a suprasensible presence. It is characteristic of Neo-Platonic speculation that it can absorb these conceptions, usually associated with primitive mentality into a self-contained metaphysical system. The theory of emanations, of the 'Great Chain of Being' succeeded in more than one sense in linking the highest with the lowest, exalted contemplation with simple superstitious practice. Divination through monsters and its use in mass propaganda may be close to the lowest level. The feeling of a revelation of universal harmony roused through the aesthetic experience may be its most sublimated form.

Art and Belief

In reconstructing a doctrine of the kind we have attempted to piece together there is always a danger of over-statement. To be sure, the elements existed in European thought, but how far were they accepted as a whole? In other words, have we any right to assume that artists and public alike really saw sixteenth and seventeenth century allegories in this strange light? Did they seriously believe them to be revelations of a higher reality whose very presence exerted its mysterious effects? Have these esoteric doctrines more than a certain curiosity value?

It is certainly not easy to answer this question. Our attitude towards the words and images we use continuously varies. It differs according to the level of consciousness. What is rejected by wide-awake reason may still be accepted by our emotions. In our dreams we all make no difference between the metaphorical and the literal, between symbol and reality. In the dark recesses of our mind we all believe in image magic. Not even the primitive, on the other hand, believes in its sole efficacy. In the history of European thought this duality of attitudes is somehow reflected in the continuous co-existence of Neo-Platonic mysticism and Aristotelian intellectualism. The tension between these two modes of thought, their interpenetrations, conciliations and divisions make up the history of religious philosophy throughout the Middle Ages and the Renaissance.

Both these tendencies certainly had a powerful influence on artists and patrons. Yet it has always been assumed that the Neo-Platonic revival of the Renaissance contributed to the emancipation of art and the acknowledgment of an independent aesthetic sphere. The importance of the new emphasis on Beauty as a token of the Divine and the significance of the new conception of the creative process in art have often been stressed. If our analysis is correct the Neo-Platonic conception of the special virtues inherent in the visual symbol should also have contributed to the new prestige of the figurative arts.

We still know too little about the way in which philosophical ideas percolate, the way in which they are first distilled into slogans which in turn direct the attitude of men towards certain values and standards. It is in this way, so it seems, that the philosopher influences the actions of his contemporaries by a process, almost, of remote control.[125] There are few indications that the leaders of the Florentine 'academy' were much interested in the art of their time. One might read through all the weighty tomes written by Ficino, Pico and Poliziano without suspecting that the writers rubbed shoulders with artists like Leonardo or Botticelli, Bertoldo or Ghirlandajo. And yet, after the lapse of hardly a generation the talk of the studio is filled with Neo-Platonic catchwords and before a century has gone by these slogans have transformed the whole position of the artist and the whole conception of art. It is in this indirect way rather than by detailed instruction that we

may imagine the metaphysical attitudes towards the symbol to have influenced the outlook of the patron and the artist in the period concerned. A glance at the heritage of these traditions in philosophy, science, archaeology and psychology suggests indeed that this kind of influence continues to the present day.

<div align="center">VI</div>

THE HERITAGE

From Giarda to Galileo

Let us return to Giarda for a last time and allow him to sum up his commendation of symbolic images in words which, for all their bombast, still help us to understand the fervour with which the monasteries and churches of Italy, Austria and catholic Germany were crowded with allegories in the subsequent century:

I tremble to praise the wisdom of those men who were the first to fix the symbolical images of the Arts and Sciences. For what could you desire, what would be fitting to demonstrate the excellence of those heavenly virgins, to delight the minds of the beholders and to kindle in the soul of all a flaming desire for them. Do you want the powers of persuasion? These are like silent messengers, dumb interpreters, witnesses worthy of all faith and authority. Do you want the enjoyment of elegance? What type of eyeglass, what mirror, what rainbow in the sky did ever show the sun to such delight of the spectators as the Symbolic Images, those clearer eyeglasses, those more brilliant mirrors, those more gorgeous rainbows, which show the forms of the Sciences in the most elegant way? Or do you want the gift to rouse the passions? The golden chains which were said to issue from the mouth of Hercules and to bind the ears and minds of men are as nothing compared to the attraction exercised by this art.[126]

Four years after Giarda published his little pamphlet an infinitely greater adherent of Platonism wrote another eulogy of painting and of the powers of the human mind: I am referring to Galileo Galilei, whose Dialogue on the *Two Main Systems*[127] reflects and surmounts the Platonic conception of the two modes of knowledge. For Galilei contrives to exalt the higher form of knowledge without devaluing discursive reason, as Tasso, for instance, had done. But then Galilei's primary subject in this passage of great beauty is not poetry, but the science of mathematics. The truth at which we arrive through mathematical proofs, he says, is the same truth which is also known to Divine Wisdom. But God's mode of knowledge is clearly infinitely superior to ours.

We arrive at our limited knowledge by discursive reason from conclusion to conclusion, while God's infinite awareness of all propositions is based on pure intuition. For instance, if we want to gain the knowledge of a few properties of the circle—of which there are infinitely many—we start from one of the simplest, and taking this as our definition, we

proceed discursively to another, and thence to a third, then to a fourth and so on. The Divine intellect grasps through the pure apprehension of its essence without any discourse in time all the infinite properties, which are then virtually implied in the definition of all things and which finally, since they are infinite, are, in the Divine mind, perhaps only one in essence. To the human mind this is not totally unknown, but dimmed by a deep and dense darkness, which only partly becomes more transparent and clear when we have mastered some firmly demonstrated conclusions and have appropriated them so fully that we can rapidly move from one to the other.... Thus I conclude that as far as the mode and the number of things understood is concerned our understanding is infinitely surpassed by God's, and yet I would not decry it so as to consider it nothing at all. Rather, when I consider how many and how wonderful things men have understood, investigated and worked, I clearly know and understand that the human mind is God's work, and one of the noblest.

It may be no accident, that in the magnificent peroration which follows, the founder of modern science proceeds to praise the visual arts only to subtly lower their status by his praise of the marvel of writing:

When I see a statue of one of the great masters I tell myself: 'Whenever would you be able to remove the surface of a piece of marble and uncover a figure of such beauty which was hidden within? Whenever blend and spread various pigments on a canvas or a wall and by that means represent all visible things as a Michelangelo, a Raphael or a Titian? When I consider what men have discovered in dividing the musical intervals and establishing the rules and precepts to control them to the marvellous delight of the ear, when could I ever cease to wonder? What should I say about so many and so diverse instruments? Reading the outstanding poets, with what feelings of the miraculous do they inspire anyone who attentively considers their inventions, their conceits and their expositions? What should we say about architecture? What about the art of navigation? But beyond all the stupendous inventions what eminence of mind was possessed by him who had the imagination to find a way of communicating his most recondite thoughts to any other person whatsoever, how ever far away he might be in space or in time? To speak with those who are in the Indies, to speak with those who are not yet born nor will be born before a thousand or ten thousand years? And with what ease? By the various arrangements of twenty little marks on a piece of paper. Let this be the seal of all the admirable human inventions and the end of our conversations today....

The Age of Reason

In the year 1726 there appeared, posthumously, Joseph Addison's *Dialogue on the Usefulness of Ancient Medals*. The little work marks a turning point in the conception of symbolism. Addison takes issue with a tradition of learning which he contemptuously dismisses as that of the 'mystical antiquary'. From the way he describes it the reader of this volume will have no difficulty in recognizing the representative of the Neo-Platonic philosophy of symbolism. A mystical antiquary to whom you show a Roman coin with a shield on the reverse (Fig. 167)

shall tell you that the use of the shield being to defend the body from the weapons of an enemy, it very aptly shadows out to us the resolution of continence of the Emperor, which made him proof to all the attacks of fortune or of pleasure. In the next place, the figure of the shield being round it is an emblem of perfection, for Aristotle has said that the round figure is the most perfect. It may likewise signify the immortal reputation that the Emperor has acquired by his great actions, rotundity being an emblem of eternity that has neither beginning nor end. After this I dare not answer for the shield's convexity that it does not cover a mystery, nay there shall not be the least wrinkle or flourish upon it which will not turn to some account.[128]

It should not surprise us that in opposing this mystical conception of the 'open sign' with its plenitude of meaning Addison appeals to the alternative tradition in the philosophy of symbolism. To him the symbols on the reverse of coins are not the revelation of unfathomable ancient wisdom, they are illustrated metaphors. Drawing on the identification of the metaphor with the poetic or rhetoric simile familiar from Aristotle's analysis he suggests that a knowledge of such linguistic uses must yield the key to the images on coins. We know that the ancients called Fabius Cunctator 'the Shield of Rome'. If the Roman Senate had a shield placed on an Emperor's coin they probably wanted to praise him as another Fabius.

From the historian's point of view Addison's proposal was not much better than that of the mystical antiquarian. The most likely explanation of the shield on a coin is its use as a trophy of victory. But what is relevant in our context is that in the eighteenth century the irrational conception of the symbol as a repository of an ancient revelation is held up to ridicule and dismissed in favour of the Aristotelian interpretation of the symbol as an illustrated metaphor.

One of the consequences of this new outlook was referred to at the very outset of this essay.[129] The Age of Reason dismissed the mysterious image as an absurdity. We have seen how Abbé Pluche in 1748 demanded clarity and rationality in allegorical imagery. In the eighteenth century the emphasis had shifted from the message of mystery to the message of beauty. Not that the guardians of the tradition in art, the Academies, belied their name by rejecting the Platonic doctrine outright; but it is now overlaid with Aristotelian rationalism.

Classicist teaching is identified with the demand that the artist should never copy crude nature but rather idealize it. But in this teachable version the element of ecstasis, the possibility for the true genius of seeing the ideas in a moment of rapture is rather played down. The student can find a repertory of Platonic ideas not in the intelligible world but in classical statues or their plaster casts. There is at least a suggestive parallel between this doctrine according to which the Idea had revealed itself to the ancients and the emphasis in Renaissance Platonism on the images of the past which embody a divine truth.

But even their divinity has been rationalized. There was an increasing identification of the Platonic idea with the Aristotelian interpretation of the universal

concept. What we see with our bodily eyes is inevitably the particular. Only through the process of generalization can we arrive at the universal. In the ancient statue this process of abstraction has already been performed. The 'accidents' of matter are not represented there. The classical artist does not portray the individual, but the type, not a particular man, but man as such.[130]

It was an unsuccessful rationalization. For while the mystical interpretation of the artist's vision may be claimed to have been at least self-consistent, this rationalized version carried the seeds of its own destruction. The idea of an inductive process through which we can rise from the particular to the general by leaving out individual traits has been challenged in logic—in the realm of the image it certainly rests on no foundations. A moment's reflection will show that the most schematic or rudimentary image can be intended as a representation of an individual while the most detailed portrait can stand for the concept or type.[131] It is not the degree of naturalism which determines the question whether the image of a horse is to serve as a symbol for the universal concept 'horse' or as a portrait of a particular horse. A photograph in a textbook or on a poster may represent the type or serve as a symbol—a mere primitive scrawl may be intended as a representation of the individual. Only the context can determine *this* distinction between symbol and representation.[132]

May be it was this Academic identification of the abstract with the generalized which finished allegorical imagery as a branch of art. The phrase of the 'bloodless' abstraction was no empty metaphor. Artists began to think that the more generalized was the concept they had to symbolize the paler and more etiolated should be the image (Fig. 168). Thus the visual symbols of invisible entities became more shadowy every day. Even in the nineteenth century they continued to parade their emblems on the corners of monuments and on the pediments of museums and stock-exchanges[133]—but they had acquired the faculty of making themselves as invisible as the abstractions they were supposed to symbolize.

Allegory versus Symbol

It is well known that this conception of Allegory gave the genre a bad name. It also led to a search for alternatives. It was this search which led philosophers of art in Germany to invest the word symbol with a new aura of mystery. If allegories were purely cerebral pictographs in the shape of insipid women in white dresses parading some conventional attribute, symbols would have to be different, more vital, more forceful and more profound. It is noteworthy that the Anglo-Saxon world never accepted this semantic proposal. In English the word symbol can be used for almost any sign in mathematics, logic or advertising. The O.E.D. gives 1620 for the term as meaning 'A written character or mark used to represent something; a letter,

figure or sign conventionally standing for some object, process, etc.' and 1700 for algebraic symbols.

This divergence of usage, which has sometimes led to misunderstandings, is not entirely due to the German Romantics.[134] Paradoxically it was the rationalist Immanuel Kant who harked back to the Platonic tradition in his discussion of aesthetic apprehension. In Paragraph 69 of the *Critique of Judgment* Kant protested emphatically against the 'wrong and absurd' usage of the word symbol among the new logicians who separated the symbolic from the intuitive act. Kant saw the symbolic as a species of the intuitive, he wanted to stress its opposition to 'discursive' thought. We are familiar with this opposition of the two modes of knowledge from the Platonic tradition that entered Christian thought particularly with the writings of the Areopagite. Kant directly appeals to this tradition when he calls all our knowledge of God merely symbolic.

Yet it would be too simple to equate what may be called the anti-rationalist conception of symbolism with the Neo-Platonic heritage. It could not have survived with such strength if it had not become fused with the very element of the Aristotelian tradition which Addison had employed in his criticism—the theory of metaphors. It was in the turbulent and immensely fertile writings of Giovanni Battista Vico that this transformation of the tradition first took shape.[135] Writing during the same decades in which Addison had attacked the mystic antiquarians Vico wished to demolish the prevalent faith in the superior wisdom of the ancients and in the true significance of the hieroglyph as a repository of revelation.

We must uproot the false opinion held by some of the Egyptians that the hieroglyphics were invented to conceal in them their mysteries of lofty esoteric wisdom. For it was by common natural necessity that all the first nations spoke in hieroglyphics.

The natural necessity to which Vico appeals is the need of the primitive mind to think and speak in metaphors. For in Vico's 'New Science' the metaphor is no longer seen as an adornment of speech, a kind of artifice which the orator or poet finds it useful to analyse and master. We cannot but think in metaphors and if this is true of man in this later period of history when rational thought has been developed and cultivated this need must provide the key to the mentality of earlier periods which gave rise to myth and poetry.

'It is . . . beyond our power', he says in a famous passage, 'to enter into the vast imagination of those first men whose minds were not in the least abstract, refined or spiritualized, because they were entirely immersed in the senses, buffeted by the passions, buried in the body.'[136]

Thus he developed his theory of the mentality of primitive man who becomes a poet by force of circumstance, creating images and symbols not out of superior wisdom, but as tools to come to terms with a world he does not understand. If all

languages use metaphors taken from the body and speak of the mouth or the arm of a river, the foot of a mountain, the teeth of a comb, the neck of a jug and so on, the reason must be that man himself is 'buried in the body' as Vico puts it, and tries to relate the unknown to the known. If rational metaphysics tells us that man becomes all things by understanding them (*homo intelligendo fit omnia*), the new imaginative metaphysics at which Vico is aiming shows that primitive man becomes all things by not understanding them (*homo non intelligendo fit omnia*).[137]

Vico tried in fact to formulate his tremendous new insights in terms of traditional Aristotelian logic. Myths and symbols, in his view, can best be described as 'imaginative class concepts or imaginative universals'. They are the terms in which people think in the pre-rational phase of history. It should not be too hard to lucidate this startling formulation through reference to the Aristotelian tradition, of symbolic demonstration. Ripa's *Severity*[138] may represent a rational concept, but it is adumbrated in art by 'imaginative universals, such as the cube, which presents a metaphor of a stable shape, or the tiger, which embodies severity concretely to the irrational mind. Vico's own example for the poet's imaginative universals are the types created by a playwright such as Menander. The physiognomic types of personification such as Ovid's *Envy* would fit his definition quite well.

Reading Vico we find in fact that his break with the past is less radical than his revolutionary theory makes us expect. Just as the theory of metaphor proved an inadequate instrument in the hands of Addison to interpret the symbols on coins, so Vico's attempts to interpret the myths and images of the past result in fantastic reconstructions which are no less abstruse than are the interpretations of the 'mystic antiquarians'. He set great store by his interpretation of heraldic signs which he took to be tokens of ownership and to have preceded the written word both in antiquity and in the corresponding phase of the second development, in the heroic Middle Ages. As an example of the uniform character of these signs and emblems in all cultures he points to the Eagle on the sceptre, a symbol which was used alike by the Egyptians, the Etruscans, the Romans and the English who, he says, still use it as an ornament of their royal arms. This is explained by 'a uniformity of ideas for in all these nations, divided though they are by immense tracts of land and sea, the symbol was meant to signify that the realms had their origin from the first divine Kingdoms of Jove, by virtue of his auspices'.[139]

There is a curious paradox in Vico's outlook and method which make his writings hard to digest: his rejection of the current veneration for the wisdom of the hieroglyphs is justified by an appeal to the wisdom of the hieroglyphs. He had read of the sequence of scripts in ancient Egypt from hieroglyphic to hieratic and hence to demotic, from the image to letters, and he saw in this development a profound parable of the course of cultural evolution from image thinking to rationality. Thus he also found it best to sum up and explain his New

Science in terms of an emblematic picture that forms the title-page to his revolutionary book and represents the 'new Homer' that his researches had revealed to him as a mythical figure.

Whatever Vico himself may have thought about the place of imaginative thought in the scheme of human development, it could certainly be assimilated to the Neo-Platonic tradition he wanted to supersede. For had not Tasso hinted that there may be two kinds of imagination, the lower one, which produces deceptive dreams, and the higher one, which was superior to reason and could be equated with that undivided intuition that the Areopagite had attributed to the higher intelligences? It would be fascinating to trace in detail the way through which Vico's doctrine of the temporal primacy of the imagination became reformulated in Neo-Platonic terms. The poet again becomes the *vates*, the seer, and what he saw at the dawn of mankind must be treated with awe as a revelation.[140] If the symbol was a necessity for man in his efforts to adumbrate the unknowable, it also was a necessity for the higher powers who could only communicate with us by accommodating their transcendent knowledge to our dimmer understanding. God spoke to early man as a father speaks to his young children, in a way adapted to their understanding. Thus a new twist is given to the ancient belief in a *prisca theologia* enshrined in myths and symbols. They should not be understood as an esoteric code to hide the truth from the profane, but as a necessity, in Vico's terms, which sprang from the disposition of early man to think in images. Inadequate as this mode of expression may have been to the divine mysteries it attempted to articulate, it can still be regarded as a form of revelation which proud reason should not be allowed to despise or obscure.

It is along this line that the opponents of the enlightenment fight their battle against the encroachments of rationalism. Art must be allowed its link with the imagination, for the imagination sees further than 'ageing reason'. As Schiller put it in his poem *Die Künstler* (1789) (The Artists):

> Was erst, nachdem Jahrtausende verflossen,
> Die alternde Vernunft erfand,
> Lag im Symbol des Schönen und des Großen,
> Voraus geoffenbart dem kindischen Verstand . . .
> Eh vor des Denkers Geist der kühne
> Begriff des ewigen Raumes stand,
> Wer sah hinauf zur Sternenbühne
> Der ihn nicht ahnend schon empfand?

(What ageing reason had only found after thousands of years had elapsed, was pre-revealed in the symbol of the Great and Beautiful to childlike understanding.

Before ever the philosopher could contemplate the bold concept of eternal space, who would look up to the starry heavens and not sense it intuitively?)

The sober answer to Schiller's rhetorical question may well be, that nobody did. But the implication that the Great and the Beautiful provide the mind with a symbol through which we can grasp a hidden truth certainly led back to Platonism. And while German classicism had thus taken the upward path on the ladder of analogy through the image of harmonious forms to the idea of harmony, Romanticism re-discovered the Areopagite's alternative, the power of the mysterious and the shocking to rouse the mind to higher forms of thought.

Of course these doctrines had continued to exert an influence underground, as it were, in the mystical movements of Jakob Boehme, Swedenborg and others which fascinated artists such as Blake or the Dutch proto-Romantic Humbert de Superville. Blake, that implacable opponent of the dominance of Reason, it will be remembered, published an engraving of the Laocoon Group (Fig. 169) which is taken to be a copy from the Cherubim of Solomon's temple and explained as a revelation of the metaphysical truth connected with the identity of good and evil. But while Blake had to wait for the twentieth century till his prophecies met with response in England, Romanticism found a more fertile soil in Germany, where Friedrich Creuzer revived the Neo-Platonic approach to ancient religion in learned books on mythology.[141]

The Revival of Neo-Platonism from Creuzer to Jung

A few quotations from Creuzer's *Symbolik* of 1810 may serve to document his kinship with the hieroglyphic tradition:

It is precisely through its lack of harmony between form and meaning and through its superabundance of content as compared to its expression that the symbol becomes significant and rousing. . . . Contact with the symbol is a moment which demands our whole being, the vision of a boundless distance from which our spirit returns enriched. For this instantaneousness appeals to a receptive imagination while our reason experiences an intense pleasure in analysing the totality which the concise image concentrates in one moment into its element and in assimilating them one by one. . . . Whenever the creative mind takes up contact with art or dares to crystallize religious intuition and faith in visible shapes the symbol must expand to become boundless and infinite. . . . In this striving it is not content with saying much, it will say everything; it desires to encompass the immeasurable. This sacred discontent is solely impelled by the dark urge of faith and intuition but in its . . . hovering lack of definition it must become enigmatic. . . . We call symbols of this character mystical. There is another alternative of the symbol restraining itself. . . . It is in this restraint that it succeeds in the hardest achievement, in making even the Divine visible. . . . It attracts the beholder with irresistible force and touches our soul with the necessity that belongs to the World Spirit. It is astir with the exuberance of upwelling living ideas; and whatever reason conjoint with the understanding aims at with their chains of successive propositions and conclusions it can gain here totally and in one moment an alliance with the senses.[142]

Creuzer insisted explicitly on the distinction between this notion of the symbol and that of a mere emblem which he feels to be entirely devoid of that significant dignity. What marks the symbol is precisely its clouding darkness, which is of course incompatible with the clarity of a sign.

Creuzer's use of the term was taken up by Goethe in the later years of his life who lent it his unquestioned authority. Moreover it was adopted by Hegel in his Aesthetic and this fact too was of great importance for its subsequent usage in German philosophical writings and in the literature which fell under its sway.

In Hegel's conception of history as a dialectical progress of the spirit the symbol is called a kind of 'pre-art', *Vorkunst*, which belongs mainly to the Orient. For Hegel art begins with what he calls 'unconscious symbolism'. His picture of Indian and Egyptian art corresponds to this idea of a phase in the development of the spirit where it still strove in dreamlike confusion for a visible expression:

The very appearance of Egyptian works of art makes us see that they contain riddles to which not only we ourselves lack the key but even those who pose them to themselves.[143]

For what characterizes the symbol in Hegel's usage is precisely the quality he calls 'inadequacy'. The symbol is a groping adumbration of something inexpressible. The monstrosity of Indian and Egyptian divinities with their animal forms and their inorganic features are for Hegel the hallmark of this inadequacy. He contrasts this symbolic art which, to him, stands only in the forecourt of the temple of art with the art of the Greeks which for him, as for Winckelmann, reveals the essence of art as such. Here meaning and sensuous appearance, 'the inward and the outward . . . are no longer distinct. . . . The manifesting and the manifested is resolved into a concrete unity'.[144]

For Hegel and his contemporaries the Apollo Belvedere was not a mere symbol of the sun god, it was a genuine manifestation of the divine in human form, a real creation of an 'adequate' form which could be sure of the consent of all right-minded judges of art.[145]

True to his principle of 'dialectics' Hegel had thus contrived to combine the two contrasting approaches to the symbol of Dionysius Areopagita, making them links in a chain of development. The mysterious, inadequate symbol or hieroglyph is superseded by the classical image of beauty which is a true but limited analogue of the divine. The limitation, in its turn, serves Hegel as a principle of contradiction that propels art onto the more spiritual plane of medieval Christian symbolism and onwards.

There is no doubt that the conception of art as an instrument of spiritual revelation which thus became part and parcel of the German tradition had a real influence on the way the educated approached works of art. There is a tell-tale sign of this connection on a title page of Haslinger's edition of Beethoven (Fig. 170).

It shows the symbol of light, the analogue of the divine, but also the ubiquitous hieroglyph of eternity, the analogue of mystery through which music is marked as a token of the ineffable. We are reminded of Hegel's great opponent, Schopenhauer, who still thought of music as a representation of the Platonic ideas.

One more quotation must suffice to document this tradition in which the symbol is set up as a counter to mere discursive reason.

It comes from the writings of another archaeologist, the Swiss classical scholar Jakob Bachofen, who reiterates the old doctrine in new words:

The symbol evokes intimations, language can only explain. The symbol touches all the chords of the human heart at once, language is always forced to keep to one thought at a time . . . language strings together isolated parts and can only affect the mind piecemeal. If anything is to gain power over consciousness, however, the soul must of necessity apprehend it in a flash . . . symbols are signs of the ineffable, inexhaustible, as mysterious as they are necessary.[146]

The road that leads from the Romantic belief in the superiority of the symbol to the Neo-Romantic movements of the symbolists and their twentieth-century successors has often been traced. But a word may still be said about the thinker whose concept of the symbol has had the most far-reaching influence on our century—Sigmund Freud. Freud, of course, saw himself as a rationalist exploring with the means of science the irrational layers of the mind. It may be claimed that in this and in many other respects his position in relation to current opinions resembles that of Vico in the eighteenth century. Just as Vico was rooted in the tradition he tried to transform, a task in which he only partially succeeded, so Freud derived many of his ideas about symbolism and the unconscious from Romanticism, thus enabling Romantics to re-absorb his formulations.[147]

The link between Freud's theory of the dream and the Romantics is provided by the book on the Dream by the Hegelian Volkelt, who drew attention to an earlier study in which the link between body imagery and the dreamer's experience were first explored. Scherner[148] had noticed dreaming of a rock hanging over a precipice and discovering that he had been in danger of falling out of his bed. His conclusions about the importance of the body for the metaphors of the dream remind us indeed of Vico's insistence on the psychological disposition of the primitive mind to see everything in terms of the body.

There is no difficulty thus in subsuming Freud's concepts of symbolism including sexual symbolism under the ancient theory of metaphor. But for Freud the metaphor is not overt but unconscious. Like the apophatic symbols of the Areopagite Freud's symbols also tend to be enigmatic, monstrous and opaque. They are in fact the masks the unconscious wishes must don to pass the censor; their meaning is only accessible to the initiated. What they share with the mystic tradition is not only their character as revelations of an otherwise unknowable and ineffable realm,

they also embody the irrational anti-logical character of that realm where contradictions are fused and meanings are merged. The plenitude of meaning of every manifest symbol is practically infinite in its overdetermination. It is free association, that will reveal to the dreamer these infinite layers of significance behind the apparent absurdity of the manifest content.

And just as Vico's revolutionary insights were fused with a revived Neo-Platonism, so Freud's discoveries were again connected with this age-old tradition in the writings of Carl Gustav Jung. Here the Freudian concept of the symbol regressed, as it were, to its origins in Neo-Platonism.[149] This is achieved—or so it seems—by fusing the transcendent realm of the religious tradition with the ineffable content of the collective unconscious that talks to us in riddles—but riddles for which the key is again provided in the wisdom of the ancients.

<p style="text-align:center">* *
*</p>

The Platonic and the Aristotelian traditions which have here been traced in their attitudes to symbolism may be said to represent two fundamental reactions to the problem which the existence of language poses for every reflecting human being. It was the Platonists who made man feel the inadequacy of 'discursive speech' for conveying the experience of a direct apprehension of truth and the 'ineffable' intensity of the mystic vision. It was they, also, who encouraged a search for alternatives to language in symbols of sight and sound which could at least offer a simile for that immediacy of experience which language could never offer. It was this attitude too that encouraged the Romantic to seek instruction from the child, the dreamer and the primitive who must have known the world before it was strained through the filter of language. But much as art owes to this impulse, we must also acknowledge the dangers which have always lain in wait of those who spurn rational speech, the lapse into inarticulacy, insanity and, worst of all, inanity, the triviality that masquerades as profundity.

It may be argued that the Aristotelians, by contrast, kept this reaction alive by overrating the powers of language. Language, after all, is a tool, an 'organon' developed by mankind under the evolutionary pressures which favoured collaboration and communication between members of a clan or tribe. It thus became adapted to the intrasubjective worlds of facts and of arguments. It could never have performed these functions if it had not categorized the world of experience and formalized the structure of statements. The way it fulfilled this task was of course first described by Aristotle, but it is notorious that the Aristotelian tradition tended to take the categories of language for the categories of the world. In thus overlooking the blank patches on the map of experience left by language the Aristotelians did not only fail to take account of those exalted moments the Platonists

wanted to convey. They failed to notice the inadequacy of language for the communication even of very commonplace subjective experiences such as muscle tone or moods. But while they overrated the power of language as a finite system they did less than justice to its flexibility and powers of creative growth. I have argued here in connection with the theory of the emblem that the Aristotelian conception of metaphor which only sees the 'transfer' of existing categories across a pre-existent network of concepts obscures the central importance of this resource which allows the speaker to re-structure reality in a passing image or a more permanent coinage. It has been equally claimed that the Aristotelian system of logic made language appear like a closed prison and that only the conception of logic as a 'meta-language' for the discussion of statements and inferences has made us understand the way knowledge can grow.

These technical points may seem to lead far away from the immediate subject of this essay. But maybe it is only by learning to appreciate the marvel of language that we can also learn to understand the growth of those alternative systems of metaphor which make great art more profound than any mystic hieroglyph can ever be.

Appendix: *Introduction to Christophoro Giarda,*
Bibliothecae Alexandrinae Icones Symbolicae

taken from J. G. Graevius and P. Burmannus,
Thesaurus Antiquitatum et Historiarum Italiae, vol. IX, part 6

1. (*Ideas Made Visible*)

Cum omnis de scientia, & virtute doctrina hominibus est utilis, tum longe omnium maxime Imaginum symbolicarum Inventrix, & Architecta, cujus beneficio animus e caelo in hanc obscurissimam corporis specum depressus, suisque in actionibus ministerio sensuum addictus, virtutum, & scientiarum pulchritudinem, & formam ab omni licet materia secretam, coloribus tamen adumbratam si minus perfecte expressam intuendo, in amorem, & illarum cupiditatem vehementius excitatur. Amor enim cognitionem, tamquam parentem amplexatur suam, cui, nisi per intimam conjunctionem, pulchrum, & bonum nubant, pulcherrimam amoris prolem in cujuspiam mente nunquam procreant. Quid autem, aut a natura pulchrius fictum, aut ab immortali Deo concessum melius ipsius virtutibus, & scientiis? quae si oculis, ut res aliae, cernerentur, profecto tam admirabiles sui amores in omnium cordibus gignerent, ut spretis voluptatibus, dominandi libidine neglecta, extincta divitiarum cupiditate ad illarum prosecutionem omnes convolarent. Nunc autem scientiae, rerum cognoscendarum Dominae, ac Reginae, agendarum vero Judices, & Arbitrae, quamquam ejus sint naturae, ut sua luce, non minora solum astra, verum ipsum etiam Solem in contentionem adductae inumbrarent: mens nihilo minus humana domicilio corporis inclusa, noctuae persimilis, immensum splendorem haud potest irretortis oculis sustinere. Est enim mens oculus animi.

2. (*The Language of Accommodation*)

Itaque, quemadmodum ignis, si crassioris hujus materiae pastu alatur, a nobis videtur; sin suam in patriam purior remearit, omnem effugit sua puritate oculorum aciem: ita prorsus nobilissimae artes, & disciplinae abstractae sensibus, quo sunt in se clariores, eo a nobis minus cognoscuntur, concretae autem ratione aliqua, & praecellenti colorum temperamento nostris mentibus accommodatae, facilius, melius, clarius suspiciuntur. Quod si una omnium sapientissimorum virorum conspiratione, & suffragio amari minime id potest, quod, aut ratione, aut sensu aliquo non cognoscitur; cognosci autem sensibus nihil potest, quod non sit veluti corpus, nihil intelligi mente sic depressa, quod non habeat corporis similitudinem; quis est, qui satis aestimet, quantum iis debeamus, qui, dum scientias ipsas, & artes praeclarissimas imaginibus expresserunt, illud sunt assecuti, non modo, ut illas cognosceremus, sed ut oculis quodammodo intueremur, versaremur simul, atque cum ipsis paene familiariter variis de rebus colloqueremur.

3. (*The inventors of the various Liberal Arts such as Moses, the founder of Divinity, Socrates, the inventor of Philosophy, Euclides, Ptolemaeus, etc. were rightly honoured by the ancients like gods and rewarded with immortal fame*)

Bene de sacrarum literarum monumentis meritus est *Moyses*, qui illas primus a Deo accepit, & tabulis consignatas ad omnem posteritatem transmisit. Magistrum sententiarum

omnis Theologorum schola ad caelum usque sustollit, quod ante alios omnes doctrinam caelo submissam ad severiorem disputationis methodum revocarit. Nam sapientissimis legum latoribus, divinos honores a populis decretos vaiiis legimus, quod suas urbes melioribus temperarint institutis. Quis enim ignoret *Socratem*, eam potissimum ob causam, sapientissimum virorum *Apollinis* oraculo declaratum, quod piinceps e caelo philosophiam evocasse crederetur? Ut interim omittam *Aesculapium* medicae artis inventorem, quem tamquam numen antiquitas omnis venerata est: Quo in honore Chirurgorum parens *Chyron*, qui etiam huic arti nomen dedit, ab omnibus semper habitus est? Te vero, *Euclides*, principem suum profitentur Mathematici: te suum ducem Astrologi, *Ptolomaee*, vocant; tibi adhaerent uni & Geometrae, & Cosmographi: Nam Architectos, non tam imitatores suos, quam laudatores habet *Vitruvius*. Nihil dicam Poesis, quemadmodum conditores tuos Deorum filios nuncuparis. Quid enim esse ad laudem oratoriae facultatis illustrius potest, quam, ut *Demetrio Phalareo* eloquentiae professoii supra trecentas sexaginta statuas *Athenienses* soli excitarint? Jam historia, & historiae soror eruditio dici vix potest, quibus laudationum generibus suos parentes fuerint prosequutae. omnes denique quotquot unquam post liberalium disciplinarum inventum genus, aut illas cogitatione animi foecunda apud se concepere, conceptas, in orbem invexere, aut alieno ex capite nascentibus sunt obstetricati, aut natas sua industria educarunt, educatas meliorem ad formam provexerunt, amplissimam suorum laborum mercedem, ac praemium, nominis immortalitem retulerunt.

At enim Doctrinae symbolicae magistri, qui has ipsas facultates praestantissimas oculis potius, quam animis subjiciendo, familiares illas, & quadam ratione domesticas hominibus effecerunt, soli omnium fraudabuntur debito laudis praeconio? mihi vero, quemadmodum nulla alia videtur, aut ad doctrinam aptior, aut elegantior ad suavitatem, aut ad perturbationem validior, hac ipsa, quae Icones symbolicas expressit: ita, qui primi artem hanc excogitarunt, non illos cum earumdem disciplinarum primis auctoribus confero, sed ipsi rerum omnium molitori, ac opifici Deo simillimos judico.

4. (*The Ideas dwell in the Mind of God*)

Viguerunt ante omnium saeculorum memoriam, vigent, vigebuntque semper in mente numinis opulentissima filiae ejusdem pulcherrimae virtutes, neque tamen a matre ullo modo distinctae, sapientia, bonitas, vis cunctorum effectrix, pulchritudo, justitia, dignitas, ac reliquae ejusmodi plurimae. Quae noscerentur, amarenturve plurimum, dignissimae omnes erant: tamen, ut prae nimia sui generis claritudine intelligi: ita prorsus ignoratae nulla poterant ratione amari. Quid hic faceret earundem parens Deus? pati, ut tam illustres filiae ab omni hominum notitia penitus sejunctae aeternum prorsus occultae suamet in luce delitescerent, haud videbatur decorum. eas vero in adspectum, oculosque mortalium adducere qui poterat id fieri, cum illinc divinarum virtutum praecellens fulgor, hinc nostrorum ingeniorum crassior hebetudo vehementius officeret?

5. (*Nature a Book of Symbols*)

Dixit, ac unius prolatione Verbi quot elementa, ac in elementis, quot rerum genera, quot in terris quadrupedum species, quot formas piscium in aquis, quot in aere volucrum discrimina, quot in sphaera ignis prodigia, quot in caelo stellas, & lumina, tot quasi perfectionum uarsum Icones symbolicas, semel, ac simul delineavit, effinxit, & in hac orbis Bibliotheca, nisi malis Theatro contemplandas hominibus proposuit.

Eant nunc mortales, querantur modo, negent, si possunt, aditum sibi ad rerum divinarum contemplationem facillimum patere, quando res omnes, quae sensibus percipiuntur, illarum sunt imagines, & quamquam imperfectae, quarum tamen adspectu, & contentione, earumdem dignitas conjici satis possit.

6. (*Superiority of Vision*)

Mihi credite; ratione haud absimili, hospites, & quasi peregrinae in hominum caetibus artes, & scientiae versatae fuissent. Nemo illas facie, pauci etiam nomine illas novissent: memoratum saepius, repetitumque nunc philosophiae nomen, jam eruditionis, aliarumque disciplinarum, sed vix prolatum, tamquam umbra evanuisset; neque quispiam apud se notitiam illarum retinuisset, praeter eruditos, si tamen hoc eruditi homines ipsi assequuti fuissent, nisi caeleste hoc institutum symbolicarum imaginum, praestantissimam illarum naturam clarius exprimendo in oculis, animisque omnium defixisset, suavitatemque ostendendo ad earum benevolentiam, ac studium, vel imperitos pertraxisset. Quid enim est, per caelitum, hominumque fidem, quod harum optimarum, facultatum vim demonstret validius, suavius recreet, commoveat vehementius hoc ipso usu Iconum symbolicarum doctissimo, eodemque plenissimo eruditionis?

Caetera probationum momenta, quae possunt afferri, & numero multa, nec virtute quidem sunt infirma; tamen acutissima ingenia, ut intelligantur, requirunt: at Icones symbolicae occurrunt ipsae contemplantibus, ac oculis intuentium sese ingerunt, per hos autem, se animis insinuant, declarant, quae nam sint, antequam perquirantur, hancque suam ipsarum humanitatem adeo prudenter temperant, ut imperitis, tantum personatae, reliquis vel mediocriter eruditis, operto vultu, omni persona exutae videantur. Quanta porro voluptate id efficiant, ipsa si loqueretur suavitas, oratione sua haud assequeretur.

7. (*The Effects of the Image*)

Primum enim habet hoc omnis imago, & similitudo, seu verbis efficta, seu coloribus expressa, ut auditores plurimum, spectatoresque delectet. Itaque sapientissimos Poetas, & Oratores, quorum illud munus, ac institutum est, ut in oratione suavitatem utilitati admisceant, Poeticis saepius, ac oratoriis imaginibus usos reperimus. Deinde maximus voluptati cumulus accedit, cum est alicujus imago rei, aut personae, quae a nobis maxime diligatur. Tunc enim quemadmodum vicaria fungitur tacite illius munere, quae abest, ac si adesset. Postremo, nisi vis haec simulachris maxima indita esset, ut animos intuentium ad eorum pellicerent amorem, & imitationem, quos exprimunt: an Graeci, an Romani, omnium populorum sapientissimi publicas aedes, privatasque virorum praestantissimorum imaginibus complevissent? an etiamnum Principes viri filiarum suarum, quas habent nubiles, tabulas diligenter elaboratas ad alios Principes transmitterent?

Hic igitur laudare verear illorum consilium, qui has artium, & scientiarum Icones symbolicas primi omnium confinxerunt. Quid enim in illis desideres, quod si haberent, appositas crederes ad ostendendam caelestium virginum praestantiam, ad oblectandos spectantium animos, ad mentes omnium desiderio, ac flammis earumdem incendendas? An vim probationis? quae sunt veluti elingues nuntiae, mutae interpretes, testes vero omni fide, & auctoritate dignissimae? An voluptatis elegantiam? quod unquam perspicillum, quod speculum unquam, quis arcus in nube rorida effictus tanta cum intuentium voluptate Solem expressit, quanta symbolicae imagines, perspicillis clariores, nitidiores

speculis, floridiores Iride, scientiarum formas elegantissimas ostendunt? An denique perturbandorum affectuum gratiam? aureae catenulae, quae ex ore Herculis profluentes dicebantur hominum, & aures, & animos vincire, ac post se vinctos trahere, si cum Iconum gratia conferantur, nullius momenti in hac trahendi arte judicentur.

8. (*The Tradition of Primeval Wisdom*)

Intellexere arcanum hoc ab ipsius nascentis mundi origine prisci illius saeculi homines sapientissimi, a quibus primum hic efformandarum imaginum usus profluxit, atque cunctorum saeculorum intervallis labentibus per omnium paene auctorum nationes pervagatus ad hanc usque nostram aetatem dimanavit. Quis enim in memoria vetustatis ita peregrinatur, qui duas illas memorabiles columnas, lateritiam alteram adversus vim ignis, alteram marmoream adversus impetus aquarum excitatas olim non audierit, aut legerit, in quibus disciplinae omnes effictae, ac sculptae posteris superstites transmitterentur?

Nam ab illis praeclaram Hieroglyphicorum doctrinam, quam nos tantopere admiramur, *Aegyptii* mutuati sunt. quorum insistentes vestigiis *Graeci*, nullam plane artem, ac disciplinam reliquerunt, quam imaginibus symbolicis non decorarint. Quod enim lapidis, aut metalli genus est, in quo illi scientiarum formas non expresserint? Quae species coloris, quam in iisdem effingendis omiserint? Res erat, quae non vulgarem saperet eruditionem, singularem majestatem prae se ferret, compleret incredibili voluptate.

9. (*Peroration*)

Cernere Graecas civitates liberali sub caelo, feraci solo, salo amico circumfusas, plenissimas signorum, imaginum, tabularum, in quibus virtutum, & scientiarum decor, quamquam pictus, ac fictus adeo emicaret, ut ignes castissimos in omnium oculos, perque oculos in animos omnium jacularetur, quibus inflammarentur ad illarum cultum, quas ex Iconum adspectu pulcherrimas conjecissent.

Utrum igitur sapienter illos fecisse, an imprudenter arbitramur? si imprudenter: o sapientiae nomen insaniens, o demens philosophia, o leges imperitae, o scientiae omnes ignarae, quae sectatores suos in re tam clara, tam turpiter allucinari passae fuissent, sin vero prudentissime illos egisse dicamus: illud etiam, quod inde sequitur, admittamus oportet, tanto illustriori laude honestandum esse harum Iconum Auctorem, quanto haec symbola omnibus, quae circumferuntur, nobiliora, atque omni ex parte absolutiora sunt. quae dum percurrimus, favete linguis, & animis. nam Icones non prius visas Musarum Alumni doctissimis, eruditissimisque viris breviter explanando in mentem revocamus.

NOTES

Notes

AIMS AND LIMITS OF ICONOLOGY

1. For this and the following, see F. H. W. Sheppard (Ed.), *Survey of London*, XXXI, 1963, *The Parish of St. James Westminster*, pt. II, pp. 101-10.

2. E. Panofsky, *Studies in Iconology* (New York, 1939) and Göran Hermerén, *Representation and Meaning in the Visual Arts* (Lund, 1969).

3. D. E. Hirsch, *Validity in Interpretation* (New Haven, 1967).

4. I have discussed this problem from a slightly different angle in 'Expression and Communication', *Meditations on a Hobby Horse* (London, 1963), especially p. 66 and p. 67.

5. Émile Mâle, *L'Art religieux du 12ᵉ siècle en France* (2nd edition, Paris, 1924; new edition 1940); *L'Art religieux du 13ᵉ siècle en France* (6th edition, Paris, 1925); *L'Art religieux de la fin du moyen-âge en France* (Paris, 1908); *L'Art religieux après le Concile de Trente* (2nd edition, Paris, 1951).

6. Andor Pigler, *Barockthemen. Eine Auswahl von Verzeichnissen zur Ikonographie des 17. und 18. Jahrhunderts*, 2 vols. (Budapest, 1956).

7. Raimond van Marle, *Iconographie de l'art profane au moyen-âge et à la Renaissance et la décoration des demeures*, 2 vols. (The Hague, 1931 and 1932).

8. Giampaolo Lomazzo, *Trattato dell' Arte della Pittura*, Milan, 1584, book VI, chapter 23. (I quote from the Rome, 1844, edition.)

9. Giorgio Vasari, *Le Vite de' più eccellenti Pittori Scultori ed Architettori con nuove annotazioni e commenti di Gaetano Milanesi*, 9 vols. (Florence, 1878-85), VI, p. 647.

10. G. G. Bottari, *Raccolta di lettere sulla pittura, scultura ed architettura scritte de' piu celebri personaggi dei secoli XV, XVI e XVII, pubblicata da M. Gio. Bottari, e continuata fino ai nostri giorni da Stefano Ticozzi*, 8 vols. (Milan, 1822-5), vol. III, pp. 31 f. For these frescoes, formerly in the Medici Palace, see also Vasari's life of Cristofano Gherardi, Vasari, Milanesi, VI, pp. 215-16.

11. Vasari, Milanesi, VII, pp. 115-29.

12. Bottari-Ticozzi, *Raccolta di Lettere*, III, pp. 249-56 (Letter of 15 May 1565). The whole letter is given here, pp. 23-25. For Taddeo Zuccaro, see J. A. Gere, *Taddeo Zuccaro* (London, 1969).

13. Vasari, Milanesi, VII, p. 129.

14. Vasari, Milanesi, VII, p. 128.

15. For Ripa see also this volume, pp. 139-144.

16. St. Thomas Aquinas, *Quaestiones quodlibetales*, ed. P. Mandonnet (Paris, 1926), VII, 14, p. 275:

 '. . . non est propter defectum auctoritatis quod ex sensu spirituali non potest trahi efficax argumentum; sed ex ipsa natura similitudinis, in qua fundatur spiritualis sensus. Una enim res pluribus similis esse potest; unde non potest ab illa, quando in Scriptura sacra proponitur, procedi ad aliquam illarum determinate; sed est fallacia consequentis: verbi gratia, leo propter aliquam similitudinem significat Christum et diabolum.'

17. E. Panofsky, *Early Netherlandish Painting. Its Origin and Character*, 2 vols. (Cambridge, Mass., 1953).

18. See H. Horne, *Alessandro Filipepi commonly called Sandro Botticelli, painter of Florence* (London, 1908), pp. 136-40, where the sources and their interpretation are discussed in greater detail.

19. Luca Beltrami, *Documenti e memorie riguardanti la vita e le opere di Leonardo da Vinci* (Milan, 1919), Document 108.

20. Beltrami, *op. cit.*, Document 107.

21. See A. Gruyer, 'Léonardo de Vinci au Musée du Louvre', *Gazette des Beaux Arts*, Vol. 36, second period, 1887; for the author and the poem see F. Cavicchi, 'Girolamo da Casio', *Giornale storico della letteratura italiana*, vol. LXVI, 1915, pp. 391-2,
 Ecce agnus Dei, disse Giovanni,
 Che entrò e uscì nel ventre di Maria
 Sol per drizar con la sua santa via
 E nostri piedi a gli celesti scanni.
 De immaculato Agnel vuol tuore e panni
 Per far al mondo di se beccaria
 La Madre lo ritien, che non voria
 Veder del Figlio e di se stessa e danni.

199

Santa Anna, come quella che sapeva
 Gesù vestir de l'human nostro velo
Per cancellar il fal di Adam e di Eva
Dice a sua figlia con pietoso zelo:
 Di retirarlo il pensier tuo ne lieva,
Che gli è ordinato il suo immolar dal
 Cielo.

22. See my review in the *New York Review of Books*, vol. 4, no. 2, 11 February, 1965.

23. Meyer Schapiro, 'Leonardo and Freud. An art historical study', *Journal of the History of Ideas*, vol. 17, no. 2, 1956.

24. For the history of this composition, see my papers 'The Renaissance Conception of Artistic Progress' and 'Leonardo's Method for Working out Compositions', *Norm and Form* (London, 1966), pp. 1 ff and 58 ff.

25. Benvenuto Cellini, *Trattato del Oreficeria*, ed. L. De-Mauri (Milan, 1927), pp. 111–12.

26. See the essay on Raphael's *Stanza della Segnatura*, p. 95.

27. Vasari, Milanesi, IV, p. 490.

28. Vasari, Milanesi, VI, p. 444.

29. Bertrand Goldschmidt, *The Atomic Adventure* (London–New York, 1964), p. 16.

30. An example may here be quoted as an apparent exception to this rule: the remark in the letter by Sebastiano del Piombo of 7 July 1533 where he tells Michelangelo that the Ganymede would look nice in the Cupola: 'you could give him a halo so that he would appear as St. John of the Apocalypse carried to Heaven'. Erwin Panofsky (*Studies in Iconology*, Harper Torchbook edition, New York, 1962, p. 213) rightly characterizes the remark as a joke, but then possibly projects too much into it.

31. See this volume, pp. 123–195.

32. Vasari, Milanesi, I, p. 193.

33. Nicole Dacos, *La Découverte de la Domus Auréa et la Formation des Grotesques à la Renaissance* (London, 1969) (Studies of the Warburg Institute, vol. 31), especially pp. 165 ff.

34. A. Perosa, *Giovanni Rucellai ed il suo Zibaldone* (London, 1960) (Studies of the Warburg Institute, vol. 24), p. 22.

35. See Harold Bayley, *The Lost Language of Symbolism*, 2 vols. (London, 1912).

TOBIAS AND THE ANGEL

1. Martin Davies, *The Earlier Italian Schools*, National Gallery Catalogues (2nd revised edition, London, 1961), p. 555, no. 781.

2. G. M. Achenbach, 'The Iconography of Tobias and the Angel in Florentine Painting of the Renaissance', *Marsyas*, III, 1943–5, pp. 71–86.

3. See G. Poggi, 'Le Ricordanze di Neri di Bicci (1453–1475)', *Il Vasari*, I, 1927, pp. 317–38.

4. Cf. A. M. Hind, *Early Italian Engraving*, 7 vols. (London, 1938–48).

5. H. Mackowsky, *Verrocchio* (Bielefeld, etc., 1901).

6. F. Lugt, 'Man and Angel', part II, *Gazette des Beaux-Arts*, vol. XXV, 1944, I, pp. 321–46.

7. Raphael medicinalis,
Mecum sis perpetualis,
Et sicut fuisti cum Thobia,
Semper mecum sis in via.

See Achenbach, *loc. cit.*, especially Fig. 11.

There is an expanded humanist version of this prayer among the unpublished epigrams of Ugolini Verino, the Quattrocento poet, Florence, Laurenziana, XXXIX, 40, *Epigrammata*, book VII, fols. 72 r-v:

Epigramma in honorem archangeli
 Raphaelis.

Assis coelestis Raphael tua sacra colenti
Maior et exiguo crescat in ore sonus
Non mihi Pierides, non his dicendus
 Apollo
Scribenti Raphael tu satis esse potes.
Tu propriore dei gemmis ornatus et auro
In solio cernis cominus ora dei
Tu citior ventis ales delapsus ab astris
Defers in terras iussa tremenda dei.
Tu procul a nobis fallaces daemones arces
Certa salus miseris praesidiumque reis
Immineant quamvis horrenda pericula
 pellis
Adventu fiunt cuncta secunda tuo
Sis foelix nobis. Adversaque cuncta
 repellas
Non homo: non daemon possit obesse
 mihi. . . .

(Come heavenly Raphael to him who celebrates your rites, May a loud voice come from my unworthy lips. Here the Muses and Apollo cannot suffice the writer, only you yourself, Raphael, can. Adorned with gold and jewels you contemplate from

close by the face of the Lord in His dwellings; swifter than the wind you transmit to the earth the dread commands of the Lord. You keep the deceitful daemons far from us, you, the assured salvation of the unhappy, you, the bulwark of the persecuted. However terrible the dangers which threaten our lives, when you come all is well. Favour us and repel all adversity, no man and no daemon can harm me. . . .)

For Ugolino Verino see my essay, 'Apollonio di Giovanni', *Norm and Form* (London, 1966).

8. J. Mesnil, 'Un peintre inconnu du XVe siècle: Chimenti di Piero. Le "Tobie et les Trois Archanges" de l'Académie des Beaux-Arts de Florence', *Gazette des Beaux-Arts*, vol. XXVII, 1902, I, pp. 252–6.

9. G. M. Monti, *Le confraternite medievali dell'alta e media Italia*, 2 vols. (Venice, 1927).

BOTTICELLI'S MYTHOLOGIES

1. W. S. Heckscher, 'The *Anadyomene* in the Mediaeval Tradition (Pelagia-Cleopatra-Aphrodite); A Prelude to Botticelli's *Birth of Venus*', *Nederlands Kunsthistorisch Jaarboek*, vol. VII, 1956, p. 1 ff.

2. P. Francastel, 'La Fête mythologique au Quattrocento: Expression littéraire et visualisation plastique', *Revue d'Esthétique*, vol. V, 1952, pp. 276 ff.

3. P. Francastel, 'Un Mito poetico y social del Quattrocento: *La Primavera*', *La Torre, Revista General de la Universidad de Puerto Rico*, vol. V, 1957, pp. 23 ff.

4. A. B. Ferruolo, 'Botticelli's Mythologies, Ficino's *De Amore*, Poliziano's *Stanze per la Giostra*: Their Circle of Love', *Art Bulletin*, vol. XXXVII, 1955, pp. 17 ff.

5. Charles Dempsey, '*Mercurius Ver*: the sources of Botticelli's *Primavera*', *Journal of the Warburg and Courtauld Institutes*, vol. XXXI, 1968, pp. 251–73.

6. See Appendix, Letter No. 3.

7. Panofsky, *op. cit.*, p. 195.

8. For his fame in England see now Michael Levey, 'Botticelli and Nineteenth-century England', *Journal of the Warburg and Courtauld Institutes*, vol. XXIII, 1960, pp. 291–306.

9. For full bibliographical data on Botticelli up to 1931 see Raimond van Marle, *Italian Schools of Painting*, XII (The Hague, 1931), pp. 14 ff. To this should be added the monographs by C. Gamba (Milan, 1936); L. Venturi ('Phaidon edition') (Vienna, 1937); J. Mesnil (Paris, 1938) (with a *bibliographie raisonnée*); S. Bettini (Bergamo, 1942); S. Spender ('Faber Gallery') (London, 1946); P. Bargellini (Florence, 1946). Among contributions not listed in *Art Index* I should like to quote further C. Terrasse, *Botticelli, Le Printemps* (Paris, 1938), T. del Renzio, 'Lustful

Breezes make the Grasses sweetly tremble', *Polemic*, May 1946, and H. Stern, 'Eustathe le Macrembolithe et le "Printemps" de Botticelli', *L'Amour de l'Art*, 1946 (IV). —R. Salvini, 'Umanesimo di Botticelli', *Emporium*, 99, January 1944, was not accessible to me at the time of writing.

10. For a comprehensive survey of earlier discussions see A. Chastel, 'Art et Religion dans la Renaissance Italienne, Essai sur la Méthode', *Bibliothèque d'Humanisme et Renaissance*, VII (1945), and P. O. Kristeller, 'Humanism and Scholasticism in the Renaissance', *Byzantion*, XVII, 1944/45, pp. 346 f.; two books not mentioned in these articles: C. E. Trinkaus, *Adversity's Noblemen* (New York, 1940), and A. Dulles, *Princeps Concordiae* (Cambridge, Mass., 1941). W. K. Fergusson, *The Renaissance in Historical Thought* (Cambridge, Mass., 1948); Delio Cantimori, 'La Periodizzazione dell'età del Rinascimento nella storia d'Italia e in quella d'Europa', *X Congresso Internazionale di scienze storiche*, Rome, 4–11 September 1955, vol. IV (Florence, 1955); Erwin Panofsky, *Renaissance and Renascences in Western Art* (Stockholm, 1960); Denys Hay, *The Italian Renaissance and its historical background* (Cambridge, 1961); Tinsley Helton, ed., *The Renaissance, a Reconsideration of the Theories and Interpretations of the Age* (Madison, 1961); Leona Gabel, *et al.*, 'The Renaissance Reconsidered', A Symposium, *Smith College Studies in History*, vol. XLIV (Northampton, Mass., 1964).

11. R. Foerster, 'Studien zu Mantegna und den Bildern im Studierzimmer der Isabella Gonzaga', *Jahrbuch der Preussischen Kunstsammlungen*, XXII, 1901, p. 166. For an English translation see Julia Cartwright, *Isabella d'Este* (London, 1904), I, p. 331 f.

12. There is a brief summary in A. Venturi, *Sandro Botticelli* (Rome, 1925); see also the bibliographies in J. Mesnil's monograph and in Van Marle, *loc. cit.*

13. Vasari, Milanesi, III, p. 312. 'Venere, che le Grazie la fioriscono, dinotando la primavera.' We have no reason to attach overmuch importance to this description, made some 75 years after the picture was painted. Wherever we are able to check Vasari's descriptions from independent sources we find that he was prone to muddle the subject-matter. Botticelli's biblical frescoes in the Sistine Chapel did not fare better in this respect than did Michelangelo's ceiling or Raphael's *Stanze*. An example more nearly comparable to our own subject is Vasari's description of Titian's Venus' feast. Vasari did not know the source, Philostratus, who describes the votive offerings given to Venus by nymphs. He therefore took Titian's nymphs for allegories of Grace and Beauty. (Vasari, *ed. cit.*, VII, p. 434.) The double significance implied in Vasari's account of Botticelli's picture 'Venus ... signifying spring' is very likely a similar guess on the part of Vasari. It conforms suspiciously well to the practice of the 'Mannerist' period and *milieu* in which he moved. There is a Venus 'signifying spring' (indicated by three signs of the Zodiac) by Angelo Bronzino which Vasari may have had in mind (E. Panofsky, *Studies in Iconology*, New York, 1939, quoted hereafter as *Studies*, p. 85). For Vasari's untrustworthiness in iconographic matters, see Introduction, p. 11.

14. The most important of these quotations from Lucretius, *De Rerum Natura*, will be discussed more fully in a different context (see below, p. 52).

15. *Sandro Botticelli's 'Geburt der Venus' und 'Frühling'* (Leipzig, 1893), now reprinted in *Gesammelte Schriften* (Leipzig-Berlin, 1932), I, pp. 1 ff.; see also my book *Aby Warburg* (London, 1970).

16. Three passages have mainly been quoted in this context. The first contains the description of Giuliano's first meeting with his lady:

> Candida è ella, e candida la vesta,
> Ma pur di rose e fior dipinta e d'erba;
> Lo inanellato crin dall'aurea testa
> Scende in la fronte umilmente
> superba ...

(White is she, and white her garment, but adorned with roses, flowers and greenery. The curled locks of her golden head fall over her brow, both humble and proud) which is similar enough in atmosphere but not in concrete details. Botticelli's 'Primavera' has no roses on her dress nor does her hair correspond to Poliziano's wonderful lines.

> Ell' era assisa sovra la verdura,
> Allegra, e ghirlandetta avea contesta
> Di quanti fior creassi mai natura,
> De' quai tutta dipinta era sua vesta.
> E come prima al gioven puose cura,
> Alquanto paurosa alzò la testa;
> Poi colla bianca man ripreso il lembo,
> Levossi in piè con di fior pieno un
> grembo.

(She was sitting gaily on the grass, and had made a little wreath of all the flowers known to nature, which also appeared on her garment. And as she first took heed of the young man, she somewhat timidly raised her head; then with her white hand she took up the hem of her dress, and got to her feet, her lap full of flowers.)

The visual charm of these lines has again exerted such a spell that many readers were tempted to overlook the difference in the situation there described from Botticelli's figure. Poliziano thinks of a timid nymph who sits on the grass, looks up as Giuliano approaches and walks away, her lap full of flowers. Fair maidens binding wreaths in spring are, after all, not confined to these two examples in Italian literature and art. They belong to the imagery of courtly love which finds its reflection in many pictures of the International Style, such as the May fresco of the Torre del Aquila in Trent. The other stanza, often quoted, may point in a similar direction. In it Amor returns to his mother's domain:

> Al regno ov' ogni Grazia si diletta,
> Ove Biltà di fiori al crin fa brolo,
> Ove tutto lascivo, drieto a Flora,
> Zefiro vola e la verde erba infiora.

(To the realm where every Grace delights, where Beauty turns the hair into a flower garden, where all aflame, Zephyr flies behind Flora, making the green meadows flower.)

Here again we have an elusive similarity to Botticelli's pictures. Zephyr and Flora dwell in the Realm of Venus. But Poliziano's description of this realm only starts in earnest after the lines quoted and we soon see that the pair, together with Beauty and Grace, share their dwelling with such personifications as Fear and Delight, Meagreness, Suspicion and Despair. Claudianus' Love Garden, on which Poliziano modelled his description, was also the archetype of all the allegorical medieval gardens culminating in the *Roman de la Rose*, of which L. F. Benedetto found a 'faint echo' in the *Giostra* ('Il "Roman de la Rose" e la Letteratura Italiana', *Beihefte zur Zeitschrift für Romanische Philologie*, XXI, 1910). Perhaps it is no mere accident that the figures of the *Roman de la Rose* also reminded Huizinga of Botticelli (*The Waning of the Middle Ages*, London, 1924). It seems to me that these aspects of the *Giostra* have often been underrated. If its imagery recalls that of Botticelli, this may be because both belong to one broad current of tradition rather than that one is the illustration of the other. The character of this tradition and its imagery of spring and love has been admirably traced by C. S. Lewis, *The Allegory of Love* (Oxford, 1936), quoted hereafter as Lewis, *Allegory*.

17. All Vasari says in his second edition (*ed. cit.*, III, p. 322) is that a portrait of a woman by Botticelli was supposed ('si dice') to represent 'l'innamorata di Giuliano de' Medici'. Probably Vasari referred to Giuliano's mistress, the mother of Pope Clement VII. Nevertheless 'La Bella Simonetta' has been identified with nearly all the female beauties in Botticelli's oeuvre. A. F. Rio, *L'Art Chrétien*, 4 vols. (Paris, 1861–7), made a beginning with Botticelli's Judith. Then came Ruskin who, in *Ariadne Florentina*, printed a letter by a Mr. Tyrwhitt on the moral aspect of painting from the nude. The writer took it for granted that it was Simonetta who posed to Botticelli as Venus, as Truth in the Calumny, and many other figures and romanced about the probable feelings of the painter on seeing her 'undraped'. Then came the suggested connection with the *Giostra* which prompted scholars like Warburg, Bode, Yashiro and Seznec to accept or defend the legend to the exasperation of J. Mesnil, who exclaimed: 'Et ce ne sont pas des préraphaélites anglais ou des miss désoeuvrées qui se sont livrés à ce singulier jeu: ce sont de graves docteurs et professeurs. . . .' (And these are not English Pre-raphaelites or unemployed spinsters who have indulged in this peculiar game, but grave doctors and professors. . . .) ('Connaissons-nous Botticelli?' *Gazette des Beaux Arts*, LXXII, 1930, II, p. 87). The outburst came too late to prevent van Marle from writing 'Botticelli was the artist who, in the Birth of Venus, illustrated in quite an idealized manner the love of Giuliano for Simonetta, an echo of which, I think, he felt in his own heart' (*op. cit.*, p. 6).

18. This tendency, so delightfully parodied in Sir Max Beerbohm's *Savonarola Brown*, has produced the oddest theories on *quattrocento* art. It has even been maintained that the two soldiers on the relief of the 'Resurrection of Christ' in the Bargello, ascribed to Verrocchio, represent Lorenzo de' Medici weeping over the murder of his brother Giuliano (Enrico Barfucci, *Lorenzo di Medici e la Società Artistica del suo tempo*, Florence, 1945, p. 183).

19. 'Non mai altra pittura si potrebbe porre più di questa a simbolo del rinascimento'. (No other painting could ever be a more fitting symbol of the Renaissance.) G. Fiocco, *La Pittura Toscana del Quattrocento* (Novara, 1945). Simonetta, too, was accorded the same honour. To Giuseppe Portigliotti, *Donne del Rinascimento* (Milan, 1927), she appears 'come il simbolo della Primavera, allegoria della fugace giovinezza, umana' (as the symbol of spring, the allegory of evanescent youth). If such statements were meant as rhetorical flourishes no objection could be raised. But in history these metaphors have a way of solidifying into 'intellectual intuitions'. In the end only those documents of a period are considered 'typical' which correspond to the 'symbol', and the most obvious circular interpretations are expounded as serious *Geistesgeschichte*.

20. 'It expresses the springtime of the Renaissance in Florence, which was soon to be overshadowed by disaster, plague and religious fanaticism.' (Stephen Spender, *loc. cit.*) I have ventured elsewhere to plead for greater precision in the use of the word 'expression' ('Wertproblem und mittelalterliche Kunst', *Kritische Berichte zur Kunstwissenschaft*, VI, 1937). (Now re-

printed in *Meditations on a Hobby Horse*, London, 1963.)

21. E. Walser (*Gesammelte Studien zur Geistes-geschichte der Renaissance*, Basle, 1932, p. 116) warned against overrating the significance of these songs which coloured the nineteenth-century view of the whole period.

22. L. Rosenthal, *Sandro Botticelli et sa réputation à l'heure présente* (Dijon, 1897). For the general problem of varying interpretations of physiognomic expression in art, see the stimulating book by Ferdinand Laban, *Der Gemuetsausdruck des Antinous* (Berlin, 1891). The way in which observers later weave a story round a work of art to account for its puzzling expression was discussed by E. Kris, 'Die Charakterköpfe des F. X. Messerschmidt', *Jahrbuch der Kunsthistorischen Sammlungen in Wien*, new series, VI, 1932. I was privileged to take part in later researches by Dr. Kris into aspects of expression in art. The problem of projection, which is inseparable from these questions, I have attempted to describe more fully in 'Portrait Painting and Portrait Photography', *Apropos, No. 3*, 1945; see my paper, 'The Evidence of Images', *Interpretation. Theory and Practice*, ed. C. S. Singleton (Baltimore, 1969).

23. W. Pater, *The Renaissance* (London, 1870): 'He . . . paints the goddess of pleasure . . . but never without some shadow of death in the grey flesh and wan flowers.'

L. Binyon, *The Art of Botticelli* (London, 1913): 'In the Spring (Venus) . . . reappears, how grave and with what pensive eyes! as if aware of the pain that comes with birth and of the sorrow that is entwined with human rapture.'

Count Plunkett, *Sandro Botticelli* (London, 1900): '. . . the sad faced woman, who may be the Venus Nutrix or the Venus Verticordia, or her, to whom Caesar reared an altar. Her face is sweet and reflective, as becomes the mother of the human race. . . .'

E. Gebhart, *Sandro Botticelli et son époque* (Paris, 1907): 'Sa main droite semble bénir; ses regards ne s'adressent à personne . . . le rôle austère de cette Vénus. . . .' (Her right hand appears to bless; her eyes do not look at anyone . . . the austere role of this Venus. . . .)

A. Schmarsow, *Sandro del Botticelli* (Dresden, 1923): 'Nur ihr neckisch übermütiges Söhnchen mit dem gespannten Bogen über ihrem Kopf macht sie als Herrin des Reiches der Liebe kenntlich, sonst hält die Erweckerin der Wonne sich im Augenblick noch bescheiden, ja mit geneigtem Haupt und fast wehmütig befangenen Zügen zurück, sodass wir nicht wissen können, ob sie Mars als Genossen ihres Lagers im Walde ersehnt oder das Schicksal ihres Adonis zurückträumt. . . .' ('Only her wanton and playful little son with his tautened bow above her head marks her as the Queen of the Kingdom of Love. Otherwise the giver of bliss still shows herself for that moment modestly restrained, indeed her head is inclined and her features almost melancholy and strained, so that we remain uncertain whether she is pining for Mars to share her bed in the forest, or dreams of the fate of bygone Adonis.')

B. Marrai, '*La Primavera* del Botticelli', *Rassegna internazionale della letteratura e dell'arte contemporanea*, Year 2, vol. 5, 1901: la Venere . . . è incinta . . . Si osservi l'atto peculiare dell' incedere, lo stesso portamento della Venere e anche il pallore speciale del volto (la *facies gestantis*, volgarmente il *visuccio*). . . .' ('This Venus . . . is pregnant. . . . Observe the strange action of her walk, her particular carriage and also the singular pallor of her face (the *facies gestantis* which we call the "tell-tale look") . . .')

G. Portigliotti, *Donne del Rinascimento* (Milan, 1927): 'Nella Primavera specialmente si nota un affusolamento del collo, una salienza dei cordoni muscolari e un accentuazione della fossetta soprasternale, che ci ricordano tante inferme di mal sottile.' ('In the Primavera we notice in particular a tapering of the neck, a swelling of the muscle fibres and an accentuation of the suprasternal hollow, which call to mind so many women suffering from consumption.')

W. Uhde, 'Zu Botticellis Primavera', *Monatsheft für Kunstwissenschaft*, vol. 1, 1908: 'der gesegnete Leib . . . sinnend hält sie die Rechte empor, sinnend neigt sie das Haupt als lausche sie einer Offenbarung . . .' ('her expectant body . . . pensively she holds up her right hand, pensively she inclines her head as if waiting for a revelation . . .').

E. Jacobsen, 'Der Frühling des Botticelli', *Preussische Jahrbücher*, 92, III, 1898:

'Die junge, in Träumen versunkene Frau
... ist Simonetta, mit den geliebten, lei-
denden Zügen ihrer letzten Zeit ... jetzt
verstehen wir auch die Seelenbewegungen
der wie in Traumgebilden versunkenen, in
sich gekehrten, jungen Frau. Sie war ja
todt, und jetzt lebt sie wieder ... Das
Leben ist auf's Neue erwacht. Sie lebt!
Sie lebt! Die neuen, allzumächtigen Ge-
fühle überwältigen sie, abwehrend streckt
sie den Arm aus. ...' ('The young woman
wrapped in her dreams ... is Simonetta,
with the beloved, suffering features of her
last days ... now also we understand the
agitation of the young woman turned in
upon herself as if her soul were immersed
in dream images. Remember she had been
dead, and now she lives again. ... Life has
awoken anew. She lives! She lives! The
new, all too powerful feelings overwhelm
her, defensively she stretches out her arm.
...')

Mela Escherich, 'Botticellis *Primavera*',
Repertorium für Kunstwissenschaft, XXXI,
1908: '(Venus) ... deren halb segnende,
halb abwehrende Handbewegung ein tief-
ernstes Noli me tangere auszudrücken
scheint. ...' ('(Venus) ... whose half-
blessing, half-defensive gesture of the hand
seems to express a profoundly serious *Noli
me tangere*. ...')

E. Steinmann, *Botticelli* (Bielefeld, etc.,
1897): '... sie schreitet langsam vorwaerts
und das ... Haupt ein wenig zur Seite
gesenkt blickt sie den Beschauer mit
holdem Lächeln an. ...' ('... she steps
slowly forward and her ... head lowered
slightly to one side she looks at the spec-
tator with a gracious smile. ...')

E. Schaeffer, *Sandro Botticelli. Die
Zeichnungen zu Dante Alighieri, Die Gött-
liche Komödie* (Berlin, 1921): '... mit sin-
nendem Lächeln blickt Venus auf ihr
ewiges Reich ...' ('... with a pensive smile
Venus surveys her eternal kingdom ...').

J. Cartwright, *Isabella d'Este*, 2 vols.
(London, 1904): '[Venus] ... advances to
welcome the coming of spring.'

A. Venturi, *Botticelli* (Rome, 1925):
'Venere, con stanco dondolio di passo,
avanza movendo la destra come a segnar
il tempo alla danza delle Grazie. ...'
('Venus advances with a tired swaying step,
moving her right hand as if to beat time
for the dance of the Graces. ...')

R. Muther, *Die Renaissance der Antike*

(Berlin, 1903): 'Blühende Zweige ... unter
denen lachend die Göttin der Schönheit
steht.' ('Flowering branches ... under
which the goddess of beauty stands
laughing.')

24. These are the titles given to the picture by
E. Jacobsen, F. Wickhoff, W. Uhde, G. F.
Young (elaborating an idea by Stillmann
and basing his interpretation on Lorenzo's
jousting device 'Le Temps revient'), and
Stephen Spender, who prefaces his inter-
pretation with the disarming remark 'Any-
way, the picture is easily understood as a
charade ... Boreas ... pushes forward the
shy young lady ... Venus presides ... and
Cupid aims his arrow at the young man.'

25. The preceding quotations would not seem
to bear out Tancred Borenius' tribute to
Botticelli for his 'perfect mastery of human
expression' (*Italian Painting up to Leonardo
and Raphael*, London, 1945).

26. L. B. Alberti, *Kleinere Kunsttheoretische
Schriften*, ed. H. Janitschek,*Quellenschriften
für Kunstgeschichte*, XI (Vienna, 1877),
p. 120.

27. M. N. Nahm, *Aesthetic Experience and its
Presuppositions* (New York, 1946), p. 270 f.,
broaches this question in connection with
a problem of Botticelli iconography: E.
Wind's discovery of the true subject of the
'Derelitta' ('The Subject of Botticelli's
Derelitta', Journal of the Warburg and
Courtauld Institutes, IV, 1940–1). The
effort and skill spent in interpreting the
expression of Botticelli's figures is prodi-
gious. The Mr. Tyrwhitt who launched
the Simonetta legend discovered in the face
of Botticelli's nudes that the lady did not
really like posing as a model. Only one
more example may be quoted here because
of its general implications. Vasari com-
mends the head of Botticelli's St. Augus-
tine as being 'expressive of the profound
thought and quick subtlety such as is usu-
ally possessed by those continually en-
grossed in difficult and abstruse questions'.
Of the same head L. Binyon wrote: 'In
1478 the plague had broken out in Florence
... something of the tragic apprehension
of life, so reiterated in the daily circum-
stances of the streets ... seems to have
passed into the painter's vision of Augus-
tine' (*op. cit.*, p. 71). The connection with
the plague shows to what length the
'physiognomic' interpretation of works of
art can go which sees in them an 'expres-

sion' of their period, even when they are controlled by a sensitivity as keen as Binyon's.

28. I have discussed what I have called 'the primacy of meaning' in 'The use of art for the study of symbols', *The American Psychologist*, vol. 20, 1965, now reprinted in James Hogg, ed., *Psychology and the Visual Arts* (Harmondsworth, Middlesex, 1969).

29. See F. Saxl, 'Die Bibliothek Warburg und ihr Ziel', *Vorträge der Bibliothek Warburg*, 1921–2, and Warburg's annotations to his Botticelli paper. Cf. also E. Panofsky, *Studies*, pp. 142 ff. and C. S. Lewis, *Allegory*.

30. 'Questa, che lieta innanzi all'altre viene,
 Vener si chiama, madre dell'amore,
 Qual con dolce catene
 Serra duo cuor gentili in un sol
 core; . . .'
(She who gaily goes before the others is called Venus, mother of love, and binds two hearts into one heart with sweet chains; . . .)
 'Quest'altro è 'l sangue che col bel
 pianeta
 Di Venere è congiunto in l'aër puro;
 La primavera lieta
 Rende 'l suo stato tranquillo e sicuro;
 Fa suo gente quieta,
 Ridente, allegra, umana e temperata,
 Venerea, benigna e molto grata.'
(That other one is the sanguinic humour which is linked to the planet Venus in the pure ether: gay springtime makes its existence peaceful and safe; it makes for a character which is calm, smiling, gay, kind and harmonious, sensual, benign and well favoured.) C. S. Singleton, *Canti Carnascialeschi del Rinascimento* (Bari, 1936), pp. 253, 149.
 Cf. also Naldo Naldi's elegy:
 '. . . Per Venerem totus quoniam
 renovatur et orbis,
 Arboribus frondes prosiliuntque suis.
 Laetaque diverso variantur prata colore;
 Floribus a multis picta relucet humus.
 Hanc igitur laeti, divamque sequamur
 ovantes,
 Matres, atque nurus, vir, puer atque
 senex,
 Laetius ut vitam suavem ducamus ab
 illa,
 Quilibet ut laetos transigat inde
 dies. . . .'
(Through Venus the whole world is re-

newed, and the leaves of the trees begin to sprout. And the happy meadows are painted in diverse colours; and the earth sparkles with a multitude of flowers. So let us gaily and rejoicingly follow that goddess, mothers and young women, men, boys and old men, so that we lead a sweet life through her influence, and that everyone may enjoy his days.)
'Elegia in septem stellas errantes sub humana specie per urbem Florentinam curribus a Laurentio Medice Patriae Patre duci iussas more triumphantium', *Carmina illustrium Poetarum Italorum*, VI (Florence, 1720), p. 440.

31. For Italian examples see L. F. Benedetto, *op. cit.* For Dante's conception of Venus see E. Wechsler, 'Eros und Minne', *Vorträge der Bibliothek Warburg*, 1921–2, p. 83; and H. Flanders Dunbar, *Symbolism in Medieval Thought and its Consummation in the Divine Comedy* (New Haven, 1929).

32. 'Ma Vener bella sempre in canti e 'n
 feste,
 In balli e nozze e mostre,
 In varie foggie e nuove sopravveste,
 In torniamenti e giostre
 Farà 'l popol fiorito;
 Staran galante e belle
 Tutte donne e donzelle,
 Con amoroso invito;
 Terrà sempre Fiorenza in canti e riso
 E dirassi: Fiorenza è 'l paradiso!'
(But Venus ever fair in songs and celebrations, in dances, weddings and spectacles, in various fashions and new guises, in tournaments and jousts, will make the people flourish; all the women and girls will be elegant and fair, with a loving welcome. She will always remember Florence in songs and laughter, and it will be said: 'Florence is paradise'.)
(*Canti Carnascialeschi, ed. cit.*, pp. 132–3.)

33. Filarete, *Treatise on Architecture*, translated with notes and introduction by John R. Spencer (New Haven, etc., 1965). Book XVIII fol. 148v.

34. Herbert P. Horne, *Alessandro Filipepi . . . Botticelli* (London, 1908), pp. 49 ff. and 184 ff.

35. For an additional document, unknown to Horne, see J. Mesnil, *Botticelli*, note 152.

36. The theory was challenged by G. F. Young, *The Medici*, 2 vols. (London, 1900), I, app. VII, but an examination of his seven points produces no convincing evidence

against Horne's theory, particularly since we now know that Botticelli did some work for Lorenzo di Pierfrancesco at Castello, thus disproving Young's contention that the Villa was never owned by him. R. Langton-Douglas (*Piero di Cosimo*, Chicago, 1946) has come out in defence of Lorenzo di Pierfrancesco.

37. The main facts known about Lorenzo di Pierfrancesco are collected in Gaetano Pieraccini, *La stirpe de' Medici di Cafaggiolo* (Florence, 1924), I, pp. 353 ff. A number of additional documents are to be found in K. Frey, *Michelangelo B. sein Leben und seine Werke* (Berlin, 1907), p. 221 f., and K. Frey, *Michelangelo B. Quellen und Forschungen zu seiner Geschichte und Kunst* (Berlin, 1907), p. 34 f. See now also this volume, pp. 79–81.

38. For Lorenzo's role in these critical days of Florentine history see J. Schnitzer, *Savonarola, Ein Kulturbild aus der Zeit der Renaissance* (Munich, 1924), I, p. 156.

39. All subsequent quotations are from Ficino's *Opera Omnia* (Basle, 1576). This edition contains letters to Lorenzo di Pierfrancesco on pp. 805, 812, 834, 845, 905, 908.

40. Ficino, *ed. cit.*, p. 805. For the date of the Vth book of the *Epistolarium* see P. O. Kristeller, *Supplementum Ficinianum*, I, p. CI, who puts the majority of its letters between September 1477 and April 1478. This fits in with the evidence about Naldi's movements (see below), who left Florence sometime in 1476, was back in 1477 and away again by April 1478. Cf. A. della Torre, *Storia dell'Accademia Platonica di Firenze*, 1902, p. 673.

41. For a comprehensive survey and bibliography of these traditions see Jean Seznec, *The Survival of the Pagan Gods*, Bollingen series, XXXVIII (New York, 1953).

42. F. Saxl, *loc. cit.*, Vorträge der Bibliothek Warburg, 1921–2, p. 6, and 'The Literary sources of the "Finiguerra Planets"', *Journal of the Warburg Institute*, vol. II, 1938, p. 73, gives a number of characteristic texts.

43. A German fifteenth-century poet, Meister Altswert, makes Venus, the Lady of Love, say:

'Waz wilde ist, dem bin ich gram,
Ich halt mich an daz zam.'
(I dislike what is savage, I keep to the civil.)
See H. Kohlhausen, *Minnekästchen im Mittelalter* (Berlin, 1928), p. 43.

44. For Cicero's dual use of the term '*humanitas*' as denoting 'urbanity' and 'culture' see Forcellini, *Lexicon*, s.v. For the roots of Renaissance usage see K. Borinski, *Die Antike in Poetik und Kunsttheorie*, I (Leipzig, 1914), p. 108 f., and W. Jaeger, *Humanism and Theology (Aquinas Lecture)* (Milwaukee, 1943), pp. 20 ff. and 72 f. For Ficino's usage see *op. cit.*, p. 635, where *humanitas* is opposed to *crudelitas* as the virtue which bids us love all men as members of one family.

45. The most famous exposition of the theory of the two Venuses and the two forms of *furor* kindled by them is in Ficino's *Commentary on the Symposium*, Second Speech, section VII. Ficino, *ed. cit.*, p. 1326. There is a German translation by Paul Hasse, 1914, and an English translation by Sears Reynolds Jayne, in *University of Missouri Studies*, XIX, I (Columbia, 1944). For the hierarchy of the Divine *furores* of which Venus represents the first, see for instance Ficino, *ed. cit.*, p. 830. 'Cum vero divini furoris species (ut Platoni nostro placet) quatuor sint, Amor, Vaticinium, Mysterium, Poësis. Atque amor Veneri, vaticinium Apollini, mysterium Dionyso, poësis Musis attribuatur.' (There are four kinds of divine frenzy as our Plato holds, that is Love, Prophecy, Religion and Poetry. Love belongs to Venus, Prophecy to Apollo, Religion to Dionysos and Poetry to the Muses.) The idea that the enthusiasm, represented by Venus, is proper to youth, is more fully developed in Ficino's letter describing Lorenzo il Magnifico's spiritual development and his ascent, in the course of his life, on the ladder of enthusiasm (*ibid.* p. 927). Ficino was not the first to introduce this idea to Florentine thought. See Warburg, *Ges. Schriften*, I, p. 328.

46. Ficino, *ed. cit.*, p. 806.

47. Della Torre, *op. cit.*, pp. 772 ff. For a supposed portrait of Giorgio Antonio Vespucci see R. Langton Douglas, 'The Contemporary Portraits of Amerigo Vespucci', *The Burlington Magazine*, February 1944. For his relation to Amerigo see A. M. Bandini, *Vita di Amerigo Vespucci*, ed. G. Uzielli (Florence, 1898). See also Appendix, Letter No. 3, this volume, pp. 80 f.

48. Since della Torre's excellent characterization of Naldi (*op. cit.*, pp. 503–6, 668–81) a number of his Latin poems have been published or commented upon. See A.

Hulubei, 'Naldo Naldi, Étude sur la Joute de Julien et sur les bucoliques dédiées à Laurent de Médicis', *Humanisme et Renaissance*, III, 1936; Naldus de Naldis Florentinus, *Elegiarum Libri III ad Laurentium Medicen*. Edidit Ladislaus Juhász, *Bibliotheca Scriptorum Medii Recentisque Aevorum* (Leipzig, 1934). See also the references to Naldi in *Scritti inediti di Benedetto Colucci da Pistoia*, ed. Arsenio Frugoni (Florence, 1939).

49. Horne, *op. cit.*, pp. 50 and 349. For the beginnings of the negotiation, see Appendix, Letter No. 2, this volume, p. 79.

50. *Gesammelte Schriften*, I, pp. 187 ff., 371 ff.

51. *Op. cit.*, 1928, pp. 46 ff.

52. *Commentary on the Symposium*, Vth speech, section II. Ficino, *ed. cit.*, p. 1334. See also Nesca N. Robb, *Neoplatonism of the Italian Renaissance* (London, 1935), p. 224 (quoted hereafter as *Neoplatonism*) and P. O. Kristeller, *The Philosophy of Marsilio Ficino*, Columbia Studies in Philosophy, VI (New York, 1943). Here, as in so many other respects, Ficino was able to build on a medieval tradition; see R. Berliner, 'The Freedom of Medieval Art', *Gazette des Beaux Arts*, 1945, II, note 49 and p. 280. The *locus classicus* for this priority of sight over hearing is, of course, Horace's *Ars Poetica*, l. 180 f.:
'The mind is slower wrought on by the ear Than by the eye, which makes things plain appear.'

53. In these efforts Ficino was closely applying the doctrine of Cicero, who thus addressed his son Marcus in *De Officiis*, I, 5: 'You can see the very form, and, as it were, the face of the good which, if it could be discerned with the eyes, would arouse wondrous love for wisdom as Plato says.'

54. '... For some time, Lorenzo, I have heard that you feel no slight abhorrence of men of bad habits. ... In order to fill you, not only with hatred, but with real horror and fear of bad men, I should like (if it pleases you to pay attention for a while) to point out with the finger, as the saying goes, the most horrible and miserable life of the depraved. The mind of those corrupted by bad habits is like a wild forest bristling with sharp thorns, made horrible by rapacious and cruel beasts of prey and infested with poisonous snakes. Or else, it is like the sea swollen with contrary winds and tossed by cruel storms and waves. Worse, it is like a human body so utterly deformed that every member is tormented with pains. Contrariwise the mind informed by excellent manners is like a well cultivated and fertile field, like a tranquil and serene sea, like a human body as beautiful as it is robust. ...' and more in a similar vein. Ficino, *ed. cit.*, p. 834 f.

55. Ficino, *ed. cit.*, p. 807. In the remainder of the letter Ficino attempts again to describe the beauty of virtue in visual terms. He asks his readers to imagine a perfect man, strong, healthy, beautiful, endowed with all the qualities, so admired by the crowd which are but a pale reflection of the true beauty of the mind. In the beauty of virtue, however, these single perfections are all combined into one wondrous beauty. 'O quam amabilis, O quam mirabilis est haec animi forma, cuius umbra quaedam est forma corporis, tam vulgo amabilis, tam mirabilis.' (Oh how lovable, oh how marvellous is the form of that mind, of which the bodily form, which to the crowd appears so lovable and marvellous, is nothing more than a kind of shadow.) The letter ends with an exhortation to his friends to keep the idea and form of divine beauty always before their eyes. The letter dates from the same period as the one concerning *Venus-Humanitas*.

56. The curious way in which a real woman could take on this role of a visual symbol, a process which underlies the Platonic love poetry and its medieval predecessors, is well exemplified in a poem by C. Landino addressed to Bernardo Bembo, asking him to select Ginevra dei Benci as his guide to the higher spheres. It is to the same Bembo that Ficino's letter on the virtue of visual concreteness is addressed.
'Hoc age nunc, Erato, Bembi referamus amores,
Sed quos caelestis comprobet ipsa Venus.
Hic nihil obscenum est turpive libidine tetrum;
Castus amor castam postulat usque fidem.
Talis amor Bembi, qualem divina Platonis
Pagina Socraticis exprimit eloquiis.
Namque amor a pulchro cum sit, perculsa cupido
Pulchrum amat et pulchris gaudet imaginibus;
Ad quodcumque bonum, pulchrum est, turpe omne nefandum:
Sic bona deposcit, sic mala vitat amor.

His flammis Bembus talique accensus
amore
Uritur, et medio corde Ginevra sedet.
Forma quidem pulchra est, animus
quoque pulcher in illa:
Horum utrum superet, non bene, Bembe,
vides. . . .'

(Now then Erato, let us sing the loves of
Bembo, but loves of which the heavenly
Venus herself approves. Here there is no-
thing obscene, nothing defiled by base lust;
a chaste love demands a chaste trust. Such
is Bembo's love as the divine text of Plato
describes in the Socratic Dialogues. For
since love is derived from beauty, love
which is struck loves what is beautiful and
enjoys beautiful images. And whatever is
good is beautiful, and whatever is base is
ugly. Thus love strives for the good and
avoids the bad. With such flames and with
such love is Bembo burning. And in the
middle of his heart sits Ginevra. For her
appearance is beautiful and there is a beau-
tiful mind within her; Bembo you are in
doubt as to which surpasses the other.)
C. Landino, *Carmina omnia*, ed. A. Perosa
(Florence, 1939), p. 162. The success of
Ficino's speculations, and his letters and
doctrines quoted above, must be seen
against this background.

57. Horne, *op. cit.*, p. 72.
58. Apuleius was the first classical author to
be published in Italy in the magnificent
Roman edition of 1469. For the background
of this edition and the preface by Giovanni
Andrea de Bussi see R. Klibansky, 'Ein
Proklos Fund und seine Bedeutung', *Sitz-
ungsberichte der Heidelberger Akademie der
Wissenschaft*, 1928–9, p. 25, and 'Plato's
Parmenides in the Middle Ages and the
Renaissance', *Medieval and Renaissance
Studies*, I, 2, 1943, p. 290. Boiardo under-
took (or polished) its Italian translation in
1478 (see Giulio Reichenbach, *Matteo
Maria Boiardo*, Bologna, 1929, p. 155).
Ercole d'Este wrote that he read the book
'every day' and Federigo Gonzaga that he
'liked it the more the longer he read it' (A.
Luzio, R. Renier, 'La coltura e le relazioni
litterarie di Isabella d'Este Gonzaga',
Giornale Storico della Letteratura Italiana,
XXXIII, 1899, p. 16). Poliziano attempted
emendations for corrupt passages (*Op.
Omn.*, Basle, 1553, p. 246), and Beroaldus
published a new edition in 1500 with a
learned commentary.

59. *Loeb Classical Library* (London-New York,
1919), pp. 524 ff. Adlington's charming
translation, printed there, is insufficiently
accurate for our purpose.
60. Warburg, *op. cit.*, I, p. 10.
61. Paride da Ceresara's programme for Peru-
gino contains the characteristic passage: 'If
you think there are too many figures you
can reduce the number as long as the chief
ones . . . remain.' Cf. Julia Cartwright, *op.
cit.*, I, p. 332. It so happens that Vasari in
his *Ragionamenti* explains why he had
painted only three of the Hours rather than
the full twenty-four: 'Questa licenza
l'usano i pittori, quando non hanno più
luogo' (painters make use of this licence
when they have no more space) (Vasari,
Milanesi VIII, p. 23).
62. Alberti, *ed. cit.*, pp. 119 and 240.
63. Filarete, *ed. cit.*, p. 650. Varro's 'rule' is
applied in a different context in Ficino's
Commentary on the Symposium, where the
number of guests corresponds to that of the
Muses, *ed. cit.*, p. 1321.
64. This was indeed the form in which 'Spring'
was represented in the procession of the
four seasons:
'Tutta coperta d'erbe, fronde e fiori
Vedete primavera
Spargere al fresco vento mille odori; . . .'
(You see the Spring all covered with
greenery, flowers and leaves, permeating
the fresh breeze with a thousand scents; . .)
(*Canti Carnascialeschi*, *ed. cit.*, p. 153). See
also the series of the four seasons formerly
in the Earl of Rosebery's collection (Lion-
ello Venturi, *op. cit.*, p. 12). I cannot see
more than such a conventional figure in the
description of the personification of May
which H. Stern ('Eustathe le Macrembolite
et le "Printemps" de Botticelli', *L'Amour
de L'Art*, IV, 1946) found in a Byzantine
novel of the twelfth century and considered
the source of the 'Primavera'. There the
month of May is described as a charming
young nobleman with long flowing hair, a
wreath on his head, a rose in his locks,
scattering flowers. Unlike Botticelli's figure
he wears a golden robe (covered with
flowers), and golden sandals. The author's
attempt to link the other protagonists of
the picture with the months of spring
through the *Fasti* of Ovid is certainly
interesting but hardly convincing.
65. For the iconography of Amor see F. Wick-
hoff, 'Die Gestalt Amors in der Phantasie

des italienischen Mittelalters', *Jahrbuch der Preussischen Kunstsammlungen*, XI, 1890, and E. Panofsky, *Studies*.

66. Panofsky having criticized my 'genteel translation' (*Renaissance and Renascences*, p. 195, n.), I have adopted his suggestion and given a more explicit reading.

67. *Ed. cit.*, p. 129.

68. Panofsky, *Studies*, p. 153; R. Foerster, 'Philostrats Gemälde in der Renaissance', *Jahrbuch der Preussischen Kunstsammlungen*, vol. XXV, 1904, p. 17.

69. That the passage was in fact unintelligible in this form is proved by the 1488 Vicenza reprint which has: '... pateret flos & atule. ...'

70. J. A. Symonds, *Renaissance in Italy, The Fine Arts* (London, 1901), p. 182. There is no evidence that the lines were inspired by pageantry. See Warburg, *op. cit.*, I, p. 321.

71. I do not wish to deny the possibility of the authors of the programme having known the passage. Perhaps they even contrived to work these and other lines into their text without using them as their main source. For this humanist technique of composite quotation see below, pp. 74–75.

72. The relevant material was collected by R. Foerster in *Jahrbuch der Preussischen Kunstsammlungen*, vol. VII, 1887, 'Die Verläumdung des Apelles in der Renaissance'; vol. XXV, 1904, 'Philostrats Gemälde in der Renaissance'; and vol. XLIII, 1922, 'Wiederherstellung antiker Gemälde durch Künstler der Renaissance'.

73. '... verbis adeo propriis et accomodatis, ut non scribere sed pingere plane historiam videatur' (... his words are so well chosen and fitting that he appears not to write but to paint the story) says the preface to the *editio princeps*.

74. H. Liebeschütz, *Fulgentius Metaforalis* (Leipzig, Berlin, 1926), *Studien der Bibliothek Warburg*, 4; E. Panofsky and F. Saxl, 'Classical Mythology in Mediaeval Art', *Metropolitan Museum Studies*, IV, 1933. E. Rathbone, 'Master Alberic of London', *Mediaeval and Renaissance Studies*, I, 1943.

75. The description still influenced Titian's Venus' Feast; since Philostratus' text does not account for the shell held by Venus.

76. For the deep meaning hidden in the names of the Gods, see Ficino, *ed. cit.*, pp. 1217 and 1902. For the importance of the true image see his quotation from Porphyrius'

allegorical description of the statue of Jupiter, *ed. cit.*, p. 935.

77. Partly reprinted in B. Botfield, *Prefaces to the First Editions of the Greek and Roman classics* (London, 1861); see also Klibansky, *loc. cit.*

78. *Ed. cit.*, p. 544 f.

79. Ficino, *ed. cit.*, p. 919. This and other interpretations of the myth are discussed by Kristeller, *op. cit.*, p. 358.

80. In one of Marullo's epigrams, dedicated to Lorenzo di Pierfrancesco, the latter is thus turned into the object of a mythical quarrel among the Gods:
'De Laur. Medice Petri Francisci Filio
De puero quondam Lauro certasse feruntur
Mercurius/Mavors/Iuno/Minerva/Venus.
Iuno dat imperium: Pallas cor: Cypria formam.
Mars animos: Maiae filius ingenium ... etc.'
(On Lorenzo di Pierfrancesco dei Medici. It is said that once Mercury, Mars, Juno, Minerva and Venus competed for the boy Lorenzo. Juno gives him power, Pallas judgment, Venus beauty, Mars spirit, and Mercury talent. ...) (M. T. Marullo, *Epigrammaton ad Laurentium Medicen Petri Francisci Filium*, I (Florence, *c.* 1490). The title-page of A. Assaracus, *Historiae* (Milan, 1516) (Fig. 34), provides an interesting parallel. The poem describes the contest between Juno and Pallas for the honour of conferring the title *Magnus* on Giovanni Jacopo Trivulzio. In the end they appoint *Fides* as arbiter, who rules that the honour is hers by right. The woodcut illustrates this inverted Judgment of Paris in which *Fides* takes the place of Venus between Juno and Pallas and hands the palm to the young prince, while King Francis I of France acts as a bystander like Mercury.

81. Some of the problems of the relation between the beholder and the picture are discussed by E. Michalski, *Die Bedeutung der aesthetischen Grenze für die Methode der Kunstgeschichte* (Berlin, 1932). The wish to establish a direct link between beholder and picture is manifest in Alberti's advice to include in the picture a figure looking at the spectator and pointing inwards (*ed. cit.*, p. 122). The story of the 'sagittarius' in the frescoes at Nuremberg, who shot his arrows at every beholder and so impressed Nicolaus Cusanus, also belongs in this context. See Kurt Rathe, *Die Ausdrucksfunk-*

tion extrem verkürzter Figuren, Studies of the Warburg Institute, 8 (London, 1938), p. 20 f.

The most daring case of the drawing of the beholder into the composition, and also artistically the most perfect, is perhaps Velasquez' 'Meninas', which is only 'complete' when the King and Queen stand in front of the picture to receive the homage of their daughter and see their own reflection in the distant mirror. But to some extent this experiment is anticipated in van Eyck's Arnolfini portrait.

82. J. Marcotti, *Guide Souvenir de Florence* (Florence, 1892).

83. The letter in question is by no means the only passage in Ficino in which Venus and Mercury are linked because of their beneficial influence on the arts and the graces of life. See Ficino, *ed. cit.*, p. 861. 'Solent ad amorem procliviores esse quorum in genesi ita Venus Mercuriusque disponuntur, ut ob mutuum aspectum vel congressum aut receptionem, aut terminum, ingenii gubernacula concordi volutate suscipiant. Tunc sane et Mercurius ingenii eloquiique magister ad Venerem trasfert utrunque et Venus ipsa gratia decorisque, et fidei mater ingenium eloquiumque lepore condit, elegantia ornat, fide veridica format.' (Those are usually more amorous in whose horoscope Venus and Mercury are so placed that their mutual aspect or meeting or reception or ending or joint will sustains the governance of the mind. Then Mercury on the one hand, the teacher of talents and eloquence influences Venus altogether, while Venus on the other, the mother of grace, beauty and trust, flavours the talent and eloquence with beauty and adorns them with elegance and imparts to them a true faith.) For similar passages see below, pp. 57 f. The interpretation is not confined to the astrological tradition. Phurnutus, *De Natura Deorum*, ch. 16, calls Mercury the leader of the Graces.

84. Warburg, *op. cit.*, I, pp. 27 ff., 327.

85. *Opera Omnia* (Basle, 1572), I, p. 106.

86. Pico's Commentary on Benivieni's *Canzone d'Amore* (Venice, 1522), libro II, cap. 15.

87. C. Landino, *Commento sopra la Commedia di Dante*, on I.2. I have used the translation given in the very instructive book by Ch. W. Lemmi, *The Classical Deities in Bacon, A Study in Mythological Symbolism* (Baltimore, 1933), p. 19.

88. Ficino, *ed. cit.*, pp. 845 ff.

89. For a fuller exposition of the doctrine of the 'daemons' and their link with the planets see the *Commentary on the Symposium*, Speech II, Section 8, Ficino, *ed. cit.*, p. 1328. Mercury, Phoebus and Venus as 'studiorum duces' and their influence on 'invention' are discussed more fully in Ficino, *De Studiosorum sanitate tuenda, ed. cit.*, p. 495; D. P. Walker, *Spiritual and Demonic Magic from Ficino to Campanella* (London, 1958) (Studies of the Warburg Institute, vol. 22).

90. Ficino, *ed. cit.*, p. 536.

91. Ficino, *ed. cit.*, p. 890. For the wider background of this letter see Raymond Klibansky, 'Plato's *Parmenides* in the Middle Ages and the Renaissance. A chapter in the history of Platonic Studies', *Medieval and Renaissance Studies*, vol. I, no. 2, 1943, p. 322. The reverse of the medal of Poliziano's wife (G. F. Hill, *A Corpus of Italian Medals*, 2 vols., London, 1930, no. 1003), shows the Three Graces with the inscription 'Concordia'.

92. *Commentary on the Symposium*, Speech V, section 2. Ficino, *ed. cit.*, p. 1335 (English translation, *ed. cit.*). In his commentary to Plotinus, *Liber de Pulchritudine*, Ficino gives for once the same interpretation, *ed. cit.*, p. 1574.

93. Ficino, *ed. cit.*, p. 862.

94. If we had gone to sixteenth- and seventeenth-century handbooks we would have found a good many more meanings to choose from—a method which is not always used with the caution it requires. It is to this passage that Professor Wind took particular exception (*Pagan Mysteries in the Renaissance, loc. cit.*). However I still tend to side with Joseph Addison, who wrote, *Dialogues upon the Usefulness of Ancient Medals*, Glasgow, 1751, p. 32: 'I dare say, the same gentlemen, who have fixed this piece of morality on the three naked sisters dancing hand in hand, would have found out as good a one for them, had there been four of them sitting at a distance from each other, and covered from head to foot.'

95. 'Sicut Christiani Theologi in divinis eloquiis quatuor sensus observant, literalem, moralem, allegoricum, anagogicum, et alibi quidem hunc, alibi vero illum praecipue prosequuntur, ita Platonici quatuor habent multiplicandorum deorum, numinumque

modos, aliumque multiplicandi modum alibi pro opportunitate sectantur. Ego quoque similiter in commentariis meis, alibi aliter quatenus locus exigit interpretari, et distinguere numina consuevi . . .' (Ficino, *ed. cit.*, p. 1370). It is characteristic that to Ficino multiplying the significance of the Gods is multiplying the Gods—hence his two Venuses and four Amors.

96. The Aristotelian 'essentialism' which underlies these uses of symbolism is discussed in a wider context in K. R. Popper, *The Open Society and its Enemies* (London, 1945), vol. II, ch. 11. An important contribution to the historical question is H. Flanders Dunbar, *Symbolism in Mediaeval Thought* (New Haven, 1929). For a bibliography of the problem see W. den Boer, *De Allegorese in het Werk van Clemens Alexandrinus* (Leiden, 1940). For a characteristic passage see Hugo of St. Victor in *Patr. Lat.*, CLXXV, col. 20 ff. quoted by R. Berliner, *loc. cit.*, *Gazette des Beaux Arts*, 1945, II. '. . . the meaning of things is much more multiple than that of words. Because few words have more than two or three meanings, but every thing may mean as many other things, as it has visible or invisible qualities in common with other things.' St. Thomas Aquinas saw and defined the difficulties arising from this conception: 'leo propter aliquam similitudinem significat Christum, et diabolum.' (The lion signifies Christ or the devil by reason of various likenesses.) (See this volume, pp. 13–14.) Cf. P. C. Spicq, *Esquisse d'une Histoire de L'Exégèse Latine au moyen âge* (Paris, 1944), p. 288.

The practical difficulties connected with establishing meanings in this mode of expression were forcefully stressed by G. G. Coulton, *Art and the Reformation* (Oxford, 1928), pp. 242 ff. An interesting example for the multiplicity of meanings attached to such a symbol as the Pine in fifteenth century Florence is discussed by A. Hulubei, *loc. cit.*, *Humanisme et Renaissance*, III, 1936, p. 183.

At the bottom of these difficulties lies the fact that 'interpreting' in a rational sense means translating these 'insight symbols' (to use H. Flanders Dunbar's term) into a discursive conceptual language. We must thus steer between the Scylla of falsifying them and the Charybdis of succumbing to their irrationalism, that is of adopting the mode of thought instead of translating it. See this volume, p. 168.

97. Ficino, *ed. cit.*, p. 848.

98. The rules demand that the player should be able to quote a classical text in support of any link he wishes to establish. He is 'cheating' when he starts changing the myth to suit the desired signification. Ficino's contention that the Graces are really followers not of Venus but of Minerva comes dangerously near 'sharp practice'. Cf. Frances Yates, 'The Art of Ramon Lull', *Journal of the Warburg and Courtauld Institutes*, XVII, 1954, pp. 115–73, for the philosophical background.

99. See A. Warburg, *op. cit.*, II, p. 464; H. Ritter, 'Picatrix', *Vorträge der Bibliothek Warburg*, 1921–2, pp. 97 ff.

100. J. Huizinga, *The Waning of the Middle Ages* (London, 1924), pp. 184 ff.; in this passage both the philosophical and psychological roots of medieval symbolism are treated with admirable lucidity. The same author poses yet another important problem in *Homo Ludens* (London, 1949), pp. 136 ff.

101. For parlour games explaining the attributes of Cupid see T. F. Crane, *Italian Social Customs of the XVIth Century* (New Haven, 1920), p. 278. The *libri della sorte* provide another link between games and magic.

102. Ficino, *ed. cit.*, p. 848 f.

103. Ficino, *ed. cit.*, p. 848, where Venus selects Careggi as her abode because of the Magnifico's poetic tributes to her.

104. R. v. Marle, *L'Iconographie de l'Art Profane*, II (The Hague, 1932), pp. 415 ff., and Douglas Percy Bliss, 'Love Gardens in the Early German Engravings and Woodcuts', *Print Collector's Quarterly*, XV, 1928.

105. Lionello Venturi: 'Venus is conceived like a Madonna', *op. cit.*, p. 19. 'Les arbres inclinant leurs rameaux forment un orbe régulier au-dessus d'elle: madonne sylvestre dans une chapelle de verdure.' (The trees bending their branches down form a regular dome above her: a sylvan madonna in a natural shrine.) C. Terrasse, *op. cit.*, p. 4.

106. 'Tertia subsequitur sedes et tertius orbis
Hic, Cytherea, tuus; vires lumenque globosque
Eloquar, et sparsas fulgenti lampade flammas.
Vos animae quaecumque polum sedesque beatas
Incolitis, Venerisque deae loca summa tenetis,

Este duces, nam vestra iuvat praesentia
vatem.
Et tu sancta Dei genitrix, quam sydere in
isto,
Diva, colo, summique sedes super ardua
coeli,
Quamque ego non nunquam Veneris sub
nomine ficto
Compellare meis ausus sum, diva dearum,
Da, precor, his animum rebus mentemque
quietam,
Ut valeam tantae describere lumina
flammae.'
(Now follows the third realm and the third
sphere, your own region, Venus; let me
praise the forces, the light, the stars, the
scattered flames of the shining torches.
May you be my guides, you souls in what-
ever blessed heaven you dwell, in the high
sphere of the goddess Venus, for your
presence assists the poet. And you, holy
mother of God whom I worship in that
star, in the highest seat above the lofty
heavens, whom I have sometimes dared to
address by the fictitious name of Venus,
you, most sacred of goddesses, give, I pray
you, for this enterprise, peace of mind and
soul, so that I shall be able to describe the
height of so great a flame.) B. Soldati, *La
Poesia Astrologica nel Quattrocento* (Flor-
ence, 1906), p. 191.

107. Huizinga, *Waning*, p. 105. For the 'two
gardens' see also C. S. Lewis, *Allegory*,
p. 151.

108. Pico took a similar line. He had no doubt
that Homer's Garden of Alcinous with its
eternal spring was a 'clear and manifest'
imitation of the Biblical description of
Paradise (*ed. cit.*, II, p. 347).

109. For the history of the motif see Henriette
Mendelsohn, *Die Engel in der bildenden
Kunst* (Berlin, 1907), p. 43.

110. I am indebted for this and other observa-
tions in this section to Professor Otto
Pächt.

111. E. Panofsky and F. Saxl, 'Classical Myth-
ology in Mediaeval Art', *Metropolitan
Museum Studies*, IV, 1933; A. Meyer Wein-
schel, *Renaissance und Antike* (Reutlingen,
1933); and E. Panofsky, *Renaissance and
Renascences in Western Art* (Stockholm,
1960).

112. Hardly two generations after Botticelli,
Pietro Aretino, Titian's friend, writes to
Federigo Gonzaga to recommend Sanso-
evino 'Credo che messer Iacobo Sansovino

rarissimo vi ornerà la camera d'una Venere
si vera e si viva che empie di libidine il pen-
siero di ciaschuno chi la mira' (I think that
Messer Iacobo Sansovino, that rare artist,
will adorn the room with a Venus so truth-
ful and so vivid that she will fill the mind
of every beholder with desire) (letter of
6th Oct. 1527; see my article, 'Zum Werke
Giulio Romano's', *Jahrbuch der Kunst-
historischen Sammlungen in Wien*, n.s., VIII,
1934, p. 95). The meaning of this offer is
plain enough. It is the more surprising that
Aretino found it necessary or advisable to
wrap it in a wording sanctioned by classical
associations. The quality he attributes to
Sansovino's Venus is that of Praxiteles'
Cnidian Aphrodite as described by Pliny.
In the classical context there is still an over-
tone of magic awe in the effect ascribed to
the idol of the Goddess of Love; in Aretino
it is an elegant form of circumventing a
social taboo. Some such pretext to sanction
the nude was still demanded for a long time
but it is a far cry from the moral earnestness
of Ficino's and Botticelli's days to the
vague classical labels of later periods.

113. 'Der Geist in dem gerade er (Botticelli)
malte, hat unverkennbar den überschweng-
lich sentimentalen Zug, der uns in der
platonischen Akademie begegnete.' (The
spirit in which he more than others painted
has the unmistakable ecstatic and senti-
mental flavour which we have encountered
in the Platonic Academy.) (K. Brandi, *Die
Renaissance in Florenz und Rom*, Leipzig,
1909, p. 126). 'De kunst van Botticelli is
mystiek, doch niet op middeleeuwsche
wijze, maar in neoplatonischen Zin. Hij
schildert, zooals Ficino leerde van 't geheim
des levens, dat schoon is en diepzinnig
tevens.' (The art of Botticelli is mystical,
but not in a medieval but in a Neo-Platonic
manner. He paints what Ficino teaches
about the mystery of life, that is both
simple and profound.) (G. J. Hoogewerff,
De ontwikkeling der italiaansche Renaissance,
Zutphen, 1921, p. 281). Nesca N. Robb
(*Neoplatonism*, p. 216) has the fullest but
also most cautious discussion of this gen-
eral impression which it is the aim of the
present study to substantiate by the outside
evidence not known to Miss Robb. See
also Warburg, *op. cit.*, I, p. 327: ' "Geburt"
und "Reich der Venus" können entschlos-
sener in die Sphäre der platonistisch-
magischen Praktiken einbezogen werden.'

(The 'Birth of Venus' and the 'Realm of Venus' can be more boldly connected with the sphere of Platonizing magic rituals.)

114. See above, p. 40.

115. '... Expensam vero huiusmodi sepulture, quam omnimodo humilem construi mandavit, rogavit Magnificum Laurentium Pierfrancisci de Medicis amicum suum, quod pro eius solita erga dictum testatorem benignitate huiusmodi impensam subire velit de eius propria pecunia.... Item mandavit librum Platonis in greco in carta bona cum omnibus dyalogis existentem in domo sue habitationis consignari debere Magnifico Laurentio Pierfrancisci de Medicis tamquam de se bene merito et ob certas iustas causas animum et conscientiam suam moventes.' (... The expenses of his tomb which he wanted to be constructed in an altogether humble manner, he asked his friend the magnifico Lorenzo di Pierfrancesco dei Medici to defray from his own funds because of his customary kindness towards the testator.... He also stipulated that the book of Plato in Greek written on good paper containing all the Dialogues which he has in his house, should be consigned to the magnifico Lorenzo di Pierfrancesco dei Medici, to whom he owed so many favours, and for the sake of certain just causes which preoccupy his mind and his conscience.) P. O. Kristeller, *Supplementum Ficinianum* (Florence, 1937), I, p. 194 f.

116. Horne, *op. cit.*, pp. 70 and 282 and Pieraccini, *loc. cit.* On the Vespuccis see H. Brockhaus, *Forschungen über Florentiner Kunstwerke*, 1902, his source Bandini, *ed. cit.*, and Appendix, Letter No. 3, this volume, p. 80.

117. Bandini, *ed. cit.* There is an immense literature on the so-called 'Medici letter'.

118. Kristeller, *op. cit.*, p. 193.

119. Poliziano's Platonism was certainly of a different stamp from Ficino's. We know that he declined the title of a philosopher altogether and regarded himself as a critic (R. Klibansky, *loc. cit.*, *Mediaeval and Renaissance Studies*, I, 2, p. 316). Nesca N. Robb also points out (*Neoplatonism*, p. 91) that 'his own predilections were mildly Aristotelian' and his interests predominantly literary. Perhaps she still overrates the Platonic ingredients in the *Giostra*, which owes so much to a different tradi-

tion. We know that the subject of astrology was one on which Poliziano and Ficino did not see eye to eye. See Ficino's letter to Poliziano on the subject which amounts almost to a recantation (*ed. cit.*, p. 958). See also Don Cameron Allen, *The Star-crossed Renaissance* (Durham, North Carol., 1941). For the Magnifico's relations to Ficino after Pulci's attack see Karl Markgraf von Montoriola, *Briefe des Mediceerkreises* (Berlin, 1926), p. 76.

120. Ficino, *ed. cit.*, p. 960; see also Schnitzer, *op. cit.*, I, p. 180.

121. The documentary evidence concerning the Magnifico's patronage of art is conveniently put together in M. Wackernagel, *Der Lebensraum des Künstlers in der florentinischen Renaissance* (Leipzig, 1938). Despite this negative evidence, the Magnifico's close association with Botticelli is still frequently taken for granted. Leaving aside such products of romantic glorification as Enrico Barfucci's *Lorenzo di Medici e la società artistica del suo tempo* (Florence, 1945), where even Lorenzo's mocking verses to the 'little tub' (Botticello) in the *Beoni* are quoted as evidence of his intimacy with the artist, we find the idea accepted in serious historical works like F. Schevill's *History of Florence* (London, 1937), who considers it a tribute to the Magnifico's 'fastidious taste that among the sculptors he chiefly favoured Verrocchio, among the painters Botticelli' (p. 403). See also my 'The Early Medici as Patrons of Art', *Norm and Form* (London, 1966).

122. For the trend of the 'second Gothic', see F. Antal, 'Studien zur Gotik im Quattrocento', *Jahrbuch der preussischen Kunstsammlungen*, XLVI, 1925.

123. V. Rossi, *Il Quattrocento*, 3rd edition (Milan, 1933), p. 391.

124. Horne, *op. cit.*, p. 188.

125. See G. Pieraccini, *op. cit.*, p. 354.

126. For Marullo see B. Croce, *Michele Marullo* (Bari, 1938).

127. G. F. Hill, *op. cit.*, nos. 1054, 1055.

128. Lorenzo di Pierfrancesco's enemies saw the emblem in a different light. Piero de' Medici's envoy to the Court of Charles VIII during the critical days before the French invasion, reports to Florence that the position is most serious; he adds that in the opinion of his colleague Piero Soderini 'the serpent has its tail in Florence'. There is little doubt that Soderini was alluding to

the emblem of Lorenzo di Pierfrancesco whose intrigues with Charles VIII against Piero probably hastened his downfall. Schnitzer, *op. cit.*, I, p. 157.

129. See this volume, p. 158.

130. For the question of the person represented in the fresco see below, p. 76.

131. *Commentary on the Symposium*, Vth Speech, Section 8. Ficino, *ed. cit.*, p. 1339. I quote from S. R. Jayne's translation, *loc. cit.*, pp. 176–7.

132. J. A. Symonds, of course, was not quite in earnest when he wrote: 'The face and attitude of that unseductive Venus, wide awake and melancholy, opposite her snoring lover, seems to symbolise the indignities which women may have to endure from insolent and sottish boys with only youth to recommend them' (*op. cit.*, p. 183). Count Plunkett, however, suggested more seriously that the picture's intention was satirical.

133. The passage in Lucretius, recently adduced by Panofsky (*Studies*, p. 63), looks tempting enough: 'Thou (Venus) alone canst delight mortals with quiet peace, since Mars, mighty in battle, rules the savage works of war, and often casts himself upon thy lap wholly vanquished by the ever living wound of love, and thus looking upward with shapely neck thrown back, feeds his eager eyes with love, gaping upon thee, goddess, and as he lies back his breath hangs upon thy lips' (*De Rer. Nat.*, I, 31). The allegorical meaning in Lucretius' context could be reconciled with Ficino's interpretation and the description of Mars with his 'shapely neck thrown back' may in fact have been embodied in the programme for Botticelli's picture, but in the poem he is clearly visualized as lying with his head in Venus' lap and looking upwards at her. That is also the position in which Cupid finds Venus and Mars at the end of the first canto of the *Giostra*.

'Trovolla assisa in letto fuor del lembo,
Pur mo' di Marte sciolta dalle braccia,
Il qual roverso li giacea nel grembo,
Pascendo gli occhi pur della sua faccia:'
(He finds her sitting on the edge of the bed, emerging from the embrace of Mars, who was lying on his back in her lap, feasting his eyes on her face.) Through a strange confusion G. F. Young (*The Medici*, I, p. 226) gives a description of the painting which is represented as a summary of the

scene in Poliziano—small wonder that the picture looks like an exact illustration of this imagined text.

134. 'Botticelli and the antique', *The Burlington Magazine*, vol. XLVII, 1925.

135. Cf. E. Panofsky and F. Saxl, *Dürers Melencolia, I, Studien der Bibliothek Warburg*, vol. II (Leipzig, Berlin, 1923). Ficino writes to the Archbishop of Florence, Rinaldo Orsino: 'I had feared that this benefice which you wished to bestow upon me would be taken away from me by some Saturnine person. At first, indeed, I almost gave up hope as I thought that Saturn was the most powerful of all the planets, as he is the highest. But then I bethought in my mind of what the ancients had told in their fables, not without reason, about Saturn and Jupiter, Mars and Venus, that is that Mars was bridled by Venus and Saturn by Jupiter, which signifies nothing else but that the malignity of Saturn and of Mars is restrained by Jupiter and Venus' (*ed. cit.*, p. 726). In a letter to Naldi the moral application of the theory is brought out more clearly. He and Cavalcanti had received Naldi's writings at a time when Luna and Mars seemed to rule the hour, but had not found them unstable as Luna or ferocious and hateful as Mars: 'they do not glow with the fire of Mars but with that of Venus, they do not serve hate but charity which makes us plainly see the truth of that Poetic and Astronomic teaching that Mars is dominated and vanquished by Venus...' (*ed. cit.*, p. 830; see also pp. 795, 802, 886). The iconographical type of Venus Victrix, holding up the armour or helmet of Mars, may be connected with this tradition; cf. R. Wittkower, 'Transformations of Minerva in Renaissance Imagery', *Journal of the Warburg Institute*, II, 1938–9.

136. For Chaucer and Astrology see W. C. Curry, *Chaucer and the Mediaeval Sciences* (New York, 1926), esp. ch. VII. Second edition, London, 1960.

137. It is said to have been 'made about my lady of York... and my lord Huntingdon...', *The Works of Chaucer*, ed. A. W. Pollard (London, 1898), p. xxxvi.

138. Ἡρόδοτος ἢ Ἀετίων, §5. The translation is that of H. W. and F. G. Fowler in *The Works of Lucian of Samosata* (Oxford, 1905), vol. II, p. 92. Count Plunkett's quotation is unfortunately inexact. For Raphael's composition based on this description, see

Foerster, *Jahrbuch der Preussischen Kunst-slg.*, XLIII (1922), p. 133.

139. 'Campo Rosso attraversato da fascia azzurra con vespe d'oro' (Field of gules debruised by a fess azure with golden wasps) (Fig. 49). The theory that the wasps are an allusion to the Vespucci's emblem is supported by Piero di Cosimo's pictures painted, as we know, for the Vespucci Palace in the Via dei Servi (Panofsky, *Studies*, p. 60). They are built round the incident of the Discovery of Honey as told in Ovid's *Fasti*. One shows Bacchus and the honey bees, the other the comic counterpart of Satyr being stung when he wanted to obtain honey from a hornet's nest (Fig. 5). True, Ovid speaks of hornets (*crabrones*), but the zoological difference matters little in the context and Renaissance commentaries speak of *crabrones et vespae* (Paulus Marsus' commentary in the Venice edition of 1485).

140. A glance at the family tree of this big clan shows the difficulty of identifying the marriage in question, the more so as the Vespuccis are not included in Litta's *Famiglie Celebri*, and Bandini's family tree (*ed. cit.*) frequently omits the date of marriage. For stylistic reasons we should be inclined to look for a marriage between 1485 and 1490. We know, of course, that Botticelli contributed decorations for the palace in the Via de Servi belonging to Guido Antonio Vespucci, for which Piero di Cosimo's 'waspish' pictures were also destined—but the palace was not purchased before 1497 and we would have radically to revise our ideas of Botticelli's late style to fit the picture in at so late a date. We do not know the date of Giovanni Vespucci's (Guido Antonio's son's) marriage. As he was born in 1475 it cannot have taken place much earlier than 1495.

The branch to which Marco Vespucci, the husband of 'La Bella Simonetta', belonged is only very remotely connected with the branch of Guido Antonio and of Amerigo. Simonetta's marriage took place in 1468 before Botticelli started on his active career. Our reading of the evidence also disposes of the romantic interpretation of Piero di Cosimo's 'Mars and Venus' as a companion piece to Botticelli's picture— the one commemorating the death of Giuliano de' Medici, the other of Giovanni di Pierfrancesco de' Medici—recently put forward by R. Langton Douglas, *Piero di Cosimo* (Chicago, 1946), pp. 54 ff., who dates the picture on the basis of this assumption. As both masters worked for the Vespuccis it is hardly surprising that Piero di Cosimo knew and adapted Botticelli's composition.

141. Apart from the sources mentioned by Giovanni Poggi, 'La Giostra Medicea del 1475 e la Pallade del Botticelli', *L'Arte*, 1902, we have now an additional description of Botticelli's standard in Naldi's poem published by Hulubei, *loc. cit.*, *Humanisme et Renaissance*, 1936, p. 176.

142. For the specific interpretation, e.g. Steinmann and G. F. Young, a more general political interpretation is advocated by J. Mesnil, *op. cit.*, and by A. L. Frothingham, 'The Real Title of Botticelli's Pallas', *Journal of the Archaeological Institute of America* XII, 1908, p. 438. The emblem is not the Magnifico's personal device, for it also occurs on monuments and medals not connected with Lorenzo. Cf. Hill, *op. cit.*, no. 1051, no. 1110 (9 and 23). The last is of particular interest in our context since it refers to Lorenzo di Pierfrancesco's ancestor.

143. R. Wittkower, 'Transformation of Minerva in Renaissance imagery', *Journal of the Warburg Institute*, II, 1938–9, was the first to stress this connection, though his interpretation, based on different material, differs slightly from the one to be suggested in this study.

144. The problem is dealt with in most books on Ficino; see P. Kristeller, 'The Philosophy of Marsilio Ficino' (New York, 1944) and bibliography. For a lucid summary of Ficino's doctrine of man see Panofsky, *Studies*, p. 134 f. A survey of similar conceptions is given by Trinkaus, *op. cit.*, pp. 80 ff.

145. Ficino, *ed. cit.*, pp. 675 ff. Translated in E. Cassirer, P. O. Kristeller, and J. H. Randall, eds., *The Renaissance Philosophy of Man* (Chicago, 1948).

146. I have not found the Centaur used in this way in Ficino's writings. In later handbooks such an interpretation is familiar. Cf. F. Licetus, *Hieroglyphica* (Patavii, 1653), p. 287: 'Quem admodum ergo biformis natura Centauri Sagittarii symbolum est humanae vitae; quae constituitur ex parte rationali superiore, ac irrationali inferiore, tanquam ex voluntate et appetitu, ex intellectu et sensu.' (So the twofold nature of

the Centaur Sagittarius is a symbol of the human life which consists of a higher rational and a lower irrational part, the will and the appetite, the intellect and the senses.) What is more important than such a parallel is the fact that Ficino's imagery constantly uses similar, if not identical pictures. The idea of the animal in man is ever recurrent in his writings and indeed belongs to his conception of man: 'Illum in primis stultissimum non iudicare non possum, quod multi bestiam quidem suam imo feram noxiam et indomitam, hoc est corpus pascunt diligentissime, seipsos autem, id est, animum ipsum quantum in eis est, fame perire permittunt' (*ed. cit.*, p. 636). (Most of all I cannot help judging it to be very stupid that many diligently feed their beast, that dangerous animal which is the body, but allow themselves, that is the mind within them, to perish of hunger.)

For the soul as the place of constant strife, see *Theologia Platonica*, lib. IX, cap. iii: 'Ac etiam si nunquam corporis impetus frangeremus, satis tamen esset pugna ipsa, quae est in nobis continua, ad ostendendum animam corpori repugnare' (*ed. cit.*, p. 205). (Even though we may never break the impact of the body, the struggle itself suffices which always goes on within us, to show that the soul and the body are antagonists.) To represent this idea Ficino usually resorts to the Platonic image of the chariot, its driver and the two horses: 'Caput autem aurigae est unifica virtus ad ipsum universi principium intellectui praesidens, cum unitate conveniens. Melior equus est virtus ipsa rationalis, . . . equus vero deterior est imaginatio una cum natura, id est vegetali potentia' (*ed. cit.*, p. 1368). (The head of the chariot is the unified virtue which controls the origin of the universal intellect and accords with unity. The better horse is the power of reason . . . the worse horse is the imagination which accords with nature, that is the vegetative power.) We have here the same trichotomy which, as we suppose, governs Botticelli's picture where Minerva takes the place of the *caput aurigae*, the 'human part' of the Centaur, replaces the *melior equus*, and the equine part, the *equus deterior*.

For the image of man as a composite being, made up of human and animal parts, Ficino also quotes Plato: 'In libro nono de Iusto, figurat hominis animam hunc in modum: Est aliqua congeries capitum plurium beluarum, quasi in globum coacta ferinum, ex hac multiplici capitum ferinorum congerie pullulat, quasi stipes aliquis ex radicibus, qui stipes hinc leo est, inde draco. Huic stipiti homo aliquis superponitur, clavam manu tenens, qua bestias verberat saevientes. Demum corpori humani pellis omnia illa circundat, per quam animal unum videatur esse, quod est simplex animal. . . . Homo est ratio . . . etc.' (*ed. cit.*, p. 395). (In the ninth book of The Republic [*Republic*, IX, xii, D] Plato depicts the soul of man as follows: It is an assembly of several animal heads, a ball of beast, and out of this mixture of many animal heads there grows like a stem from its root, here a lion and there a serpent. Onto this stem a man is superimposed holding a club in his hand, with which he beats the wild beasts. Finally he wraps all this into a human skin so that it looks like a single animal which is also one creature. . . . Man is reason. . . .) This complicated allegory could not easily be translated into a visual image, though the Centaur might almost serve instead.

147. See also Ficino, *ed. cit.*, p. 717. Cf. Michelangelo's 'archers' as interpreted by Panofsky, *Studies*, after a parallel passage from Pico.

148. Cf. E. Panofsky, *Hercules am Scheidewege, Studien der Bibliothek Warburg*, 18 (Leipzig, Berlin, 1930), p. 63.

149. R. Wittkower, article cited. The philosophy of conciliation between virtue and the senses, which is presupposed in his theory, differs from Ficino's conception.

150. The quotation is from Lorenzo de' Medici's *Altercazione* (capitolo IV, 19), in which Ficino is made to expound his ideas on the search for the *Sommo Bene*. In this speech the dualism between the sensual and the rational parts of the soul is carried further in a number of scholastic distinctions: the rational powers are subdivided into the natural and acquired faculties, the latter into speculative and active, of which the former is the higher. It is split into three parts, the contemplation of terrestrial, celestial and supra-celestial things. The last, in turn, is divided into two parts, the lower form in which the soul is still wedded to the body and the highest form of contemplation in which the intellect leaves

matter behind. This no mortal mind can achieve without Divine assistance from above, symbolized by the virgin Goddess Minerva: 'E come sanza madre è il santo Numine,/cosi sanza materia netto e puro/si separi dal corpo il nostro acumine.' (And just as the sacred divinity is without a mother, so our understanding is separated from the body, neat and pure and free of matter.)

151. It is from the same sarcophagus, which also provided the model for 'Mars and Venus'. Cf. E. Tietze-Conrat, *art. cit.*

152. See this volume, p. 53.

153. Eckart Peterich, 'Gli Dei Pagani nell' Arte Cristiana', *La Rinascita*, V, 1942, p. 56.

154. Ficino, *ed. cit.*, p. 1217.

155. Pico, in his commentary to Benivieni's *Canzone d'Amore*, II, 17, gives a more simplified version of the same interpretation: 'Seguendo adunque la espositione da noi addotta, habbiamo ad dire che tutto quello che communica Celio à Saturno, cioè quella plenitudine delle idee laquale descende da Dio nella mente, sono e testicoli di Celio, perochè separati quelli da esso, rimane sterile, et non è più generativo, cascono questi testicoli nel mare, cioè nella natura informe Angelica, et come prima con quella si conjungano nasce essa Venere, laquale come e detto, e quello decore, quello ornato, et quella gratia, resultante della varietà di quelle idee, et perchè quelle idee non harebbono in se quella varietà et distintione, se non fussino mischiate à quella natura informe, ne sanza quella varietà vi puo essere bellezza, meritamente segue che Venere non potessi nascere se non cadendo e testicoli di Celio nelle marittime acque.' (If we therefore follow the interpretation which we have adopted, we must say that everything which Chronos communicates to Saturn, that is, that plenitude of ideas that descends from God into the intellect, is signified by the testicles of Chronos, for as soon as they are taken from him, he remains sterile and no longer generative; they throw these testicles into the sea, that is into the shapeless Angelic nature, and when they first unite with it, Venus is born who, as has been said, is that beauty, that adornment and that grace that springs from the variety of these ideas. And since these ideas would be devoid of variety and distinctions among them if they were not blended in with that formless nature,

and since without variety there can be no beauty, it follows that Venus could not have been born if the testicles of Chronos had not fallen into the watery sea.)

156. This observation was made by F. Saxl in a lecture. I have selected the example from Baldovinetti without suggesting that this was necessarily the model the artist had in mind. The group on Ghiberti's door, for instance, comes even closer to his scheme in certain details; there two administering angels are represented flying, not unlike the winds on Botticelli's picture. How far the artist, in making use of such a formula, was thinking of its precise theological significance, it is, of course, impossible to determine. An interesting classical parallel has been suggested by Toby E. S. Yuen, 'The *Tazza Farnese* as a source for Botticelli's *Birth of Venus* and Piero di Cosimo's *Myth of Prometheus*', *Gazette des Beaux-Arts*, vol. 74, 1969, pp. 175–8 (Fig. 56).

157. Apuleius, *ed. cit.*, p. 542.

158. In a fifteenth-century manuscript of Apuleius (Florence, Laurenziana 54, 24) this description of the appearance of the goddess (fol. 67v) carries the marginal note 'Descriptio Veneris'.

159. I quote from the translation of F. J. Miller in the Loeb Classical Library (London, etc., 1916).

160. It has usually been assumed that the Liberal Arts on the fresco must tally with the description in Martianus Capella, but this is, of course, rather unlikely.

161. A. d'Ancona, 'Strambotti di Leonardo Giustiniani', *Giornale di Filologia Romanza*, vol. II, no. 5, 1879.

162. *Commentary on the Symposium*, Speech *III*, chapter 3, Ficino, *ed. cit.*, p. 1329, and Ficino, *ed. cit.*, p. 924, where the 'liberal arts' provide the only pleasure left to man. (For the history of this moralized conception of the Arts called 'liberal' according to Salutati because they 'liberate' the mind from carnal lust, see Nesca N. Robb, *Neoplatonism*, p. 37.)

163. The identification of the Villa Lemmi with a property owned by Giovanni Tornabuoni should be re-examined. Vasari's circumstantial description of the property as lying so close to the river Terzolle that it was partly in ruins when he wrote, would seem to contradict this identification.

164. For a review of these discussions prior to the appearance of P. Kristeller's book see

R. Montano, 'Ficiniana', *La Rinascita*, III, 1940.

165. See R. Klibansky, *The Continuity of the Platonic Tradition* (London, 1939).

166. *History of Magic and Experimental Science* (New York, 1934), IV, pp. 562 ff.

167. E. Panofsky and F. Saxl, *op. cit.*

168. E. Panofsky, *Studies*, p. 165.

169. N. Ivanoff, 'La beauté dans la philosophie de Marsile Ficine et de Léon Hebreux', *Humanisme et Renaissance*, III, 1936. For further literature see P. Kristeller, *op. cit.*, and A. Chastel, *Marsile Ficin et l'art* (Geneva, etc., 1954).

170. This connection has been stressed in J. Festugière, *La philosophie de l'amour de Marsile Ficin et son influence sur la littérature française au XVI siècle* (Paris, 1941), and by Dr. Walter Moench, *Die italienische Platon-renaissance und ihre Bedeutung für Frankreichs Literatur und Geistesgeschichte 1450–1550* (Berlin, 1936).

171. Cf. Julius v. Schlosser, *Die Kunstliteratur* (Vienna, 1924); E. Panofsky, 'Idea', *Studien der Bibliothek Warburg* (Leipzig, Berlin, 1924); A. Blunt, *Artistic Theory in Italy 1450–1600* (Oxford, 1940); R. Wittkower, 'The Artists and the Liberal Arts', *Eidos*, vol. I, 1950, pp. 11–17.

172. Ficino, *ed. cit.*, p. 637.

173. For this tradition see W. Weisbach, 'Der sogenannte Geograph des Velasquez', *Jahrbuch der Preussischen Kunstsammlungen*, XLIX, 1928; and E. Wind, 'The Christian Democritus', *Journal of the Warburg Institute*, I, 1937–8, pp. 180 ff.

174. Ficino, *ed. cit.*, p. 118.

175. Ficino, *ed. cit.*, p. 944.

176. See Horne, *op. cit.*, p. 280.

177. Ficino, *ed. cit.*, p. 229. For Cosimo de' Medici's remark: 'Ogni dipintore dipigne sè' and its reflection in literature, see C. S. Gutkind, *Cosimo de' Medici* (Oxford, 1938), p. 234.

178. Michelangelo was a youth of 16 or 17 when he sat at the Magnifico's table; he was a man of 22 or 23 during the time he worked for Lorenzo di Pierfrancesco, who advised him to convert the Amor into a fake-antique. For this period in Michelangelo's life see K. Frey, *op. cit.*

179. 'Non exprimis (inquit aliquis) Ciceronem. Quid tum? Non enim sum Cicero, me tamen (ut opinor) exprimo' (Epistolarium VIII, Poliziano, *ed. cit.*, p. 113). For the context of this remark see F. Ulivi, *L'imitatione nella Poetica del Rinascimento* (Milan, 1959). For the theory of expression in humanist art theory see R. W. Lee, 'Ut pictura poesis', *The Art Bulletin*, XXII (1940). P. O. Kristeller, 'Humanism and Scholasticism in the Italian Renaissance', *Byzantion*, 17, 1944–5, p. 373 warns against overrating the connection between Renaissance art and Romantic notions about the creative genius of the artist which 'were largely foreign to the Italian Renaissance'. Admittedly the relationship is more complex than the nineteenth-century view of the period realized. In my article on Giulio Romano (*Jahrbuch der Kunsthistorischen Sammlungen in Wien*, New series, IX, 1935, p. 140 f., and, together with E. Kris, in 'The Principles of Caricature', *The British Journal of Medical Psychology*, XVII, 1938, pp. 331 ff.) I have attempted to define more closely in what way the new theory of art influenced stylistic development.

180. I came across these letters (and identified the writer of No. 3) in 1949. I am most grateful to Professor Nicolai Rubinstein for checking and correcting my transcript and translation.

AN INTERPRETATION OF MANTEGNA'S 'PARNASSUS'

1. 'Se Zoanne Bellino fa tanto male voluntieri quella historia, como me haveti scripto, siamo contente remetterne al justicio suo, pur chel dipinga qualche historia o fabula antiqua, aut de sua inventione ne finga una chè representi cosa antiqua, et de bello significato.' (If Giovanni Bellini is so unwilling to do that subject as you have written, we are content to leave the matter to his own judgment provided only that he paint some ancient story or fable or that he devise one of his own invention which represents a classical subject with a beautiful meaning.) (Letter to Michel Vianello, June 28, 1501, publ. W. Braghirolli, *Archivio Veneto*, XIII, 1877, p. 377.)

2. R. Foerster, 'Studien zu Mantegna und den Bildern im Studierzimmer der Isabella Gonzaga', *Jahrbuch der preussischen Kunstsammlungen*, XXII, 1901, pp. 78 ff. and

154 ff.; E. Wind, *Bellini's Feast of the Gods* (Cambridge, Mass., 1948), pp. 9–20; E. Tietze-Conrat, 'Mantegna's *Parnassus*. A discussion of a recent interpretation', *Art Bulletin*, XXXI, 1949, pp. 126–30; and E. Wind, *ibid.*, pp. 224–31.

For full bibliography see the Catalogue of the Mantegna Exhibition in Mantua, 1961 (G. Paccagnini, *Andrea Mantegna. Catalogo della Mostra . . .*, Venice, 1961), under no. 45, p. 64. For bibliography concerning Isabella's *Studiolo*, Ercolano Marani and Chiara Perina, *Mantova, Le Arti*, II (Mantua, 1962), pp. 378 ff.

3. VIII, 266–369.

4. This dual attribution has caused some confusion in the literature and in library catalogues. It is most easily sorted out with the help of Pauly-Wissowa, *Real-Encyclopädie*, s.v. Herakleides (45) and Herakleitos (12).

5. For the *editio princeps* and the principal MSS see F. Oelmann's preface to the Teubner edition, Heraclitus, *Quaestiones Homericae* (Leipzig, 1910). The Latin translation by Conrad Gesner was published in Basle, 1544, and frequently reprinted, e.g. in Th. Gale, *Opuscula Mythologica* (Amsterdam, 1688) (still under the name of Heraclides Ponticus).

6. E.g. Vienna, Nat. Bibl. Ms. phil. Gr. 133, and Paris, Bibl. Nat. 2403. Cf. F. Oelmann's preface, *loc. cit.*

7. *Problemata* 69, Teubner ed., pp. 89–90.

Νῦν τοίνυν ἅπαντα τἄλλα ἀφέντες ἐπὶ τὴν διηνεκῆ καὶ χαλεπῶς θρυλουμένην ὑπὸ τῶν συκοφαντῶν κατηγορίαν τραπώμεθα. ἄνω γοῦν καὶ κάτω τραγῳδοῦσι τὰ περὶ Ἄρεος καὶ Ἀφροδίτης ἀσεβῶς διαπεπλάσθαι λέγοντες· ἀκολασίαν γὰρ ἐμπεπολίτευκεν οὐρανῷ καὶ τὸ παρ' ἀνθρώποις, ὅταν γένηται, θανάτου τιμώμενον οὐκ ἐδυσωπήθη παρὰ θεοῖς ἱστορῆσαι, λέγω δὲ μοιχείαν.

ἀμφ' Ἄρεος φιλότητος ἐϋστεφάνου τ' Ἀφροδίτης,
ὡς τὰ πρῶτα μίγησαν ἐν Ἡφαίστοιο δόμοισιν·

εἶτα μετὰ τοῦτο δεσμὸ καὶ θεῶν γέλωτες ἱκεσία τε πρὸς Ἥφαιστον Ποσειδῶνος· ἅπερ εἰ θεοὶ νοσοῦσιν, οὐκέτι τοὺς παρ' ἀνθρώποις ἀδικοῦντας ἔδει κολάζεσθαι. νομίζω δ' ἔγωγε καίπερ ἐν Φαίαξιν, ἀνθρώποις ἡδονῇ δεδουλωμένοις, ᾀδόμενα ταῦτα φιλοσόφου τινὸς ἐπιστήμης ἔχεσθαι· τὰ γὰρ Σικελικὰ δόγματα καὶ τὴν Ἐμπεδόκλειον γνώμην ἔοικεν ἀπὸ τούτων βεβαιοῦν, Ἄρην μὲν ὀνομάσας τὸ νεῖκος, τὴν δὲ Ἀφροδίτην φιλίαν. τούτους οὖν διεστηκότας ἐν ἀρχῇ παρεισήγαγεν Ὅμηρος ἐκ τῆς πάλαι φιλονεικίας εἰς μίαν ὁμόνοιαν κιρναμένους. ὅθεν εὐλόγως ἐξ ἀμφοῖν Ἁρμονία γεγένηται τοῦ παντὸς ἀσαλεύτως καὶ κατ' ἐμμέλειαν ἁρμοσθέντος. γελᾶν δ' ἐπὶ τούτοις εἰκὸς ἦν καὶ συνήδεσθαι τοὺς θεούς, ἅτε δὴ τῶν ἰδίων χαρίτων οὐκ ἐπὶ φθοραῖς δισταμένων, ἀλλ' ὁμονοοῦσαν εἰρήνην ἀγόντων.

For other texts on 'Harmony' in the Renaissance, see E. Panofsky, *Studies in Iconology* (New York, 1939), p. 163.

8. 'Un Marte e una Venere che stanno in piacere con un Vulcano et un Orpheo che suona, con nove Nimphe che ballano' (A Mars and a Venus who have their pleasure, with a Vulcan, an Orpheus playing and nine dancing nymphs); cf. G. Paccagnini, *op. cit.*, p. 64.

9. Either the artist himself or somebody at a later date has scratched a line (faintly visible even in E. Tietze-Conrat, *Mantegna*, London, 1955, pl. 138), which continues the direction of Cupid's blowpipe and ends at the tip of Vulcan's sex organ.

10. *Ioannis Ioviani Pontani Carmina*, ed. B. Soldati (Florence, 1902), vol. I, pp. 3–4.

11. Pontanus read the *Urania* to his Academy in February 1501; earlier versions appear to have lacked the present invocation. Mantegna's painting was in place in 1497.

RAPHAEL'S *STANZA DELLA SEGNATURA* AND THE NATURE OF ITS SYMBOLISM

1. Vasari, Milanesi, vol. IV, pp. 329–30, '. . . dove giunto . . . cominciò nella camera della Segnatura una storia, quando i teologi accordano la filosofia e l'astrologia con la teologia; dove sono ritratti tutti i savi del mondo che disputano in varij modi.'

2. For a discussion of the *Stanza della Segnatura*, see especially J. Klaczko, *Jules II* (Paris, 1898), chapter 12, and L. Pastor, *Storia dei Papi*, III (Rome, 1959), book III, chapter 10; most recently L. Dussler, *Raphael, a Critical Catalogue*, London, 1970, and John Pope-Hennessy, *Raphael* (London and New York, 1970).

3. Oskar Fischel, *Raphaels Zeichnungen*, text volume (Berlin, 1913).
4. Harry B. Gutman, 'Medieval content of Raphael's "School of Athens" ', *Journal of the History of Ideas*, vol. 2, no. 4, pp. 420–9, has found few followers with his proposal to accept Vasari's interpretation.
5. Giovanni Pietro Bellori, *Descrizione delle imagini dipinti da Raffaelle d'Urbino nel Palazzo Vaticano, e nella Farnesina alla Lungara* (Rome, 1751), Preface, pp. lx–lxi.
6. Johann D. Passavant, *Rafael von Urbino und sein Vater Giovanni Santi*, 3 vols. (Leipzig, 1839–58).
7. Anton Springer, 'Raffael's Schule von Athen', *Die graphischen Künste*, vol. 5, 1883, p. 87.
8. Franz Wickhoff, 'Die Bibliothek Julius II', *Jahrbuch der Königlichen preussischen Kunstsammlungen*, 1893, no. 1.
9. See Pope-Hennessy, *op. cit.*, ch. IV, note 20.
10. Heinrich Wölfflin, *Die klassische Kunst* (Munich, 1904).
11. Julius von Schlosser, 'Giustos Fresken in Padua und die Vorläufer der Stanza della Segnatura', *Jahrbuch der kunsthistorischen Sammlungen des allerhöchsten Kaiserhauses*, vol. XVII, 1896, pp. 13–100.
11a. Cf. L. Dorez, *La conzone delle Virtù e delle Scienze*, Bergamo, 1904, chapter IX.
12. Vincenzo Golzio, *Raffaello nei documenti, nelle testimonianze dei contemporanei e nella letteratura del suo secolo* (Vatican City, 1936), p. 14.
13. Fiorenzo Canuti, *Il Perugino*, 2 vols. (Siena, 1931); vol. I, pp. 138–9.
14. Karl Müllner, *Reden und Briefe italienischer Humanisten* (Vienna, 1899).
15. *Iohannis Tuscanellae oratio pro legendi initio*, Müllner, *op. cit.*, pp. 191–7.

16. Vasari, Milanesi, vol. IV, pp. 335–6.
17. The books the two philosophers hold, the *Timeo* and the *Etica*, did not exist as such in Raphael's time. There were no separate Italian translations of these two treatises.
18. A. Springer, *loc. cit.*
19. Cicero, *De Oratore*, I, 9.
20. Cicero, *Pro Archia Poeta*, I, 2.
21. *Gregorii Tiphernii de studiis litterarum oratio*, Müllner, *op. cit.*, pp. 182–91.
22. Poggio Bracciolini, *Oratio in laudem legum*, Eugenio Garin, ed., *La Disputa delle arti nel quattrocento* (Florence, 1947), pp. 11–15.
23. *Ed. cit.*, pp. 11–12.
24. Golzio, *op. cit.*, p. 24.
25. See Introduction to this volume, pp. 1 ff.
26. Karl Bühler, *Die Darstellungsfunktion der Sprache* (Jena, 1934).
27. See this volume, pp. 183 f.
28. *Iohannis Argyropuli, Die III. Novembris 1458, hora fere XIV, In libris tribus primis Physicorum*, Müllner, *op. cit.*, p. 43.
29. See my essay, 'The use of art for the study of symbols', *The American Psychologist*, vol. 20, 1965, now reprinted in James Hogg, ed., *Psychology and the Visual Arts* (Harmondsworth, Middlesex, 1969).
30. Oskar Fischel, *Raphaels Zeichnungen*, vol. 5 (Berlin, 1924), vol. 6 (Berlin, 1925).
31. John White, 'Raphael and Breugel. Two Aspects of the Relationship between Form and Content', *The Burlington Magazine*, vol. CIII, no. 699, June 1961; and Pope-Hennessy, *op. cit.*, pp. 58 ff.
32. Wölfflin, *op. cit.*
33. Wölfflin, *op. cit.*
34. Mario Praz, *Studies in Seventeenth-Century Imagery*, 2 vols., Studies of the Warburg Institute, 3 (London, 1939).
35. See above, note 29.

HYPNEROTOMACHIANA

1. Karl Giehlow, 'Die Hieroglyphenkunde des Humanismus in der Allegorie der Renaissance', *Jahrbuch der kunsthistorischen Sammlungen des allerhöchsten Kaiserhauses*, XXXII, 1915.
2. 'Entrò Bramante in capriccio di fare in Belvedere in un fregio nella facciata di fuori alcune lettere a guisa di jeroglifi antichi, per dimostrare maggiormente l'ingegno ch' aveva, e per mettere il nome di quel pontefice e'l suo; e aveva così cominciato:

Julio II Pont. Maximo, ed aveva fatto fare una testa in profilo di Julio Cesare, e con dua archi un ponte che diceva: *Julio II Pont.*, ed una aguglia del circolo Massimo, per *Max*. Di che il papa si rise, e gli fece fare le lettere d'un braccio che ci sono oggi alla antica, dicendo che l'aveva cavata questa scioccheria da Viterbo sopra una porta, dove un maestro Francesco architettore messe il suo nome in uno architrave intagliato così, che fece un San Francesco,

un arco, un tetto, ed una torre, che rilevando diceva a modo suo: *Maestro Francesco Architettore*.' Vasari Milanesi, IV, p. 158. The passage does not occur in the first edition of 1550.

3. A reprint of Aldus' first edition of 1499 was published in London in 1904.

4. *Hypnerotomachia* fol. p. vi, verso; Giehlow, *loc. cit.*, p. 54.

5. The interest in hieroglyphic studies in Bramante's Rome is well attested. Cf. Giehlow, *loc. cit.*, p. 97.

6. Mario Praz, *Studies in Seventeenth-Century Imagery*, I, Studies of the Warburg Institute, 3 (London, 1939), p. 192.

7. Giehlow, *loc. cit.*, p. 40 ff. According to Vasari, Milanesi, *loc. cit.*, this Francesco Architettore might be identical with Pierfrancesco da Viterbo but there is no evidence to support this conjecture.

8. Giehlow, *loc. cit.*, pp. 43 ff., and F. Saxl, *Lectures* (London, 1957), vol. I, pp. 186–8.

9. Diary of Paride de Grassis, cf. V. Golzio, *Rafaello nei documenti, nelle testimonianze dei contemporanei e nella letteratura del suo secolo* (Vatican City, 1936), p. 14.

10. Perhaps this same aversion also helps to account for the Pope's decision to have an obelisk that was found at the beginning of his pontificate covered up again, cf. Giehlow, *loc. cit.*, p. 98.

11. Cf. Giehlow, *loc. cit.*, pp. 97 and 115 f.

12. L. Pastor, *History of the Popes*, VI (London, 1898), pp. 479 and 655.

13. For the role of 'Caesar's obelisk' in hieroglyphic studies cf. Giehlow, *loc. cit.*, pp. 30 ff. and p. 54.

14. Egidio da Viterbo, *Historia viginti seculorum*, Cod. C., 18, 9, Biblioteca Angelica, Rome, fol. 245: '. . . ad religionem facere ut templum ingressurus facturusque rem sacram non nisi commotus attonitusque novae molis aspectu ingrediatur, . . . animos quoque affectum expertes immotos perstare, affectu concitos facile se ad templa arasque prosternere.' (Printed in Pastor, *loc. cit.*, vol. III, Appendix.)

15. This of course, was the solution finally adopted under Sixtus V after it had already been mooted before Bramante's time. Cf. Schüller-Piroli, *2000 Jahre St. Peter* (Olten, 1950), pp. 499 and 617 ff., and plates pp. 505, 506.

See also B. Dibner, *Moving the Obelisks* (Norwalk, Conn., 1952), and Cesare d'Onofrio, *Gli Obelischi di Roma* (Rome, 1965).

16. 'Il quale altissimo Obelisco minima fede ancora ad me non si lassa havere, che unaltro conformitate monstrasse, ne similitudine. Non gia il Vaticanio. Non il alexandrino. Non gli Babylonici. Teniva in se tanta cumulatione di miraveglia, che io di stupore insensato stava alla sua consideratione. Et ultra molto piu la immensitate dillopera, et lo excesso dilla subtigliecia dil opulente et acutissimo ingiegnio, et dilla magna cura, et exquisita diligentia dil Architecto. Cum quale temerario dunque invento di arte? Cum quale virtute et humane forcie, et ordine, et incredibile impensa, cum coelestae aemulatione tanto nellaire tale pondo suggesto riportare? . . .' *Loc. cit.*, fol. b, recto.

17. An obelisk in a similar, slightly eccentric position in front of a large centralized building occurs in Franciabigio's fresco of Cicero's triumph in Poggio a Cajano (Fig. 104). Since Giovio is said to have had a share in the programme of these paintings a direct connection with the projects of Bramante is at least conceivable.

18. R. Wittkower, *Architectural Principles in the Age of Humanism*, Studies of the Warburg Institute, 19 (London, 1949), esp. p. 23 f.

19. J. S. Ackerman, 'The Belvedere as a classical villa', *Journal of the Warburg and Courtauld Institutes*, 14, 1951, pp. 70–91; and *The Cortile del Belvedere* (Vatican, 1954).

20. A further study of this relationship would not only entail a detailed comparison between the *Hypnerotomachia* woodcuts and Bramante's architecture, but would raise the problem whether these illustrations influenced Bramante or whether Bramante could possibly have influenced the illustrations.

21. Ackerman, *op. cit.*

22. A. Michaelis, 'Geschichte des Statuenhofes im Vaticanischen Belvedere', *Jahrbuch des kaiserlich deutschen archäologischen Instituts*, v, 1890. J. Klaczko, *Jules II* (Paris, 1898). P. G. Hübner, *Le Statue di Roma*, I (Leipzig, 1912). An important new aid for the reconstruction of the setting of these statues is provided by E. Tormo, *Os Desenhas das antigualhas que vio Francisco d'Ollanda, Pintor Portugués* (Madrid, 1940). Hans Henrik Brummer, *The Statue Court in the Vatican Belvedere* (Stockholm, 1970), includes a critical discussion of this essay.

23. Cf. G. Tiraboschi, *Biblioteca Modenese*, IV (Modena, 1783), pp. 108–22. See also Gertrude Bramlette Richards, *Gianfrancesco Pico della Mirandola*, a typescript thesis in the Library of Cornell University, press no. T. 1915, R. 515.

24. L. Pastor, *History of the Popes*, VII (London, 1908), p. 5 f. and VIII, p. 406 f.

25. Pastor, *loc. cit.*, V, 1898, p. 216.

26. W. Amelung, *Die Skulpturen des Vaticanischen Museums* (Berlin, 1908), no. 42, pp. 112–15.

27. Pico may have known this painting as he was in Mantua in 1506. Cf. A. Schill, *Gianfrancesco Pico della Mirandola und die Entdeckung Amerikas* (Berlin, 1929), p. 12.

28. G. F. Pico della Mirandola, *De Venere et Cupidine expellendis* (Rome [Jacobus Mazochius], December 1513). A copy of this rare edition is in the Warburg Institute.

'Nostin Lili Venerem atque Cupidinem vanae illius Deos vetustatis? Eos Iulius secundus Pont. Max. accersivit e romanis ruinis, ante paululum erutos, collocavitque in nemore citriorum illo odoratissimo constrato silice, cuius in meditullio Caerulei quoque Thybridis est imago colossea. Omni autem ex parte antiquae Imagines, suis quaeque arulis super impositae. Hinc pergamei Laocoontis exculptum uti est a Vergilio proditum simulacrum. Inde pharetrati visitur species Apollinis, qualis apud homerum expressa est, sed et quodam in angulo spectrum demorsae ab aspide Cleopatrae: cuius quasi de mammis destillat fons vetustorum instar aqueductuum, excipiturque antiquo inquod relata sunt Traiani Principis facinora quaepiam marmoreo sepulchro. . . .' Fol. b iv, recto.

29. *Hypnerotomachia*, *loc. cit.*, fol. d viii, recto: 'Laquale bellissima Nympha dormendo giacea commodamente sopra uno explicato panno . . . ritracto il subiecto brachio cum la soluta mano sotto la guancia il capo ociosamente appodiava. . . . Per le papule (quale di virguncule) dille mammille dilla quale, scaturiva uno filo di aqua freschissima dalla dextera. Et dalla sinistra saliva fervida. Il lapso dambe due cadeva in uno vaso porphyritico,' etc.

30. *Loc. cit.*, fols. b iv, r–v: 'Ad hunc ego lucum saepe cum diverterem, non philosophandi gratia, ut olim sub umbra platani propter Ilissum ad quae murmur coloratos lapillos inter strepentis, minus aut adorandi aut mactandi pecudes ergo, ut vani culto, res ritus consuevere, sed causa negotiorum, et vel pacem, vel arma tractandi, quibus tandem in patriam ditionem iterum exul, iterum redux fierem. Non visum est mihi ex re fore inutili ut otio torporem, quin ita subito quod malebam non prestaretur, . . . excudere igitur vel exordiri aliquod placuit opus, aut homine dignum, aut supra brutum.'

31. For the philosophical background to Pico's conception of the 'brutalizing' power of lust, cf. H. Caplan, *Gianfrancesco Pico della Mirandola on the Imagination*, Cornell Studies in English, XVI (New Haven, 1930), especially p. 45. I am greatly indebted to Dr. H. C. Talbot for help and advice in interpreting Pico's letter.

32. The subject had already been treated by Giovanni Francesco's uncle and continued to preoccupy him. Cf. H. Caplan, *loc. cit.*, p. 74.

33. This edition is accompanied by a letter to Konrad Peutinger: '. . . Argumentum praebuit carmini, antiquum Veneris et Cupidinis simulacrum: uti in epistola ad Lilium non paucis retuli. Sed sane eo in simulacro simul et artificis ingenium licebat suspicere: et simul admirari vanae superstitionis tenebras verae luce religionis ita fugatas, ut nec ipsorum Deorum imagines nisi truncae, fractae, et pene prorsus evanidae spectarentur.' (The poem was occasioned by the ancient statue of Venus and Cupid, as I explained at length in my letter to Gyraldus. Truly in this statue it was possible to perceive at the same time the gifts of the maker and to reflect about the way in which the darkness of the false superstition had been put to flight by the true religion that not even the images of these gods could be seen except in broken fragments and almost withered away.) Thus the statue of Venus in the Vatican is here turned into the innocuous symbol of the broken idol. Instead of Mantegna's Psychomachia one may think of the traditional representations of the Flight into Egypt where the pagan statue falls from its column as the Holy Family passes by. The 'vanity' of the pagan gods is another constant theme of Pico, who was, however, convinced of the truth of ancient demonology. Cf. this volume, pp. 176 f. His dual interpretation of the Venus felix as a brutalizing demon and a vanquished deity corresponds to this attitude.

34. See Introduction to this volume, pp. 1 ff.

35. *Lettere di M. Pietro Bembo* (Rome, 1548), I, p. 90 ff., dated 25th April 1516. The letter has often been reprinted, e.g. in Golzio, *loc. cit.*, pp. 44–5: 'che me la vagheggerò ogni giorno molto più saporitamente, che Voi far non potrete per le continue occupatione vostre. . . . Deh, Monsig. mio caro, non mi negate questa gratia. . . . Aspetto buona risposta da V.S., et ho già apparecchiato et adornato quella parte, e canto del mio camerino, dove ho a riporre la Venerina. . . .'

36. L. Pastor, *loc. cit.*, VIII (London, 1908), p. 176. The author emphasizes that it would be hard to believe this story, were it not attested in a contemporary letter by Baldassare Castiglione. Though E. Walser, *Gesammelte Studien zur Geistesgeschichte der Renaissance* (Bâle, 1932), p. 114 f., has rightly pointed out that we must not accept the institutionalized licence of Carnival songs and symbols as symptomatic of the outlook of the age, the form which this licence took remains yet of psychological significance.

37. Cf. G. Negri's letter of 17th March 1523: 'Et essendoli ancora mostrato in Belvedere il Laocoonte per una cosa eccellente et mirabile disse; sunt idola antiquorum.' (And when the Laocoon in the Belvedere was also pointed out to him as an excellent and marvellous piece, he said, these are ancient idols.) *Lettere di Principi*, etc. (Venice, 1581), p. 113. L. Pastor, *loc. cit.*, IX (London, 1910), p. 73. By the middle of the sixteenth century that point of view had won through; the 'idols' were screened by shutters. Michaelis, *loc. cit.*, p. 57.

38. The book had not been printed at the time of Colonna but the dependence is quite apparent from a comparison of the texts. I quote from the English translation by Ray Nadeau in *Speech Monographs*, 19, Ann Arbor, 1952: 'Let anyone marveling at the beauty of the rose consider the misfortune of Aphrodite. For the goddess was in love with Adonis but Ares, in turn, was in love with her; in other words, the goddess had the same regard for Adonis that Ares had for Aphrodite. God loved goddess and goddess was pursuing mortal; the longing was the same, even though the species was different. The jealous (*zelotypon*) Ares, however, wanted to do away with Adonis in the belief that the death of Adonis would bring about a release of his love. Consequently, Ares attacked his rival but the goddess, learning of his action, was hurrying to the rescue. As she stumbled into the rosebush because of her haste, she fell among the thorns and the flat of her foot was pierced. Flowing from the wound, the blood changed the color of the rose to its familiar appearance and the rose, though white in its origin, came to be as it now appears.'

Colonna, *op. cit.*, fol. z vi, verso: 'Et in questo loco etiam similmente la Sancta Venere uscendo di questo fonte nuda, in quelli rosarii lancinovi la divina Sura, per soccorrere quello dal zelotypo Marte verberato.' (And it was also in this place that holy Venus emerging naked from this fountain tore her divine foot in those rosebushes while rushing to the assistance of him who was being beaten by jealous (*zelotypo*) Mars. . . .)

39. W. Friedländer, 'La tintura delle rose', *The Art Bulletin*, XX, no. 3, pp. 320–4.

40. For a full description of this room with its fresco cycles, cf. Frederick Hartt, *Giulio Romano*, 2 vols. (Newhaven, 1958).

41. For the date and previous bibliography see Leopold Dussler, *Sebastiano del Piombo* (Bale, 1942), p. 34. The author's description offers an interesting test case for the interdependence of iconography and formal appreciation. Having failed to notice the episode of the roses he criticizes the posture of Venus as a breach of decorum.

THE SALA DEI VENTI IN THE PALAZZO DEL TE

1. Frederick Hartt, *Giulio Romano*, 2 vols. (New Haven, 1958).

2. I have not been able to trace the origin of this sentence, which may be very roughly translated as 'For it is undecided which stars may lay hold of you' (*excipiant* may mean 'catch you' or 'please you'—an ambiguity which may not be unintentional).

In its form the inscription recalls Manilius, in whose second book we find no less than three lines beginning with *Distat enim* in the sense of 'it is undecided': 'Distat

enim gemina duo sint duplane figura' (*Astr.* II, 174); 'Distat enim (an) partis consumat linea iustas' (II, 347) and 'Distat enim surgatne eadem subeatne cadatne' (II, 651).

3. About this doctrine of the so-called *paranatellonta* and its sources cf. F. Boll, *Sphaera* (Leipzig, 1902), esp. pp. 379–404.

4. Subsequent references will be to the Teubner edition by W. Kroll and F. Skutsch in association with K. Ziegler (Leipzig, 1913).

5. The way in which the two classical authorities on the stars are combined and elaborated in these frescoes presents a remarkable parallel to the methods of J. Pontanus. In the corresponding books of his *Urania* (books III and IV) the same constellations are, in fact, described in their influence, but a comparison between the poem and the paintings shows that both go back to the same classical sources without being directly related. All references are to the edition of Manilius by T. Breiter (Leipzig, 1908), and the English translations are taken from *The Five Books of M. Manilius . . . done into English Verse* (London, 1697).

6. Cf. below; p. 113.

7. This composition, of course, strongly influenced Poussin's so-called 'Dance to the Music of Time' in the Wallace Collection.

8. The idyllic mood of the scene, the profusion of flowers and the emphasis on the female element may well be due to Manilius, v, 254 f.:

'. . . hinc dona puellae
namque nitent, illinc oriens est ipsa puella.
ille [*sic*] colet nitidis gemmantem floribus
 hortum,
pallentes violas et purpureos hyacinthos
liliaque et Tyrias imitata papavera luces
vernantisque rosae rubicundo sanguine
 florem;
caeruleum foliis viridemve in germine
 collem
conseret et veris depinget prata figuris,
aut varios nectet flores sertisque locabit.'
('They give Soft Arts, for here the Virgin
 Shines,
And there the Virgin's Crown, and each
 combines
Soft Beams agreeing in the same Designs.
Births influenc'd then shall raise fine Beds
 of Flowers,
And twine their creeping Jasmine round
 their Bowers;

The Lillies, Violets in Banks dispose,
The Purple Poppy, and the blushing Rose:
For Pleasure shades their rising Mounts
 shall yield,
And real Figures paint the gawdy Field.')
 Ed. cit., book v, p. 65.

9. Cf. Venturi, *Storia dell Arte Italiana*, XI/1, 1938, fig. 260, and the discussion of this problem by J. Hess, 'On Raphael and Giulio Romano', *Gazette des Beaux Arts*, 1947, p. 102, note. According to C. d'Arco, *Giulio Pippi Romano* (Mantua, 1842), p. 65, the fresco had nearly disappeared but the restoration must be substantially correct.

10. *Gesammelte Schriften*, I (Leipzig-Berlin, 1932), p. 303. Cf. Manilius, v, 390 ff.:
'Anguitenens magno circumdatus orbe
 Draconis
cum venit in regione tuae, Capricorne,
 figurae,
non inimica facit serpentum membra
 creatis;
accipient sinibusque suis peploque fluenti
osculaque horrendis iungent impune
 venenis.'
('When Ophieuchus mounts, and joyns the
 Goat,
Those that are born shall live an Antidote
To strongest Poyson; they may safely take
The frightful Serpent, and the Venom'd
 Snake
Into their Bosom: Whilst the Monster's
 Cling
About their Bodies kills their fiercest
 Sting.')
 Ed. cit., v, p. 70.

11. *Philostrats Gemaelde*, No. 74.

12. Manilius, v, 660 f.:
'. . . extentis laqueare profundum
retibus et pontum vinclis armare furentem.
et velut in laxo securas aequore phocas
carceribus claudent raris et compede
 nectent
incautosque trahent facularum lumine
 thynnos.'
('No Fish shall swim secure whilst Nets
 can sweep
The troubled Ocean, and confine the Deep:
Those that but now could wanton o'er the
 Main
Shall lye fast bound, and wonder at their
 chain.')
 Ed. cit., v, p. 81.

13. *Ed. cit.*, v, pp. 71–2; Manilius, v, 415–45.

14. Both Vasari, who visited the Palace in 1541, and Giacomo Strada in 1577, thought that

the medallions represented the occupations of the months. Individual roundels were also engraved with wrong titles. Thus the gladiators of the *Ungula Tauri* were published with the inscription 'Trigeminorum Horatiorum Curiatiorumque pro Patria Gloriosum Certamen' (The glorious contest of the three Horatii and Curiatii for the Father Land) by A. Salamanca in 1541. (B. xv, 29, 2.)

15. Cf. A. Warburg, 'Italienische Kunst und Internationale Astrologie im Palazzo Schifanoja zu Ferrara', *Gesammelte Schriften*, II, p. 459 f.

16. Manilius, II, 439–47. Cf. Warburg, *loc. cit.*, fig. 107 and p. 470. The identification of the twelve Olympian Gods on the ceiling and their separation from the twelve months is due to Frederick Hartt, *op. cit.*

17. For a full view of the ceiling, cf. Frederick Hartt, *op. cit.*, Pls. 192, 193.

18. Cf. J. C. Webster, *The Labors of the Months in Antique and Mediaeval Art* (Evanston and Chicago), 1938.

19. Cf. Lucas Gauricus, *Opera Omnia* (Bâle, 1575). The months are discussed in the *Calendarium Ecclesiasticum*, p. 694 (misprinted as 946) *et seq.*, and in *De Geometria et eius Partibus*, p. 1753 f. of the edition cited.

20. Gauricus, *loc. cit.*, p. 694 (*sc.* 946).

21. Cf. *idem, loc. cit.*, p. 693, and p. 1760.

22. *Idem, loc. cit.*, p. 1760.

23. *Idem, loc. cit.*, p. 1762.

24. *Idem, loc. cit.*, 1762.

25. *Idem, loc. cit.*, p. 1763.

26. *Idem, loc. cit.*, p. 1764.

27. *Idem, loc. cit.*, p. 1764.

28. *Idem, loc. cit.*, p. 1755.

29. Cf. the letter by Calandra of the 27th September 1527: 'Ho veduto la camera dei venti, alla quale se lavora et de stucchi et de pictura; ... in la volta hanno dipinto doi di quelli spatii che dicono mandole ed comincio la terza, in una hanno fatto un Jano, in l'altra putti che coliono frutti d'una oliva.' (I have seen the room of the winds where work is proceeding in stucco and painting. ... On the vault they have painted two of the compartments they call lozenges, and have begun a third. In one they have made a Janus, and in the other *putti* picking fruit off an olive tree.) Cf. S. Davari, *Il Palazzo del Te*, *L'Arte* (1899, and Mantua, 1904 and 1925). According to the verses by Dracontius it is November,

not December, when the olives are harvested; cf. D. Levi, 'The Allegories of the Months in Classical Art', *The Art Bulletin*, 1941, p. 270.

30. The classical terminology of the winds according to Vitruvius and others is also explained by L. Gauricus, *loc. cit.*, p. 1741 f., who also discusses and illustrates an amended windrose with 16 winds which he calls a fairly recent invention.

31. G. Romano, *Cronaca del Soggiorno di Carlo V in Italia* (Milan, 1892), p. 262. See below.

32. Cf. G. Romano, *op. cit.*, p. 262 (the chronicler speaking was probably L. Gonzaga): 'Poi entro nell'altra camara qual si chiama la camara delli Pianetti et Venti, dove ora alloggi il prefato Sr. Marchese, quale camara sommamente piacque a sua Maestà. ...' (Then he entered the other room which is called of the Planets or the Winds where the aforementioned Marchese lives, and this room pleased his Majesty exceedingly. ...)

 P. 266: '... et sua Maestà si ritirò nella camara delli venti, et ragionò per un'hora cosi publicamente con il Cardinale Cibo, laudando molto queste camare, et cosi il Maestro et inventore di esse, et di tante diversitati di cose vi furno et erano, et cosi minutamente sua Maestà volse intendere il tutto. ...' (... and his Majesty retired into the room of the winds, and thus visibly he talked for an hour with Cardinal Cibo, praising these rooms very much and also their master and designer and all the diversity of things they contained, and so his Majesty wanted to have it explained down to the last detail.)

33. Cf. E. Percopo, 'Luca Gaurico, ultimo degli Astrologi', *Società Reale di Napoli, Atti della Reale Academia di Archeologia, Lettere e Belle Arti*, XVII, parte II, 1895.

34. *Lucae Gaurici Neapolitani Prognostica ad illustrissimum ac invictissimum Mantuae Marchionem ... 1503–1535; Op. Omnia*, p. 1572.

35. He was resident in Mantua in and about 1512 and probably again in 1524. Cf. E. Percopo, *loc. cit.*

36. In a prognostic pamphlet 'Al Clemente 7 Pontifici clementissime ...' we read this advice: 'A Federico Gonzaga, marchese de Mantua, Illust. Illustrissimo Signore, per tutto Junio 1526 te aquisterai gran gloria in lo mistiero dele arme et li nimici poco

poteranno offendere tua Maiesta, starite sano se fugirite el superfluo coito et alcun sinistro de Cavalli per liquali haverite gran danno, tua Matre clarissima havera uno poco de alteratione. . . .' (To Federico Gonzaga, Illustrious Marquis of Mantua: Most illustrious Lord, for the whole of the month of June you will acquire great glory in war-like pursuits and your enemies will not be able to harm your Majesty much; you will remain healthy if you avoid superfluous intercourse, and a certain bad horse in your stable which would harm you greatly; your most famous Mother will change a little.) Federigo's horoscope is published and discussed by Gauricus in his *Tractatus Astrologicus* (Venice, 1552), p. 44.

37. Cf. the preface to Bonincontri's *De Rebus Coelestibus* (Venice, 1526). 'Illustrissimo Mantuae Marchioni Federico Gonzagae . . . L. Gauricus Neapolitanus Felicitatem. Quom septimo Idus April. 1526 statuissem invictissime Imperator, pro communi utilitate, Laurentii Miniatenis Bonincontri De rebus cum naturalibus, tum Divinis Libellum Aldinis typis excudendum promulgare, e vestigio oblatae sunt nobis literae Maiestatis tuae, quibus ultro accersitus nefas duxi absque munusculo tuam adire celsitudinem, imitatus Parthorum consuetudinem, apud quos non licebat quempiam ire salutatum claros sine munere reges. Suscipe igitur Augustissime Princeps Fausto Sidere pro Gaurici Munusculo Bonincontri opusculum paene divinum. . . .' (Most Illustrious Marquis of Mantua, Federico Gonzaga . . . L. Gauricus of Naples wishes you happiness. When, invincible general, I decided on the seventh Ides of April 1526 to have published Lorenzo Bonincontri's book on natural and divine matters, by the Aldine Press, for the benefit of all, at that moment your Majesty's letters were brought to me, by which I was roused and thought it a crime to approach your Highness without some little present, following the custom of the Parthians who would not permit anyone to go and greet their famous Kings without bearing a gift. Accept therefore, most august Prince, under a lucky star, this little work of Bonincontri as the present of Gauricus.)

Researches which the Director of the Archivio Gonzaga, Dottore Giovanni Praticò, had the great kindness to undertake in Mantua, confirm that Gauricus wrote to the Marchese from Venice on April 9, 1526, expressing the wish to come to Mantua and offering to serve him 'viribus et ingenio', but no evidence concerning their further relations has so far come to light.

38. Pietro Aretino, *Judicio over pronostico de mastro pasquino quinto evangelista de anno 1527, a marchese Federico Gonzaga*. The preface made fun of Gauricus and 'quella pecora de Abumasar'. Unfortunately the pamphlet is not preserved. Cf. E. Percopo, *loc. cit.*, p. 25.

39. Cf. A. Luzio, *Pietro Aretino . . . e la Corte dei Gonzaga* (Turin, 1888).

I have referred elsewhere to Aretino's praise of Sansovino's Venus (see this volume, p. 213). The continuation of the passage is perhaps even more outspoken: 'Ho detto a Sebastiano, pittor miracoloso, che il desiderio vostro e che vi faccia un quadro de la invenzione che gli piace, purchè non ci sien sù ipocrisie nè stigmati nè chiodi. Egli ha giurato di dipingervi cose stupende.' (I told Sebastiano that marvellous painter that you want him to paint you a picture, and that any invention will please him, provided it contain neither hypocrisies, stigmata or nails. He has sworn that he will paint stupendous things for you.) Pietro Aretino, *Il Primo libro delle Lettere*, ed. F. Nicolini (Bari, 1913), p. 16.

40. It is impossible to overlook the 'Aretinian' ingredients in the Sala di Psiche. It is all the more interesting to ponder the inscription which runs round the cornice of that strange room: FEDERICVS GONZAGA. II. MAR . . . HONESTO OCIO POST LABORES AD REPARANDAM VIRT. QUIETI CONSTRVI MANDAVIT. (Federico Gonzaga, the Marquis . . ordered this to be built for honest leisure after work to restore strength in quiet).

The emphasis on the salutary and restorative functions of 'honestum ocium' may, of course, be no more than an attempt to anticipate and disarm criticism. But is it a pure coincidence that we have a treatise by none other than Lucas Gauricus, entitled 'De Ocio Liberali' in which the sentence occurs: 'Est huiusmodi ocium nihil aliud, nisi vacatio quaedam, et intermissio a gravibus seriisque rebus, ad relaxationem animi, atque vires aliquantum reparandas quum nullum in se turpitudinem habeat, sed potius honestatem'? (And this form of leisure is nothing but a kind

of emptying and an interruption of grave and serious matters, for the relaxation of the mind, and a certain restoration of the spirit which is not shameful, but rather honourable.) (*Ed. cit.*, p. 1849.) Admittedly the *tractatus* in question was apparently published later, but the similarity of wording is still noteworthy.

THE SUBJECT OF POUSSIN'S *ORION*

1. Sacheverell Sitwell, *Canons of Giant Art. Twenty Torsos in Heroic Landscapes* (London, 1933). The volume contains two poems and notes on Poussin's *Orion*.

2. 'Per lo Signore Michele Passart, Maestro della Camera de' Conti di Sua Maestà Cristianissima, dipinse due paesi; nell'uno la fauola d'Orione cieco gigante, la cui grandezza si comprende da un homaccino, che lo guida in piè sopra le sue spalle, et un'altro l'ammira', G. P. Bellori, *Le Vite de' pittori, scultori, et architetti moderni* (Rome, 1672) (reprint of 1968, Quaderni dell'Istituto di storia dell'arte della Università di Genova, 4), p. 546.

3. T. Borenius, 'A Great Poussin in the Metropolitan Museum', *The Burlington Magazine*, LIX, 1931, pp. 207–8.

4. Lucian, *The Hall*, ed. A. M. Harman, The Loeb Classical Library, vol. I (London, etc., 1913), p. 203.

5. A. Félibien, *Entretiens sur les vies et sur les ouvrages des plus excellens Peintres* ... (Trévoux, 1725), vol. 4, Entretien VIII.

6. Quoted by Douglas Bush, *Mythology and the Renaissance Tradition in English poetry* (Minneapolis, 1932), p. 31.

7. Charles Mitchell, 'Poussin's *Flight into Egypt*', *Journal of the Warburg Institute*, I, 1937–8, p. 342 and note 4, first drew attention to Poussin's use of Natalis Comes.

8. J. Seznec, *The Survival of the Pagan Gods*, trans. B. F. Sessions, Bollingen Series, XXXVIII (New York, 1953).

9. Comes uses the form Aerope instead of Merope to interpret the meaning of the name as 'Air' in this context.

10. Natalis Comes, *Mythologiae, sive Explicationis fabularum libri decem* ... (Padua, 1616), book VIII, chapter XIII, p. 459.

11. W. Hazlitt, *Table Talks*, vol. II (London, 1822).

12. *Loc. cit.*, p. 208.

ICONES SYMBOLICAE

1. *Histoire du Ciel*, II, p. 427, quoted by Jean Seznec, *The Survival of the Pagan Gods*, Bollingen Series, no. XXXVIII (New York, 1953), p. 273 n. This line of attack had been developed in J. B. Du Bos' *Reflexions Critiques sur la Poésie et sur la Peinture* (Paris, 1719), part I, sect. 24.

2. This is the idea underlying the definitions of allegorical imagery in most eighteenth- and nineteenth-century writings, e.g. K. H. Heydenreich, *Aesthetisches Wörterbuch über die bildenden Künste* (Leipzig, 1793): 'Die Allegorie ... ist ein ... Mittel, welches der Künstler anwendet, um durch Hülfe symbolischer Figuren, ... und durch andere Dinge, wegen welchen man sich übereingekommen ist, geistige Gedanken und abstrakte Ideen mitzuteilen.' (Allegory is a method which artists use ... to communicate mental ideas and abstract thoughts by means of symbolic figures ... and other objects which have been established by convention.)

3. Hans Tietze, 'Programme und Entwürfe zu den grossen Oesterreichischen Barockfresken', *Jahrbuch der kunsthistorischen Sammlungen in Wien*, vol. XXX, 1911. The aesthetic relevance of these programmes is stressed by K. L. Schwarz, 'Zum aesthetischen Problem des Programms', *Wiener Jahrbuch für Kunstgeschichte*, vol. XI, 1937.

4. The full title of the book is *Bibliothecae Alexandrinae Icones Symbolicae P. D. Christofori Giardi Cler. Reg. S. Pauli Elogiis illustratae, Illustrissimo Ioanni Baptistae Trotto Praesidi et Reg. Consiliario dicatae*. There are two editions *apud Io. Bidellium* (Milan), 1626 and 1628. The text and illustrations are reproduced in G. Graevius et P. Burmannus, *Thesaurus Antiqu. et. Histor. Italiae*, IX, 6. The author, Christophoro (Pietro Antonio) Giarda, was a member of the Barnabite order; born in 1595 at Vespolata (Novara), he took the vows in 1613, studied rhetoric at Milan and

philosophy and theology at Pavia, became a priest in 1620 and for three years taught rhetoric at Montargis (France). He then returned to the Barnabite Institution of S. Alessandro in Milan. This important college had been given a library by the Milanese nobleman and diplomat Carlo Bossi (1572–1649). According to Giarda's preface this 'Alexandrian' library was the worthy heir of the original one by reason of the wealth, variety, order and beauty of its volumes. Its divisions (*scrinia*) were decorated with the personifications of 16 Liberal Arts which marked the grouping of the library books. It is significant that we are not told who the artist was who designed them—judged by the feeble engravings of Giarda's book he was not a great master. Perhaps the programme for these figures had been drawn up by the donor, C. Bossi, himself, as we know that he was interested in emblematics, a manuscript *De impresiis et emblematibus* being listed among his works.

Giarda's speeches or sermons on the allegorical figures of the 'Alexandrian' library were delivered on the occasion of a meeting of the Barnabite Congregation at Milan in 1626, when custom demanded that the professors at the College should present the guests with a sample of their skill. He dedicated the published version to G. B. Trotto, a president of the Milan Senate.

Giarda's subsequent fate is interesting. After preaching with great success in Bologna and Rome he rose in the hierarchy of the order and became ultimately the director of its entire Roman Province. Thanks to the patronage of Cardinal Francesco Barberini he was called to the Congregation of the Index. After the accession of Innocent X he seems to have mainly been engaged in pressing for the canonization of St. François de Sales. In May 1648 his life took a dramatic turn. The Pope in person consecrated him Bishop of Castro. This appointment proves that Giarda's reputation for loyalty and courage must have stood high. For Castro was no ordinary Bishopric. A dispute raged between the Pope and the House of Farnese as to their respective rights in this small town in the Orvieto area. Giarda did not proceed to his contested seat immediately but stayed in Rome for another ten months. In March

1649 he left with a small retinue to take up his appointment and was promptly murdered by Ranuccio Farnese's *bravi* while spending the night in an inn on the way. The Pope's revenge was terrible. Castro was destroyed and a pillar erected with the inscription: '*Qui fu Castro.*' The diocese, of course, ceased to exist.

Cf. P. G. Boffito, *Scrittori Barnabiti o della Congregazione dei Chierici di San Paolo 1533–1933*, with full bibliography.

The text of the Introduction is given in an Appendix, this volume, pp. 192–195.

5. Giardia, *op. cit.*, see Appendix, paragraph 1.

6. See Robert Klein, 'La Théorie de l'expression figurée dans les traités Italiens sur les *Imprese*, 1555–1612', *La Forme et l'Intelligible* (Paris, 1970), p. 146.

7. Cf. E. Panofsky, *Studies in Iconology* (New York, 1939), pp. 3 ff. In the terminology of Charles Morris, *Signs, Language and Behavior* (New York, 1946), we would have to distinguish between images as 'iconic signs' and as 'post language symbols'. See also the Introduction to this volume, p. 3.

8. Carl Nordenfalk, 'Van Gogh and Literature', *Journal of the Warburg and Courtauld Institutes*, x, 1947, pp. 132 ff.

9. Edwyn Bevan, *Holy Images, An Inquiry into Idolatry and Image-Worship in Ancient Paganism and Christianity* (London, 1940), p. 29.

10. A. Warburg, 'Heidnisch-antike Weissagung in Wort und Bild zu Luthers Zeiten', *Gesammelte Schriften* (Berlin, 1932), p. 491. See also my *Aby Warburg* (London, 1970).

11. See my 'The Cartoonist's Armoury', *Meditations on a Hobby Horse* (London, 1963).

12. Cf. Roscher's *Mythologisches Lexikon*, s.v. *Personification* (by L. Deubner), and see my Paper, 'Personification', *Classical Influences on European Culture*, ed. R. Bolgar (Cambridge, 1971), and Morton W. Bloomfield, 'A grammatical approach to Personification Allegory', *Modern Philology*, LX, 1963, pp. 161–71.

13. The preliminary probings I have made in the paper quoted in the previous note suggest that this mode of thought and speech is known in India and Persia but not in China.

14. Ruth S. Magurn, *The Letters of P. P. Rubens* (Cambridge, Mass., 1955), no. 242, pp. 408–9.

15. Carlo Ridolfi, *Le Meraviglie dell'arte* (Venice, 1648), vol. 2, p. 43.

16. Ernst Robert Curtius, *European Literature in the Latin Middle Ages* (London, 1953), p. 131.

17. The greatest exponent of Abbé Pluche's view was Benedetto Croce, who banished allegory from the 'aesthetic sphere' because he, too, saw in it a purely conventional and arbitrary 'mode of writing' which belongs, at best, to the 'practical sphere'. In his review of Seznec's book (*op. cit.*) in *La Parola del Passato*, I, 3, 1946, Croce even dismissed iconographic research because the solution of these 'mysteries' usually proved to be 'without importance'. While his warning against a 'detective' approach to the past which tries to reveal 'an invisible history behind the visible one' is certainly justified, the present argument may help to show that his division into 'spheres' can hardly do justice to the complex problem of symbolic imagery.

18. 'bey einer *opera* muss schlechterdings die Poesie der Musick gehorsame tochter seyn', Ludwig Schiedermair, *Die Briefe W. A. Mozarts und seiner Familie* (Munich, 1914), vol. 2, p. 128. 13 October 1781.

19. Fritz Saxl, 'Veritas filia temporis', *Philosophy and History. Essays Presented to Ernst Cassirer* (Oxford, 1936).

20. Adolf Katzenellenbogen, *Allegories of the Virtues and Vices in Medieval Art* (London, 1939) (Studies of the Warburg Institute, no. x). For the tree imagery see also Frances Yates, 'The Art of Ramon Lull', *Journal of the Warburg and Courtauld Institutes*, vol. xvii, 1954, pp. 130, 139, 153.

21. Quoted by W. H. Auden, *About the House* (London, 1966), p. 66.

22. Epinetron by the 'Eritreia Painter', *c.* 420 B.C., Athens, National Museum. Cf. P. E. Arias, *A History of Greek Vase Painting* (with photographs by M. Hirmer and Notes revised by B. Shefton) (New York, 1961), no. 203.

23. Pausanias, *Periegesis*, v (Elis), 18, 1.

24. See Katzenellenbogen, as quoted under note 20 above.

25. Oxford, 1936.

26. R. Pfeiffer, 'The Image of the Delian Apollo and Apolline Ethics', *Journal of the Warburg and Courtauld Institutes*, vol. xv, 1952, pp. 20–32.

27. Propertius, *Elegies*, II, 12. I quote from H. E. Butler's translation in the Loeb Classical Library, 1912.

28. Ausonius, *Opuscula*, ed. R. Pfeiffer (Leipzig, 1886), book xviii, 33. For illustrations of this epigram, see R. Wittkower, 'Chance, Time and Virtue', *Journal of the Warburg and Courtauld Institutes*, vol. i, 1937–8, pp. 313–21.

29. I quote from the translation by I. T. (1609) as printed in the Loeb Classical Library, 1918, pp. 131–2. For the background see T. Gruber, 'Die Erscheinung der Philosophie in der *Consolatio Philosophiae* des Boethius', *Rheinisches Museum für Philologie*, N.F., Frankfurt a.M., 1969.

30. W. Molsdorf, *Christliche Symbolik der mittelalterlichen Kunst*, Leipzig, 1926.

31. *Loc. cit.*, p. 177.

32. Howard R. Patch, *The Goddess Fortuna in Medieval Literature* (Cambridge, Mass., 1927). And A. Doren, 'Fortuna im Mittelalter und in der Renaissance', *Vorträge der Bibliothek Warburg*, 1922–3, pp. 71–144.

33. Hans Liebeschütz, *Fulgentius Metaforalis* (Leipzig, 1926) (Studien der Bibliothek Warburg, no. iv). About the author and the history of the genre see, above all, Beryl Smalley, *English Friars and Antiquity in the Early Fourteenth Century* (Oxford, 1960).

34. Liebeschütz, *op. cit.*, pp. 79 ff.:
 '... De pictura autem poetica caritatis sub ymagine dei Iovis notare possumus, quod Iupiter iste pingitur:
 Vertice curvatus, arena locatus,
 aquilis stipatus, cum palma sceptratus,
 auro velatus,
 vultus est amenus et color serenus;
 fulmen iaculatur et cornu cibatur.
 Iste sunt novem partes picture Jovinialis, quibus corespondent novem proprietates benivolencie et amoris. Nam Jupiter pingitur cum vertice curvato, quia pingitur cum capite arietis. Et bene convenit virtuti benivolencie et amoris, que virtus est capitalis et principalis inter ceteras virtutes. Aries enim dicitur ab Ares Grece quod est virtus Latine; et ideo capud istius virtutis est arietinum ad signandum dignitatis et perfeccionis excessum, quem habet caritas in ordine omnium aliarum virtutum. De cuius dignitate tractat Augustinus in diversis locis sicud 15. de trinitate. ...
 'Secunda pars picture est de Iovis situacione. Nam poete eum vocant Amon, id est arenosum; unde recitant poete:

Iupiter iste potissime colitus in arenis Libie, ubi solempne est templum deo Amoni, Iovi scilicet, dedicatum, sicud tangit Lucanus in sua poesi. Et istud proprium amoris veri et benivolencie se ostendere pro loco et tempore necessitatis et indigencie. Necessitas enim probat amicum, ut dicit Cassiodorus libro [de amicicia]; . . .

'Quia ergo arena est locus adversitatis, quia in arena consueverunt apud antiquos gladiatores pugnare et se mutuo interficere, ideo locus vere amicicie a poetis ponitur in arena. Et ideo signanter dicit Seneca in quadam epistula, quod ille errat, qui amicum querit in atrio vel aula. De isto multa essent notanda, que scriptura dicit sacra, sicud patet in proverbiis, in ecclesiastico et aliis locis.

'Tercia pars picture est de Iovis administracione. Nam poete fingunt aquilam armigerum dei Iovis; et ideo pingitur a poetis vallatus undique aquilis, sicud dominus aliquis magnus consuevit circumdari armigeris suis. Quomodo autem istud conveniat virtuti caritatis, pulcre docent auctores. Nam, ut docet Plinius in historia naturali, in aspectu et auditu aquile terrentur omnes aves alie et ex terrore aves, que sunt aves prede, cessant a predacione. Applicando ergo ad virtutem caritatis docet Hugo de sancto Victore in sua exposicione super regulam beati Augustini, quomodo demones, qui aliquando in scriptura dicuntur aves et celi volucres, quia sunt in celo . . . iste, inquam, aves nichil tantum timent in hominibus quantum caritatem. Si distribueremus totum, quod habemus, pauperibus, hoc diabolus non timet, quia ipse nichil possidet; si ieiunamus, hoc ipse non metuit, quia cibum non sumit; si vigilamus, inde non terretur, quia sompno non utitur. Sed si caritate coniungimur, inde vehementer expavescit, quia hoc tenemus in terra, quod ipse in celo servare contempsit. . . .'

35. See Beryl Smalley, quoted above, n. 33.
36. Frances Yates, *The Art of Memory* (London, 1956).
37. For this tradition see F. Saxl, 'Macrocosm and Microcosm in Medieval Pictures', *Lectures*, vol. I (London, 1957), pp. 58–72 with further bibliography.
38. Fritz Saxl, 'A spiritual encyclopedia of the later Middle Ages', *Journal of the Warburg and Courtauld Institutes*, vol. V, 1942, pp. 82–134.

39. Saxl, *loc. cit.*, p. 128.
40. Carlo Pedretti, *Studi Vinciani* (Geneva, 1957), pp. 54, after Giampaolo Lomazzo, *Trattato dell'arte della Pittura* (Milan, 1584), book VI, chapter 54.
41. Lomazzo, *loc. cit.*, VI, 55.
42. Rosamund Tuve, 'Notes on the Virtues and Vices', *Journal of the Warburg and Courtauld Institutes*, vol. XXVI, 1963, pp. 264–303 and vol. XVII, 1964, pp. 43–72; see also the same author's book, *Allegorical Imagery. Some medieval books and their posterity* (Princeton, N.J., 1966).
43. Emil Mâle, *L'art religieux de la fin du Moyen-Âge en France* (Paris, 1908), p. 335. See also R. Tuve, *loc. cit.*, part I, pp. 278 ff.
44. Erna Mandowsky, 'Ricerche intorno all' Iconologia di Cesare Ripa', *La Bibliofilia*, vol. XLI, 1939, and the same author's Hamburg dissertation, *Untersuchungen zur Iconologie des Cesare Ripa*, 1934, of which a duplicated copy is at the Warburg Institute.
45. Quoted from the Basle edition of 1586, *Praelectiones*, CCXXII, p. 731. See also B. Smalley, *op. cit.*, p. 180.
46. I quote from the edition of 1603, pp. 16–17.
47. See above note 1.
48. Cesare Ripa, *Iconologia*, ampliata da G. Zaratino Castellini (Venice, 1645), p. 568.
49. Francesco Patrizi, *De Regno et Regis Institutione* (Paris, 1567).
50. The mind remains unmoved and the tears flow in vain.
51. The last example comes from Aristotle's *Posterior Analytics* 96 where the theory of definition 'by division' is discussed.
52. For this belief see J. Seznec, *op. cit.*, chapter II, and this vol., pp. 119–122.
53. For the relation between 'attributes' and 'accidents' in Aristotle see e.g. *Posterior Analytics* 83.
54. See W. Bedell Stanford, *Greek Metaphor* (Oxford, 1936). The example here discussed comes from *Poetics* XXI.13.
55. cf. Giotto's representation of *Desperantia* in the Arena Chapel.
56. *Ad Pisones* 180–1.
57. Giarda, *op. cit.*, see Appendix, paragraphs 6 and 7.
58. *Phaedo*, 109–10. I quote from the translation by H. N. Fowler in the Loeb Classical Library, 1926, pp. 375–7.
59. *I Corinthians*, XIII.12.
60. Plato, *Laws*, II. 656D. I have discussed this

passage and its implications in *Art and Illusion* (London, 1960), chapter IV.

61. Hans Leisegang, *Die Gnosis* (Leipzig, 1924), p. 13.

62. Giarda, *op. cit.*, see Appendix, paragraphs 4, 5.

63. See above, Introduction, p. 14.

64. J. Seznec, *op. cit.*; see also Charles Trinkaus, *In Our Image and Likeness*, 2 vols. (London, 1970), chapter XV.

65. See D. P. Walker, 'Orpheus the Theologian and Renaissance Platonists', *Journal of the Warburg and Courtauld Institutes*, vol. XVI, 1953, pp. 100–20 and 'The *Prisca Theologia* in France', *ibid.*, vol. XVII, 1954, pp. 204–59; also Frances Yates, *Giordano Bruno and the Hermetic Tradition* (London, 1964).

66. *Jewish Antiquities*, I, 70–72, a story taken up in Petrus Comestor's *Historia Scholastica*. Migne, P. L., CXCVIII, col. 1079.

67. Giarda, *op. cit.*, see Appendix, paragraph 8.

68. *Oeuvres Complètes du Pseudo Denys L'Areopagite*, traduction, préface et notes par Maurice de Gandillac (Paris, 1943 and 1958), p. 191.

69. For the Neo-Platonic origin of these distinctions cf. Hugo Koch, *Pseudodionysius Areopagita in seinen Beziehungen zum Neuplatonismus und Mysterienwesen* (Mainz, 1900), pp. 208 ff.

70. Cf. E. Bevan quoted above, note 9.

71. Frederick Hartt, *Giulio Romano* (New Haven, 1958), vol. I, pp. 249–50.

72. Giovanni Pico della Mirandola, *Heptaplus*, ed. E. Garin (Florence, 1942), p. 188.

73. *Ed. cit.*, p. 192.

74. Giarda, *op. cit.*, see Appendix, paragraph 2.

75. Giarda, *op. cit.*, see Appendix, paragraphs 1, 2.

76. Erwin Panofsky, *Idea* (Leipzig-Berlin, 1924) (Studien der Bibliothek Warburg, no. V) (English translation, Columbia, 1968).

77. Giovanni Pietro Bellori, *Le Vite de' Pittori, Scultori et Architetti Moderni* (Rome, 1672), p. 370 f.

78. *Oesterreichische Kunsttopographie*, III, Hans Tietze, *Die Denkmale des politischen Bezirkes Melk* (Vienna, 1909), p. 197.

79. H. Tetius, *Aedes Barberinae* (Rome, 1642). For the programme to Sacchi's fresco see Giovanni Incisa della Rocchetta, 'Notizie inedite su Andrea Sacchi', *L'Arte*, vol. XXVII, no. 2–3, 1924, p. 64.

80. Torquato Tasso, 'Del Poema Eroico', *Opere* (Venice, 1735), vol. V, p. 367.

81. Plotinus, *Ennead*, V, 8 (see also chapter 6). See George Boas, *The Hieroglyphics of Horapollo* (New York, 1950), and F. Cumont, 'Le Culte Egyptien et le Mysticisme de Plotin', *Monuments Piot*, vol. XXV, 1921–2.

82. Ficino, *Opera Omnia* (Basle, 1576), p. 1768:
'*Sacerdotes Aegyptii ad significanda divina mysteria, non utebantur minutis literarum characteribus, sed figuris integris herbarum, arborum animalium, quoniam videlicet Deus scientiam rerum habet non tanquam excogitationem de re multiplicem, sed tanquam simplicem firmamque rei formam. Cap. VI.*
'Excogitatio temporis apud te multiplex est et mobilis, dicens videlicet tempus quidem est velox, et revolutione quadam principium rursus cum fine coniungit: prudentiam docet, profert res, et aufert. Totam vero discursionem eiusmodi una quadam firmaque figura comprehendit Aegyptius alatum serpentem pingens, caudam ore praesentem: caeteraque figuris similibus, quas describit Horus.'

The first to draw attention to this important passage was Karl Giehlow, 'Die Hieroglyphenkunde des Humanismus', *Jahrbuch der kunsthistorischen Sammlungen des allerhöchsten Kaiserhauses*, XXXII, 1915.

83. See G. Boas, *op. cit.*

84. See pp. 95–96.

85. Since Weinhandel, *Das aufschliessende Symbol*, has investigated the role of the visual symbol in the visions of St. Nicolaus of Flue various writers have dealt with this type of 'insight symbol', cf. Helen Flanders Dunbar, *Symbolism in Mediaeval Thought* (New Haven, 1929), and W. M. Urban, *Language and Reality* (London, 1939). Maybe this attitude towards the symbol can best be described as a blurring of the distinction between representation and symbolization in a particular direction. The symbol is thought to represent the entities it signifies. The Eastern mystic who meditates on the holy syllable 'Om' hopes to learn from its qualities (including the silence which precedes and follows it) something about the nature of the Divine. I have attempted to discuss some of the psychological implications of this approach in my address to the Annual Convention of the American Psychological Association, 'The Use of Art for the Study of Symbols'

The American Psychologist, XX, 1, January 1965, reprinted in J. Hogg (ed.), *Psychology and the Visual Arts* (Harmondsworth, 1969).

86. Mario Praz, *Studies in Seventeenth Century Imagery*, vol. 1 (Studies of the Warburg Institute, vol. 3) (London, 1939) (originally published as *Studi sul concettismo*, Milan, 1934).

87. Quoted in Praz, *op. cit.*, p. 53.

88. See Robert Klein, cited above, note 6.

89. Emmanuele Tesauro, *Il Cannocchiale Aristotelico* (Venice, 1655); I quote from the Venice edition of 1696.

90. *Loc. cit.*, p. 416, see Praz, *loc. cit.*, p. 56 f.

91. Scipione Bargagli, *La prima Parte dell' Imprese* (Siena, 1578). See also Praz, *op. cit.*, p. 60 f.

92. Henry Estienne, *The Art of Making Devices* translated into English by T. Blount (London, 1646), p. 13.

93. Camillo Camilli, *Imprese Illustri di diversi, co i discorsi* (Venice, 1586).

94. Jean Cousin, *Livre de Fortune*, ed. L. Lalanne (Paris and London, 1883), no. 86.

95. Cf. Rosamund Tuve, *Elizabethan and metaphysical Imagery* (Chicago, 1947), particularly pp. 371 ff.

96. Girolamo Ruscelli, *Le Imprese Illustri* (Venice, 1566), pp. 363–9.

97. *Henry IV*, Part I, Act I, scene 2.

98. W. Bedell Stanford, *Greek Metaphor* (Oxford, 1936).

99. Cicero, *De Oratore*, III, 155. I quote from the translation by E. W. Sutton in the Loeb Classical Library, 1942.

100. Cicero, translation after *ed. cit. loc. cit.*

101. For a recent discussion and bibliography of Metaphor, see C. C. Anderson, 'The Psychology of Metaphor', *The Journal of Genetic Psychology*, vol. 105, 1964, pp. 53–73; see also Max Black, *Models and Metaphors* (Ithaca, 1962).

102. The allusion is mainly to Benjamin Lee Whorf, *Language Thought and Reality* (New York etc., 1956).
Here as always I am indebted to Sir Karl Popper, who has made me see both the interest and the limitations of Whorf's hypothesis: Language need be no barrier to critical thought.

103. Cicero, *De Oratore*, III, 161, translation after *ed. cit.*

104. R. L. Colie, *Paradoxia Epidemica. The Renaissance Tradition of Paradox* (Princeton, N.J., 1966).

105. L. Volkmann, *Bilderschriften der Renaissance* (Leipzig, 1923), p. 17.

106. Dionysius, *ed. cit.*, p. 182: For the antecedents of this doctrine see Peter Crome, *Symbol und Unzulänglichkeit der Sprache*, Munich, 1970.

107. M. Ficino, *Sopra lo Amore ovvero Convito di Platone*, ed. G. Rensi (Lanciano, 1914), Orazione VII, chapter 13:
'De lo amore divino, e quanto è utile, e di quattro spezie di furori divini
'. . . Il furore divino è una certa illustrazione della Anima razionale, per la quale, Dio, l'anima da le cose superiori a le inferiori caduta, senza dubbio da le interiori a le superiori ritira. La caduta della Anima da un principio dell' universo infino a' corpi, passa per quattro gradi, per la mente, ragione, oppenione e natura. Imperocchè essendo nell' ordine delle cose sei gradi, de' quali il sommo tiene essa unità divina, lo infimo tiene il corpo: ed essendo quattro mezzi i quali narrammo, è necessario qualunque cade da 'l primo insino a l'ultimo, per quattro mezzi cadere. Essa unità divina è termine di tutte le cose e misura: senza confusione e senza moltitudine. La mente Angelica è una certa moltitudine di Idee: ma è tale moltitudine che è stabile e eterna. La ragione della Anima è moltitudine di notizie e d' argomenti, moltitudine, dico, mobile, ma ordinata. L' opinione ch' è sotto la ragione, è una moltitudine di immagini disordinate, e mobili: ma è unita in una sustanzia e in un punto. Conciò sia che la Anima nella quale abita la opinione, sia una sustanzia la quale non occupa luogo alcuno. La natura, cioè la potenzia del nutrire che è da l' Anima, e ancora la complessione vitale, ha simili condizioni: ma è per i punti del corpo diffusa. Ma il corpo è una moltitudine indeterminata di parti e d' accidenti, suggetta al movimento, e divisa in sustanzie, momenti e punti. L'Anima nostra risguarda tutte queste cose: per queste discende, per queste saglie.'

108. Ficino, *op. cit.*, chapter 14.

109. Goethe, *Faust* I, Hexenküche:
'Ich kenn' es wohl, so klingt das ganze Buch;
Ich habe manche Zeit damit verloren,
Denn ein vollkommner Widerspruch
Bleibt gleich geheimnissvoll für Kluge wie für Thoren.'

110. The connection between this tradition and

Florentine Neo-Platonism is traced fully by Will-Erich Peuckert, *Pansophie, Ein Versuch zur Geschichte der weissen und schwarzen Magie* (Stuttgart, 1936 and Berlin, 1956).

111. Goethe's *Faust*, Parts I and II (abridged) translated by Louis MacNeice and E. L. Stahl (London, 1965), pp. 21–2.

112. *Geheime Figuren der Rosenkreuzer aus dem 16. und 17. Jahrhundert* (Altona, 1785; reprinted Berlin, 1919). I have chosen plate 8, intended to show 'how three kinds of world have their effects in this world, the terrestrial sun-world, the heavenly and the infernal, and also how the Land of the Dead (the limbo and utter darkness) . . . no less than the Land of the Living and heavenly Paradise or the Third Heaven, are not outside this world. And that man harbours all things, heaven and hell, light and darkness, life and death, in his heart.' The three worlds are shown as intersecting circles enclosed in the divine circle and all sharing the central area of the heart. The inscriptions and pictographs facilitate interpretation and meditation. H. Birven, *Goethes 'Faust' und der Geist der Magie* (Leipzig, 1924), pp. 75 ff., points to Georg von Welling, *Opus Mago-Cabbalisticum et Theosophicum* (Hamburg vor der Hoher, 1735), p. 96. For a cosmic diagram of this kind, Harold Jantz, *Goethe's 'Faust' as a Renaissance Man* (Princeton, N.J., 1951), pp. 61 ff., refers to the pictures found in the writings of Fludd and similar works.

113. For an analysis of this book and its implications see D. P. Walker, *Spiritual and Demonic Magic from Ficino to Campanella* (London, 1958) (Studies of the Warburg Institute, vol. XXII), and Frances A. Yates, *Giordano Bruno and the Hermetic Tradition* (London, 1964), especially chapter 4.

114. F. Saxl, *Antike Götter in der Spätrenaissance* (Studien der Bibliothek Warburg, VIII), p. 17: 'Dieser Begriff der Form entspricht der Rolle des Namens in der Zauberei. Beide sagen etwas über das Wesen des Dinges aus.' Cf. G. Santayana's remark on the Judgment of Paris: 'The disrobing of goddesses . . . does not conform to my principles of exegesis, and I pronounce it heretical. Goddesses cannot disrobe, because their attributes are their substance.' (*Soliloquies in England and later Soliloquies*, London, 1937, p. 241.)

115. *Opera Omnia*, p. 355.

116. Frances A. Yates, *The French Academies of the Sixteenth Century* (London, 1948) (Studies of the Warburg Institute, vol. XV), pp. 36 ff.

117. Battista Fiera, *De Iustecia Pingenda*, ed. and trans. James Wardrop (London, 1957). See also my paper quoted above, note 12.

118. Migne, *PL* LXXVI, col. 1251. In Gregory the name may only signify 'power', but in popular literature the identity of names seems to have led to an identity of concepts. Cf. C. S. Lewis, *The Allegory of Love* (Oxford, 1936), p. 86: 'The seven (or eight) Deadly Sins, imagined as persons, become so familiar that at last the believer seems to have lost all power of distinguishing between his allegory and his pneumatology. The Virtues and Vices become as real as the Angels and the Fiends.'

119. P. Lomazzo, *Trattato dell'arte della Pittura*, etc. (Rome, 1844), book VII, chapter iii.

120. Cf. E. v. Möller, 'Die Augenbinde der Justizia', *Zeitschrift für christliche Kunst*, XVIII, 1905.

121. Cf. A. Warburg, *I Costumi Teatrali per gli Intermezzi del 1589*, ed. cit., esp. p. 280, where it is shown that certain emblems were in fact invisible to the audience and that even intelligent and learned observers remained ignorant of the true significance of these figures.

122. Giovanfrancesco Pico della Mirandola, *Strix, sive de ludificatione daemonorum* (Bologna, 1523), liber II. For the Neo-Platonic theory of visual manifestations cf. Ficino, ed. cit., pp. 876 and 938. The former passage is noteworthy because it refers to those 'good demons' who are wedded to their (spiritual) body and who 'preside' over certain animals, fruits, temperate winds, good weather, and—among us men—over the arts and music, medicine, gymnastics, etc. We are again at the frontier between demonology and allegory.

123. Cf. Dante, *Paradiso*, IV, 40 f., where the doctrine of accommodation is given in the rational Thomistic form. For his sources cf. G. A. Scartazzini's edition (Leipzig, 1882), III, pp. 88 ff. See also this volume, p. 26.

124. Cf. K. Lange, *Der Papstesel* (Göttingen, 1891); A. Warburg, *Heidnisch-antike Weissagung in Wort und Bild zu Luther's Zeiten*, ed. cit., p. 524; H. Grisar, S.F. and F. Heege, S.J., *Luthers Kampfbilder*, Lutherstudien, V, 3, 4 (Freiburg, 1923).

125. Modern art and literature provide a number of interesting examples of this type of influence. The impact of theories like those of Freud or Jung extends much further than the small circle of those who read and understood the technical writings in which these ideas were first expounded. Some of the catchwords derived from these theories were often distorted beyond recognition but this did not deprive them of their fascination and influence. The attraction and effect of 'Platonic' words like *idea* or *furore* may well be compared to that of terms like 'unconscious', 'symbol', 'pattern' or 'integration', which become heavy with vague but emotional significance.

126. Giarda, *op. cit.*, see Appendix, paragraph 7.

127. Galileo Galilei, *Dialogo dei due Massimi Sistemi del Mondo, Le Opere di Galileo Galilei*, edizione nazionale (Florence, 1933), vol. 7, pp. 129–31.

128. Joseph Addison, *Dialogue on the Usefulness of Ancient Medals* (London, 1726), pp. 30–1.

129. See above, p. 123.

130. Cf. Reynolds, *Discourses*, IV. 'A history painter paints man in general; a portrait painter, a particular man, and consequently a defective model.'

131. I do not wish to imply that these remarks exhaust the problem of the universal in art. But the word 'abstract' is rather apt to confuse the problems involved. As I. A. Richards observed in relation to his own field of study: 'It is perhaps important to insist . . . that abstract thinking is not a highly specialised sophisticated intellectual feat . . . the simplest organism when its behaviour is selective is abstracting. . . . English philosophical thought . . . was distracted into fruitless argument by a blunder about this. . . . it was supposed that the mind began with concretes and then performed a peculiar operation which resulted in abstract ideas. But the mind is primordially abstractive; of whatever it handles it takes some aspects and omits others. . . .' (*Interpretation in Teaching*, London, 1938, p. 380.) See also the title essay of my *Meditations on a Hobby Horse* (London, 1963) and my *Art and Illusion* (London, 1960).

132. See my review of Charles Morris, *Signs, Language and Behaviour* (New York, 1946),

The Art Bulletin, vol. XXXI, 1949, pp. 70 ff.

133. There are a few satirical remarks about this usage in the lecture by Jakob Burckhardt of 1887. 'Die Allegorie in den Künsten', *Gesamtausgabe*, vol. XIV, ed. E. Dürr (Stuttgart, 1933).

134. For the history of this divergence see Karl Bühler, *Sprachtheorie* (Jena, 1934), pp. 185–6, and Lieselotte Dieckmann, 'Friedrich Schlegel and Romantic Concepts of the Symbol', *Germanic Review*, 1959. In 1827 C. F. v. Rumohr ridiculed the vogue of the term symbol in his *Italienische Forschungen* (ed. J. v. Schlosser, Frankfurt, 1920), p. 21. For the history of the French usage of the term see Lloyd James Austin, *L'Univers Poétique de Baudelaire* (Paris, 1956), chapter I. In what follows I have drawn on my paper on The Use of Art for the Study of Symbols, quoted above, note 85.

135. '*The New Science*' of Giovanni Battista Vico, translated from the 3rd edition by T. G. Bergin and M. H. Fisch (Ithaca, 1948), para. 435.

136. Vico, *ed. cit.*, para. 378.

137. Vico, *ed. cit.*, para. 405.

138. See above, p. 141.

139. Vico, *ed. cit.*, para. 487.

140. Ernest Lee Tuveson, *Millennium and Utopia* (Berkeley etc., 1949), especially the appendix, 'The Age of Fable and an Approach to Romanticism'.

141. Arnaldo Momigliano, 'Friedrich Creuzer and Greek historiography', *Journal of the Warburg and Courtauld Institutes*, vol. IX, 1946, pp. 152–63, and Ernst Howald, *Der Kampf um Creuzers Symbolik* (Tübingen, 1926).

142. Quoted in Howald, *op. cit.*, pp. 63–8.

143. G. W. F. Hegel, *Sämtliche Werke*, ed. H. Glockner (Stuttgart, 1927), vol. XII. (*Vorlesungen über die Aesthetik*, part II, section I, *ed. cit.*, p. 407.)

144. *Ed. cit.*, p. 480.

145. *Ed. cit.*, p. 420.

146. Johann Jakob Bachofen, *Oknos der Seilflechter*, ed. M. Schroeter (Munich, n.d.).

147. M. Dorer, *Historische Grundlagen der Psychoanalyse* (Leipzig, 1932).

148. R. A. Scherner, *Das Leben des Traumes* (Berlin, 1861).

149. Yolande Jacobi, *Complex, Archetype, Symbol* (New York, 1959).

Bibliographical Note

Details of those papers in this volume previously published are as follows:

TOBIAS AND THE ANGEL. *Harvest*, 1: Travel, 1948, 63–67.

BOTTICELLI'S MYTHOLOGIES. A STUDY IN THE NEO-PLATONIC SYMBOLISM OF HIS CIRCLE. *Journal of the Warburg and Courtauld Institutes*, 8, 1945, 7–60.

AN INTERPRETATION OF MANTEGNA'S *PARNASSUS*. *Journal of the Warburg and Courtauld Institutes*, 26, 1963, 196–8.

HYPNEROTOMACHIANA. *Journal of the Warburg and Courtauld Institutes*, 14, 1951, 120–5.

THE SALA DEI VENTI IN THE PALAZZO DEL TE. *Journal of the Warburg and Courtauld Institutes*, 13, 1950, 189–201.

THE SUBJECT OF POUSSIN'S *ORION*. *The Burlington Magazine*, 84, 1944, 37–41.

ICONES SYMBOLICAE: PHILOSOPHIES OF SYMBOLISM AND THEIR BEARING ON ART. Originally published as 'Icones Symbolicae. The visual image in neo-Platonic thought', *Journal of the Warburg and Courtauld Institutes*, 11, 1948, 163–92.

LIST OF ILLUSTRATIONS
AND
INDEX

List of Illustrations

INDEX

242

JSC Willey Library
337 College Hill
Johnson, VT 05656

DAT